KITCHENER
The Road to Omdurman

KITCHENER

The Road to Omdurman

JOHN POLLOCK

CONSTABLE · LONDON

First published in Great Britain 1998
by Constable and Company Ltd
3 The Lanchesters, 162 Fulham Palace Road
London W6 9ER
Copyright John Pollock © 1998
The right of John Pollock to be identified as the author of this work
has been asserted by him in accordance with the
Copyright, Designs and Patents Act, 1988
ISBN 0 09 479140 6
Set in Monotype Poliphilus 12pt by
Servis Filmsetting Ltd, Manchester
Printed in Great Britain by
St Edmundsbury Press Ltd
Bury St Edmunds, Suffolk

A CIP catalogue record for this book
is available from the British Library

for

Henry Herbert
3rd Earl Kitchener

CONTENTS

CONTENTS

PART THREE:
FIGHTING FOR PEACE 1900–1902

ILLUSTRATIONS

Photographs snapped on the Omdurman Campaign by Captain the Hon Edward Loch, Grenadier Guards, afterwards Major General 2nd Lord Loch (Sir Hugh Stucley, Bt)
Wingate interrogates Mahmud; 'Friendlies' ready for action; Sudan Military Railway: Gunboat sections; Early morning toilet; The Grenadiers at ease, waiting for battle; 'Friendlies' do a War Dance; The Memorial Service for Gordon; A Lancer and a Grenadier hold Gordon's telescope; Father Brindle, DSO, the best loved man in the Expedition

Between pages 202 and 203

ACKNOWLEDGEMENTS

This book, the first of a two-part life, is based mainly on the very extensive Kitchener Papers now in the Public Record Office. They were deposited in 1959 by the Field Marshal's great-nephew, the 3rd Earl Kitchener of Khartoum and of Broome. I am most grateful to Lord Kitchener for allow-ing me unrestricted use of this material, which is his copyright, and for his great encouragement and the provision of material not in the PRO.

The Kitchener family have made the research and writing a delightful expe-rience by their enthusiasm and sharing of their own discoveries and impres-sions, and for kind hospitality to my wife and myself. In addition to Lord Kitchener, I particularly wish to thank Lady Kenya Tatton-Brown; the Hon. Mrs Charles Kitchener and her daughter and son-in-law, Emma and Julian Fellowes. Julian most kindly read the book in typescript and made excellent suggestions; his father, Mr Peregrine Fellowes, kindly shared impressions and memories of the Anglo-Egyptian Sudan. Mrs Peter Hall, granddaughter of General Sir Walter Kitchener, the Field Marshal's youngest brother, let me copy her valuable collection of letters, loaned me books and pictures and helped in other ways. Mrs Harriet King, great-granddaughter of Millie Parker, their sister, let me copy Kitchener's letters to her, especially valuable for his youth and young manhood. Mr John Chevallier Guild and his mother, Mrs Cyril Chevallier Guild, showed us round their moated manor where Fanny Kitchener (née Chevallier) was born and brought up. Mrs Ralph Toynbee (née Monins) shared childhood memories of her cousin, the Field Marshal.

The Royal Archives are a mine of fresh material, and I gratefully acknowledge the gracious permission of Her Majesty The Queen to quote from the journals of Queen Victoria, King George v and Queen Mary and from letters written by them, and to make use of other material in the Royal Archives and of material not in the Royal Archives but of which the copyright belongs to Her Majesty. I thank Mr Oliver Everett, CVO, Librarian at Windsor Castle, and the Registrar, Lady de Bellaigue, MVO, and her assistants, whose welcome and efficiency made my research a great pleasure.

The Royal Engineers, Kitchener's Corps, have again been very helpful and generous, as they were with my research on Gordon, and I thank warmly the Secretary of the Institute, Colonel M. R. Cooper, his predecessor, Colonel J. Nowers, and Dr John Rhodes and their staff.

For permission to quote or use copyright material (manuscript or printed) I thank the Marquess of Salisbury (and his archivist, Mr Robin Harcourt-Williams), Lord Birdwood, Lord Gainford, Sir Hugh Stucley, Bt., General Sir Anthony Farrar-Hockley, GBE, KCB, DSO, MC, Mr Duncan H. Doolittle, Mr Archie Hunter, Mr Henry Keown-Boyd, Mrs Lambert, Mr Philip Mallet CMG, Mr Richard Marker, Mr Kenneth Rose, CBE, and Mr Charles Sebag-Montefiore (Magnus Papers).

Many others have helped in one way or another and I thank: Dr Gordon Alexander, Lady Anne Bentinck, Mr Gavyn Arthur and Mrs Caroline Kenny, Miss Constance Biddulph, Mr Julian Byng, Dr George H. Cassar, Sir Howard Colvin, Mr John D'Arcy, The Revd Alan Duke, Rector of Barham, Kent, Lady Dunboyne, Mr Otto Fisher, Brigadier Denis FitzGerald, DSO, OBE, Desmond FitzGerald, Knight of Glin, FSA, Mr David Gordon, Mr Bryan Hall, Miss Hilary Heighton Harper of Foyle Fisheries, Professor Cameron Hazlehurst, Mrs Peter MacKinnon and Lady Mogg, the Diocesan Archivist (the Revd Father A. P. Dolan) of Nottingham (Roman Catholic) Diocese, Sir Godfrey Ralli, Bt., Sir Maurice Renshaw, Bt., Lord Richardson, LVO, FRCP, Dr Michael Robbins, CBE, FSA, Mrs E. Rogers, Mr John N. Ross, Mr Trevor Royale, The Revd Canon Michael Saward, Mr R. C. Stanley-Baker, Mr Richard Taylor and his daughter, Mrs Deborah Hinsch, Mr J. T. H. Thomson (Payne Hicks Beach), Colonel John Walker, Mr Allan Woodliffe and Mr Philip Ziegler, CBE.

I am grateful to the following institutions for advice on papers: the Army Historical Branch, the University of Birmingham Library Special Collections, the City Library of Dinan, France, the Local Studies Library of

Dover, the Sudan Archive of the University of Durham Library, Exeter City Library, Regimental Headquarters, Grenadier Guards, the Guild of St Helena, the Institute of Ophthalmology (University College, London), Regimental Headquarters, Irish Guards, Lambeth Palace Library, Liddell Hart Centre for Military Archives (King's College, London), the London Library, National Army Museum, Nuffield College, Oxford, Pretoria City Library, the Public Record Office, the Royal Army Chaplains Department, the Royal Norfolk Regimental Museum, the Worcestershire Regiment Museum, the Wellcome Institute for the History of Medicine.

A special word of thanks to the staff of the Public Record Office, especially Dr Alexandra Nicol and Mr Andrew McDonald.

For illustrations and maps I am grateful for the generosity of Lord Kitchener, the Hon. Mrs Charles Kitchener, Sir Hugh Stucley, Bt., Miss Elizabeth Blunt, Mr David Gordon, Mr A. A. de C. Hunter, Mrs Harriet King, the Institute of Royal Engineers and the Officers of the Royal Engineers. The portrait of Sir Walter Kitchener was bequeathed by his daughter Mrs Murray to the National Army Museum. I am grateful to Mrs Murray's daughter, Mrs Michael Butler, and niece, Mrs Peter Hall, and the Museum, and to Mr Christopher Hall who took the photograph.

To all these, and to any inadvertedly omitted, my warm thanks, and to Mrs J. E. Williams of Bideford who once again has impeccably typed my manuscript; and finally a very warm thank you to Mr Benjamin Glazebrook, my publisher, and his team at Constable.

JOHN POLLOCK
Rose Ash
Devonshire

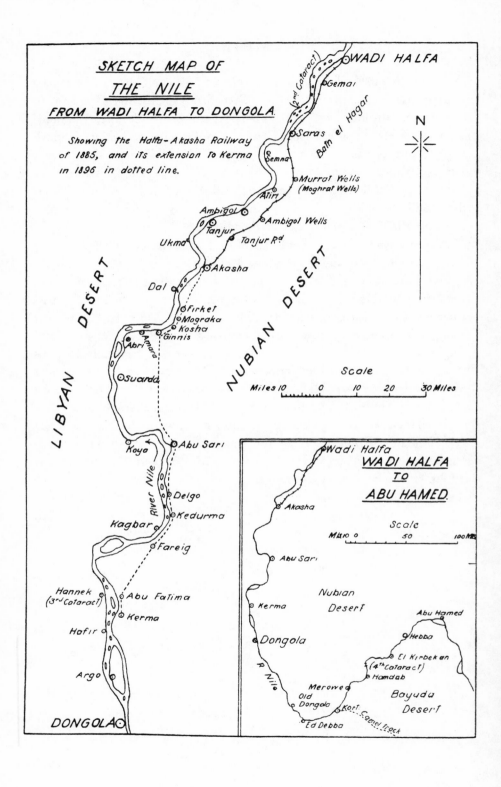

SKETCH MAP OF
THE NILE
FROM WADI HALFA TO DONGOLA.

Showing the Halfa-Akasha Railway
of 1885, and its extension to Kerma
in 1896 in dotted line.

N

WADI HALFA
Gemai
2nd Cataract
Batn el Hagar
Saras
Semna
Murrat Wells
(Moghrat Wells)
Atiri
Ambigol
Ambigol Wells
Tanjur
Ukma
Tanjur Rd
Akasha
Dal
Firket
Mograka
Kosha
Ginnis
Amara
Abri
Suarda

LIBYAN DESERT

NUBIAN DESERT

Scale
Miles 10 0 10 20 30 Miles

Koya
Abu Sari
River Nile
Delgo
Kedurma
Kagbar
Fareig
Hannek
(3rd Cataract)
Abu Fatima
Kerma
Hafir
Argo

DONGOLA

Wadi Halfa

WADI HALFA
TO
ABU HAMED.

Scale
Miles 10 0 50 100 Mls

Akasha

Abu Sari

Nubian
Desert

Kerma

Abu Hamed
Hebba
El Kirbekan
(4th Cataract)
Hamdab

Dongola

R. Nile

Merowe
Old
Dongola
Korti
Camel track
Ed Debba

Bayuda
Desert

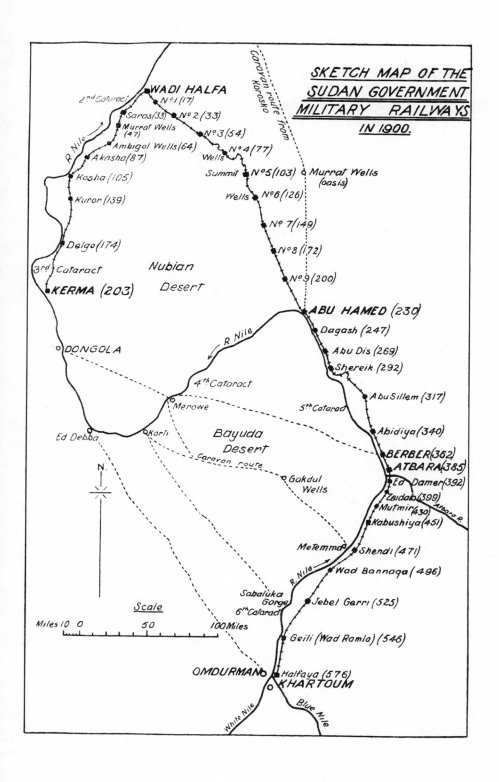

SKETCH MAP OF THE
SUDAN GOVERNMENT
MILITARY RAILWAYS
IN 1900.

Caravan route from Korosko

2nd Cataract

WADI HALFA
Nº1 (17)
Saras (33)
Nº2 (33)
Murrat Wells (47)
Nº3 (54)
Ambigol Wells (64)
Nº4 (77)
Akasha (87)
Wells
Kosha (105)
Summit
Nº5 (103)
Murrat Wells (oasis)
Kuror (139)
Wells
Nº6 (126)
Nº7 (149)
Nº8 (172)
Delgo (174)
Nº9 (200)
3rd Cataract
KERMA (203)
Nubian Desert
ABU HAMED (230)
Dagash (247)
DONGOLA
R. Nile
Abu Dis (269)
Shereik (292)
4th Cataract
Merowe
5th Cataract
Abu Sillem (317)
Ed Debba
Karli
Bayuda Desert
Abidiya (340)
BERBER (362)
Caravan route
ATBARA (385)
Gakdul Wells
Ed Damer (392)
Zaidab (399)
Mutmir (430)
Kabushiya (451)
MeTemma
Shendi (471)
R. Nile
Wad Bannaga (496)
Sabaluka Gorge
6th Cataract
Jebel Gerri (525)
Scale
Geili (Wad Ramla) (546)
Miles 10 0 50 100 Miles
OMDURMAN
Halfaya (576)
KHARTOUM
White Nile
Blue Nile
R. Nile
Arbara R.

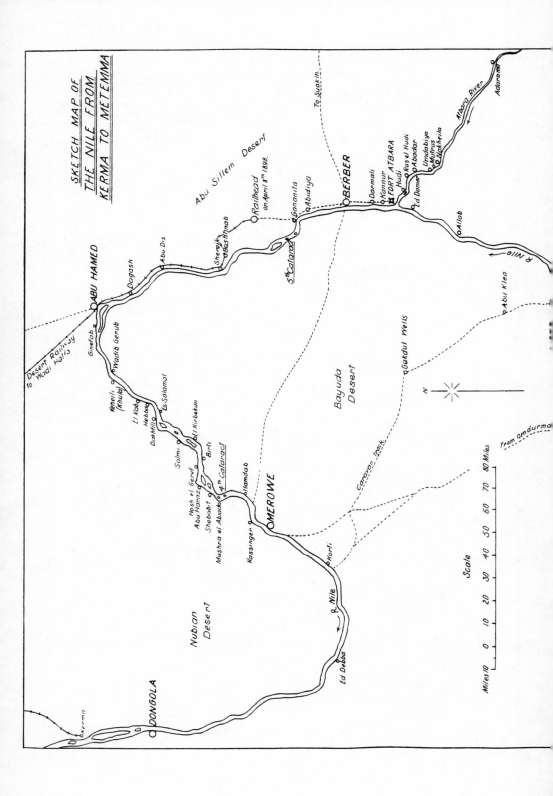

SKETCH MAP OF
THE NILE FROM
KERMA TO METEMMA

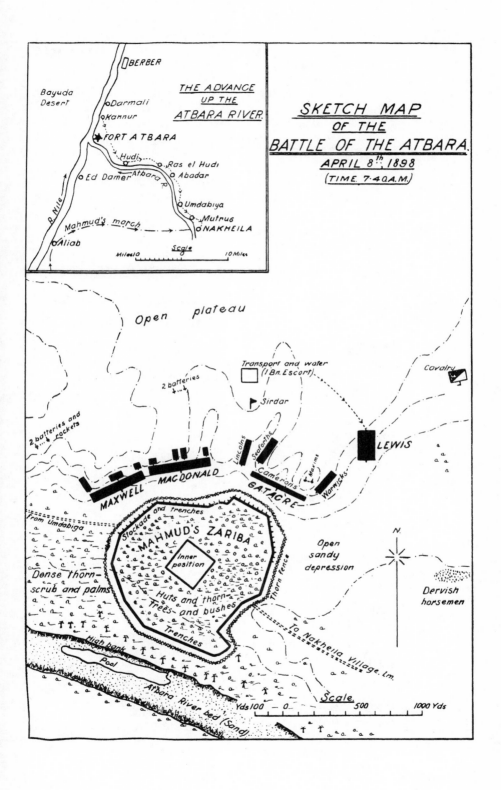

BERBER

Bayuda
Desert

Darmali
Kannur
★ FORT ATBARA
Hudi
Ed Damer Atbara R. Ras el Hudi
Abadar
Umdabiya
Mutrus
NAKHEILA
Mahmud's march
Aliab

R. Nile

THE ADVANCE
UP THE
ATBARA RIVER.

Miles10 Scale 10 Miles

SKETCH MAP
OF THE
BATTLE OF THE ATBARA.
APRIL 8th, 1898
(TIME 7·40 A.M.)

Open plateau

Transport and water
(1 Bn. Escort)

Cavalry

2 batteries

Sirdar

2 batteries and
rockets

Lincolns
Seaforths
Maxims
LEWIS

MAXWELL MACDONALD Camerons GATACRE Warwicks

Stockade and trenches

MAHMUD'S ZARIBA

from
Umdabiga

Inner
position

Open
sandy
depression

N.

Dense thorn-
scrub and palms

Huts and thorn
Trees and bushes

Thorn fence

Trenches

Dervish
horsemen

High bank

Pool

To Nakheila Village. 1m.

Atbara River bed (Sand)

Yds100 0 Scale 500 1000 Yds

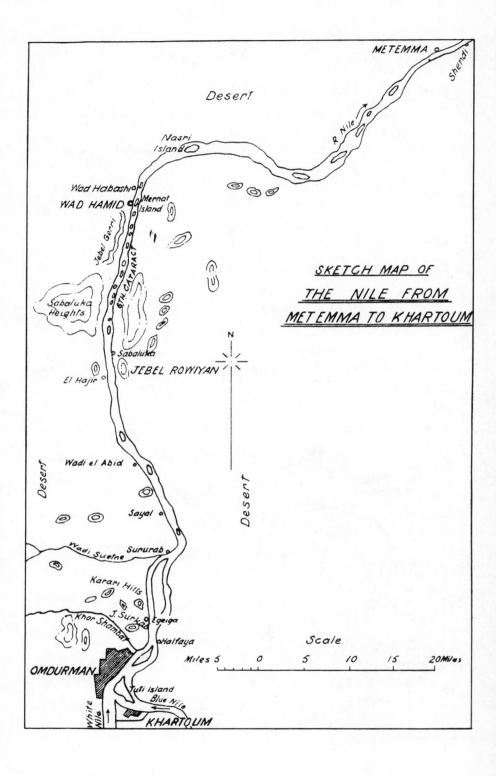

SKETCH MAP OF
THE NILE FROM
METEMMA TO KHARTOUM

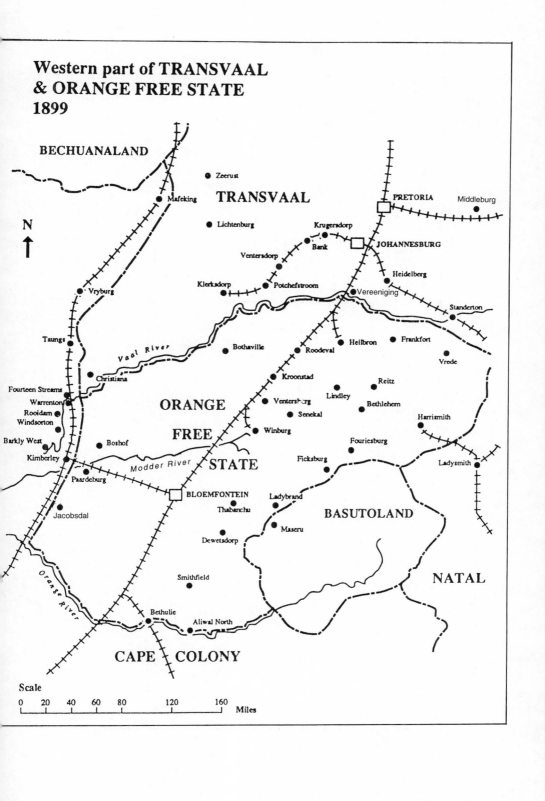

Western part of TRANSVAAL
& ORANGE FREE STATE
1899

Simplified Family Tree

KITCHENERS
of Lakenheath, Suffolk

2nd wife
William 1799 Emma
Kitchener = Cripps
(Tea Merchant, London) 1772-1853
1768-1807

Mary = Thomas William = Ann Philip = Elizabe
Clarke Kitchener Kitchener Orbett Kitchener Thornt
 1801-1837 (Solicitor, Newmarket) (Land Agent in Ireland)
 1803-1872 1807-1875

 EMMA = Wilham FRANCES = Francis
 Kitchener Day Elliott Hammond
 FRCS Kitchener 1838-1915
 (headmaster)
 1838-1915

Henry = Mary Thomas Florence = Alexander
Kitchener Laud Day 'COUSIN FLO' Marc
1865-1882| of Champneys
died in fire in
New Zealand
 Emma Green (♦) = Lt Col Henry Horatio
 Kitchener
 1805-1895
1 daughter
and 3 sons KAWARA Kitchener

 Eleanor Fanny 1877 (Henry Elliott) Chev
 Lushington = Kitchener
 d.1898 'CHEVALLY'
 (2nd Earl)
 1846-1937

 Adela 1916 Henry F. C. Nora 1908
 Monins = Kitchener Kitchener = Patr
 (cousin 'TOBY' 1882-1919 à Bec
 parents of 3rd Earl) 1878-1929

CHEVALLIERS OF ASPALL
Suffolk

The Rev Temple Chevallier

3rd wife
5th son = Elizabeth
The Rev John Cole
Chevallier of Aspall
1794-1846

3rd daughter = John
Harriet COBBOLD
d.1851 of Ipswich
d.1860

COBBOLD COUSINS

Emily = The Rev Richard
Chevallier Monins

Charles = Fanny
Chevallier Cobbold
of Aspall (cousin)

John = Edith
Monins Cobbold
(cousin)

Chevallier of Aspall
(now Chevallier-Guild)
(cousin)

ne) Frances
Chevallier

John
Monins

1916
Adela = Henry
Kitchener
TOBY
(Viscount Broome)
(cousin)

rances) Emily Jane = Harry
Kitchener Parkers
'MILLIE' 1837-1912
1848-1925

1869

(Horatio)
HERBERT
Kitchener
Field Marshal
1st Earl Kitchener
of Khartoum
1850-1916

1898
ARTHUR = Edith
Buck Paterson
Kitchener d.1908
1852-1907

1884
Lt Gen = Caroline
Sir (Frederick) Fenton
WALTER 'CARRY'
Kitchener 1856-1901
1858-1912

3 sons
2 daughters

2 daughters

Charles
1886-89

Henry
Kitchener
'HAL'
1890-1984

3
daughters

PROLOGUE: K OF K

ON AN EARLY autumn evening of 1898 an extraordinary number of Londoners converged on the terminus of the London, Chatham and Dover Railway at Victoria Station.

They came on foot, by carriages and hansom cabs, by the underground District Railway, which still used steam; one or two rich men drove up in new-fangled motor cars. Police and railway officials had not prepared for so many people, who pushed and jostled in great good humour, impeding the official welcome party that included the two royal princes who had served in the Sudan, the Secretary of State for War, and the greatest generals of the day, Lord Roberts and Lord Wolseley.

A special train from Dover was bringing Major-General Sir Herbert Kitchener, the victor of Omdurman, the liberator of the Sudan from tyranny, the man who had wiped out the disgrace of General Gordon's murder at the fall of Khartoum thirteen years before. Queen Victoria had created him a peer, telling him by telegram herself. The peerage had not yet been gazetted, but the nation already thought of him as Lord Kitchener of Khartoum, K of K.

As the train steamed in to the station the cheering, clapping crowd surged forward, almost engulfing the dignitaries. Passengers stood on the roofs of trains at other platforms. When Kitchener and his staff alighted, the police could hardly force a way through this 'remarkable demonstration of popular feeling', as *The Times* described it. Kitchener, who personally loathed public-ity, had caught the imagination of the country by his painstaking river cam-

[1]

paign, his two great battles, his most moving memorial service for Gordon in the ruins of the palace at Khartoum, and his calm diplomacy at Fashoda to avert a war with France.

Four years later Kitchener received an even greater if better-organized welcome when he was greeted at Paddington Station by George, Prince of Wales, and taken in a carriage procession through cheering thousands to St James's and then to the King, Edward VII, temporarily bedridden at Buckingham Palace. General Viscount Kitchener of Khartoum and the Vaal had returned the victor of the South African war and, above all, the negotiator of a most generous peace treaty of reconciliation between Boer and Britain which he had forced through in the teeth of British politicians who had demanded unconditional surrender and a vindictive peace.

Fourteen years later wartime London was stunned on a June morning in 1916 when news broke that Field Marshal Earl Kitchener, Secretary of State for War, the creator of the New Armies, had been drowned at sea with his staff by enemy action when HMS *Hampshire* was sunk off the Orkneys. His body was never recovered.

Kitchener was at the height of his prestige in the popular mind when he died, aged nearly sixty-six. He had always been a figure of controversy, hated or traduced by some, almost worshipped by others. After his death, criticisms and estimates abounded. Four years later his official biography appeared in three volumes by Sir George Arthur, his Private Secretary (civil) at the War Office. Arthur's well-documented book was inevitably somewhat bland, for many of those who opposed Kitchener were still active and their papers not available; he also had a tendency to describe savage battles as if sporting events, but his volume enhanced Kitchener's memory and formed the main source for lesser lives.

In 1958 Philip Magnus (Sir Philip Magnus-Allcroft) published *Kitchener: Portrait of An Imperialist*. Magnus had been loaned the entire Kitchener Papers, which afterwards were deposited in the Public Record Office by the 3rd Earl, the Field Marshal's great-nephew. Magnus was an elegant biographer and a literary figure of the day, but Kitchener's surviving relations and friends were indignant at his false view, as they saw it, of their Uncle Herbert.[1] Six years later Lady Winifred Renshaw, the widow of one of Kitchener's closest friends, writing to the 3rd Earl's brother, Charles Kitchener, added a PS: 'I don't know whether I told you of Magnus' remarks last year: "I know I've got the man wrong, too many people have told me so." When I protested at the

further sale, "I am waiting until I am asked to write another life of him, mean-while it is having a great sale in America."[2]

His interpretation, however, became standard. Despite two Kitchener biographies, both published in 1985, Magnus still colours the popular view.

It is time for a re-discovery based not only on the Kitchener Papers but on the Royal Archives and other papers in public or private hands. Kitchener's achievement was of great importance to the Britain of his day. His dramatic story remains relevant, not least because of his character — his true character, not the versions which became fashionable after his death. And that character was formed on the road to Omdurman.

PART ONE

'What a fellow Herbert is'

1850–1883

I

A LOVING,
AFFECTIONATE CHILD

In the autumn of 1849 Lieutenant-Colonel Henry Horatio Kitchener, newly retired, crossed over to Ireland and bought a bankrupt estate on the banks of the Shannon.

In the aftermath of the Great Potato Famine the British Parliament had passed the Encumbered Estates Act to attract fresh owners, whether Irish or English, who had capital to invest in the decayed and depopulated countryside. Colonel Kitchener was wholly English.

His first recorded ancestor was a Hampshire yeoman, Thomas Kitchener, born at Binsted near Alton in 1666. At the age of twenty-seven he was offered a chance to better himself when the local magnate, Sir Nicholas Stuart of Hartley Maunditt, who was already seventy-seven and lived to be ninety-three, needed a resident agent for his distant manor of Lakenheath in north-west Suffolk, on the edge of the fens. In 1693, therefore, Thomas Kitchener moved more than a hundred miles from Alton to manage the manorial lands for the rest of his life. He married, bought a farm of his own (or was given it by Sir Nicholas) and founded a new Kitchener dynasty in East Anglia.

His grandson Thomas kept the Lakenheath land but became also a dealer in tea at Bury St Edmunds, the nearby market town. He outlived his own eldest son, William, born at Lakenheath in 1768. William Kitchener migrated from Suffolk to London and became a prosperous tea merchant in the China trade. He rose in the social scale by marrying the daughter of a clergyman from an old Suffolk county family, but she died five years later leaving two sons. In 1799 he married Emma Cripps, again a clergyman's

daughter, well connected in Lincolnshire and Yorkshire. Through her mother, née Catherine Buck, Emma Kitchener was a first cousin of Sir Francis Wood, father of the first Viscount Halifax, and of the wife of Thomas Clarkson, the Abolitionist.

Emma brought up her stepsons and gave William sons of their own in quick succession. Two had died in infancy and two were in the nursery of their house in Bunhill Row in the City, the street where Milton had written *Paradise Lost,* when she gave birth to another son on 19 October 1805, two days before the Battle of Trafalgar. Inevitably, with their East Anglian connections, they gave him Nelson's name.

Henry Horatio Kitchener was only two years and eight months old when his father died suddenly, aged thirty-nine. The widow was left in comfort, and her elder stepson, who rose to be Master of the Clothworkers' Company, was generous, so that when Henry was twenty-four and decided to enter the army they helped him purchase a commission as a cornet in a cavalry regiment, the 13th Light Dragoons. His peacetime soldiering brought him no active service or distinction. He purchased his promotion to lieutenant, glorious in whisker and the regiment's distinctive blue, yellow and gold. To achieve his captaincy he exchanged into a less costly regiment, the 29th Foot (Worcestershires) in January 1841. He sailed with them to India in May 1842, landing near Calcutta in August.

He was already in love. He had often stayed with his next elder brother, William, in Newmarket. William's little girl Emma was his favourite niece. At the age of twelve, Emma went to share a governess with her great friend Fanny Chevallier (rhyming with *cavalier*) at Aspall Hall, a moated manor near Debenham in Suffolk. Henry Kitchener visited Aspall to see Emma and fell in love with Fanny, who was not yet old enough to marry.[1]

The Chevalliers were descended from the sixteenth-century Huguenot scholar Anthony Chevallier (who had also taught French to the future Queen Elizabeth 1) and were settled in Jersey until 1702, when Clement Chevallier bought the Aspall estate with its small Jacobean mansion. In 1728 he had sent to Normandy for a special stone wheel for crushing apples to make the Aspall cyder that became famous in East Anglia and later was widely exported. His descendant, Fanny's elderly father, the Reverend Dr John Chevallier, was both squire and parson ('squarson') of Aspall, a practical landowner who first cultivated the celebrated Chevallier barley. He had qualified as a physician before ordination and earned a doctorate of medicine for work on mental

affliction, then little understood: he was one of the earliest to treat it by kind-
ness. He added a storey to the house, putting his family upstairs and the
patients in the best rooms on the first floor, each with an inspection window.
In 1842 he had eleven boarders, three being certified lunatics. Fanny
Chevallier grew up accustomed to deranged or depressive patients wandering
in the garden. She was the youngest of a large family, as the reverend doctor
had been twice widowed before marrying Fanny's mother.[2]

Fanny (Anne Frances) was not quite nineteen when Captain Henry
Kitchener, aged thirty-nine, came back on home leave and married her at
Aspall in July 1845. They sailed at once, taking eighty-seven recruits for the
regiment, which Kitchener rejoined outside Lahore in February 1846, having
just missed the two battles of the brief but bloody First Sikh War. He was soon
promoted major, without purchase, on the death from wounds of Major Barr.
Six months afterwards he exchanged into the 9th Foot (later the Royal
Norfolks). The Kitcheners were stationed at Kussowrie in the foothills below
Simla when their eldest son was born in October 1846 and christened Henry
Elliott Chevallier. He was always known by his third name, pronounced
Chevally as the family had pronounced their name until the Napoleonic Wars.

The climate of India did not suit Fanny. Major Kitchener loved the army,
but he loved Fanny more and brought her back to England. Their second
child Frances Emily Jane ('Millie') was born in London in 1848. Battling
with ill health, his wife's and his own, he purchased a lieutenant-colonelcy and
went on half-pay, a form of reserve, and looked around for a livelihood.[3] To
recover his health he went to south-west Ireland on a visit to his younger
brother Phillip, who had recently become land agent to the Earl of Dunraven
at Adare in County Limerick, close to the Shannon estuary. Phillip suggested
setting up as a landowner in the neighbourhood since Irish land was so cheap
after the famine. In April 1850 Henry sold his commission and bought a bank-
rupt estate on the southern shore of the estuary between the little fishing ports
of Tarbert to the west and Glin in the east, about 160 miles from Dublin.
Called Ballygoghlan, it lay partly in the parish of Ballylongford, County
Kerry, and partly in County Limerick, 'a property', the colonel described it,
'beautifully situated but in a wretched state of farming,' so much so that the
agreement allowed him to pay by instalments over ten years.[4] The rambling
residence, formed by several detached buildings, stood in decay on a wooded
hill above the meadows sloping down to the estuary, with the shores of Clare
beyond.

The colonel began to restore it. Fanny was pregnant again. The hammering and sawing must not stop, so when her time neared in June 1850 he took her with four-year-old Chevally and two-year-old Millie a short distance to stay with a retired clergyman, Robert Sandes, and his wife at Gunsborough Villa, four miles north-west of Listowel. Here, on 24 June 1850, Fanny gave birth to her second son, whom they named Horatio Herbert but called him Herbert. He was not christened until December, when they were fully settled at Ballygoghlan and could ask the Sandes to come over to their Church of Ireland church outside Ballylongford, at Aghavallen. Two years later Fanny had a third son, Arthur Buck Kitchener, born at home.

Meanwhile the colonel was making a success of Ballygoghlan. Determined to farm much of it himself, he evicted a number of the small tenants on generous terms. He was not the cruel landlord of later legend. He waived the half-year's rent due, paid their rates and charges and bought their crops at valuation. Those who decided to emigrate to America could sell him their stock; those who wished to farm elsewhere could leave their cattle on his land until suited. He got 'all the land I wanted without any trouble, generally receiving the blessing of those who are represented in England as ready to murder under such circumstances'.

He used the smaller tenants as labourers, paying some seventy-five men and women to drain the land, make roads, carry turf and do other work under his Scots steward, who kept a sharp eye since they were inclined to be lazy. The land was fertile, and Kitchener soon found that under proper farming he could get good crops. He pioneered the use of lime on the land; he brought lime by the river and built a lime kiln, still standing, and sent off his crops by water. He also built a brick kiln and a pottery.

'I have received the greatest kindness from all ranks', he wrote in a letter to *The Times*, in which he urged more Englishmen to 'come over with capital to employ the poor and improve the land'. He had good neighbours of the Ascendancy, plenty of game, with 'yachting close by', and, confident of success, he was sinking 'all I am worth in the venture'.[5]

He brought in two young Englishmen to learn farming and assist him, but according to local legend he began to increase rents on tenant land which he had improved by draining, clearance and liming, and like many landlords of the time he would evict those who would not or could not pay. One of them, Seán MacEniry, was a poet who lampooned him in verse, claiming that the

colonel stank when he sweated and that to be thus afflicted by 'the Devil's fire' was a sign of utter depravity.

In 1854 the neighbouring Castle Glin estate, with the ancient title of Knight of Glin, passed to the highly eccentric John Fraunceis Eyre FitzGerald, who made the colonel his pet aversion. The peculiarities of 'The Cracked Knight' were famous. He would ride into neighbours' front halls, he would drink porter out of a chamber-pot, he used his horsewhip freely. He set his dogs on the bailiffs summoned by the colonel to evict tenants whose families had once been his own tenants, and later challenged him at Tralee races to a whipping match when he disgraced the colonel to the amusement of the crowd. The Knight of Glin called him 'Colonel Stinkener'; but this not uncommon affliction of stinking sweat (*bromidrosis*) is not mentioned by any of the colonel's family in later life, though they wrote frankly about him between themselves.[6]

By 1857 the colonel had prospered enough to buy a second, more profitable estate, twenty miles south-west. Crotta House, built in the reign of Charles I by a branch of the Anglo-Irish Ponsonbys, stood a mile and a half from the village of Kilflynn, half-way between Listowel and Tralee. The small mansion, in Elizabethan style, had beautiful well-timbered grounds and, being close to the hills, was better for Fanny's health. Crotta became the main Kitchener residence, the family migrating in summer to Ballygoghlan, which the children loved best, their first home, where each had a little garden to cultivate as they liked: Herbert showed early his love of flowers.

At Crotta, in September 1858, Fanny gave birth after a six-year gap to her youngest son Walter (Frederick Walter Kitchener, a future major-general and colonial governor). She was never really well again. 'Consumption' (tuberculosis) was gradually taking hold. Fanny was also rather deaf, presumably a congenital deafness because four of her five children were hard of hearing as they grew older. But the deafness skipped Herbert. His hearing was normal or he might never have been a field marshal.

In the autumn of 1858 a young woman joined the household as nanny, on her way to a career in schoolteaching. Sixty years later, as Mrs Sharpe, she wrote at Millie's request her memories of Herbert between the ages of eight and ten. She provides the earliest clear picture, although perhaps coloured a little by hero-worship, of the late field marshal, 'my ideal of all that was noble and good in manhood'.[7]

[11]

Writing at the age of eighty or more, she recalled with delight her arrival at Crotta, 'their beautiful home in sight and sound of the Kerry mountains covered with broom or heather with the waves dashing at the foot'. Chevally was now twelve and Millie ten. Her special charges were the two younger brothers and the baby, and of these three 'Herbert soon had an absorbing interest for me . . . the little boy with his serious face asking questions'. He had a fair complexion, light brown hair (which became darker as he grew up, but was always distinctively brown) and small pearly teeth; 'a sweet smile, grey penetrating eyes, which looked you through and through and a very soft deliberate *Yes*', which remained a characteristic. His eyes were generally considered blue rather than grey, and a very slight cast in one of them would become more noticeable after a war wound.

'He was a very loving, affectionate child,' remembered Mrs Sharpe, 'very reverent and earnest in everything he did and always ready to do a kind action, truthful and honourable to a degree in a little child of 8 or 9'.[8] Nanny did not find him solemn or lacking in fun, but he was specially tender-hearted to towards his invalid mother, who knew she was unlikely to see her children grown up and was particularly concerned for Herbert.

One day Nanny missed him, then found him hiding under a bed crying quietly because a heavy stone had fallen on his hand. She bathed and bound it and he then slept. At six o'clock, when she collected the children for them to see their mother lying on her couch in her bed-sitting-room, Herbert tore off the bandage, saying, 'Oh, please don't tell Mother'. He hid his hand all the time they were with her. His young Nanny said nothing at the time but, duty-bound, mentioned it the next day. His mother commented: 'Herbert is so very reserved about his feelings, I am afraid he will suffer a great deal from repression'. She had spotted a lifelong facet of his character.

The colonel certainly expected a stiff upper lip. He ran the household with military order and discipline, backed by forceful language.[9] He was a stickler for punctuality. He scolded a servant who brought breakfast to the dining-room one minute after eight, and Nanny saw the lady's maid, Sarah, standing outside Mrs Kitchener's room with the breakfast tray on one hand and a watch in the other, awaiting the precise hour to enter. Mrs Sharpe was not surprised, years later, to hear that her former charge was a rigid disciplinarian: 'it was bred in him'.

No firm evidence suggests that the colonel was a tyrant, frustrated by missing the Crimean War or the Indian Mutiny; he was training his boys for the army. The children respected and a little feared him. Once Nanny went to

fetch Herbert and found him with dirt on his hands and pinafore, hair ruffled, not at all a young gentleman. He often dirtied himself helping the farm labour-ers to sort potatoes or pack peat ready for the winter fires. The steward, Stephens, said he would rather have Master Herbert pack the turf than any man on the estate: 'he is particular about making them fit in so that they never fall'. This evening he had been in a barn trying to do a kindness to bats. Nanny told him that the colonel was in the hall talking to the Kilflynn shoemaker. She hoped Herbert could slip by, 'but nothing escaped the colonel's quick eye. "Come here, sir." The poor boy hung his head. "A nice pickle you are!"'

The colonel turned to Nanny and said they had better get a sack, make holes for his arms and tie it around Herbert's neck. 'Then he smiled so the poor boy knew he was not angry'. Nanny recounted the incident to Mrs Kitchener. 'Let him wear it,' she said. 'He is different from other boys. He does not need to do it now, the knowledge may be useful in years to come. At any rate, there is the kindly action'.

Their mother encouraged Herbert and Arthur to recount the events of the day and each to recite a hymn or read a New Testament passage which she would then explain. Herbert was not a good reader, but Nanny, as devout a Christian as her mistress, noticed that he was quick to grasp a truth or an idea and would never forget what he was told if it were important – an early indica-tion of an exceptional memory. One evening, after several doctors had been at Crotta for a consultation and servants' gossip had exaggerated his mother's danger, Herbert was 'very thoughtful and very tenderly said, "Are you better, Mother?"' She replied that she was a little easier and asked if he had anything to tell her. Herbert had chosen a verse from a hymn-book on Nanny's table about 'a calm, a sure retreat . . . found beneath the mercy-seat'.[10] His mother explained the mercy-seat (an Old Testament symbol). 'It means,' she said, 'being alone with God in prayer. Try and remember all through life in any trouble, any difficulty, any perplexity or sorrow, go alone in prayer to the mercy-seat. Do you understand me?'

That night he asked Nanny if he might say his prayers alone instead of in her hearing, the custom in most nurseries. 'Then I knew he wanted to be alone with God'. Next morning he found his mother looking no worse and was happy, unaware that 'consumption' had then no permanent cure.

The children were affectionate among themselves. 'I never remember hearing them quarrel', Nanny Sharpe recounted. 'They led a very simple country life,

no playfellows, no expensive toys'. They all rode and hunted with the local packs, and as children of a soldier they probably played out mock campaigns in the woods and seem to have imposed pretence field punishments on each other if the story is true that Herbert was once found pegged out under a hot sun, tied uncomplainingly to croquet hoops in lieu of the wagon wheel of Field Punishment No. 1.[11]

As for education, the colonel would not send his elder sons away to public school in England or Dublin. Many gentry families of the period still preferred to use tutors, yet the colonel's choice of Church of Ireland clergymen was not a success. A clever young nephew, Francis Elliott Kitchener, came to stay. He was on the threshold of an academic career as Fellow of Trinity College, Cambridge, assistant master at Rugby under Temple and then headmaster of a Staffordshire high school.[12] The colonel asked Frank to examine the boys. He reported of Herbert that he had never known a boy more totally devoid of any groundwork of education but that he was quick to appreciate a work of art.[13]

If devoid of classical knowledge, Herbert was learning about estate man-agement and rural improvement, about cattle and horses, crops and timber. He took a particular interest in his father's operations to drain the marshes and add to his fields. Even fifty years later, when Herbert, now a field marshal and peer, revisited Crotta, he could remember the Irish names of all the fields.[14] As he grew taller, though not yet strong, he liked working with the farm hands. Taking for granted his parents' assumption that Protestant landlords were superior to Catholic peasantry he was the reserved young master, who could not display the warmth he would always feel for the poor.

When he became famous any local memory of 'Colonel Kitchener's boy' would tend to be linked to Herbert. Thus a Kerryman recalled that on market-days the landlord of the Listowel Arms hotel had instructions to refuse the boy breakfast until he had sold the cattle.[15] 'The boy' was more likely to have been Chevally, nearly seventeen, than Herbert, who was aged about twelve. And the boy who rode up to the estate workers as they felled timber and was dis-pleased and struck young Jamesey Sullivan with his riding crop sounds like Chevally. Jamesey, temper flaring, knocked the young master off his horse; he fell against a tree and landed insensible, to the horror and fear of the men, who might all be dismissed, if not prosecuted. The sequel, however, sounds like Herbert, for when he came round he made light of it and won the respect of the men by refusing to tell his father or have Jamesey punished.[16]

By 1863, with Herbert turning thirteen, his father was more accepted as an agricultural expert and the land was improving, but Fanny Kitchener was declining.* The doctors insisted that she could never recover, in the moistness of south-west Ireland. They urged Switzerland where the mountain air was a standard cure for tubercular and bronchial diseases before the discovery of penicillin. The colonel did not hesitate. He sold Crotta and beloved Ballygoghlan.

Thus Herbert Kitchener left Ireland before his thirteenth birthday. He never thought of himself as Irish or Anglo-Irish, his parents having come to Ireland only a few months before his birth. His Irish years had given him an unusual if deficient early education, with an emphasis on mathematics and history rather than on the classics. His home had moulded him to be at ease with his close-knit family but shy with others. He had absorbed a simple Christian faith from his mother and Nanny and the eager if small congregation of Kilflynn church. His future attitudes suggest that he did not feel estranged from those who worshipped differently.

He had absorbed the social structure of home and neighbourhood. He accepted his father's right to command him and the peasantry's duty to obey him, yet he must oversee every detail. And his mother had taught him to care for the poor.

* The legend that the colonel contributed to her decline by insisting that they sleep in sheets of newsprint and not in linen is nonsense. He adopted this foible only several years after her death. Madge Kitchener to Sir Philip Magnus, 3 November 1958. Magnus papers. Another view in the family is that the habit should be attributed to his eldest son, not to the colonel.

2

NO CRICKET
AT 'THE SHOP'

Davos was not identified as the best place for consumptives until 1865. In 1863 the Kitcheners went to the little spa of Bex above the right bank of the Rhône as it left the Valais to flow to Lake Geneva. The three elder boys were sent to a French school at the other end of the lake near Geneva. Their Chevallier blood helped them to pass from the stilted schoolroom exercises of Crotta to an easy fluency in French, with passable German.

Bex failed to halt Fanny's disease. The Kitcheners moved the few miles to Montreux on the northern lake shore, where the pure air, soft climate and mountain views had attracted a British colony of invalids and retired officers or their widows. Fanny continued to decline. The boys were summoned. During the summer of 1864, when Herbert was turning fourteen, the mother he adored and trusted, who understood his shyness and his hopes, died at the age of thirty-nine and was buried in the graveyard of Christ Church, Clarens, the English church of Montreux. (In the 1930s the land was required for railway lines and she now lies in Aspall.)

Her death was the great sorrow of his life. Ever after, he sought to live as she would have wished. He placed women on a pedestal, to be honoured as he had honoured her. Her death increased his shyness and his tendency to repress which his mother had noticed, and his inner loneliness; perhaps retarded his sexual development. The full effect cannot be measured because he revealed so little of his feelings.

Chevally went to England to a crammer and then to the Royal Military College at Sandhurst. The colonel decided to stay on in Montreux with Millie

[16]

and placed Herbert, Arthur and seven-year-old Walter at the English board-ing-school run by Bennett, the chaplain of Christ Church, at the Château de Grand Clos, five miles to the south in the village of Rennaz, outside Villeneuve. Bennett specialized in educating boys who were expecting to work away from England; other pupils were the sons of British subjects living in Switzerland. With such a disparate lot, the shock for the half-educated Kitcheners was probably less than if they had been thrown into an English public school.

The next two and a half years are a biographical shadowland with no con-temporary evidence except a brief undated letter from the Rennaz school in which Herbert tells his father that Walter has stomach ache.[1] A curious item in the George Arthur papers may indicate that Herbert hated the school and washed it from his memory.[2] To make matters worse, he and Walter soon had no home, for the colonel went off to New Zealand. He had used capital from the sale of his Irish properties to invest in land in the South Island. Gold had been found in the province of Otago and he was persuaded that raising sheep would be profitable. After purchasing a commission for Chevally in the 46th (Duke of Cornwall's Light Infantry), the colonel decided to inspect and develop his New Zealand estate.

Before leaving Switzerland he married Millie's music mistress, (Mary) Emma Green, at Berne on 10 January 1867. He took her and Millie, now eighteen, and Arthur, but not Herbert or little Walter. Herbert had set his heart on the Royal Engineers (his father would have preferred the cavalry but agreed), and a voyage to New Zealand would disrupt his preparation. Arthur, on the other hand, had no wish for the army; he wanted to be a mining engineer or an agriculturalist and ended by being both. New Zealand, and the excellent high school at Dunedin, would be useful to Arthur. Walter, aged eight and destined for the army, was left at de Grand Clos in the care of Herbert.

The colonel settled at Waihemo Grange, north-west of Palmerston and below the Horse Range hills. The next run was owned by Sir Francis Bell, one of the pioneers of New Zealand, an expert on Maori affairs and a member of the first representative ministry after the grant of self-government. Late in 1867 the colonel's only child by his second marriage was born in New Zealand and christened Henrietta Emma Kawaru. She was always known as Kawaru, after the Kawaru gorge and river in the centre of Otago province, where perhaps they had spent a holiday.

With their father on the other side of the globe, Herbert and Walter would have spent the holidays at Aspall with their grandmother and Uncle Charles, now the 'squarson'. Herbert always had a great love for Aspall. Uncle Charles had married a Cobbold, of the rich Suffolk brewing family who were already related to the Chevalliers, so that Herbert had many Cobbold cousins. He would also have stayed with his Aunt Emily, his mother's sister, who had married a Suffolk clergyman, John Monins.* Their son, John, became Herbert's great friend.

In 1867 Herbert left the Swiss school to cram for Woolwich, staying partly with his cousin Frank Kitchener at Rugby or in his rooms at Trinity College, Cambridge, before Frank had to vacate his fellowship on marriage, and partly in Kensington with a well-known crammer, George Frost.

Between them, with his own hard work, they educated him enough to pass the examination and win a place at the Royal Military Academy, coming twenty-eighth in a list of sixty successful candidates.[3] In February 1868 he joined the army as a gentleman-cadet at Woolwich, aged seventeen years and seven months.

The Royal Military Academy (nicknamed 'the Shop') stood on Woolwich Common a short distance south of the arsenal and the old dockyard on the Kentish bank of the Thames. The Shop prepared youths for commissions in the Royal Regiment of Artillery and the Corps of the Royal Engineers. Future gunners and future sappers trained and drilled together. Discipline was strict, hours long, but over the preceding twenty years, after various riots and reforms, the food and living conditions had improved. The age of entry had risen. The Shop was less of a cross between a public school and a recruit barracks and growing more like a university college under arms. Inevitably there was plenty of horseplay, but less bullying, and because their commissions could only be earned, not purchased as in the cavalry and infantry, cadets at Woolwich had a strong incentive to work.

The records of Kitchener's career at the Shop were lost with almost all records in the fire of 1873. They would not have been remarkable. The other boys in Kitchener's batch did not spot that he had a great future. When his official biographer trawled for memories he found a tinge of annoyance that Kitchener 'should have become famous without giving them early warning of

* Pronounced *Munins*.

[18]

it'. They thought him quite an ordinary youth, with plenty of common sense, a plodder at his books but a slow learner. His great height was not yet matched by strong physique. He did not play cricket or football but was 'a very good rider'. His shyness, increased by the rough-and-tumble and strangeness for someone who had not been at an English public school, made him difficult to know well, yet he was not unsociable 'and never unpopular'.[4]

Other cadets did not realize that he was handicapped. His squint was scarcely noticeable and his blue eyes were clear. But he could not see straight. During the rebuilding of Khartoum thirty years after he had left Woolwich, Major-General Lord Kitchener happened to be discussing recreations with a young sapper officer, Lovick Friend. In a rare admission of any weakness, Kitchener told him:

Throughout my life I have been much handicapped, owing to my defective eyesight. I have never been able to compete with any boys or men in *any* games. It is not that I cannot see, but that my eyes do not work together, and one eye has to follow the other, and in any games played with a ball my eyes work too loosely to enable me to take part.[5]

He was also a bad shot, perhaps explaining why he later named three gundogs 'Bang', 'Miss' and 'Damn'.

At the Shop he disguised this defect but as he grew older he would find that he might address one person and be answered by another or by both. A hostile journalist in the Boer War thought him devious, not answering questionners by looking them straight in the eye. His Cabinet colleagues in the Great War were often uncertain whom he addressed.[6] The defect added a touch of mystery since he would never admit to it in public.

Among those senior to him at Woolwich was Prince Arthur, Queen Victoria's third son, afterwards Duke of Connaught. Although only seven weeks older than Kitchener, he had entered a year earlier and was treated more as a prince than a cadet. He was a Knight of the Garter already. In old age he recalled Gentlemen-Cadet H. H. Kitchener as 'a tall lanky young man, very quiet and unassuming'. 'I have always liked him very much', he told King George V in 1916, 'and we always got on well together'.[7]

During the summer vacation of 1868 Kitchener went down to Cornwall, soon after his eighteenth birthday, to stay with a Mr Henderson whose two sons were about his age.

The young ladies in Truro quite indulged his vanity, he wrote to Millie in New Zealand. They saw 'so very few young gentlemen that they are very different from les belles de Londres', who probably scorned him as gauche and shy, although smartly dressed, at the balls given by the Shop or by the gunners across the common. In Truro were 'some nice people called the Chilcots – very pretty and nice girls. We went to several croquet parties there'. After about a week of very hot weather the Chilcot household prepared for the family holiday at Newquay on the North Cornwall coast. On the last evening Kitchener and the Hendersons were invited to croquet as usual, and at dusk they all went in and the four girls sang. As the carpets were already up, and the folding doors open between the music- and the drawing-room, Kitchener sug-gested dancing. They got a candle and began, but the Henderson boys were no dancers: 'one wouldn't and the other would but couldn't so almost all the dancing devolved upon your humble slave'.

He asked Millie to imagine the hot evening and then to

think of me with four young ladies, each longing for her turn. I really thought I should break a blood vessel or do something dangerous as they each caused great strain upon my legs. However I got over it and enjoyed it very much as the candle which lighted us was put out (quite by accident) and we got on very well without it.

After the Chilcots left, the boys found amusement picking up the arrows for the ladies at the archery butts, and they went down the river with five young ladies through beautiful scenery to Falmouth and visited a man-of-war lying offshore. Next they made a walking tour to the Lizard peninsula and round by Land's End, 'very fine cliffs, beautiful coves and caves but nothing so awfully grand as the Alps'. Back in Truro they had another excitement. Henderson was captain of the fire brigade, and one night it was called to a burning haystack. The boys followed on foot as fast as they could and had 'some very good fun'. They helped pump water from the engine, and after the fire was out they woke up the farmer who plied them all with brandy.[8]

Kitchener returned to Woolwich for the next term on 7 August and con-tinued his hard plod. His handwriting at this time was still a typically Victorian longhand, which might have become more difficult to read as he grew older and wrote faster, but he was becoming interested in survey work and gradually developed the very clear script that he kept all his life, a biographer's delight.

His great friend at this time, though senior, was another intending sapper with skill in surveying. He had first met Claude Reignier Conder at the crammer. Eighteen months older than Kitchener, Conder was the son of a civil engineer and grandson of Josiah Conder, a prominent nonconformist writer and editor in the early years of the century. Like Kitchener, Conder had some French blood, being descended from the French-born sculptor, Louis Roubiliac, celebrated for his statue of Isaac Newton at Trinity College, Cambridge, and fine monuments in Westminster Abbey. Conder was attracted to the languages of the Near East. He invited Kitchener to join him in learning Hebrew, thus laying a linguistic foundation and increasing their understanding of the Old Testament. Conder was to exert a strong influence on Kitchener's early career.

At the turn of the year or early in 1869 the colonel brought the family back from New Zealand after placing the Waihemo Grange estate in the hands of a manager. A few years later he gave the post to his nephew, Captain Henry Kitchener, on his retirement from the army, a choice to prove disastrous for the estate and for Henry.

The colonel did not stay in England. Probably for economy, since his capital was tied up in the South Island, he settled in north-east Brittany, near the almost unspoiled medieval town of Dinan, perched above the Rance some eighteen miles up river from St-Malo, with its ferry to England: Dinan had a large English colony. He bought the château of Le Grandcour in Tressaint outside the ramparts.[9] The boys came over when they could, Chevally from his regiment, Herbert from the Shop. Arthur was about to enter the School of Mines in London, and Walter, still at de Grand Clos, would go to Bradfield, one of the newer public schools, as soon as he was old enough. Millie was with them at Dinan but not for long. Not yet twenty-one, she had become engaged in New Zealand to an English landowner, Harry Parker, who had come out to farm with his brother Ned in another part of Otago: they had met at a ball in Dunedin. Harry Parker was thirty-two and lord of the manor of Rothley in Leicestershire. His parents were dead. His father, Sir James, had been a judge and his mother the daughter of Thomas Babington, MP, of Rothley Temple, a close friend of Wilberforce and uncle of Thomas Babington Macaulay (Lord Macaulay), the historian. Millie had made an excellent match materially, especially as she was an expert horsewoman and would be able to hunt in the shires when they settled at Rothley. But both loved New

Zealand. Harry Parker was coming back to claim his bride, and then they would return to Otago.

A letter written by Kitchener to Millie a few weeks before her wedding at Weybridge on his nineteenth birthday, 24 June 1869 (two days after her twenty-first), gives another glimpse of him at the Shop. He was now a cadet sergeant, 'and you would be amused at my military swagger with a stick about 5 inches long and as upright as a flagstaff. I think you would be also amused at my giving the orders which I do in a very imposing voice', despite having a false tooth 'which feels as if it was always going to fall out and is not very comfortable'.

The RMA had recently had a sports day in beautiful weather. Kitchener did not compete in the high jump or long jump but ran in three races without winning cup or medal. For the steeplechase they had dug out a hole 'about 20 ft square and five feet deep filled with water. Nobody being able to jump it everybody went in – some dived in and swam across, others stumbled through it'. The Prince of Wales was on a stand where he could see the fun and Kitchener thought the water jump 'a most amusing sight except for those who were in the water like me'.

Before the sports the Shop gave a magnificent lunch for 1,500 in the gymnasium, with silver vases and flowers all up the five long tables. The Prince of Wales, Prince Arthur, six generals and about a hundred officers of all the regiments of the Woolwich garrison came in full dress: 'the horse gunners with all their gold lace made a grand show and there were crowds of ladies'.

Kitchener got tickets to the lunch for 'Sir R Jarvis who honoured us with his company and the Gordons and party'.[10] Kitchener had been welcomed into the Woolwich home of (Sir) Henry Gordon, a senior official of Ordnance who was soon to be commissary-general. The Gordons had a large family, some being about Kitchener's age, and he was the eldest brother of Colonel Charles George Gordon, Royal Engineers. And thus, through Sir Henry, Kitchener met the hero of his life.

'Chinese' Gordon, as he was known to all, was only thirty-six but famous for his brilliant campaign in China, six years earlier, which had ended the Taiping Rebellion.

Returning to England a Chinese field marshal, Charley Gordon had refused to be lionized. He was now in the comparatively lowly post of Commanding Royal Engineer at Gravesend, a few miles down the Thames from Woolwich, and spending most of his spare time relieving the poor and

sick, and teaching poor or destitute boys, to whom he was always most gener-
ous. Rather small, he had the prominent and penetrating blue eyes which were
a Gordon family trait. He seemed almost to stare when conversing, and the
Sudanese later would say they never could tell a lie in his presence.

Gordon disliked social occasions but was fond of his brother and his
nephews and nieces. He was also a close friend of Prince Arthur's governor,
Major Howard Elphinstone, and would sometime ride on Woolwich
Common with him and the prince. Moreover, the new governor of the
Academy, Major-General Sir Lintorn Simmons, was Gordon's former com-
manding officer on the Armenian boundary commission. Gordon was thus
well known to the cadets and especially to any who, like Kitchener, were
welcome at the Henry Gordons.

'Chinese' Gordon's exotic fame, his whimsical humour and his obvious
love for those around him (unless they disobeyed an order) were captivating to
a young man, and he had a vibrant Christian faith. 'I had unbounded admira-
tion for your brother', Kitchener would write to Augusta Gordon after his
death.[11] In that summer of 1869 neither man could imagine how closely and
tragically their lives would be intertwined fifteen years later. Moreover, if
young Kitchener could not fail to notice Gordon, Gordon did not notice
Kitchener among the other cadets. His awareness sprang later from
Kitchener's skill and achievement as a sapper, not knowing they had met; for
eight years afterwards he wrote a note to another officer: 'Let me introduce to
you Lieut. Kitchener (whom I have never seen). Introduce him to L'Estrange
and do not go sitting up and talking the "Langwidge".'[12]

3

HEART AND SOUL

KITCHENER LOST ONE term through an unspecified illness but passed out successfully from the RMA in December 1870. He crossed the Channel to Dinan for Christmas and to await his commission.

France was engulfed in the closing stages of the disastrous Franco-Prussian War. The emperor and his best army had been captured at Sedan in September. Paris was under siege. The new Republic had ordered a *levée-en-masse* and the young men of Dinan were conscripted to the Army of the Loire. French tradition insists that Kitchener enlisted as a private in the 6th Battalion of the *Gardes Mobile* of the Côtes-du-Nord, the local Reserve.[1] This is doubtful, for as late as 26 January he and another young Englishman, Harry Dawson, were still at Dinan looking for a means to reach the front, where they would offer their services. Colonel Kitchener found a staff officer about to leave who took them by diligence to Rennes, the capital of Brittany, some forty-five miles south. Next day they went a further forty-five miles eastwards in a train 'crammed with soldiers, and there were several officers in our compartment. They were very civil and polite to us', wrote Dawson.

At Laval they were admitted to the headquarters of General Chanzy, who had been summoned from Algeria after the disaster of Sedan. He was France's best soldier, of indomitable will, but he had been defeated in a three-day battle around Le Mans because his Breton reservists ran away. Despite heavy casualties he had executed a skilful retreat and was now re-forming. The battle of Le Mans had ended seventeen days before Kitchener reached the army, disproving claims that this was his baptism of fire and that he saw the slaughter

of large numbers of men and horses without showing emotion.[2] His baptism of war would have been only the harrowing sights of field hospitals and walking wounded and the chaos of a defeated army re-forming. Chanzy had received fresh, if raw, troops and was preparing a fresh offensive. 'We expect the sound of cannon at any moment', wrote Dawson on 27 January. They were still trying to obtain horses to ride to the front when, next day, the news came that Paris had fallen, the French government had asked for an armistice and the war was over.[3]

Kitchener accepted an invitation from a French officer to go up in a balloon to see the distant German lines. But he did not take enough warm clothing and caught a chill in the late January air. The chill turned to pleurisy and pneumonia. Harry Dawson, refusing the offer of a commission in the French artillery to stay with him, sent an urgent wire to Colonel Kitchener, who arrived to find his son lying in great pain in an insanitary village inn.

As soon as Herbert could stand the journey, his father took him back to England for better treatment. He had nearly died and took many months to throw off the effects. He also nearly had his commission revoked for unneutral activity in France. He was ordered to present himself before the Commander-in-Chief at the Horse Guards. The officers of the British Army in 1871 were a close-knit family, very much soldiers of the queen. Queen Victoria signed every commission, and if an officer were court-martialled the Judge Advocate General had to report the verdict to her in person. It was therefore not surprising that the Commander-in-Chief, HRH the Duke of Cambridge, should personally rebuke a new and insignificant twenty-year-old lieutenant of the Royal Engineers, especially as the duke had only lately relinquished the titular governorship of the Shop.

The duke tongue-lashed Kitchener with a plentiful flow of the oaths for which he was famous; told him he was a disgrace to the British Army, a deserter, had behaved abominably, did not deserve a commission, etc. Kitchener stood ramrod straight and never said a word, although inwardly impenitent, holding that as he was domiciled in France, had left the RMA yet not received his commission, he was entitled to do what he liked. His logic was a little flawed, for he had known that the queen's commission as a lieutenant, RE, would arrive at Dinan any day. When received, it was dated 4 January, so that he was a serving officer of neutral Britain when he joined Chanzy.

The flow of oaths continued. Then the duke paused and 'with a funny sort

of twinkle' murmured: 'I am bound to say, boy, that in your place I should have done the same thing'.[4]

In April 1871 Lieutenant Kitchener reported to the great barracks at Brompton, above the Medway close to Chatham, which was the depot of the Corps of Royal Engineers and its School of Military Engineering. For the first time, he walked in the spacious grounds where his own equestrian statue would stand, and dined in the magnificent mess with its portrait of Gordon in the robes of a Chinese mandarin. His own portrait, in the khaki of his campaign that avenged Gordon, would be placed near it a quarter of a century later.

At Chatham he went through the normal training of a young officer, including the making of a survey of twenty square miles, with two men under him. 'It is jolly in this weather', he told Millie, now back in New Zealand with her husband, when congratulating her on 'my promotion to the ranks of uncle. It must be awfully jolly for you. I suppose my nephew is like his father with his mother's eyes. All babies are'.[5]

The family meant much to Herbert. Arthur had returned to New Zealand with the Parkers but was now nearly home. When Herbert saw their father, over in England to meet Arthur, he invited both to Chatham. A few days later the colonel announced Arthur's arrival but absent-mindedly addressed his letter to Woolwich. 'On my not answering this unreceived epistle he takes umbrage and will not let Arthur come down and see me'. Fortunately, Herbert wrote again when Arthur did not turn up and was able to catch him in London before father and son went to France. Arthur later returned to London to study chemistry, and Herbert was able to give him an occasional day's hunting. Young Walter, now at Bradfield, also came to stay, a jolly boy who has 'greatly grown and perhaps will overtop me'.[6]

Except with the family, Kitchener still kept rather to himself, preferring long rides on his mare to jaunts with brother officers, partly because he had nothing except his pay and a small legacy from his mother. His father could not provide an allowance when his capital was tied up in New Zealand and yielded little. 'The Gov. is very hard up'.[7] Frugality became natural to Herbert Kitchener.

He made one very good friend soon after arrival at Brompton barracks. Not yet fully recovered from the illness contracted during the Franco-Prussian War, he had been glad to find himself given a room of his own and made it comfortable. He had hardly settled in when he and the subaltern next door received

orders to quit. A new instructor, Captain R. H. Williams, required both rooms. Kitchener was upset and rushed to William's office.

A very tall and very slight youth burst into the room and blurted out:

'My name is Kitchener, and I am ordered to move out of my little room because you want it. I know you would not wish for such a thing, sir.' He was looking terribly ill, and his evident distress caused me to offer him one of my two rooms. In a week we understood one another, took our daily exercise in company, sat next each other at mess, went to evensong together, became inseparable.[8]

Williams was a High Churchman. As they talked, rode and worshipped together, Kitchener came to love more ritual and to give a higher place to the Eucharist. Ferment in the Church of England over vestments, incense and lights had led recently to a Royal Commission which had ruled against many of the pre-Reformation practices which were being reintroduced by the Oxford Movement, to which Kitchener became an enthusiastic adherent. He and Williams kept festival and fast, Kitchener finding an ingenious way to keep a 'fast' in an officers' mess: 'We must find something unpleasant', he would whisper as they sat down.[9]

As his batch neared the end of their course (he did not do too well in exams) Kitchener dreaded being posted to India, perhaps because India had broken his mother's health. The only consolation would be a hope of meeting Millie and Harry Parker on their way home if he went out by North America and Japan. Millie had asked him to be godfather to her second son, the future Parker Pasha.

In the spring of 1873 the general at the War Office who was to attend the Austro-Hungarian manoeuvres selected Kitchener as his aide-de-camp, perhaps because of his height and military bearing. General Greaves promptly fell ill in Vienna, so that Kitchener, twenty-three, found himself representing the queen, mingling with foreign generals and sitting next to Emperor Franz Josef at meals. The emperor allowed him to study Austrian military bridging, very useful for a report he was writing at Chatham.

His posting came through – not to India but to Aldershot, to join the mounted Telegraph Troop which was training to lay and operate electric telegraph lines on campaign, a fairly new skill for the Royal Engineers.

'Aldershot Camp', as it was generally known, had been laid out less than twenty years before in the Crimean War around a small village in the little-populated Hampshire heathlands where parades, exercises and manoeuvres could take place unhindered. By 1873 it was still a dreary landscape of barrack squares and lines of mostly wooden buildings which became the centre of a vast tent town when companies, battalions and volunteer formations from all over southern Britain arrived for summer camp.

Except for the hunting and tent-pegging Kitchener disliked the place, although he enjoyed a rain-drenched exercise down on distant Dartmoor. That October the Commanding Officer of RE troops at Aldershot in his confidential report described Kitchener as 'A most zealous and promising officer – thoroughly acquainted with his special work, and performs his duties to my entire satisfaction'.[10] The Commanding Officer was Lieutenant-Colonel Sir Howard Elphinstone, who combined regimental duty with his work as comptroller to Prince Arthur, now Duke of Connaught: Kitchener dined with them occasionally. Elphinstone's great friend Gordon was twice briefly in England at that time, before taking up his dangerous post as governor-general of the equatorial southern Sudan, the first step by which 'Chinese' Gordon became 'Gordon of Khartoum'. Young Kitchener could have again come under his spell.

When Captain Williams was also posted from Chatham to Aldershot, 'We were very happy', Williams recalled, 'in a never-to-be-forgotten brother-hood of keen Churchmanship brought to high pressure under a remarkable man, Dr Edghill'. John Cox Edghill was senior chaplain at Aldershot and later chaplain-general for sixteen years. He had taken over a gaunt 'tin taber-nacle' as garrison church. Williams, Kitchener and others helped him make it 'better fitted for Church worship, with an enlarged Altar and seemly sur-roundings, an organ and a choir'.

During the summer camps they must have gone round to different units to persuade them to drop Sunday church parades in their own lines and march instead to Edghill's church, for Williams says that 'the original congregation of 30 quickly grew to one of 800 assembled inside, with another hundred or two waiting outside. Officers and men were equally enthusiastic and a sung Eucharist was well attended'. Since Edghill was more of a ritualist than most army padres of the day, and the newspapers were full of the vestments dispute, 'there was just enough persecution to keep us all at white heat'.[11] Kitchener could never express his deepest feelings and hated any 'undressing' of soul, but

he could show his faith by externals. And when in 1874 Disraeli's new government responded to widespread public fears and episcopal dislike of 'Roman' practices by passing the ill-advised Public Worship Regulation Act, Kitchener became a member of the English Church Union which defended them.[12]

Professionally, Kitchener was very ambitious, determined to reach the highest rank. 'You are too tall', said his father. 'Only little men get to the top!'[13] He was probably thinking of Napoleon and possibly Havelock or Wolseley, just becoming famous. Little 'Bobs', the future Lord Roberts, was still unknown to the general public, but Wolseley, was 'the very model of a modern major-general', and was forming his expedition to put down the murderous King of Ashanti. Kitchener volunteered. 'At least', he told Millie in New Zealand, 'I have said if they order me I shall be glad to go. So the next thing you may hear will be my slaying niggers by the dozen'.[14] His services were not required.

The Royal Engineers at that time carried out many works that in a later age would be done by civil engineers and surveyors. Although in peacetime the cavalry, brigade of guards and gunners despised sappers as mere professionals, the letters RE after an officer's name carried great prestige. Kitchener's com-mandant at the Shop, Lintorn Simmons, a future field marshal, had master-minded the expanding railway system of Britain before the Crimean War, and Gordon had demarcated the new frontiers between the Ottoman and Russian Empires after it. Sappers had first begun to survey the Holy Land in 1864. The Palestine Exploration Fund (founded in 1865) paid and reaped the glory, while the War Office welcomed detailed knowledge which could be used in war. Kitchener's old friend, Lieutenant Claude Conder, was now in command of the survey.

While waiting for an opportunity, Kitchener accepted two months' leave (by no means unusual for home forces) in January and February 1874, which he spent in Dinan for reasons of economy. The colonel had sold the château and bought a house in Rue Saint-Charles known as L'Ancien Presbytère. Here Kitchener improved his stamp collection and taught himself the still-complicated art of photography. He was also training what became a remark-able memory, in the spirit of his words to Millie about her small son: 'Above all things work at his memory when he is young, make him learn things by heart. Euclid is a good thing for that'.[15]

But his father and stepmother were falling out: 'there is always an element

of discord which drives one wild'.[16] A year or two later they separated, though never divorced. The colonel lived in England. His wife made L'Ancien Presbytère her home with Kawara, who was much loved by her father and half-brothers and Millie. Mrs Kitchener survived three of her stepsons, dying in 1918, honoured in Dinan for the hospital work of mother and daughter in the Great War.[17]

Herbert did not return to Dinan for his next, shorter leave in the summer of 1874. He went to Hanover to improve his German and to study fortifications. In Hanover he heard from Conder in Palestine. Conder had been assisted by a civilian, Charles Tyrwhitt-Drake, who although only twenty-eight was already a distinguished explorer and naturalist. Tyrwhitt-Drake had died on 23 June. Conder urged Kitchener to apply and had strongly recommended him. This was the very post Kitchener had wanted. 'I am one fully determined to do so many things which never come off that it is quite surprising to be able to say, what I intended is accomplished'.[18]

4

'THE FOOTSTEPS
OF OUR LORD'

KITCHENER ENTERED HANOVER railway station and was standing on the platform beside his japanned uniform case marked with his name and rank when a well-dressed English youth shyly approached. The boy confessed that he had recklessly broken his journey from the University of Lüneburg to dine and sleep and hear a famous singer at the opera, which had all cost more than he had expected: he was stranded.

Kitchener asked his name, cross-examined him severely, then bought his ticket to London, kept him under his eye, fed him throughout the journey and, so the young man's brother related many years later, 'finally saw him and his luggage into a cab for home'.[1]

In London, the Palestine Exploration Fund's sponsors, including Sir George Grove, more celebrated for creating the Royal College of Music and *Grove's Dictionary*, and the secretary, (Sir) Walter Besant, better known to contemporaries as a novelist, were impressed by Kitchener, who then took a course in Arabic. He saw his eldest brother Chevallier ('Chevally'), now passed staff college, and Walter, still at Bradfield. Arthur was 'a little put out' because his father had chosen a thirty-six-year-old nephew to manage the New Zealand estate instead of a twenty-two-year-old son. His motive probably was to safeguard Arthur's career as a mining engineer; Arthur went off to Mexico, while Captain Henry Kitchener began his ruinous career in New Zealand. The colonel himself and his second wife were still living in France.

Early in November, 'having left everyone perfectly well and happy, I started with a clear conscience and a ticket for Venice'. The Fund paid all expenses.

Kitchener spent a day's sightseeing at Venice, then embarked at Trieste in an Austrian-Lloyd steamer for Alexandria, with a rather grand Egyptian pasha, a German family, an Englishman and an American couple – a dull husband and a wife who 'was fun, such quaint expressions and mannerisms I never met'. After they had all recovered from a bout of rough weather, she scandal-ized the pasha and charmed the rest by 'singing on deck by the light of the moon Yankee Doodle and such like'.[2]

After sightseeing in Alexandria with the eagerness of a first-time tourist and watching a dance of coal-black Nubians, he took the Jaffa steamer.

Next day Sunday 15th November I got up early to see the sun rise over the Holy Land. It was glorious more from association than anything else, seeing for the first time that land which must be the most interesting for any Christian. The sun rose in a golden halo behind the hills and we rushed on towards it through the deep blue sea.[3]

The ship anchored outside the harbour. Kitchener was rowed to the beach and carried ashore by half-naked Arabs.

His luggage from England arrived two days later, and he left the bazaars and orange groves of Jaffa that evening, having bargained for two mules, a horse and a guide, and rode the forty miles up through the hills. (He does not say why he chose to travel at night: possibly to avoid robbers.) 'Such a ride over terribly rough country'. The guide, with a better horse, kept cantering away into the darkness 'while I blundered on, trusting entirely to my horse. We went all the short cuts' and sometimes had to jump from ledge to ledge of rock as the road climbed steeply. Kitchener was very thankful when they reached Jerusalem and the hotel at 4 a.m. Conder came later that morning, and next day they rode out of Jerusalem through the stony hills of southern Judaea to the survey camp.

Palestine at that time was a corner of the Ottoman Empire, thinly popu-lated by Muslim Arab shepherds and farmers and rather neglected by the Turkish rulers. In the north were many Maronite Christian villages, but the massacre of 1860 had reduced the number of Christians. Orthodox monasteries had long existed here and there. Pilgrims could visit the holy sites, and small colonies of Germans and Americans awaited the Second Coming of Christ. Jewish refugees from Eastern European pograms were coming in, supported mostly by charity raised in the West.

Biblical archaeology was in its infancy. The Royal Engineers' map would be an essential tool. Conder and Kitchener, Sergeants Armstrong and Black and one corporal worked closely together, supported by thirteen servants, six tents, seven mules and seven horses: Kitchener's horse was a little arab named Salem, 'all mane and tail'.

The work was highly demanding. They were not making sketch maps but an ordnance survey of the most precise accuracy. They would rise at seven for tea and bread, ride out and survey, with a break at noon for a substantial break-fast, brought with them on a mule, then back at four. 'Dinner at 6, a cup of tea at 8 and very early to bed'. Heavy rain, high winds, and fever among the servants drove them back to Jerusalem, but Kitchener managed to photograph the rugged valley where King Saul's son Jonathan had climbed alone except for his armour-bearer and routed the Philistines.

On New Year's Day 1875, with the weather better, the expedition took the dreary road from Jerusalem down to Jericho, then a mere 'collection of hovels inhabited by extremely dirty Arabs' surrounded by trees and the fertile green-ery of the Jordan plain. After the cold of Jerusalem in winter, the semitrop-ical warmth made surveying delightful, and when they saw the Dead Sea 'the water looked so blue and nice we were soon stripped and in it. The sensation is extraordinary . . .' They could only float and the salt got into their eyes.

Kitchener 'paid dearly' (in Conder's words) for their visit to the Jordan plain. On their return to Jerusalem he went down with 'Jericho fever', the worst of the local varieties, almost certainly malaria, since swamps still lay on the edge of the town. The term is unknown to medical textbooks.[4] Conder feared that Kitchener might be invalided home, but he was saved by the English doctor, Chaplin, and Conder as 'a capital nurse' and by downing a glass of light beer at a critical moment. Chaplin kept him convalescent in the expedition's curious house in the Jewish quarter, with thick stone walls between the rooms, while Conder resumed the survey on 25 February.

Kitchener worked up their notes and resumed his sightseeing. He revelled in the colours and excitement of the East. He visited the Wailing Wall and a service at a synagogue, he walked about the Arab quarter, wholly oriental in noise and movement, and secured a permit to the Muslim Dome of the Rock on the site of the Temple and marvelled at its beauty. But 'the Holy Sepulchre was naturally the first place I visited'. He was not impressed by the different sects who jealously guarded their corners of the church, and he doubted the authenticity of the traditional sites: 'I think divine wisdom has been shown in

hiding them. Such fearful scenes of fighting and bloodshed could never be allowed round the sacred spot of our Lord's sacrifice and His tomb'; and the place where the church was built, he held, could not have been outside the city wall, whatever clever men might write. It would be left to Gordon, eight years later, to make famous an alternative site on the skull-like hill beyond the present saracen walls, afterwards known as Gordon's Calvary.

On 7 March, waiting alone for lunch, Herbert opened his heart to Millie:

... I find that writing letters to one's friends is almost as delightful as receiving them. It brings before one old times, happy days. Their faces seem to gleam through the inner self and smile, their voices again talk with the same tones sweet and low and so one is apt to dream away a morning while writing a letter. What a glorious land this is when one can see it through the spectacles of imagination – those grand old knights, so fierce in war, so gentle in religion.

He saw the old Crusaders, each a Lion and a Lamb, leaving pleasant homes to undergo most terrible privations to fight in their quaint armour for their God against a far superior force and probably to die amid a heap of corpses.

'*After lunch*. I have read over the preceding remarks and laughed to find how spiritual fasting makes you'. He was inclined to tear it up but it would provide variation in a long letter.[5]

Six days later, on the evening of 13 March, Conder recorded that Kitchener rejoined him, 'with Habib, the groom, the little dog Looloo, her new puppy, and the baggage. The camp was once more increased to six tents, and the meeting was cheerful'.[6]

Fit again, Kitchener threw himself into the work, scrambling over stony country on little Salem, taking angles, setting up the camera here, sketching a little there, or exploring a ruin to record inscriptions, 'but principally feeling an interest in the donkey with the grub ... Then coming back in the evening satisfied with a good day's work to our tents'.

On 5 April they were at Askelon on the coast and went for their daily bathe in the sea. Conder was caught in an undertow and would have been drowned had not Kitchener, a strong swimmer, reached him in time and dragged him back to shore. They next worked in Galilee. When Kitchener passed his twenty-fifth birthday on 24 June he was thoroughly enjoying the life. Conder and he were on excellent terms. A French archaeologist who

saw them from time to time noted Kitchener, as tall, slim and vigorous, 'a frank and most outspoken character, with recesses of winsome freshness'. His 'high spirits and cheeriness', contrasting with Conder's sadder disposition, might sometimes lead to headstrong acts, but his 'ardour for work astonished us' and he showed 'marked proficiency' as an archaeologist.[7] His identifications were not always confirmed. He made an impassioned appeal to save the ruins of the synagogue of Capernaum, 'hallowed by the footsteps of our Lord', but excavations many years later proved that the site was not where he contended.[8]

The survey had been aware of latent suspicion among the Arab country folk, based on fears that Christians had designs on their lands, but no serious incident occurred until 10 July 1875 in the hills of upper Galilee, at Safad, a fanatical Muslim town. On arrival, Conder had sent the Imperial Ottoman prescript, an imposing document, to the local Turkish governor, who would then at his leisurely convenience pay a courtesy call. The surveyors had just laid out their camp in an olive grove when an elderly sheikh or headman arrived with a small crowd, brandishing shotguns and shouting anti-Christian blasphemies. When he tried to steal a revolver hanging on a tree, Conder arrested him and tied him up to await the Turkish authorities. This enraged the crowd, who advanced yelling. Conder prudently untied the sheikh and tried to calm matters, but within seconds a battle began with a shower of stones and a charge. The unarmed Europeans had nothing to hand but their hunting crops and canes: Conder laughed as he saw Sergeant Armstrong all ready to repel a charge, holding the camera obscura legs as if a rifle and bayonet. Soon matters were desperately serious. A huge black slave whirled a nail-studded club and would have smashed Conder's skull if he had not dodged and butted so that the club fell on his neck in a damaging wound. The slave was about to strike again. 'I must inevitably have been murdered, but for the cool and prompt assistance of Lieutenant Kitchener', whose thigh was severely bruised by a stone yet managed to reach Conder under a hail of blows and stones and fight off the slave with his cane.

Other villagers were coming through the olive grove and vineyards, converging on the Europeans. 'Unless the soldiers arrived at once we must all die'. Conder gave orders to bolt back to a hill a hundred yards off, Kitchener covering the retreat with his now-broken steel-handled hunting crop, while a bullet whistled by his ear.

The Turkish soldiers ran up. The crowd dropped their stones and pre-
tended to be innocent sightseers.[9]

Conder brought forward the planned three-week holiday on Mount
Carmel above Haifa, then suspended the survey, since the expedition could not
work anywhere safely until the Safad rioters were punished: moreover, a
cholera epidemic had broken out in northern Palestine. Conder's wound had
not healed, and he handed over command to Kitchener. The rioters, after a
long trial, received derisory sentences and fines (given to the Fund) which were
increased after diplomatic pressure.

With the cholera unabated, Conder still wounded and Kitchener and the
sergeants suffering from fever, they decided in October to go home temporarily.
Kitchener insisted on their riding the forty miles down to Jaffa in one day. He
fell off his horse unconscious as they reached the garden of the German hotel.
Conder hurried for help, returned to find no sign of him, and was relieved to
discover him in bed, having come round and then crawled through the garden.

For Christmas leave he crossed to Dinan, where despite the worsening
domestic discord he completed *Lieutenant Kitchener's Guinea Book of Photographs
of Biblical Sites*, the only book he ever produced. When Besant cut it from fifty
photographs to twelve, he wrote back 'utterly disheartened and disgusted',
then apologized in his next letter: 'You know I daresay what it is to be seedy
and cross, and I was very much of both when I last wrote'.[10]

They had expected to return to Palestine early in 1876, but as Conder was
not fit they spent the entire year based on London. Using rooms in the hideous
muddle of buildings off the Cromwell Road which then comprised the South
Kensington Museum (renamed the Victoria and Albert when rebuilt) they
worked up the map and compiled 'Memoirs', copious notes on Palestine's
flora, fauna, topography, archaeology and other matters, seven composite
volumes in all, some by Kitchener, most by Conder.

The year was lightened for Kitchener by the Parkers' return from New
Zealand. Kitchener was able to meet his godson, his two other nephews and
a niece before Millie and Harry took a castle in Ireland while waiting for
tenants to vacate Rothley Temple and they could settle down in Leicestershire.
Some years later, Harry's bad management of his estate caused him to sell up
and take them all back to New Zealand.

Early in that year of 1876 Kitchener joined a new brotherhood, the Guild of
the Holy Standard. Major Wyndham Malet of the Horse Guards, a clergy-

man's son, had found that many young men who had been communicants of the Church of England abandoned their religious practices after enlistment, through fear of ridicule or from the pressures and temptations of the barrack-room and the public houses outside. He therefore founded the guild in 1873, with John Edghill (Kitchener's padre at Aldershot) and others, to protect and encourage men by binding them to a voluntary rule. Guild Brothers of the Holy Standard pledged themselves to support one another and set a Christian example, 'to be sober, upright and chaste; to be regular in their private prayers; to receive the Holy Communion at least three times a year, to be reverent during services, to avoid immoral books, to pray for other people, help the chaplains and promote the religious and social welfare of soldiers and their families'. Kitchener became a Brother on 1 January 1876 and, as the obituary in the guild magazine tactfully stated, 'he remained a silent member till the day of his lamented death'.[11]

Conder was still not passed fit by the end of 1876. Kitchener replaced him in command and was given a larger expedition.

Before he left England he met Gordon again, back briefly from the Sudan. Gordon had long planned to spend a year in Palestine, meditating and studying the holy sites, and Kitchener may have expected to show his hero many of them. But Gordon's hopes of the Holy Land were postponed for another five years. The persuasions of the Khedive of Egypt, backed by the orders of the Duke of Cambridge (and a little sortilege) sent him out again to the Sudan as governor-general of the entire country with powers greater than those of a viceroy of India. Gordon admired Kitchener's fine presence and his character. He heard much about him later as one of the best of officers – with a cool head and a hard constitution; but the turn of the year 1876–7 was the last time they could have met face to face in England.[12]

Kitchener went out by Constantinople, where he made useful contacts, and reached Beirut on 6 February 1877, went up to Damascus and then to Jerusalem. In the next months he surveyed in northern Palestine, where they had been abused, and had a triumphal return to Safad, where he graciously remitted the remainder of the fine.

He now had a strong party of eighteen men ('quite a little army to feed'). 'I have six horses and a number of dogs as companions', he wrote to a friend of the family early in May. 'My time is fully taken up with work from morning to night. I enjoy the life amazingly'.[13] A few days earlier he had learned that Turkey and Russia were at war. He felt no cause for alarm. He realized that

Disraeli's England might be drawn into the conflict but almost certainly on the Turkish side. Nevertheless the outbreak of war brought urgency: he must finish the survey as fast as possible lest it be stopped by the Turks or he was recalled for special service.

He urged on his men. Where Conder had been short-tempered, quick to beat a slow servant, Kitchener had the gift of evoking enthusiasm. He was always in anxiety because he had Christian servants and Muslim soldiers (placed under his command for the expedition's protection). One day in June, when the temperature was 105°F in the shade, he had to break up a knife-fight between two servants by pulling them apart. 'A sound thrashing and summary dismissal settled their business. In this hot weather it is unpleasant to have to scrimmage with one's servants'.[14]

That summer was the hottest in Palestine for fifteen years, and he was often in the saddle for over eight hours. In late August, on the way down from the Lebanon mountains, where he had rested the party and worked up his notes and measurements,

> the sun was dreadfully hot and I got a slight sunstroke. I had to lie under a tree for 2 hours with water being poured over my head. I then tried to get on but was so weak I had to stop wherever there was the least shade. I got to Sidon at 12.30 a.m. and had dinner at 1 in the morning. My dogs nearly died on the road and everyone suffered considerably.[15]

During these months Kitchener came into his own. He was physically hard with great powers of endurance. The work of the ordnance survey had increased his mastery of detail and his thoroughness. Negotiating with Arabs and Turks, with civil authorities and suspicious Muslim imams, and with Christian priests and patriarchs had developed his natural tact and diplomacy (the Orthodox patriarch was particularly difficult about preserving Jacob's Well). He was proud that by careful preparation and use of resources he kept within his budget, no mean feat in a Middle Eastern land.[16] He and Conder added many hundreds of placenames and identified sites, so that Besant could fairly claim for the survey that 'nothing has ever been done for the illustration and right understanding of the historical portions of the Old and New Testament, since the translation into the vulgar tongue, as this great work'.[17]

On 2 October 1877 Kitchener reported in a biblical phrase that the

mapping was finished 'from Dan to Beersheba'. Many discoveries remained to be examined in more detail, while the distant war and the rumbles of revolt made the country more dangerous and officials less helpful, probably because any Western European was believed to be an ally of Russia. At Nablus on 3 November the expedition was stoned. The acting governor rejected Kitchener's complaint, so he had several offending boys tied up and beaten publicly, as if to emphasize that a British officer's innate authority counted for more than a minor official.

On 26 November Kitchener paid off the servants, saw his sappers into a steamer for home – and hurried to Constantinople and onwards to Bulgaria to see the fighting. He had many adventures which he afterwards described in *Blackwood's Magazine*. He saw scores of Bulgarian corpses hanging by their necks – the 'Bulgarian horrors' that Gladstone would soon make famous in his 'bag and baggage' pamphlet – and reached the frontline head-quarters of Valentine Baker Pasha. Baker had commanded the 10th Hussars for thirteen years with great success, then made a notable journey in Central Asia. When assistant quartermaster general at Aldershot he was sent to prison for assaulting a young woman in a railway carriage. He was therefore cashiered. He was now a Turkish pasha winning glory but had ruined a promising career in the British Army and was a marked man. Ambitious young British officers were told that they should not become closely involved with him, a fact which was to be awkward for Kitchener six years later.

Kitchener next helped to rescue two British newspaper correspondents about to be shot as spies, one of whom described him as 'lean as a gutted herring, as active as a panther and tanned . . . to the blackness of an Arab com-plexion'.[18] Kitchener ended his war as a stowaway in a troop train returning to Constantinople, to the amusement of the Turkish officers who discovered him under the seat. And so to England, just too late for Christmas.

'Herbert is home again', wrote nineteen-year-old Walter Kitchener, on leave from Sandhurst, to Amy Fenton, an older sister of the girl he would not be allowed to marry for nearly another seven years, continuing:

We had not heard from him for a long time and only knew he had gone to see some fighting; of course we were in a tremendous fright and were just merging from the passive to the active state when he suddenly appears among us . . .

You've no idea what a fellow Herbert is, I don't think there *is* anyone a bit like him. Talking to him does one good, it has something like the same effect as staying at Clanna* – it changes one altogether and leaves one full of determination.[19]

* The house at Lydney, Gloucestershire, where the Fentons were then living.

5

THE CYPRUS SURVEY

WHEN DISRAELI and Lord Salisbury brought back 'peace with honour' from the Berlin Congress of June 1878 they also brought Cyprus. Predominantly Greek with a Turkish minority, it would remain nominally in the Ottoman Empire, but under British administration, and needed an accurate survey. Thomas Cobbold MP, a former diplomat, recommended to Lord Salisbury that Lieutenant Herbert Kitchener, his cousin through the Chevalliers, was the right man to make it.

Recommendations through Parliamentary 'interest' were then normal. Kitchener wrote to Cobbold 'to thank you for a most delightful appointment . . . It is exactly what I like and will be a great advancement for me professionally when I have done it. I expect I shall take 2½ to 3 years to finish it'.[1] His instructions were to make a detailed ordnance survey map at one inch to the mile, with larger scale where necessary, and he was allotted a twenty-three-year-old sapper subaltern, Richard Hippisley, and four NCOs and men. Kitchener was particularly pleased that he was to report direct to Salisbury, the Foreign Secretary.[2]

Still working on the Palestine map and notes, Kitchener was living with his father in Albert Mansions, Victoria Street, one of the first tall buildings in London to be designed as 'flats'. Young Walter, on leave from the Curragh and soon to sail with his regiment for India and the Afghan War, told Hetty Fenton: 'He has a room fitted up entirely in Eastern fashion where he sits cross-leged [sic] and receives his friends at afternoon tea'.[3] He wore an early version of a neat imperial beard (for a short time) and the famous moustache.

Herbert handed over the completed Palestine map, receiving highest praise, and hurried out to Cyprus with Hippisley to reconnoitre. After landing at Larnaka they dined with the Bombay Sappers and Miners 'and slept or rather laid awake scratching' in the house of a Greek then travelled by mail cart through the lower eastern mountains and down to Nicosia, where Kitchener found Britain's first High Commissioner (and Commander-in-Chief) of Cyprus encamped in a monastery garden. Lieutenant-General Sir Garnet Wolseley, famous already for the Ashanti campaign and his reforming zeal at the War Office, was 'very agreeable and pleasant though I don't like his manner much or that of his staff. I hope eventually to have very little to do with them'. Kitchener put his finger at once on the trouble with empire-builders: 'It is just what I expected – the English have come with English ideas in every-thing and a scorn for native habits or knowledge of the country. The result is fatal – they work hard and do nothing absolutely except mistakes, absurd laws etc that have to be counter-ordered. All is in fact chaos'.[4]

As soon as HMS *Humber* arrived (late) on 17 October with the sappers and equipment, Kitchener began the survey, starting a baseline, climbing moun-tains to fix points and finding the existing maps of the interior 'excessively wrong'.[5]

He liked the island, the life and the inhabitants and did not expect to be bothered much by staff officials; but very soon the Treasury in London was grumbling at the expense, and Wolseley became tiresome. Herbert wrote to Millie on 2 February 1879: 'The survey goes pretty well – lots of worries, I am quite losing my sweet temper. Lady W. they say drives the coach. I don't much like her. Sir G. is very civil but they are all a dangerous lot saying one thing and meaning another, like women eh!' Wolseley summoned Kitchener and over his almost insubordinate protests ordered him to limit the survey to a chart of the land instead of the map he had been ordered to create with exact con-tours, buildings and archaeological sites. Kitchener soon hoped Wolseley would be posted to South Africa, where the Zulu War went badly, and indeed he was, but not before he had suspended the survey altogether for financial reasons. The surveyors were two days' journey from Nicosia by bullock wagon in early May when they were recalled.

Kitchener deplored the decision on both public and personal grounds. The acting governor's assurance that their work was highly approved did not lessen Kitchener's distress. He wrote at once to Lord Salisbury that 'the whole of my prospects as a surveyor are injured by the sudden recall'. He implored his lord-

ship to let him bring his work home for inspection and not allow it to be lost. Years later Wolseley admitted 'handsomely and openly' that he had been wrong. He had already noted Kitchener as a highly professional if tiresomely independent soldier.[7]

Kitchener returned to England and stepped straight into another appointment. Articles 61 and 62 of the Treaty of Berlin had enjoined the Ottoman Empire to reform its administration in Anatolia (Asia Minor) and to relieve oppressions, ensure religious freedom for Armenian and other Christian communities and prevent atrocities by Circassians and Kurds. Four British military vice-consuls and a consul-general would oversee the reforms and report back.

The Foreign Office had appointed as consul-general the sapper who had founded the Palestine Survey, Lieutenant-Colonel Charles Wilson, who six years later would achieve unfortunate fame as commander of the force that arrived two days too late to save Gordon. Wilson knew Kitchener well enough to secure his services as one of the four vice-consuls.

In August 1879 Kitchener left London nonstop by ferry and train for Vienna, his diplomatic courier's pass most useful for passing Customs and obtaining comfortable carriages. He went down the Danube and by the Black Sea to Constantinople and the ambassador's summer residence, the wooden palace at Therapia, 'a charming place on the Bosphorus. I dined and spent the night in no end of luxury'.[8] Some years earlier, Therapia palace had been the setting of the fateful meeting with Nubar Pasha which had sent Gordon to the Sudan.

The British Ambassador was now Sir Henry Layard, better known to posterity as the archaeologist who excavated Nineveh the ancient Assyrian capital. He immediately asked Kitchener to investigate Circassian atrocities at Ada Bazar in the nearer part of Anatolia, 'rather annoying' as his baggage had gone by sea direct to Sinop and his intended base at Kastamonu. Instead, he went by train with a cook and an interpreter to Izmit (Nicea), where he was put up by the Armenian bishop, who rode with him next day through beautiful scenery towards Ada Bazar. The first deputation of welcome awaited him four hours from the town. By the time he reached the gates he had about a hundred horsemen and several cartloads behind him. 'The streets were crowded with thousands of people and I had to go bowing right and left. A lot of little boys with banners went singing in front, then came 4 soldiers, then myself, then the

[43]

Bishop and a crowd of notables. All the church bells were ringing'. He held a reception at the bishop's house, shaking hands and making speeches.

On the Sunday he had to attend the Armenian cathedral in state where the bishop officiated in an enormous mitre and 'preached an eloquent sermon about the Queen and the reforms that were to be introduced'. Kitchener was seated 'in a great chair and was specially prayed for'.[9] He spent much of the week receiving petitions from people who had been robbed by soldiers or dispossessed, or whose relatives were among the seventeen people whose throats had been cut by Circassians 'and the authorities did nothing'. Next Sunday he attended the service of the Presbyterian community of some three hundred converts, who sang 'God Save the Queen' and prayed for him in English.

When he reached his own consular area round Kastamonu he received almost royal honours wherever he went, with crowds to see him arrive, officials backing out of his presence, and peasants pathetically expecting immediate relief and reforms. The reports he wrote were damning: bribery in the law-courts; speculation and misappropriation; blackmail and extortion. Petitioners against corrupt officials must first pay high fees, while complaints about robbers would bring them back with a vengeance after they had squared the police. No reforms had been made in the police, prisons or in education. Kitchener's heart was specially touched by a group of refugees who had nothing to give their children except vegetables, soon to be all eaten. 'They have no houses and sleep under trees'. He urged the Foreign Office that the Turkish government should act for the safety of the district and to 'prevent these people dying of want'.[10]

He hated the cold of his first winter for many years. 'My house is all windows and consequently all draughts, it is impossible to warm it', he wrote with 'frozen' hands.[11] Yet he delighted in Anatolia, 'with its lovely scenery and the glorious feeling of being the biggest swell in the country',[12] for alongside the ardour of his spiritual mission to bring justice to the poor, sat a slightly contradictory love of social prominence. When an invitation came early in 1880 to return to Cyprus, after only five months as vice-consul, he was tempted to refuse it and stay on under Wilson – and soon would have been unemployed, for after the British General Election that spring the victorious Gladstone reversed Disraeli's forward policy and withdrew the military consuls.

Major-General Sir Robert Biddulph, who had been Wolseley's deputy, succeeded him as High Commissioner of Cyprus and recognized that the survey

must be made. He appointed Major Lloyd of the Indian Survey Department to resume it temporarily and asked for Kitchener,[13] who returned to Nicosia on 2 March 1880. On 18 April he wrote to Millie: 'What do you think they sent me from Kastamunia! a little bear! Such a funny little brute. I mean to teach him all sorts of tricks'.

Kitchener was sharing a house in Nicosia with a daredevil young Scotsman, Lord John Kennedy of the Royal Scots Fusiliers, the Marquess of Ailsa's son, who soon had the bear making happy mischief; but when the bear took a bathe in a bath prepared for Kitchener and proceeded to dry himself by climbing into his owner's bed he was banished.[15]

By Kitchener's thirtieth birthday on 25 June the survey was going well. In the first six months Kitchener and his men surveyed 1,058 square miles, including the lands of 197 villages, 19 monasteries and 16 farms.[16] As Land Registrar in addition to his work as Director of Survey, he computed them for revenue. His wide travels in the island convinced him that Cyprus, when handed over, had been in 'a thoroughly exhausted and ruined condition', for the Turkish system took all it could and gave nothing in return. The British were creating a new and happier land.[17]

In August he was at the camp, about 6,000 feet above the sea among pine trees on a 'rather narrow ridge' below Mount Troovos, which the government and military pitched as a summer capital. The views all around were magnificent and the climate 'simply heavenly'. 'There are a good many ladies up here now', he told Millie. 'Lady Biddulph came up last week, had a fearful journey'. He dined with the Lancashire Fusiliers on their annual celebration of the battle of Minden (1 August 1759) and was amused that 'we drank the *health!* of the heroes who fell in solemn silence. The band then marched round the table playing the Minden March'.[18]

Late in September he arranged to work near Limassol on the southern coast because his brother Arthur had promised to break his journey to New Zealand. Arthur had left Mexico, refusing a better mining position, to take charge of the New Zealand estate, Colonel Kitchener being unhappy with his nephew' reports. 'Herbert came off in a boat to meet me', Arthur wrote to their father. 'He looks wonderfully well – broad, strong, very sunburnt, and in capital spirits'. He had pitched camp under trees close to the sea. 'The tent is about the best thing of the East I have ever seen, plenty of room, nicely carpeted and furnished, and of very brilliant oriental colours'. The brothers bathed in the sea, ate figs before breakfast, then rode into the countryside wherever

Herbert's duties as Surveyor or as Land Registrar might call, then dined with the local garrison. 'Everyone here seems awfully jolly and like the place', wrote Arthur, while Herbert was 'awfully glad' that Arthur had come.[19]

Arthur resumed his voyage to New Zealand, where he found Waihemo Grange in decline and his cousin Henry secretly drinking and behaving badly to his wife Mabel and his six children. His contract not renewed, Henry settled in Dunedin and went to the bad. Mabel tried to run their home as a boarding-house, but it burned down on 1 July 1882. Three of their small children lost their lives in the fire, and Henry and the baby died of their burns soon after. Arthur rushed to Dunedin and did all he could. 'It is a sad sad story. To be reduced to poverty, and disgrace, by Henry's misconduct and then finally to have four children swept away, it seems almost too dreadful'.[20]

Arthur had seen his brother at his most relaxed, his chest much broader than he remembered from their last meeting some years back. To a colleague in Cyprus Herbert Kitchener seemed

> very slight in figure and spare for his height. The thick brown hair was parted in the middle; clear blue eyes looked straight and full at you; a shapely moustache concealed the upper lip, while the upright figure and square shoulders gave an impression of vigour and alertness which was not belied by a manner decidedly shy and reserved.[21]

He joined in the social life of Nicosia when not upcountry surveying. He was a whip to the garrison hounds, hunting hare, and rode in the races. The mare Salem, which he had brought from Palestine, was not too successful, but the following year he won two races with Kathleen, 'a well bred Arab'. In the Welter Steeplechase, recorded the *Cyprus Herald*, 'Kathleen kept the lead, the neat way in which she took her fences standing her in good stead'. She won by four lengths from Derviche, ridden by Charles King-Harman, Biddulph's Private Secretary and future son-in-law.[22]

When the garrison put on theatricals, Kitchener had a long part. He attended balls and went out to dinner.[23] When one military couple, the Bovills, were to be stationed in Leicestershire near the Parkers, who had returned from New Zealand to The Temple, Rothley, Herbert wrote to Millie: 'I am sure you will like her and both she and her husband have been *most kind* to me out here'.[24]

[46]

But he signs off the letter as 'Your affectionate brother, unmarried and unlikely to be'. Victorian officers were discouraged from marriage before their later twenties: they must put the service first. Kitchener was now over thirty but too dedicated to his profession to want a wife. When his second-in-command, Grant, came back married, Kitchener grumbled that they would probably have lots of children and put them before the work.

He was thoroughly happy in his surveying and land registering and as a sideline seized opportunities to excavate ruins, with such skill that the British Museum invited him to superintend the excavations at Nineveh. He was tempted if he could match his present generous salary. He suggested ingenuously that he double as British consul in Mosul. The Foreign Office was not amused.

Cyprus also brought him an abiding passion for collecting, especially ceramics. The British administration had activated an Ottoman law, hitherto a dead letter, by which archaeological finds were divided between the owner of the land, the finder (who usually bought out the owner) and the state. Kitchener helped to found the Cyprus Museum and was its first secretary. He also sent pieces to the South Kensington Museum and kept less valuable items to form the nucleus of his own collection. He had already brought early pottery back from Palestine. When his father had moved house he wrote to Herbert: 'Your "crockery" had a narrow escape – other things were smashed but your treasures are safe. Hurrah!'[25]

In July 1881 Herbert took his three-month home leave and found the family in uproar over the secret engagement of young Walter, still in India, to Caroline ('Carry' or 'Cary') Fenton, youngest of the three daughters of Captain Charles Fenton, their father's best friend. All three were in love with Walter and he was in love with Carry. She was older than Walter and not in the least economical. Fenton had consented, subject to the colonel's approval, but neither he nor Walter told the colonel, who considered that an early marriage at twenty-three would be ruinous to Walter's military career. Worse, the colonel discovered the engagement shortly after he had left Albert Mansions to share the Fentons' pleasant new home near Lymington in Hampshire. 'We ought to be grateful that such charming people can take him and make his life more cheerful', Herbert had written to Arthur, but on discovering that Fenton had consented behind his back the colonel removed himself at once to Millie and Harry at Rothley, where Herbert found him 'very much upset'.[26] He asked Chevally and Herbert to advise. They wrote stiff letters to Fenton before

he would agree that Walter remained free, and to Walter that 'the Governor' disapproved but that if Walter worked hard and became a captain and adjutant they could marry, but not correspond meanwhile.

Once Fenton had agreed to consider the engagement suspended, Herbert took the colonel back to Lymington, where he found Carry quietly determined and wearing Walter's presents. Herbert was sure they would marry but doubted she would make a good wife; but when they married in Bombay in 1884 the marriage was supremely happy until her tragic death in South Africa during the Boer War. Of sweetest character, devoted to Walter and their children she became a recognized artist of Indian scenes in oils and watercolour.

'I am very thankful', Arthur had written during the uproar, to his father 'that you have Herbert with you, his clear way of looking at matters will I feel sure bring things right'.[27] The 'Governor' became cheerful again, despite worsening eyesight, but living with the Fentons did not prove happy, as Herbert had foreseen. Instead, Millie and Harry offered 'the Governor' a house on their estate, Cossington Manor, where he lived the rest of his life. Herbert had returned to Cyprus. His father wrote to him that Cossington was rather larger than he needed but it was nice. 'I wish you were here; you seem to have the knack of making any place I am in comfortable'.[28] And indeed his dedicated soldier son had a fastidious eye for porcelain, furniture, carpets and flowers which critics long after would seize upon as evidence of a sexual bent which would have horrified Herbert.

In Cyprus, his third tour of duty was uneventful except that one December day he was shot at by a brigand who missed. But stirring events were occurring in Egypt. Kitchener, restless that he had seen no active service – the only way to the top – took a step that might have brought his military career to an abrupt end.

6

ARABI AND AFTER

EGYPT WAS a province of the Ottoman Empire which was self-governed under a hereditary khedive or viceroy. Khedive Ismail II's imperial ambitions and extravagance had forced him to sell to Britain his shares in the newly opened Suez Canal, yet he went deeply into debt to Britain and France. They formed a Commission of the Debt – to give the creditors a first claim on the revenues of Egypt and the Sudan, where Gordon, seconded to the khedive's service from the British Army, was attempting to rule for the benefit of the Sudanese rather than for Egypt and to bring peace and good government and to suppress the slave trade.

The khedive had summoned him to Cairo to help reorganize his finances, but Major Evelyn Baring, as the British Commissioner of the Debt, had out-manoeuvred Gordon and forced Ismail to abdicate in favour of his son, Tewfik. Before long, Gordon, in despair at being thwarted at every turn, resigned the governor-generalship of the Sudan, which soon lapsed back into the venal corruption he had fought.

In 1882 the increased control of Egypt by the European creditors had incensed a large group of nationalists, who staged a revolt under the Minister for War, Arabi Pasha. Khedive Tewfik fled from Cairo. The Egyptian Army supported Arabi, who seized Alexandria. The large European and Levantine communities were engulfed by riot, looting and arson. The free passage of the Suez Canal was in danger.

Kitchener was too junior and too far away to have the slightest influence on these events, but news of the riots and destruction in Alexandria, and the

assembling in Cyprus of a small British force to secure the Suez Canal, made him itch to see action. Detained at Nicosia by a bout of malaria, he sent a request to the High Commissioner in the tented capital in the hills for a week's leave of absence, which Sir Robert Biddulph granted, assuming that Kitchener would convalesce by the sea or in the hills.

Kitchener went to Limassol in plain clothes, not uniform, and took the weekly steamer to Alexandria. He made no secret of his destination (the *Cyprus Herald* reported it on 5 July) and maintained for the rest of his life that as he worked under the Foreign Office and could go wherever he liked in Cyprus, 'leave of absence' implied absence from the island. But he did not tell Biddulph that he was going to Alexandria. This omission prompted Charles King-Harman (echoing Biddulph's view) to remark in later years that though he sensed that Kitchener would one day achieve a great position, if conscience came into conflict with self-interest, self-interest would win.[1]

At Alexandria Kitchener boarded the flagship, HMS *Invincible*, and sought out the Military Liaison Officer, Lieutenant-Colonel Tulloch, who was pleased to see 'a tall, thin subaltern of engineers' who said he spoke fluent Arabic and Turkish and offered his services. 'Certainly', replied Tulloch. 'I hope you will be able to stay with me'. Few British officers spoke Arabic in 1882 as the army had not yet served in Arabic-language lands.

Together they went on a dangerous reconnaissance by train in Arab-held territory. Tulloch disguised himself as a Levantine official since he might be recognized, and indeed a few days later a fair-bearded Syrian was dragged out of the train and his throat cut in the belief that he was Tulloch. Kitchener went in his own plain clothes.[2] They returned safely in time to witness from HMS *Invincible* the great bombardment of Arabi's new forts and batteries on 11 July after the expiry of Admiral Seymour's ultimatum. Kitchener watched as the forts of Alexandria fired back, salvo after salvo, doing little damage to the twenty-eight British ironclads which pounded them remorselessly until the last fort was silenced after ten and a half hours. The admiral signalled the cease-fire; but *Invincible*'s armament included an experimental ordnance that could be only be unloaded at risk to its gun-crew. The admiral gave permission for this one final shell to be fired, and it hit the upper works of a fort exactly on target. A cloud of dust and debris darkened the air. 'But', Kitchener would recall with amusement, 'when this cleared away, an old woman rushed frantically from an outhouse and chased in some fowls!'[3]

Kitchener was not allowed to accompany shore parties to spike the guns

because he was not in uniform, but he persuaded Admiral Seymour (nick-named 'the Ocean Swell' for his genial ways and dressy attire) to wire for an extension of leave. Biddulph refused: Kitchener was absent without leave and must return by the next steamer, which he missed because Tulloch did not hand him the telegram until the steamer had sailed. He returned at the very first opportunity, arriving six days after his leave had expired to find that a furious Biddulph had talked of a court-martial. 'No one was so ludicrously astonished as I was', Kitchener later told a brother officer, 'when I arrived in Cyprus to find I was in disgrace. I had never dreamt of having done anything insubordinate'. He reported to Biddulph and tried to explain that as a 'civil-ian' he had acted correctly. 'The General was so angry about the matter that I dropped the subject, but I little knew then what damages he would do me in the W.O. I hear I am put down as a most insubordinate character and that Lord Wolseley has a special black mark against my name'.[4]

'Herbert is all right', wrote Colonel Kitchener to Arthur on 7 August. 'He is back in Cyprus having got a wigging from Sir R. B. What was wrong was he was attached to nobody'.[5]

Herbert wrote to Biddulph: 'I have been very much pained ever since my return at the view you took of my absence in Alexandria'. He was 'extremely anxious' to see service in Egypt and mentioned a post on the intelligence staff which was kept open for him (by General Sir Archibald Alison). He assured Biddulph of his ambition to finish the survey but feared his career would suffer if he remained in civil work, because a soldier's first duty was to serve in the field and not to remain at ease while others were fighting. Kitchener added, somewhat ingenuously, that he had not sought the post but if he were asked for and Biddulph opposed, 'it would absolutely capsize all my hopes in the service for the future'.[6]

When the Liberal government decided to suppress Arabi's rebellion, Alison did indeed ask the High Commissioner to release Kitchener for the expedition that led to Wolseley's victory of Tel-el-Kebir on 13 September 1882.[7] Biddulph refused without telling Kitchener, who wrote in all inno-cence to Arthur on 30 September:

I did my utmost to get over again to Egypt to be in the row but all unsuccess-ful, there was no place for outsiders with everyone in England trying to go. I had just a chance of being sent with the Turkish troops but now they are not going and all is over. It has been an exciting time here so close to the

scene of action and Cyprus has been made use of a good deal which will do the Island good. When I have finished here I should not mind a berth in Egypt, but I must stay here to finish the map and that will take at least another year unless the publisher puts on much more steam than at present.[8]

Biddulph gave Kitchener full credit for his 'great professional skill' in car-rying out the survey and noted in his Confidential Report (always seen and signed by the officer concerned) that he had considerable self-reliance, very good general ability and good professional acquirements; but he added that Kitchener was 'a well-informed officer of active habits, rather impulsive and does not always foresee results'.[9]

Biddulph and his secretary King-Harman (a year younger than Kitchener) regarded him at this time as rather superficial. As strong Evangelicals they probably assumed that his love of ritual masked a shallow faith, but they thought his whole character lacked depth. He was still a young man, and King-Harman in old age recognized warmly that the Herbert Kitchener he had known in Cyprus had not yet undergone the desert experiences, physical and spiritual, which would lead to greatness.[10]

Kitchener continued his Cyprus survey. He won golden opinions from the Greek Orthodox Church for his fairness and patience in the land registration, and he had grown to love the Greek liturgy, although he could not attend often because of Orthodox suspicion of Protestants and because he must support the English chaplaincy. He was popular also with the Turkish and French communities.[11]

Meanwhile Gladstone's government in London had decided to re-create the Egyptian Army, disbanded after its defeat by Wolseley, under British lead-ership. Major-General Sir Evelyn Wood, VC, a fifty-year-old veteran of the Crimea, the Mutiny and the Ashanti and Zulu Wars, one of Wolseley's 'Ring', was appointed to command with the title of Sirdar, the Anglo-Indian word for 'leader'. Wood was to select twenty-five British officers as Commanding Officers and seconds-in-command of the twelve regiments and corps to be formed. Fifteen of his twenty-five rose to general's rank or above in the British Army.

Sir Evelyn Wood owed his appointment to Gordon's recommendation. Gordon also recommended Kitchener as one of the twenty-five, telling Reginald Brett, Parliamentary Private Secretary at the War Office, of his fine

physical presence and character, his cool head and hard constitution.[12] Wood reached Cairo shortly before Christmas 1882. On 28 December he wired to 'Captain Kitchener, Cyprus' (although the promotion was not gazetted until 4 January): 'Will you join me for soldier's duty being spoiled five hundred and fifty no allowances except forage two years engagement. Wood.' Kitchener wired back: 'Very sorry present work will not permit me leave Cyprus for one year'. On 30 December Kitchener received a second wire from Wood: 'Write your plans as we wanted you for second in command cavalry regiment'.[13]

A story did the rounds (leaving no documentary evidence) that when Wood had stopped briefly in Cyprus Kitchener had arranged with the aide-de-camp for an immediate follow-up telegram, knowing that Biddulph would refuse to release him on the first.

With Biddulph's blessing he crossed to Cairo. A British journalist saw him early one morning standing in the centre of a circle of riders – Egyptian former officers and non-commissioned officers – trying to keep their seats, although some had not ridden much or at all. With his long boots, dark cutaway coat and tarboosh (fez) he only needed a long whip to look like a circus master as he and his Commanding Officer, Taylor of the 19th Hussars, slowly selected fifteen for training as cavalry officers. Kitchener hardly said a word. 'He's quiet', murmured Taylor to the journalist, 'that's his way . . . he's clever'.[14]

Back in Cyprus to clear up and hand over the survey, although he would retain overall responsibility for publication, Kitchener wrote to Millie: 'I feel pretty well satisfied I did right in accepting although it is not a paying billet, still I want to do some soldiering now having been a civilian for so long and I could not get a better chance than the present'.[15]

On 21 February 1883 he began service as a *bimbashi* (equivalent to major) in the new Egyptian Army. 'I am getting on all right', he wrote to Millie a month later, 'and rather like my new life. It is a tremendous change of course from being a civilian to becoming all at once a sort of sergeant major'.[16] He worked with an intensity that did not make him too popular. Arthur Kitchener had written from New Zealand: 'I have the character of being a very hard task-master – and I am glad of it, as I am sure it is just what these people want, if they only knew it'.[17] This too was Herbert's attitude. He was already drawn to his Egyptians, many of whom were *fellahin* (peasants), but he kept his warm feelings locked behind a stern exterior. And easygoing British officers disliked his devotion to work, although one wrote later with tongue in cheek that at first they had hated the sight of him because he was a sapper (only one other sapper

had been chosen) and because the light blue uniform he designed for his cavalry was finer than theirs. But later 'We got fond of him'.[18]

He joined in the cosmopolitan social life of Cairo, telling Millie of balls and dinners, and how at a great parade he had charge of the harem enclosure, 'which was very pleasant as some of the Egyptian princesses are very pretty and amiable. How would you like a dusky sister-in-law?'[19]

When his regiment moved out to Abbasia barracks on the edge of the desert a few miles north-east of the centre of Cairo he joked that the only two British ladies on the station were 'followed about by a long train of generals and colonels so that there is no chance of speaking to them hardly. As they are both ugly this is not much to be regretted'.[20]

In that year of 1883 he became a Freemason, being initiated at Cairo in La Concordia Lodge, Number 1226, English constitution. Two years later in London he was founder-member of the Drury Lane Lodge, Number 2127, and kept a lifelong involvement in the Craft at home and abroad, rising to high masonic rank.[21]

The hard work of Kitchener and his Commanding Officer was rewarded when the Sirdar inspected. Sir Evelyn Wood was delighted by their regiment, saying they had showed him a wonderful performance, whereas one infantry regiment was so poor that he stopped its colonel's leave.

In November Kitchener left Egypt to spend his own leave surveying the Sinai Desert at the invitation of the Palestine Exploration Fund, with an Oxford geologist who found him an agreeable companion and most useful for his knowledge of Arabic and local customs. He often worked away from the main party and once returned to find Professor Hull confronted by a sheikh who had refused to let him climb Mount Nebo and was demanding a large entrance fee to Petra. Kitchener trumped the sheikh by producing the Ottoman sultan's *firman*, provided in Cyprus, requiring all his subjects to give free access and assistance to Kitchener and his party wherever he wished to go.[22]

On 31 December the surveyors and geologists were near the Dead Sea when four Arabs, who had ridden post-haste from Egypt by camel, handed Kitchener an urgent letter from Sir Evelyn Baring, the former British Commissioner of the Debt who had returned from India to be British Agent and Consul-General. A simmering rebellion in the Sudan under the leadership of the thirty-five-year-old Muhammad Ahmad, a mystic who had proclaimed himself el-Mahdi (the Expected One), had become dangerous. The

Mahdi had trapped and slaughtered an expedition of the new Egyptian Army under Hicks Pasha, was raising the country and advancing on Khartoum. Kitchener must return at once with all speed.[23]

Disguising himself in Arab dress as an Egyptian official with the name of Abdullah Bey, he set off on his small horse to ride two hundred miles across country, alone except for the four Arabs on their camels. The tribes were not too loyal, so he could not wear his tinted spectacles which would have betrayed him as a Westerner, and his eyes 'burned'. They lost the clear blue of his youth, and the slight squint became a little more pronounced and fearsome. The last two days were the worst, with a strong west wind blowing the sand in their faces and almost stopping the camels. He marvelled at the skill of the Arabs, using no compass yet missing the way only once. Kitchener's endurance, riding ten hours daily without stopping, gave rise to further legend, in which he crosses the Sinai Desert alone, gets lost, and only by great self-control recovers his route.[24]

And thus, by an epic desert ride, he came to his destiny.

PART TWO

Gordon's Land

1884–1899

7

BLOOD BROTHERS
OF THE DESERT

UNAWARE OF ADVENTURES to come, Kitchener began 1884 tamely at Abbasia barracks. Colonel Taylor had been ordered to join a British contingent for the defence of Suakin on the Red Sea coast of the Sudan. Kitchener had been recalled to take temporary command of their Egyptian cavalry regiment. With war in the offing, he put men and horses through rigorous training, including early-morning steeplechases.

He shared a house on the edge of the desert with his second-in-command, Captain La Terrière, who found his chief's devotion to duty rather trying, with irregular hours, meals and sleep. Thanks to the dry heat Kitchener was now extremely fit, so slender that he seemed even taller than he was, so sunburned that his brown moustache looked almost white. He could be brusque, and the 'curious cast in his left eye gave you the feeling that he saw right through you', but La Terrière recalled him as 'in many ways just a boy – with a boy's hearty laugh and cheery manner'.

Off duty he was working up his 2,000 square miles of Sinai survey. He could seldom spare time for polo or the station's paperchases or their jaunts to Cairo, but in these congenial surroundings he was less shy, 'nor did he run away from the ladies', noted La Terrière. 'He had a few friends of his own, his taste in womankind tending rather to the motherly and "unsmart".' La Terrière thought him most unworldly because not interested in the fleshpots of Egypt.[1] Besides, he had fallen in love, or at least was attracted to a beautiful girl.

Hermione Baker was rising seventeen, the elder of the two daughters of the

celebrated Valentine Baker, hero of the Russo-Turkish War whom Kitchener had met in the Balkans, and niece of Sir Samuel the explorer and administrator whom he also knew. Valentine Baker Pasha might have been selected rather than Wood as first Sirdar of the new Egyptian Army had he not been cashiered from the British. He was away in the eastern Sudan commanding an Egyptian column sent against the Mahdi's ally, Osman Digna. At the first battle the Egyptian conscripts ran away. Baker thus lost the fight through no fault of his own but saved his life by a supreme act of courage. His wife, with Hermione and her sister Sybil, were living at Cairo's Shepheard's Hotel, where Kitchener visited them. The Bakers certainly believed that he was in love with Hermione and that they would marry when her age and his service allowed.[2]

In after years his cousin Edith would deny that Herbert loved Hermione; but Valentine Baker's disgrace in the British Army would be a serious handicap to any officer married to his daughter. The ambitious, self-controlled Kitchener would surely have kept himself from close involvement with the Bakers unless he were in love.

Late on 24 January Kitchener was attending a Royal Engineers dinner in Cairo when the senior officer present, Major-General Sir Gerald Graham, was handed a message that General Gordon, his dearest friend, and Lieutenant-Colonel Donald Hammill-Stewart as Chief of Staff would soon be arriving at Cairo railway station. Gordon had been sent out by the British Cabinet at very short notice in response to the national clamour of 'Gordon for the Sudan' but with confused instructions. He had been ordered to Suakin to report on the situation, but Baring had dispatched Wood to Port Said to divert him to Cairo, where he would be made governor-general with executive powers to effect the evacuation of the Egyptian garrisons and of civilian families, of whatever race, who wished to leave, and to select a Sudanese successor.

Gordon was Kitchener's hero. Stewart was a close friend since they had been vice-consuls together in Anatolia. The quiet Scot was five years older than Kitchener and, despite long service in a smart cavalry regiment, shared his taste for a rough life under canvas and boiled rice in the desert rather than the delicacies of an officers' mess. They were together again in Egypt in 1883 when Stewart was writing up his report after being sent hastily round the garrisons in the Sudan to advise on response to the Hicks disaster.

General Graham immediately left the dinner for the railway station, and Kitchener surely would have been among the small party of officers which

went with him to greet Gordon and Stewart. During their twenty-four hours in Cairo Kitchener had no part in the round of conferences and calls which confused, even more, the exact purpose of Gordon's mission, but he can reasonably be assumed to have spent at least an hour or two with Stewart and to have met Gordon again, with his penetrating blue eyes and a sense of mystical power, faith and dedication. Neither Kitchener's intense loyalty in the tragic months ahead, and his lifelong veneration, nor Gordon's admiration for Kitchener can be explained if their only contact was through telegrams and native runners.

Kitchener was too junior to be at Wood's farewell dinner but probably stood among the well-wishers at the railway station to see them off on the night of 25 January, with Gordon looking upset because he had been refused the Sudanese ex-slave-trader, Zubair Pasha, his surprising but inspired choice as right-hand man and potential successor, a refusal that contributed to disaster.

Two weeks later, while Gordon was still on his way to Khartoum, Kitchener was ordered to hand over his regiment temporarily. He went by railway to Assuit, then by Thomas Cook's regular steamer to Keneh (Qena) in Upper Egypt, where the Nile is closest to the Red Sea. Taking a local escort, he rode across the desert by camel to Kosseir on the coast, assessing whether the wells, the terrain and the tribes of the caravan route would allow the passage of an Anglo-Egyptian army. Cairo assumed that if Gordon were unable to achieve evacuation by his personal influence and diplomacy, Gladstone would authorize a sufficient force to support him, as Gordon himself believed.

Kitchener exceeded his brief and made a thorough study of the friendly Ababdeh tribe, more nearly related to the Berbers of north-west Africa than to the Semitic Arabs of the Sudan: blue eyes like Kitchener's were not unknown; he could pass as one of them. He recommended the formation of an Ababdeh Field Force to assist in future operations. His report was approved warmly in Cairo and London.

By then he was back with his regiment and restless, his thoughts with Gordon and Stewart in Khartoum. They had been sending civilians down-river to safety, but the Mahdi's forces were closing in while the British Cabinet dithered. Herbert wrote to his father on 20 March:

We are going on pretty much as usual, drifting through very exciting times for Egypt . . . You know much more in England what is going on than we

do here. I do not think England will stand Gordon being deserted. It is the most disgraceful thing I ever knew, had they taken anyone's advice that knew anything about the country Gordon would be safe now.[3]

Baker's defeat was reversed by General Sir Gerald Graham, who trounced Osman Digna in two battles near Suakin, though with grievous British casualties at Tamai on 13 March. Graham wired to Cairo for permission to lead his victorious force across the desert to Berber and up the Nile to reinforce Gordon and complete the withdrawal. Twelve days later Kitchener was ordered to undertake a special mission to Berber to open the Suakin caravan route and make contact with Gordon, now isolated by the cutting of the telegraph line. 'It is a very important job', he told his father, 'and I am very glad to go' despite the heat and hard work. Leslie Rundle, a quiet gunner some years his junior ('a charming fellow'), was to go with him. [4]

They set off by train and steamer. Kitchener was confident: 'I expect we shall have English troops at Berber before long and begin a Sudan campaign next autumn'. But at Aswan they were ordered to wait, 'through the utter incompetence of the Cairo and home authorities to make up their minds for 5 minutes consecutively . . . I feel quite sure if we go on much longer in this way Gordon's blood will be on the G.O.M.'s head. How the English people can stand it I cannot understand'.[5] Gladstone refused to let Graham march. Berber surrendered, and less than a year later the English people would reverse Gladstone's nickname of GOM ('Grand Old Man') to MOG. ('Murderer of Gordon'). Graham would regret bitterly that he had not advanced into the desert, far from the telegraph, without waiting for orders.

At Aswan Kitchener and Rundle raised the Ababdeh Field Force. They worked well together. Kitchener discovered by chance that Rundle was in love with a Leicestershire girl, daughter of a neighbour of Millie's, but they could not get engaged through lack of means. Kitchener remembered the girl and urged Millie to organize a grand family party when they got home 'and let these poor lovers meet'.[6] As for his own love-affair, he was able to visit Hermione when recalled to Cairo briefly in May to report. He found her father recovering from facial wounds received at Tamai, and Hermione ill. On Kitchener's last hurried visit the wife and ten-year-old daughter, Bonte, of Professor Shelton Amos, a judge who lived next door to Shepheard's Hotel, were about to enter Hermione's room with her beef tea.

Many years later Bonte recalled how a tall young officer came up and spoke

hurriedly to her mother, who drew back and they waited on a couch. 'But why?' asked young Bonte. 'Doesn't she want her beef tea?' 'Yes, but Major Kitchener is going to marry her, and wants to see her quietly'.[7] No unmarried male would have been admitted to a young lady's sickroom unless either a close relative or a fiancé.

He never saw her again. Eight months later, on 13 January 1885, she died during an epidemic of typhoid fever. He was deep in the Sudan. Whether they had written to each other cannot be known because Kitchener destroyed most of his personal correspondence. Her sister Sybil (Lady Carden) was never in doubt that Hermione's death was a great tragedy in Kitchener's life, and her first cousin Annie (Lady Wood), 'who had an extremely accurate mind, was quite certain that it is true that K and Hermione were in love'.[8]

Hermione's mother died of typhoid less than a month later. Valentine Baker gave Kitchener a gold locket containing a miniature of Hermione which may have been worn by her mother. He wore it under his shirt (not, probably, on active service). Before his last voyage in 1916 he sent it to the Baker family for safekeeping; it is believed to lie in the sarcophagus supporting his effigy in St Paul's Cathedral.[9]

In mid-May the Sirdar ordered Kitchener, Rundle and their Abadeh Field Force further upriver to Korosko in Upper Egypt, known as the gates of hell for its summer heat.

Together they organized a line of desert strongpoints between the Nile and the Red Sea, about 200 miles long. Kitchener had been made Special Commissioner for the Arabs. He had over 1,500 men under his command 'and am charmingly independent'.[10] He gathered intelligence and secured the loyalty of tribes by the careful distribution of subsidies. Heavily bearded, wearing a turban and Arab robes, he rode about with an escort of twenty men 'all dressed in white on good camels with lances bearing green banners – all picked men who will go anywhere with me'.[11] They had made him their 'blood brother' and had taken an oath, administered by a holy man with their hands crossed on the Koran, that 'his enemies should be their enemies and his friends their friends',[12] an oath they never betrayed. The Sirdar (Wood) and the Commander-in-Chief of the British Army of Occupation (Sir Frederick Stephenson) were most impressed by Kitchener's influence on the Ababdeh, whose loyalty was essential to the safety of the lines of communication up the Nile. They admired his 'very great tact, energy and great devotion'. The

frontier duty, Stephenson told the War Office when recommending Kitchener for promotion, 'required the exercise of those qualities in a high degree, and I know of no other officer in the Egyptian Army – there is certainly none in the English – capable of performing it so well'.[13]

His field force chased and nearly caught a marauding emir sent by the Mahdi to harry Egypt, and Kitchener warned headquarters that unless the home government acted quickly the day would come when Egypt would be invaded and 20,000 men would be needed to reconquer the Sudan, a figure near the total which he himself would command fourteen years later. His warnings were passed to London and not believed.

In late July Cairo urgently wanted to encourage the wavering mudir (governor) of Dongola, about three hundred miles up the Nile from Korosko. Only an Egyptian, they believed, could reach him, since the river route included two long cataracts and would be too slow: he must ride six days across the desert, through possibly hostile tribes.

An Egyptian officer volunteered to go if given an escort of 1,200 men and a reward of £10,000, so high was the risk. Kitchener offered to go for nothing, alone except for his faithful twenty. He was sure that to send more than one Englishman would be fatal, though Rundle, to be left in command at Korosko, dearly longed to go too.

During this long desert ride, and others later, Kitchener's sense of eternity deepened: the silence, the vast vistas; the escorts' faithfulness in stopping for Muslim prayers; the knowledge that he was doing it all to help Gordon, a man of profound faith. From now on, Kitchener seemed to see life through desert eyes. When, a few months later, he was a member of the headquarters mess of the Relief Expedition, with excellent food at low cost, he commented: 'I have grown such a solitary bird that I often think I were happier alone.'[14]

On 2 August he reached Dongola. The mudir would not have received him had he not come in Arab dress. Mustafa Yawar was a white Circassian, like many in the Egyptian service. Kitchener's diplomatic skills and authority to promise subsidies swung him away from a half-formed desire to change sides; a few weeks later he repulsed a dervish raid. But Kitchener reckoned him an intriguer, untrustworthy and probably corrupt. He was a fanatical Muslim. 'We Christians are dogs', Kitchener discovered, 'but are to be tolerated until we have bitten the adversary!'[15]

After two days with the mudir Kitchener went upriver to the town of Debbeh in the lush strip of vegetation beside the Nile. Debbeh had a ram-

shackle Turkish garrison of rapacious, cruel bashibazouks (irregulars) serving the khedive and robbing the locals. With Debbeh as his base, he went out again among the tribes, sometimes with the mudir and his cumbrous entourage, more often alone except for his escort. He encouraged the sheikhs and detected where loyalty wavered. He knew that when he entered an uncertain camp he might be seized as a spy. His probable fate was brought home to him when he returned once to the mudir's camp to find a dervish spy being flogged with a rhinoceros-hide whip until he died. The sight and sound prompted Kitchener to carry a phial of poison.

8

LIFELINE TO GORDON

MAJOR KITCHENER, just thirty-four, was the link between Gordon and the outer world. The telegraph line being cut, Gordon could no longer cause corrupt officials to jump to attention and salute when a telegraph clerk deciphered a Morse-coded message: 'It is I, Gordon Pasha. I see along the wire. I am watching you. Do not demand that bribe. Let that man go'. Another story that Kitchener heard concerned a bey whom Gordon wanted promoted to pasha. Cairo refused; Gordon persisted. The exchange ended when Gordon requested cancellation of previous wires 'as I have had occasion to hang the man'.[1]

No wires came now from Gordon. Kitchener organized undercover messengers who went and came back (or did not) by the desert or river routes, with letters and telegrams and small personal necessities. If he were glad to push his career, telling his father to feed the press morsels from his letters, the dominant motive was to save his hero, to be the first to reach him and help him complete the evacuation of the garrisons and to leave a settled government.

The more Kitchener cross-examined his men when they returned from Khartoum, the more grew his admiration for Gordon: his skill in organizing the defence and maintaining the morale of the mixed-race population, his improvisations, his love for the Sudanese, whom he had ruled with such success in the previous decade, his unwavering Christian faith.* Kitchener

* For Gordon in Khartoum, see the present writer's *Gordon: The Man Behind the Legend*, Constable, 1993, pp. 288–317.

commented to Millie soon after Gordon's death: 'His character will hardly ever be really understood for it had no smallness in it'.[2] At that time, and in after years, whenever he reminisced at a dinner table, his hearers were left in no doubt of his 'veneration little short of hero worship'.[3]

Gladstone spread the long-enduring myth that Gordon had disobeyed orders, had turned a mission of peace into an occasion of war (Kitchener knew better). Public opinion, pressure from Lord Wolseley, as he had become after Tel-el-Kebir, and finally a threat of resignation by the Secretary of State for War forced the Prime Minister's hand. On 5 August he asked Parliament for funds to send out what became known (to Gordon's indignation) as the Gordon Relief Expedition. It left England on 26 August 1884, and on 9 September Wolseley arrived in Cairo. Kitchener had been fortifying Debbeh, laying in stores for the arrival of British troops while maintaining the tenuous link with Khartoum. His name was mentioned to Queen Victoria when Downing Street explained plans to her Private Secretary and concluded: '. . . by this means we may have reasonable hope under Kitchener's intelligent supervision, of communicating with Gordon, and finding out what he wants and what he proposes to do' (about evacuation when reinforced).[4]

The Sirdar ordered Kitchener to report on the expedition's alternative routes from Debbeh to Khartoum, 'it being of course understood that as you will not be able to traverse the routes yourself, you must be dependent on what you hear'.[5] But compiling information was not enough for his adventurous spirit. Having decided that the route across the Bayuda desert was probably best, he determined to test it. He persuaded three sheikhs to escort him to within three days' march of Khartoum and back.

Soon afterwards he heard that Gordon intended to take the offensive. A force under Stewart, in the steamer *Abbas* and ten boats, would burn occupied Berber. Stewart in the *Abbas*, carrying Gordon's journal and code-books and a mass of letters, would continue downriver to give accurate information to the expedition, which Gordon optimistically supposed was already coming up the Nile. Kitchener wired the news to Cairo and was told to stop Gordon burning Berber and to help Stewart all he could. Kitchener wired back that he could do so if allowed to take Turkish troops from Debbeh and if a steamer lying idle at Dongola could be ordered far upriver to Merowe to awe the unreliable Monasir tribe before Stewart's steamer entered their territory.[6]

Red tape was still keeping Kitchener from carrying out his plan when he learned that Stewart had started. In alarm, Kitchener immediately sent out letters to the Hannaniyeh tribe in the Bayuda desert and the Monasir sheikhs along the Nile, ordering them to protect and assist. Sure that a trap was planned, he sent a spy to intercept Stewart at Berber with an urgent warning to take the desert route and not to continue downstream. Stewart never received it.[7]

On 2 October a runner reached Debbeh, sent on by the mudir's deputy higher up the Nile, with news that Stewart's steamer had grounded on a rock near the start of the Fourth Cataract in the Monasir country, seventy miles from safety. The runner did not know what had happened to Stewart and his party, but the steamer was stuck fast near the village of the young sheikh Suleiman Numan wad Qamar, whom Kitchener rated unreliable.

He sent the runner back with a message to Suleiman: 'If any harm befall Stewart, for every hair of his head I will have a life'.[8] Rumours of disaster swept the Debbeh bazaars. Kitchener was alone, with no Englishman to consult, with no authority to move Turkish troops. Worrying how to save his friend, he spent almost sleepless nights, each morning sending almost insubordinate wires to his faraway superiors urging plan after plan. 'I did all I knew to help him'.[9]

After two days another spy reached Debbeh with news that Stewart and his companions were dead, murdered two weeks earlier before Kitchener had even heard they were in trouble. Trusting Suleiman's offer to supply camels to complete their journey, they had accepted an invitation to enter the nearby house of a blind man for coffee and dates. When asked to leave their escort outside and enter unarmed (except for Stewart's revolver), they had relied on the law of Arab hospitality. But the blind man was a fanatical Mahdist and had persuaded young Suleiman to betray the law. Hidden dervishes rushed in, seized the revolver and cut at them with swords. Stewart and others fought with their fists until overcome. Then their soldiers and the crew were surrounded and slaughtered, though some were believed to be alive.

Kitchener begged Cairo to allow him to rescue the survivors by diplomacy. 'I would promise to do nothing rash. Please ask General Wood if I can be trusted in this respect'. The request was refused.[10]

Kitchener was deeply upset by Stewart's death, 'a dear friend of mine and the finest soldier I have ever met. It is terribly sad that he suffered such a fate

but he died trying to save others. His name will live as a hero for ever'.[11] His death had a lasting effect on Kitchener. He realized that the powerful emotions he had experienced, of worry, devotion and grief, could have affected his military judgement. More than ever, he must rigidly control the warmth and tenderness of his heart.

Not until almost two months later, on 1 December 1884, could Kitchener write to his father from Debbeh: 'The steamer is now in sight bringing 200 men of Sussex under Colonel Tolson so I give over my command here. It has been rather amusing being OC Troops here'.[12]

Lord Wolseley, for valid reasons, had rejected the shorter route across the desert and was sending the Relief Expedition up the Nile, a slower and more laborious task than he had expected, even had he not lingered in Cairo waiting for Canadian *voyageurs* to help him with the boats. On 24 November Kitchener had been 'still waiting here for the Expedition. What a time they take getting up'.[13] As commandant of Debbeh he was receiving and transshipping 'stores, hospitals etc' arriving in advance.

Even more important, he was still the only link with Gordon. Telegrams would arrive from Sir Charles Wilson, now chief of intelligence and Kitchener's immediate superior: 'November 16. A message for Gordon will be sent to you tomorrow. Please find messenger who will start at once and [in cypher] *promise good pay*'.[14] Not every messenger reached Khartoum; Gordon complained in his journal of lack of news. Moreover, he could not read cypher telegrams as he had sent the cypher-book with Stewart. And when Kitchener sent newspapers wrapped around some goods, Gordon nearly missed them.

But he was grateful. He wrote in his journal, sarcastically, 'It is delicious to find not one civil word from any official personage except Kitchener', and pasted in a letter he had received from Sir Samuel Baker, former governor-general of equatorial Sudan, Hermione's uncle: 'I like Baker's description of Kitchener. "The man whom I have always placed my hopes upon, Major Kitchener, R.E., who is one of the few *superior* British officers, with a cool and good head and a hard constitution, combined with untiring energy . . ."' That same evening (26 November) Gordon added: 'Whoever comes up here had better appoint Major Kitchener governor-general for it is certain after what has passed, *I am impossible* (what a comfort!).' Twice more he recorded his belief that Kitchener would be 'the best man'.[15]

Gordon would go up on the roof of the palace with his telescope in vain. As Kitchener wrote in Debbeh: 'The expedition is rather dragging'.[16]

Wolseley had formed two camel corps from volunteers of the British heavy cavalry and the Household Division (foot guards and Household cavalry). His plan was to concentrate at Korti and Amuskol, further up the Nile, then send the camel-mounted column under Sir Herbert Stewart (no relation of the murdered Colonel Stewart) by the short cut across the Bayuda desert. The main body would continue up the Nile, punish the murderers, recapture Berber and meet the desert column at Metemmeh. The whole expedition would then advance on Khartoum.

Kitchener (now again in British uniform, without beard and with a moustache smaller, he thought, than shown in the illustrated papers) had been appointed to Stewart's staff as head of intelligence. He hoped to be the first to shake hands with Gordon. Then a wire reached him at Stewart's camp near Korti that Wolseley did not wish him to go. A disappointed Kitchener supposed that 'My Lord Wolseley has not forgotten or forgiven'[17] his long-ago insubordination in Cyprus. And certainly Wolseley, before leaving England, had rejected Cairo's recommendation that Kitchener be promoted from captain to brevet-major in the British Army. Cairo had repeated the recommendation even more strongly, and the Duke of Cambridge approved it after Wolseley had left.[18]

But Kitchener had misjudged him. When Wolseley arrived at Korti by river, at dusk on 16 December, so Kitchener told his father,

I was on the bank in a crowd of soldiers and officers – almost the first thing I heard was Ld.W. saying 'Is Major Kitchener there' – then some one said 'Yes' and he then said 'Let him come on board at once, I wish to see him'. I had to go down a broad flight of steps and on board he shook hands and asked the news which I told him. Next day I met him walking about and he called me and said some very nice things about my services – I dined with him the same evening.

Writing on 26 December, Kitchener went on:

However the greatest honour was done to me last night, Xmas, the men had a bonfire and sang songs. Lord W. and everyone was there. After the songs

cheers were given for Ld. W., Genl. Stewart, and then someone shouted out 'Major K.' So 2,000 throats were distended in my honour. I am very proud of that moment and shall not forget it in a hurry. After that Genl. Buller was cheered. I expect we shall be at KHARTOUM before you get this letter – Genl. Sir H. Stewart is an awfully nice man and I like him very much – he has been very civil and kind to me – he will command the troops advancing across the desert.[19]

Kitchener would be there after all; Wolseley had decided to let him go.

At sundown on Wednesday 7 January 1885 Kitchener and his escort left Korti as advance scouts of a convoy of a thousand camels under the inefficient command of Colonel Stanley de Astel Calvert Clarke, equerry to the Prince of Wales ('Nothing could be worse managed', was Wolseley's comment).[20] Stewart's main body left the following day in excellent order. They all reached the wells of Gadkul a week later, but Kitchener was unable to contact the local tribe. Then, to his renewed disappointment, an express messenger summoned him back to Wolseley's camp, where he arrived on 16 January after a hard ride by camel. Wolseley needed him to handle communications with Gordon, such as they were, and Kitchener therefore missed the short but bloody battle of Abu Klea when the ansars (dervish cavalry) broke into the British square before being repulsed. Colonel Fred Burnaby, famous as a traveller in Central Asia, was killed. Two days later, in a minor engagement when they reached the Nile, Stewart was mortally wounded. The command of the column fell on Colonel Sir Charles Wilson, a distinguished surveyor and intelligence chief but with no experience of directing a campaign.

Wolseley received news of Abu Klea and of Stewart's wound, but no more. The main body working upriver had been held up, but Lord Charles Beresford's gunboats had passed Berber, with some damage, and met Stewart's force. Gordon's own steamers had fought their way down to meet it.

Wolseley therefore sent his Chief of Staff, Redvers Buller, to take over from Stewart. He also sent the Royal Irish Regiment, 'magnificent looking men, wiry and strong',[21] as reinforcements. They marched off on foot in the small hours of 29 January after a dust storm had dropped. Kitchener went with them as chief intelligence officer and expected to see Gordon within days.

Kitchener made a great impression on the Royal Irish. After the regiment had returned home, a young priest in Plymouth was visiting Catholics in

the local jail and and entered the cell of a soldier. The soldier chatted about the Sudan and mentioned a remarkable officer: 'Oh, he is not known, sir. But if you wish really to know, he is only a major in a black regiment'. The priest asked him name. 'Kitchener, sir. If you like to follow him, sir, he will *own the whole of the British Army!*' When asked what sort of man, the soldier used the Irish slang for excellent (like the Scottish 'grand'): 'A terrible man, sir!'[22]

During the six-day march Kitchener came to know the best-loved man of the whole expedition, the Roman Catholic padre of the Royal Irish, Father Robert Brindle. A Liverpool man aged forty-seven, he always marched with the men instead of riding with the officers, and with blistered hands and neck had been stroke-oar of the boat on the upward Nile journey which won Wolseley's prize of £100 for the first to arrive without loss. He was a man of great humour. His favourite story was of the sermon he preached on the first Sunday in Lent, telling the men that he could not ask them to fast on a campaign, but 'It would please our Lord and me very much if this Lent you gave up *bad language*'. A few minutes after the service he happened to walk on the sand behind a group of privates and heard one say: 'That was a b////y good sermon the f////g Father gave us this morning!'[23]

Thirteen years later Father Brindle would be with Kitchener at a highly emotional moment.

And one morning on that march on the well-trodden caravan route a young, very small but smart staff officer, rather sore from his early efforts to master his camel, was riding alone when 'a tall officer, with bronzed face and piercing blue eyes, ranged himself alongside of me and said pleasantly that, as we were both for the time unattached, we might as well ride together'. Sir George Arthur (a baronet) introduced himself. After some trivial chat he drew from Kitchener an exciting account of his doings and learned of his 'desperate efforts to save Stewart from the trap laid for him' and of his veneration for Gordon.[24] Arthur, a great favourite in London society, was a High Churchman like Kitchener. Their friendship, begun that day, would culminate in Arthur's becoming Kitchener's Private Secretary (civil) in August 1914.

The march reached the wells of Gadkul, where on 2 February they were horrified to be told that Khartoum had fallen. After a three-day delay (for which Kitchener never blamed Wilson) the steamers had fought their way to

within sight of Khartoum, one day too late. They withdrew under fire and learned later than Gordon had been killed.

'The shock of the news was dreadful, and I can hardly realise it yet', Kitchener told his father more than a month later. 'I feel that now he is dead, the heart and soul of the Expedition is gone'.[25]

9

HIS EXCELLENCY

On the lawns of Osborne House, Isle of Wight, at noon on a very hot 14 July 1885, the sixty-six-year-old Queen Victoria stepped down from her carriage and paid the Heavy and Guards Camel Corps (their camels left in the Sudan) and the staff officers who had travelled home with them the signal honour of walking down every rank. The *Australia* had anchored that morning in Cowes Roads, and they had at once been commanded to march to Osborne House to receive her thanks. If she was a trifle disappointed that they had hastily darned and brushed their war-soiled uniforms, they were more than a little disappointed, despite being thrilled by the honour, that the Household had forgotten they would be thirsty.[1]

All officers were presented, and thus Lieutenant-Colonel Herbert Kitchener (brevet gazetted 15 June 1885) met his sovereign for the first time. She had heard much of him and again when the Foreign Secretary asked Baring to obtain his views on the policy of retreat from Korti, to Wolseley's indignation: 'Such a request is unheard of', he complained to the Queen; it should have been made through him.[2]

After the death of Gordon, Kitchener had marched with Buller to the Nile. Then they had been ordered to withdraw to the wells of Abu Klea, where they had wondered whether the Relief Expedition would re-form, take Berber and recapture Khartoum, or retire. Kitchener wrote to his father, 'Some say it has been a dismal failure . . . Altogether the organization of the Expedition has been very bad', and to a friend a month later, 'Nothing up here but mismanagement and mistakes'.[3] One mistake, which would have brought

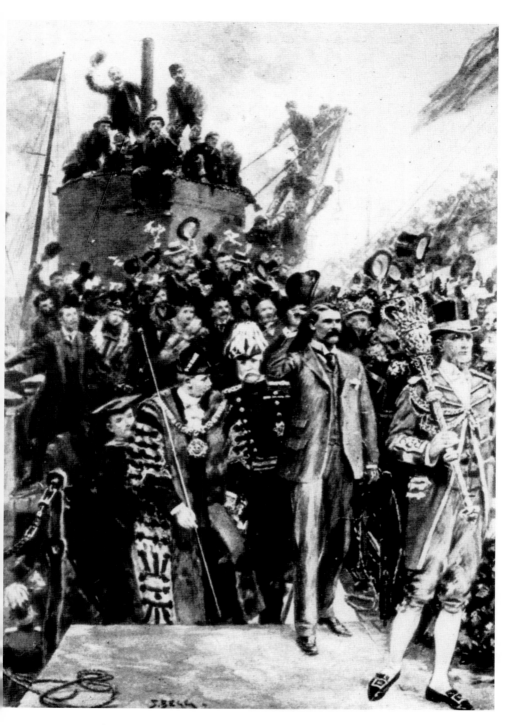

The Victor of Omdurman lands at Dover, 27 October 1898

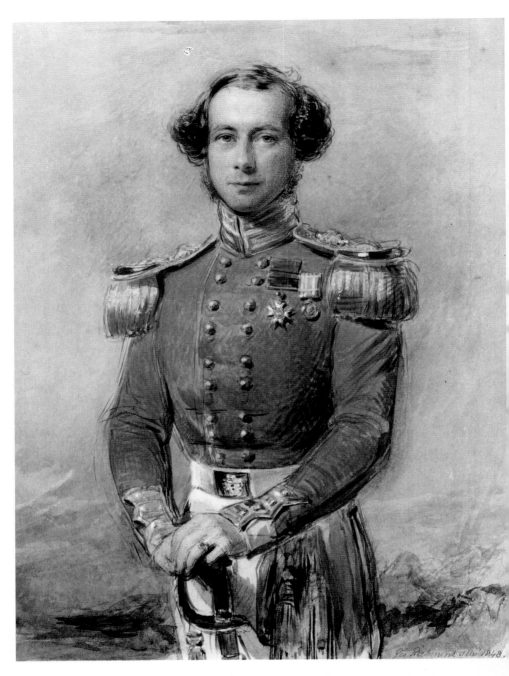

Henry Horatio Kitchener, aged 37, when Captain, 29th Foot, by George Richmond
(sittings 1842 before HHK left for India; delivered 1843)

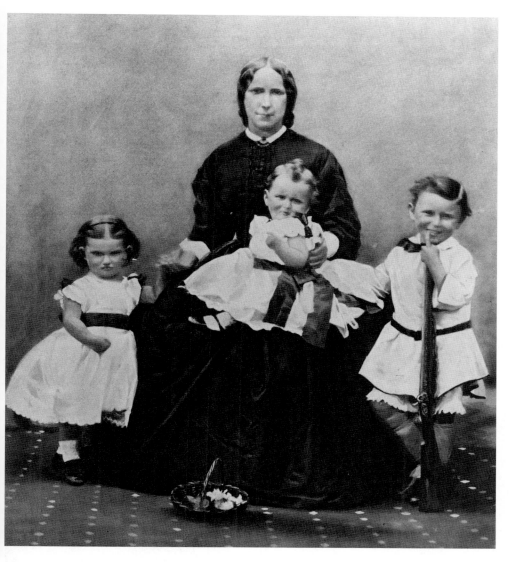

Fanny Kitchener (*née* Chevallier) 1851. Herbert on her lap;
Chevallier ('Chevally') and Emily ('Millie')

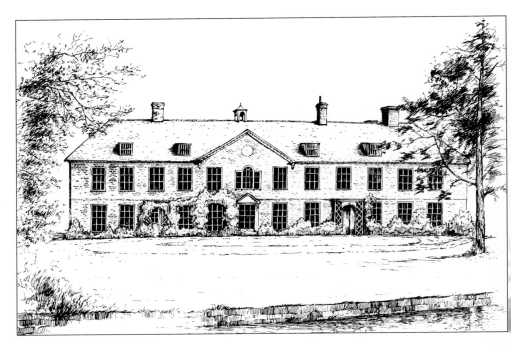

Aspall Hall in 1898, the moated ancestral manor of the Chevalliers

Crotta House, the Kitcheners' 'beautiful home in sight of the Kerry mountains'

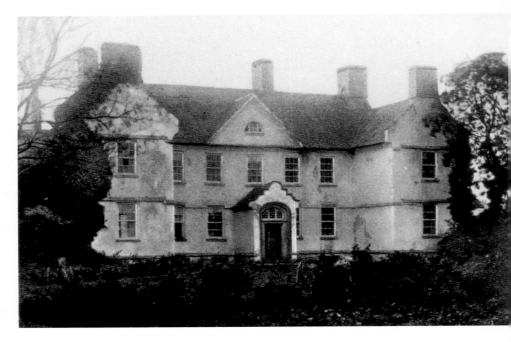

Herbert aged 18, a keen rider

Herbert (right) with Chevally, Millie and
Walter 1869, before Millie's wedding

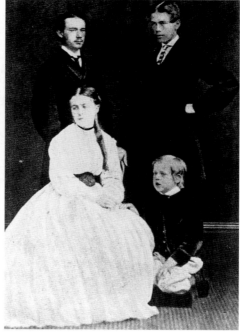

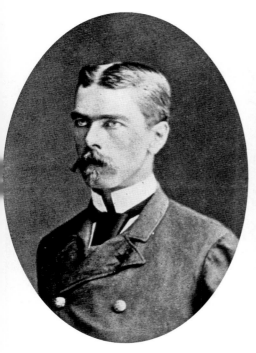

Herbert at 28,
on return from Palestine, 1878

1869;
aged nearly 19

Cyprus,
September 1880,
aged 30

aged 48

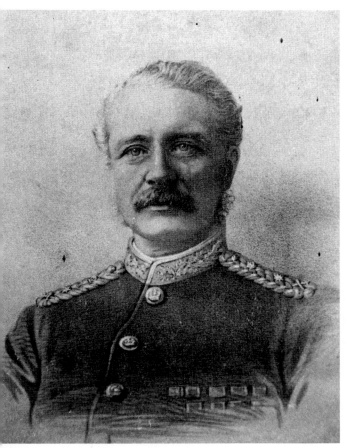

General Gordon,
Kitchener's hero

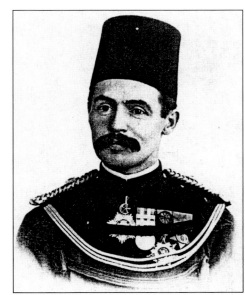

'Monkey' Gordon, his nephew, Kitchener's
Director of Supplies

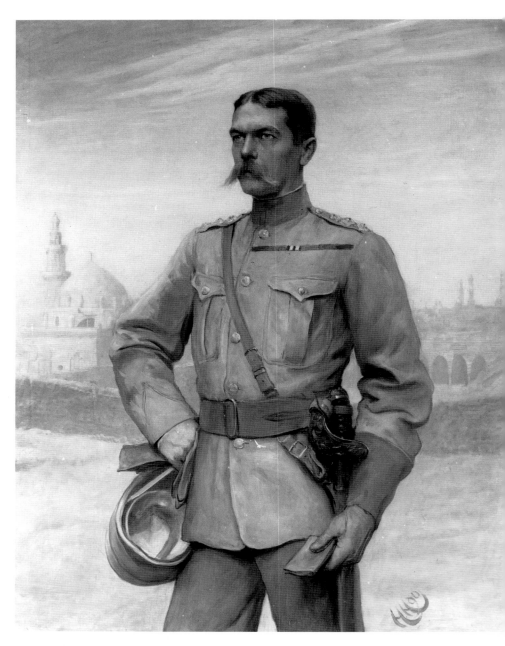

Colonel Herbert Kitchener Pasha, CB, CMG, 1890, aged 40,
by Sir Hubert von Herkomer

disaster on Buller's column, was put right by Kitchener himself. He had learned that a large dervish force was advancing on the wells of Abu Klea. Buller decided to retreat across the desert, but when Kitchener urged that the wells be filled in so that the dervishes could not pursue, the kind-hearted Buller was aghast: to deprive an enemy of water in a desert was against the rules of war. The staff supported Kitchener until at last Buller agreed reluctantly that they could fill in the principal well. Kitchener jumped up: 'Verner, you know the biggest well. Get some men at once and fill it in'. Turning to another officer: 'Fill in the biggest well you can find. I'll go and see about the rest'.[4]

The expedition re-formed at Korti on the Nile.[5] Wolseley failed to secure permission to advance on Khartoum. Early in May Gladstone found an excuse to order total evacuation. Kitchener wrote: 'It is a sad end to the campaign. I wish I had been taken ill with any disease sooner than stay and see it'.[6] The welfare of the Sudanese, the safety of Egypt and the canal, the memory of Gordon cried out against it. Kitchener was sure it must be reversed one day, probably at great cost. The failure of the campaign drove deep into Kitchener the fundamental need for exact and thorough preparation at every level.

All these last weeks Kitchener had been compiling the official report on the fall of Khartoum and the death of Gordon. He had been touched to receive a kind letter from Gordon, written many weeks earlier, which had been sent down the Nile with his journal and other papers in the last steamer to leave before the end.'It is the best reward that I shall get for many months hard work', he told his father, 'so please keep it most carefully'.[7] Unfortunately he lost it.

Kitchener examined refugees from Khartoum as they trickled in across the desert or down the Nile. He believed, on the evidence then available, that when the Mahdi's men broke through the weakened defences Gordon had been killed by rifle fire when walking with his escort from the palace to the armoury in the former Austrian mission, where he planned a last stand. Later evidence suggests that he was killed by a thrown spear on the palace stairs, as in the famous picture, though the truth can never be known.

As Kitchener compiled his report he was more than ever impressed by Gordon's 'indomitable resolution and resource' in maintaining the defence for 317 days. 'Never was a garrison so nearly rescued, never was a commander so sincerely lamented'.[8] Kitchener was determined to avenge him.

After the parade at Osborne came two months' leave, which included visits to Leicestershire to stay with his father and with Millie and her family. He also

made two lifelong friends. Pandeli Ralli, a bachelor five years older than Kitchener and of Greek extraction, was a partner in the great trading firm of Ralli Brothers. A close friend of the murdered Colonel Donald Stewart, he had written as a stranger to Kitchener in the Sudan for details. This mutual friendship brought them together in London. Ralli's fine London house in Belgrave Square would become Kitchener's home on later leaves. And he was invited to Taplow Court near Maidenhead by the celebrated oarsman, athlete and Member of Parliament, 'Willy' Grenfell, who had swum Niagara twice and climbed the Matterhorn by three different routes. They had first met two years earlier when Grenfell had visited his younger brother Charles, serving in Egypt with the 10th Hussars. More than thirty years later Willy Grenfell (Lord Desborough) recalled the Kitchener of that time, before the Sinai Desert ride had affected his eyes, as 'a most striking figure, tall and spare, with the most wonderful piercing bright blue eyes, set very far apart'. At Taplow Court in 1885, Grenfell, who was not yet married and knew nothing about Hermione's recent death, noticed a strange atmosphere of loneliness about him.[9]

Most of the leave was spent in London, studying oriental law. Kitchener was one of the few whose reputation had been enhanced by the Gordon Relief Expedition. In Cairo the khedive, when decorating him, had made 'some very nice remarks which he started in English, tried hard to bring out in French and then relapsed into Arabic in which he was fluent in my praise which will not bear translation being oriental in character'.[10] But the Royal Engineers did not like their officers to be away too long from regimental duty. Kitchener expected to build barracks in Ireland. Gordon, after his triumphs when seconded to the emperor of China, had spent five years at Gravesend renovating Thames forts, happily giving his spare time to the poor and the sick and to poor boys. Kitchener's shyness would not have encouraged him along that path, but he wanted to return to Egypt 'where I have a pet scheme for getting the Fellaheen out of their financial difficulties'.[11] He had been concerned that poor peasants in the hands of moneylenders could be left destitute when a creditor foreclosed. Kitchener wanted to prevent this, but twenty-eight years would pass before he had the authority to bring in a law himself.

Instead of Egypt he received orders for Ireland. A few days later these were revoked. The Foreign Office required his services again.[12] He found himself briefly caught up in the 'scramble for Africa' as British representative on the Zanzibar Boundary Commission. On 29 November 1885 he landed in

Zanzibar, the island of cloves and port of the slave trade (still active, if clan-destine, harried by the British Navy), and was welcomed by the legendary Sir John Kirk, once Livingstone's fellow explorer, now the British consul and dominant influence on the sultan.

The sultan of Zanzibar considered himself suzerain of the mainland which would later be Tanganyika and Kenya. Germany had been annexing much of it by treaties not recognized by Britain and France; but until the powers settled exactly how far inland lay the sultan's boundaries, they could not carve up the rest.

Kitchener thought the German representative shifty and difficult, and by the new year, still stuck in Zanzibar in the yellow flat-roofed consulate, he was longing for the work to be over: 'One is dreadfully cut off from the world without the satisfaction of a wild life'.[13] Later, in January 1886, the commis-sion sailed some forty miles along the coastline, taking evidence at each harbour but not penetrating the interior, the land of plenty and beauty which Kitchener would later come to love.

The commissioners argued among themselves and sent long dispatches to their governments, only to have the matter settled in the capitals of Europe behind their backs. Kitchener suggested Mombasa as a British naval base. Otherwise, the Zanzibar commission had wasted energy and time, although it brought him the Foreign Secretary's warm approval and a CMG.*

In August 1886 he had at last started home when at Suez he was handed a wire appointing him His Excellency the Governor-General of the Eastern Sudan and the Red Sea Littoral – a resounding title which meant nothing but control of the coastline by ships of the British Navy, plus the port and town of Suakin and some fifteen miles of hinterland; Osman Digna had recovered much territory when Sir Gerald Graham's large force had been withdrawn in 1884. Suakin and the littoral were essential to the safety of the route to India and to prevent arms being landed for the Mahdists. The governor-general also commanded 2,500 British and Egyptian troops, with the local rank of colonel. The previous governor-general had been removed after only a few months as useless in command.[14]

A small naval vessel took Kitchener back down the Red Sea and through

* Companion of the Most Distinguished Order of St Michael and St George. He had hoped for a CMG for his Cyprus map (published at last in April 1885), and no doubt that and his Sudan service counted.

the narrow difficult channel, some two miles long, to the safe basin between Suakin island and the mainland, where he found the squalid little town in sweltering heat and 'a large rambling ruined house' which was His Excellency's residence – 'it is quite good enough for me and I have made myself to be fairly comfortable'[15] – together with his aide-de-camp, Peel, and the garrison engineer, young William Staveley Gordon, 'a nice little chap' nicknamed 'Monkey'.[16] The late general's nephew, he had the family's large, rather staring eyes. 'Oh, you have Gordon's eyes!' exclaimed Kitchener.

The Mahdi had died less than five months after Gordon, of smallpox or possibly poison, and had been succeeded by the caliph who had directed the siege, known to the British as the Khalifa.[17] His rule was already proving brutal and arbitrary, he was bleeding the country to maintain a huge army, and Kitchener soon found that many of the local tribes were less certain of their allegiance to the Khalifa and his local subordinate, the redoubtable Osman Digna.

Kitchener employed a policy of tact and the offer of forgiveness for any rebel who would come in. He had a slogan placed on the gate: 'Peace to those who enter and who leave this place'. 'I always did my best', he wrote, 'to use all kindliness, justice and truth to those under my rule'[18] After he had recaptured Tamai, up the coast, he wrote letters to the neighbouring sheikhs. When they came to see him and complained of the unsettled state of the country, he replied that they could follow Mahdism if they liked but to secure peace they should abandon this false creed (which most Islamic leaders held to be heretical and the Mahdi a false Messiah).[19] 'Kitchener', wrote the new Sirdar, Sir Francis Grenfell, 'first succeeded in detaching the tribes from Osman and making an anti-Dervish league. He got to know every sheik personally and completely gained their confidence and respect. It is most disgusting to see him held up to abuse'.[20]

For when he stopped trade with the interior he was attacked in *The Times* and in letters to Lord Salisbury by Augustus Wylde, a trader who had been ruined by the rebellion and wanted to trade with the Mahdist empire, and William Fox, a Quaker engineer who believed that if he were allowed to build a railway from Suakin to Berber, all would be peace, that every shot fired at a Sudani was wicked, and Kitchener's whole policy was wicked and wanton.[21] Baring himself, misled by the British consul, the quarrelsome Donald Cameron, was doubtful of Kitchener's policy at first, 'but I must confess', he wrote after visiting Suakin, 'that all I have heard and seen lately has impressed me very favourably with him'.[22]

[78]

Kitchener was carrying out Lord Salisbury's policy under Baring's instruc-tions. But one initiative backfired. Cut off from world news, Kitchener had persuaded Baron Reuter to extend his wire service to Suakin, promising in return 'the most wonderful and thrilling news from the Sudan'. But when Reuter's reported a speech of Lord Salisbury in which he said that Egypt was only justified in holding Suakin as a means to end the slave trade, Kitchener suppressed the paragraph because the loyalty of the people would not be encouraged if safety from Osman Digna depended merely on humanitarian feelings in England.[23]

When not away on operations or diplomacy Kitchener Pasha kept up a liberal establishment at Government House, spending all his considerable pay to do so. He gave frequent dinners, mainly male affairs since only three white women (one a bride) were resident.

Each day he would rise early and ride, inspecting troops and fortifications to keep both to his high standards; then go to his office at 8 a.m. until 5 p.m. except for lunch, 'settling all sorts of questions for everything has to come to me'. At five o'clock he would ride down to watch tennis or sometimes to play polo. In one match they had 'a most dreadful' accident when his brigade major's pony fell and rolled over him fatally. 'It was a great loss to me as well as everyone', Kitchener told his brother Arthur, 'as he was a most charming little fellow and we hit it off exactly'.[24]

Arthur Kitchener was coming home from New Zealand on leave and to work out details of their father's decision to amalgamate his sheep run with Sir Francis Bell's. Herbert was most disappointed that Arthur's ship did not stop at Aden so that he could not reach Suakin. Herbert tried to persuade Millie to come out on a winter visit, and he wrote regularly to his father, who was going blind. 'Thank you', wrote the old colonel, 'for writing so big and plain . . . your letters are the only ones now I can read . . . your beautiful big hand – it must take you long to do but helps me much'.[25]

In late 1887 Osman Digna, strengthened by appropriating the trading cara-vans before Kitchener had stopped the trade, had been laying waste the nearby country and sending raids almost to the suburbs of Suakin. 'Monkey' Gordon built a wall of coral, at great speed, and several outlaying forts. The loyal tribes were angry with Osman, and in early January 1888 Kitchener saw an oppor-tunity of catching him at his base in the village of Hardub and liberating a

large number of slaves. Kitchener secured the Sirdar's permission to attack, provided he used no regular British or Egyptian troops but relied on friendly tribesmen, Turkish irregulars (bashibazouks) and Egyptian police.

He concentrated his force of four hundred men in the middle of the night. His second-in-command, T. E. Hickman, noticed a suspicious number of Black Sudanese regulars (who hated Mahdism) dressed in shirts and drawers and pretending to be scallywags. 'Shall I turn them out or turn a blind eye?' he asked Kitchener. 'Turn a blind eye!'

The night march took the Mahdists by surprise and nearly caught Osman, but when the enemy counterattacked from the rear the tribal friendlies and the bashibazouks bolted, while the liberated slaves ran in all directions. The Blacks and Egyptians rallied on a hillock. Both sides were pouring a hot fire at each other. Kitchener rode forward, intending to lead the Blacks in a final charge to win the day. As he turned along the line a bullet hit the lobe of his right ear, splintered a piece of his jaw and lodged close to the throat. He had missed death by an inch. He kept his seat, and the medical officer, Galbraith, rode up and tied a handkerchief around the jaw since Kitchener dared not dismount.

The Blacks never charged. The raid failed. Kitchener, barely able to speak, handed over command to Hickman, who conducted a fighting retreat under heavy fire. By the time Kitchener was helped off his horse at Government House he was in great pain. On examination Galbraith found the jaw unbroken but a splinter of bone had lodged near the windpipe, tonsils and glands. The neck had swollen, and he could not find the bullet, which moved later and nearly choked Kitchener until he managed to swallow it, or so he always claimed.

The deputy commandant, A. B. Makepeace Shakespear, wrote to Millie: 'Your poor brother has a very nasty wound in the face. He is anxious to make light of it but that is all nonsense'. Shakespear described the injuries. There was no cause for alarm but 'it is too severe a wound for him to remain here so I am sending him up in the Starling and he will leave today. I have taken over his duties until his return but I dare say you will see him at the Temple before I shall see him back at work here. The Queen has just telegraphed to ask after him. We are able to say there is an improvement this morning though the improvement is slight. The fact is he is a bad patient. He worries himself about his work here and about leaving it. I shall be glad to hear of him arriving in Cairo where he will have all the comforts of the grand hospital they have in

the Citadel',[26] where the Sirdar visited him and laughingly said he supposed he ought to court-martial him as the names of several Sudanese regulars were on the comparatively short casualty list.

No one seemed to mind that Hardub was a defeat. Wolseley wrote from the War Office. 'Everyone here was extremely grieved to hear of your wound and all wish you a speedy recovery. We shall be badly off at Suakin until you are well enough to return there which I hope and trust for your own sake as well as the country's may be very good [sic, a slip for 'soon'].'[27] In his reply Kitchener praised the hospital and asked Wolseley to write and thank the three army doctors and the sister concerned.

At Suakin Kitchener's ADC wrote to Millie three weeks after the battle: 'You can guess how terribly cut up we all were about your brother, and it is very pleasing that the whole town felt it very much and they never cease to enquire how he is getting on'. Millie came out briefly to Cairo and when Kitchener returned in mid-March to Suakin he told her of 'a most cordial reception from the people who all turned out when I landed and illuminated the town in the evening'.[28]

On 11 April he was not only promoted colonel (brevet) but Queen Victoria was personally[29] pleased to appoint him one of her aides-de-camp. This, he commented to Millie, was a most unexpected surprise. 'It is another jump successfully negotiated on the rather tiring course through this life'.[30] The Sirdar had written a glowing report: 'His garrison has been kept in perfect order, while he has worked hard at his civil duties. He has great influence with native tribes, speaking Arab fluently'. His capacity for command was 'very great'.[31]

Kitchener was on his way to the top. But fame was never so strong a spur as duty and the will of God.

10

SIRDAR

THE WOUND REFUSED to heal. In the spring of 1888 Kitchener took early leave, and in London the doctors cured him. But the handicap of 'one eye following the other' became a little heavier. Moreover, the honourable scars now gave his face a somewhat cruel look, which those who did not know him, or its cause, supposed an indication of character. To others he seemed to scowl, or glare or frown. He was happy to exploit his face to keep unwanted people at a distance, but the harsh look disappeared when he smiled.

While on leave he was summoned by the Prime Minister, Lord Salisbury, who was his own Foreign Secretary. Salisbury was 'much impressed with him', recalled Lord Edward Cecil, his fourth son. 'That I clearly remember, for my father was not often impressed'.[1] Lord Edward, a twenty-one-year-old ensign in the Grenadier Guards, met Kitchener for the first time when Salisbury followed up his official interview by the rare honour of an invitation to stay a weekend at Hatfield, his Jacobean mansion in Hertfordshire. As Kitchener climbed the Grand Staircase he would have seen the Duke of Wellington's trophy from his early Indian wars, Tipu Sahib's sword which the Duke had given to an earlier Lady Salisbury, a spur to any ambitious young commander.

Although Kitchener astonished the household by his early rising, since the day began late at Hatfield, he immediately found himself at home among the Cecils. Their unusual blend of intellectual pursuits, politics, science and fun, with no inhibitions between the generations, and a strong but unself-conscious Christianity, was well able to encourage a gauche and shy soldier on the verge

of great achievement. The eldest son, Jem (Viscount Cranborne), and his young wife became particular friends. Jem, twenty-seven, was a Member of Parliament, a keen officer in the Militia and a zealous churchman, so they had much in common.

His wife, born Lady Alice Gore, daughter of an Irish earl, was then twenty-one. She had dark hair and a rather severe beauty which belied her delightfully happy personality. Like Kitchener she had lost her mother in childhood. She had been brought up by her grandmother, Lady Joscelyn, a woman of charm and beauty who had been one of Queen Victoria's Coronation trainbearers. Lady Joscelyn was a fervent Evangelical but full of sorrows: her husband and four children all died in her lifetime. The gloom of the Cross rather than the joy of the Resurrection pervaded Alice's childhood. Her own sincere faith came to its fulness in the relaxed atmosphere of Hatfield and a most happy marriage. She had gifts of understanding which would mean much to Kitchener in the years ahead. She was in tune with his desire to help the poor, for the great philanthropist Lord Shaftesbury had been her great-uncle by marriage and she loved to follow his example.

Kitchener would find a sympathetic correspondent in Lady Cranborne (it was always 'Dear Lady Cranborne,' never 'Dear Alice') and she kept his letters, written to be shown to her husband too, but most unfortunately he destroyed hers with almost all his private archive.

At Hatfield that week-end Salisbury offered Kitchener the post of Adjutant-General of the Egyptian Army, second-in-command to the Sirdar (the appointments were controlled by the Foreign Office, not the War Office). Kitchener wrote to Arthur in New Zealand: 'I do not much like the change as I shall not be so independent but I believe it is best to accept, which I have done.'[2] When he went on to Cossington, where the colonel was well but had aged and was very blind, he found his eldest brother Chevallier, still a major, and wrote to Arthur: 'I cannot understand him, he seems more queer than ever and is I feel very jealous of my promotion, a funny thing for a brother to be.'[3] Harry and Millie were about to revisit New Zealand, promising to stay with Herbert in Cairo on the way back. Herbert finished his leave by shooting in Scotland, where he got his first stag 'and a good many grouse'.

Before he could settle down in Cairo in the spacious house allotted to the Adjutant-General, he went with Grenfell and reinforcements to Suakin, where Osman Digna had been strengthened by Baring's mistake in revoking Kitchener's ban on trade with the interior. Grenfell defeated Osman in a brief

campaign. Kitchener handled the cavalry well. By late January 1889 Sirdar and Adjutant-General were in Cairo.

In the hot weather that year Kitchener was on leave in England when he was summoned back to find the Sudanese frontier aflame. The dervishes were assembling for an invasion of Egypt. He wrote from Aswan on 24 July to Millie, now returned from New Zealand: 'What a change it was, in only 12 days from London gaieties to organizing a force here with the thermometer at 110 in the shade.' The dervishes had brought their women and children but no food, 'so they leave them to starve, the poor creatures come in to us in the most ghastly state, mere walking skeletons'.[4]

Nine days later, on 3 August 1889, the dervish invasion was totally stopped by Grenfell at the battle of Toski, Kitchener again commanding the cavalry, who headed off a dervish flanking movement. Western firepower inevitably wrought a great slaughter.

Grenfell's confidential report for 1890 noted Kitchener's strengths and weaknesses:

> . . . a very capable, active clear-headed officer. Can drill with all arms. A good brigadier, very ambitious, his rapid promotion has placed him in a somewhat difficult position. He is not popular, but has of late greatly improved in tact and manner and any defects in his character will in my opinion disappear as he gets on in the service. He is a fine gallant soldier and a good linguist, and very successful in dealing with orientals.[5]

He hoped to succeed Grenfell as Sirdar. Then Baring, early in 1890, asked him to reorganize the Egyptian police. Kitchener demurred, saying that acceptance might injure his career. 'My dear Colonel,' replied Baring, 'if you do not accept posts that are offered you, you may have *no* career!'[6] Kitchener accepted, reorganized the police to Baring's satisfaction and resumed the Adjutant-Generalship.

The Grenfells had shown no sign of moving 'so I go on waiting', he had written to Millie. 'It is a poor game, but perhaps it is worth it. Anyway, unless something v. good turns [*sic*] I think I ought to stick on.'[7]

One year later, in January 1892, Khedive Tewfik died after a short illness through the incompetence of native doctors. He was succeeded by his eighteen-year-son, Abbas Hilmi II, fresh from an Austrian military school in Vienna. The British government decided to recall Grenfell after seven years as

Sirdar. The English officers of the Egyptian Army hoped that the pasha in command at the frontier, Jocelyn Wodehouse, would succeed, being genial and a fighting soldier, but Baring (who became Lord Cromer this same year) recommended Kitchener. Cromer knew from his own early military experience that an administrator rather than a fighter was required for the reconquest of the Sudan, if ever approved. It would depend more on thorough organization, training and strict economy than on strategic brilliance. Kitchener was not yet forty-two, young to be 'a full blown Sirdar and a brigadier-general'.[8]

Lord Cromer thought that twenty more years might pass before the reconquest could be attempted, for no money was available from the Egyptian treasury and none likely from the British, especially when Lord Salisbury was defeated at the General Election of 1892 and Gladstone returned. Kitchener, however, determined to be ready. He set himself to enlarge the Egyptian Army without asking for more money. He appointed 'Monkey' Gordon as Director of Stores, who quietly prepared all manner of equipment to avenge his uncle. Kitchener promoted Reginald Wingate to be Director of Intelligence. Wingate had already mastered all aspects of Mahdism and set up a network of spies, whose evidence of the maladministration and misery of the Sudan was overwhelming. His final estimate was eight million dead by execution, rebellion, disease or hunger. Wingate had made contact with Rudolf Slatin, the Khalifa's prisoner in Omdurman, and engineered his escape, accomplished by Slatin's own courage and resource.

Ten years earlier in Cyprus General Biddulph and Charles King-Harman had concluded that the young Kitchener went for the popular line, for immediate rather than long-term results. These characteristics had been rubbed away by his desert experience. Since the Gordon disaster his eye was on the distant horizon. He saw already how to reconquer the Sudan and all else must be secondary. 'Comfort, affections, personalities, all were quite inferior considerations', noted Lord Edward Cecil, whose close observation came a little later but was true already. The aim came before everything. 'He felt he was defrauding the Almighty if he did not carry out his task'.[9]

He could be 'brutal in his methods', thought Cromer's Third Secretary, Horace Rumbold, 'and would get the last ounce of work out of a man'. To Rumbold, not knowing him well, he seemed 'quite devoid of emotions or sentiment'.[10] Easy-going officers criticized him for not playing tennis or racquets. He would not reveal the reason, his inability to focus both eyes. Inspecting the ranks, he never spoke to a private soldier, but he would not disclose why, that

if he addressed one, another might answer. He cared for them but did good by stealth.[11]

He weeded out the inefficient. On his annual leave in England he would interview promising young officers attracted by the higher rank, better pay and prospect of action. He insisted on an undertaking that they would not marry for two years or even get engaged. The service must not be hindered by domes- tic ties. In Egypt he could not prevent casual sexual liaisons, but he himself was chaste, scorning those who had mistresses or visited brothels. He put women on a pedestal and was hurt when he knew of any treated as chattels.[12] He enjoyed feminine company when duty allowed. He flirted mildly with Ellen Peel, his former ADC's sister but cooled off when she hoped for a proposal. She married one of his officers. Daisy Rogers, sister of a swell dragoon, fell in love with Kitchener but her landowner father suppressed any romance with a mere sapper. Daisy never married.

He also had the social life of Freemasonry. By 1895 he was a member of five Lodges in Cairo, and held the rank of Past Senior Grand Warden of Egypt.[13]

Each year Cairo became a winter capital of European society, including rich and aristocratic Britons, several of whom became Kitchener's friends. He told Lady Cranborne that he had plenty of room; she and Jem could bring whom they wished.[14] With his strong family feeling, he longed for Millie. When the Parkers were going to New Zealand, he wrote: 'I hope you are not going through without staying with me, that would be *too bad* and you promised. The Khedive is continually asking after you'.[15] Another year he suggested she come for the three winter months with her two girls. 'My house wants looking after and I find a lady is quite necessary but it is too difficult to find one to marry'. Later he was half-jokingly threatening her: 'If you do not do something in the way of helping in the entertaining I shall be driven into some rash alliance of a matrimonial nature, so you have your warning and better look out'.[16]

When he liked, Kitchener was a good host, even giving fancy-dress balls, but he kept ambitious mothers and their eligible daughters at a distance. One winter visitor was Margot Tennant, then twenty-eight. Daughter of a Scottish industrial magnate and future second wife of Asquith, she wrote in her sharp- edged journal:

I had heard a good many stories of Colonel Kitchener but never met him till he took me in to dinner at the Residency, after which he came several

times to see me. He is not popular, and I can see that neither Mr. Milner nor
Sir Evelyn Baring like him; but I found him an interesting study; not really
interesting, but a study. Though a little underbred, he is not at all vulgar, and
though arrogant is not vain; but he is either way very stupid or very clever,
and never gives himself away.[17]

The new young khedive was strongly nationalistic and chafed at the British
occupation. During 1892 Lord Cromer needed all his experience and tact to
prevent Abbas undermining the balance of power in the eastern
Mediterranean. In the summer of 1893, while Cromer was in Scotland,
Abbas appointed a crony, Maher Pasha, as deputy war minister, who at once
showed anti-British prejudice and signs of subverting the loyalty of the
Egyptian Army to its British officers. Fearful of another rebellion like Arabi's,
eleven years earlier, with massacres of foreigners and disruption of the
economy, Cromer was seeking an occasion to bring Abbas to heel.

In January 1894 the khedive announced his wish to inspect the Nile garri-
sons between Aswan and Wadi Halfa. Kitchener made every preparation to
honour him and display a smart, efficient army, but before the khedive and
Maher arrived a secret document was betrayed to Wingate. It revealed the
khedive's deliberate intention to humiliate the Sirdar and to force British
officers out of the Egyptian Army. Forewarned, Kitchener ordered Wingate
to keep an official diary of the inspection. The Sirdar would provide details
when Wingate was not in ear shot.

Knowing that Abbas was little more than a boy, Kitchener reacted calmly
when the khedive criticized a smart Sudanese battalion for holding their rifles
wrongly: Abbas later insulted a black Sudanese officer and complained at
having to give commissions to negroes. The following morning, on parade,
he remarked loudly, that the Sirdar knew nothing of the finer points of arms
drill, and when the German attaché praised the drilling he was ignored.
Next, the khedive complained that the British surgeon-general was incom-
petent and ignorant. Kitchener respectfully replied that the khedive had not
had opportunity to make any judgement and that Surgeon-General Graham
was exceptionally able. Abbas praised every Egyptian, criticized every
Briton.

The climax came at Wadi Halfa as the entire garrison marched past.
Whenever a British-led formation passed the saluting base, the khedive abused
it to the Sirdar. Finally, as they rode from the parade, he exclaimed: 'To tell you

the truth, Kitchener Pasha, I consider it is disgraceful for Egypt to be served by such an army'.

Kitchener, fully aware of the tensions between Cromer and the khedive, replied in a most respectful tone: 'I beg to tender Your Highness my resigna-tion'. The khedive was aghast but the Sirdar held his ground: 'Your Highness, I am not in the least angry, but in resigning I consider I am only doing my duty'. He told the khedive that all the English officers would probably resign and no replacements would volunteer. Three times, to make his point, the Sirdar stated his intention to resign.

The khedive by now was alarmed at what he had done, and begged the Sirdar to withdraw his resignation. The Sirdar, making no definite promise, wired Cromer the facts. Cromer supported him immediately. Backed by Lord Rosebery, the Foreign Secretary (and soon to be Prime Minister), he demanded that the khedive apologize to the army and dismiss Maher. Kitchener withdrew his resignation.[18]

To show their confidence, the British government promptly advised the Queen to knight him. He became Sir Herbert Kitchener, KCMG, CB.* 'So glad my dear old father has lived long enough to be pleased', wrote Herbert to a cousin.[19] The old colonel was now wholly blind. That August of 1894, with Kitchener, on leave, at his bedside in Cossington Manor, he died after several days in a coma. The others were all in India (where Herbert had spent one leave with Walter at Poona) or New Zealand. Their half-sister Kawara came over from Dinan and their cousin Frank Kitchener, now a headmaster, and a few surviving friends attended the funeral, which was 'quietly but nicely done . . . I was able to secure a very nice place for his grave just under the East window of the church here'.[20] Herbert then paid off the servants, sold up and settled 'the governor's' small estate in England by the end of the month, writing long, affectionate letters to Arthur about the debt-ridden New Zealand land. Herbert worried that Arthur would spoil his own career as an engineer if he stayed, yet they must sell up first and the times were bad.[21]

Herbert had thought he might go out to New Zealand on his next annual leave but greater events supervened.

On each leave in England he had lobbied for an advance into Dongola province, which would begin the reconquest of the Sudan. He had lobbied

* He had been made a Companion of the Bath in 1889 for his part in the battle of Toski.

so hard in 1894 that Cromer, on leave in Scotland, 'did not like it. Now I have to be quiet for a while', Kitchener told Wingate.[22] In June 1895 Lord Salisbury returned to power. On Kitchener's annual weekend at Hatfield that summer he thought Salisbury sympathetic but in no hurry to commit British troops or money.

Back in Cairo, Kitchener found another block to his plans. A report on the vital question of irrigation in the Nile Delta had proposed a dam at Aswan in Upper Egypt, near the island that Kitchener had sought as a country retreat and experimental farm, still known as Kitchener Island. The official in charge of irrigation, (Sir) William Garstin, was determined to have the Aswan dam. Early in 1896 his proposal had a firm claim for any available funds, despite a worry that the French in Central Africa might annex the equatorial province of the Sudan where the Mahdist hold was weak. A Captain Marchand was preparing an expedition to reach the Upper Nile at Fashoda and claim it for France. This remote threat did not displace the dam's priority.

Suddenly, on 1 March 1896, the situation changed. Far away in the moun‑ tains of Abyssinia (as Ethiopia was then known) an Italian army, advancing from their colony of Eritrea, which they had annexed six years earlier, was soundly beaten and almost wiped out by a huge army of Abyssinians in the battle of Adowa. While the surviving Italians were being marched into captivity (some having been castrated), the Italian ambassador in London begged Lord Salisbury to stage a diversion on the Nile lest the Mahdist regime in the Sudan seize the opportunity to attack the Italian garrison in Kassala on the western border of Eritrea. On the evening of 12 March, following two Cabinet meetings and consultation with Lord Wolseley, Salisbury sent a tele‑ gram to Cromer with a copy to the Sirdar, while the War Office sent another to General Knowles, commanding the British Army of Occupation. Although differing in detail, their effect was to order an advance into Dongola, the northernmost province of the Sudan.[23]

Salisbury's cypher telegram reached the Egyptian War Office after mid‑ night. It was taken for decoding to Lord Athlumney of the Coldstream Guards and Jimmy Watson, 60th Rifles, Kitchener's ADC, both in the Egyptian Army, who were living at the Turf Club. Excited by the decoded message, they each set out in different directions to find the Sirdar, who might still be attending the social functions to which he was engaged, for late hours were kept in Cairo. Finding that he had gone home, Watson hurried to the palatial Sirdarieh, where Kitchener lived alone with his already impressive

collection of ceramics, armour, carving, screens and antiquities (which aston-
ished his brother Walter when he saw them).[24] The servants' quarters were in
the garden. It was now 3 a.m. on 13 March 1896.

Kitchener awoke to hear pebbles rattling at the window. Annoyed, he lit a
lamp and threw open the window to see the night watchman standing respect-
fully beside Captain Watson, who was waving a piece of paper. Kitchener
came down in his pyjamas and read the decoded telegram. When Athlumney
arrived a few moments later he saw the Sirdar, a lamp in one hand and the tele-
gram in the other, dancing a gentle jig with Watson.[25]

11

ADVANCE UP THE NILE

AT THE RESIDENCY lights were burning and Cromer was drafting orders, although annoyed that Salisbury had forced his hand two years before he was ready. Together, Cromer and Kitchener sent out the orders in the khedive's name to the khedive's army, then remembered that he had not been told. They hurried to the Abdin Palace; Abbas was still asleep.[1]

No time could be lost if the Expeditionary Force were to be far enough upriver to use the Nile's high-water season, when transports could move freely and gunboats support the final assault on Dongola. Cromer worked on the Commissioners of the Debt to produce the money.[2] He obliged a reluctant khedive to reject the Ottoman sultan's veto on the use of the Egyptian Army. Kitchener put into motion the plans he had already drawn up.[3]

Only three days after Lord Salisbury's telegram, a mixed column moved into the Sudan and in four days, almost unopposed, reached the village of Akasha, eighty-seven miles higher up the Nile, and immediately fortified the village and made it into the advanced base. Meanwhile, unknown to Kitchener until the matter was settled, the War Office was trying to give the command to General Knowles, until Salisbury ordained that the Sirdar should command, reporting to Cromer and thus to the Foreign Office, not to Wolseley at the War Office.[4] No British troops were to be used except for Maxim machine-gunners of the Connaught Rangers and one battalion (North Staffords) in reserve. At Kitchener's urgent request an Indian brigade freed the Egyptian garrison at Suakin for service on the Nile.

Success would depend on men and supplies reaching the front without

interruption from cataracts or low water. The ruined railway of 1885 must therefore be relaid. Troops, convicts and locals were put to repairing the old bed through the wild country of the Womb of Rocks (or Belly of Stones – Batan el Hagar). Kitchener remembered that after the withdrawal from the Sudan, which he had so deplored, many railway sleepers had been used to roof barracks at Wadi Halfa. He ordered the roofs to be stripped and the sleepers relaid as the line advanced. Sleepers were found in native huts; the dervishes had built gallows with others. Every relaid sleeper helped the budget that Cromer had set at a minimum. Kitchener had to improvise and commandeer. He was able to boast that he made one stretch of ten miles for nothing. ('What slave-driving and sweating!' was the comment of one of Queen Victoria's ladies.)[5]

Kitchener summoned a young sapper lieutenant from Woolwich, a French-Canadian who had worked on the Canadian Pacific railway. Percy Girouard proved to be a genius at railway repair and construction, and with his trans-atlantic background was not afraid of Kitchener. On one occasion after the line had reopened, the Sirdar, in a hurry, became impatient when a crazy old engine would not pull a heavily laden train as fast as he wanted. He mounted the footplate, left half the train behind and told the driver to 'go like hell'. They rattled and rocked over the corkscrew line until the Sirdar emerged at his destination exclaiming: 'What a dreadful journey we've had, Girouard! Terrible, terrible!' Girouard, twenty-nine years old, adjusted his eye-glass and faced the Sirdar: 'You will break the record and your own neck one day!' Kitchener damned him, then grinned, for he loved a man who would speak his mind. He learned much from Girouard.[6]

Before the railway could be ready, and afterwards for operations, camels were essential. Kitchener was determined not to repeat the wastage of camels from the inexperience of British officers during the Gordon Relief. His brother Walter had worked with camels in the Second Afghan War. Walter came from India to be Director of Transport. He was efficient and hard-working, rather deaf, and not afraid of Herbert although greatly admiring him. And the always spruce Herbert's brotherly affection tolerated Walter's untidiness.[7]

Lord Salisbury, however, was worried when he heard that the Sirdar had bought large numbers of camels. 'I would much rather see him without them', fearing they would tempt him to make a dash for Khartoum, whereas a railway 'can't move'; the Cabinet had not yet decided whether the money would run to an advance beyond Dongola province. Cromer reassured him, repeating his

earlier verdict that Kitchener 'is cool and sensible and knows his job thoroughly, and is not at all inclined to be rash'.[8] Yet on 1 May Salisbury told Cromer with some amusement that several Cabinet ministers were still scared 'that Kitchener meditates an expedition into the wilderness at the head of a string of camels. I do not share their apprehensions – tho' I have as much horror of the camel as they have'. Wolseley had even wanted to send out 'some great English General'.

Salisbury's misreading of Kitchener, despite an avuncular interest, and his ignorance of the demands of the terrain would soon be rectified. Long ago Lord Edward Cecil (Nigs to his family, Ned to his friends) of the Grenadier Guards had daringly asked Kitchener to take him as an ADC if the opportunity offered. Knowing that Cecil had proved a good ADC to Wolseley, the Sirdar sent a wire. So keen was he to have a direct line to Salisbury that he ignored his own veto on married officers, for Cecil had a wife and a son of six months. The High Church Cecil had married the atheist Violet Maxse after a whirlwind courtship, against the advice of his parents. The rather caustic, gloomy Nigs and the bohemian Violet were ill-matched. Cecil may have been glad to get away.[9]

Jimmy (or Jemmy) Watson continued as senior ADC, and Kitchener's choice of him is a comment on his own character. For Watson went through life laughing and telling ridiculous stories and making up limericks to lighten tensions at the worst moments. He had the kindest of hearts and was universally popular as well as protective of his Sirdar, who trusted him implicitly. Watson kept a diary, but only of the briefest chronological kind, so that posterity has lost the stories he could tell and is left with the gloom of Cecil's private, almost illegible diary of the campaign and his perceptive, sympathetic essay of twenty years later. Watson had won a reputation for bravery and cheerfulness with the 60th Rifles in India. Accepted for the Egyptian Army, it was he who first identified at Wadi Halfa a scruffy nervous vagabond in Arab dress as Rudolf Slatin, known to have escaped from Omdurman. Watson fetched a glass of beer: an Arab would have refused it; a thirsty Austrian gulped it down.[10]

For Chief of Staff Kitchener had Rundle, his old companion of 1884, but left him at Wadi Halfa to deal with base affairs and acted virtually as his own Chief of Staff. As second-in-command he had the remarkable and outstanding Archie Hunter, eight years younger than himself, a brave, rather quiet Scot who gloried in fighting and had great experience in Arab warfare

and was a clever tactician. More popular than Kitchener, many wished at first that he were in command. The strait-laced Cecil thought him licentious. He may have boasted of the Abyssinian mistress he had kept when governor of Suakin (he shocked brother officers who put their native mistresses into back-street lodgings by having her to stay at Shepheard's Hotel). He was not wanton, and like other staff officers had learned not to talk of such things before the chaste Sirdar. Hunter was inclined to be impulsive where Kitchener was cautious. A journalist dubbed him 'Kitchener's sword-arm' but his part in planning Kitchener's battles may have been exaggerated.

Even more important to the success of the expedition was Reginald Wingate, Chief Intelligence Officer, with Rudolf Slatin as his deputy. Rex Wingate was dubbed 'the White Knight' (from the *Alice* books) for the bits of equipment that tended to hang about him. He had kept up his remarkable network of spies and contacts. The Khalifa believed that the Sirdar never made a move without consulting Wingate, who would come every evening to the Sirdar's tent to report and advise.[11]

Almost the whole Egyptian Army was engaged in the campaign. Each bat-talion's lieutenant-colonel (El Kaimakam) and company commanders (El Bimbashi) were British, with Egyptian and Sudanese officers under them, and a sprinkling of British among the warrant-officers and sergeants. The brigade commanders (El Miralai) were all British, the most colourful being 'Fighting Mac', Hector MacDonald, a former sergeant-major in the Gordon Highlanders who had been promoted from the ranks by Roberts in Afghanistan for his courage and leadership, with the exceptional honour of a commission in his own regiment.[12] Of middle height, broad-shouldered and trim he had a determined jaw and steely eyes, and a 'smile so winning that when his white and perfect teeth showed beneath the closely trimmed mous-tache the whole face was lit up as by a sunbeam'.[13] He had already dis-tinguished himself in frontier battles commanding the 11th Sudanese, now in his brigade. Unlike the lighter-skinned Egyptians, who were Arabs and almost all Muslims except for a few Coptic Christians, the Sudanese came from the equatorial south, and with their negroid features and very dark skin were affectionately known as 'the Blacks'. Many had left the Sudan as children when Gordon evacuated the families of his loyal southern soldiers in 1884 before the Mahdi closed the route; older ones had either taken part in the attempted relief of Khartoum or had escaped from the Mahdist regime. Mostly animists (from later fruitful fields for the Christian gospel), they revered

Gordon almost as a god because he had put down the slave trade. Irrepressible, they adored fighting (and looting if they got the chance). Off duty they liked to strip down to the national dress of their Shilluk and Dinka tribes – stark naked. War correspondents who saw them bathing in the Nile marvelled at these well-endowed young Hercules. Their women and children were camp followers in the African and eastern way, and when the Sirdar once ordered that the women should stay behind a deputation called on him. Their language was so explicit that with his mastery of colloquial Arabic he was seen to blush under his brick-red sunburn.[14]

The Blacks hated the Khalifa and his tribe, the Baggara, who formed the core of his army, and so did the Ababdeh tribesmen who provided Kitchener's 'friendlies' of 1884, and the Jaalin of the lands north of Khartoum: the campaigns of 1896–8 were as much a civil war as an invasion. And although the Mahdi had been born in Dongola, Wingate was now receiving many secret messages from sheikhs in Dongola with one refrain: 'We long for you to come'.[15]

Early in April Wingate reported that an advance force of the enemy lay at Firket, some sixteen miles upriver from Akasha.

Anxious to know whether the Egyptian and the Sudanese battalions would fight well enough to ensure victory, Cromer had asked Kitchener to bring the dervishes to battle at the earliest opportunity. Back in March, after examining the logistics, Kitchener had told him that he would fight on 7 June.

On 1 June, with 10,000 troops south of Wadi Halfa, the Sirdar ordered Hunter to ride by night until he could see into the enemy camp at dawn, and plan its capture. Undetected, Hunter found the enemy concentrated before Firket village, which straggled along the east bank of the Nile, with a hill rising about half a mile behind Hunter. He came back to Akasha at about eleven in the morning, wrote out detailed orders and then rode north to meet Kitchener 'and explained the whole thing to him which he accepted in toto'.[16]

During the night of 6 June two columns set out. The River column commanded by Hunter, which Kitchener accompanied, marched on Firket from the north, between the Nile and the hill. The Desert column, which included the cavalry, swung out into the desert beyond the hill and approached from the south-east to cut off the enemy's flight. Despite the distances, the two columns attacked simultaneously at dawn on 7 June 1896.

Surprise was complete. The enemy, in their uniform of white *jibbah* (smock) with black or dark blue patches, fought hard but were overwhelmed. Some

fell back to the houses and resisted to death, many surrendered, others threw away their weapons and swam across the river, naked and unarmed. A number of horsemen fled through an undetected gap. Kitchener ordered his cavalry to pursue but not to intercept; he wanted none of his own men killed by dervishes brought to bay.

More than eight hundred dervish dead were counted, including their commanders, to trifling Egyptian loss and no British officer killed. Slatin had the curious experience of finding the bodies of several of his former tormentors. He assured Queen Victoria, who had given him the privilege of writing direct to her, that the enemy's wounded were cared for and the prisoners well treated: 'They were astonished at the clemency and the mercy', since many had murdered innocent people.[17]

The army had proved it could fight, and the Sirdar that he could win without wasting lives and material. 'Kitchener has done the whole thing admirably', Cromer wrote on 20 June. 'I always felt confident he would do so, as he is a first rate man'.[18] Cromer and the British press gave Kitchener the credit for the night march and Hunter's brilliant tactics, 'and quite right too', Hunter assured his brother. 'He was responsible and if it had failed he would have been blamed, and so I am quite satisfied he will do me justice when the proper time comes – I know he trusts me. He knows I am as keen for his success as he is himself, in fact we sink or swim, and so does everyone in the show, together, and we are a united and not an unhappy family'.[19]

Hunter and Wingate wanted the Sirdar to make a dash for Dongola town, more than two hundred miles upriver, believing it could now be seized without a shot. Kitchener may not have known of Salisbury's worry about a string of camels in the wilderness, but he would not risk being counterattacked and besieged at the end of an overlong line of communication and without his gunboats. Instead, he sent Hunter back to bring the gunboats up the difficult and dangerous nine miles of the Second Cataract, a gorge of great granite steps under surging water. Hunter succeeded but resented Kitchener's refusal to come to see him do it. The Sirdar had given his orders, trusted his subordinate and saw no need to pat him on the back for doing his duty. Hunter in old age claimed that the Sirdar had never thanked him.[20] But by the end of Hunter's operation Kitchener was under intense pressure.

Before Hunter had left for the railhead and the Second Cataract Kitchener had selected a site at Firket for the army to await the gunboats and fresh supplies.

Hunter pointed out that it was too near the place where they had buried the dervish dead and persuaded him to move it some miles upstream to Kosheh.

Hunter ascribed Kitchener's mistake to his 'cursed bad eyesight'.[21] Eyestrain gave constant headaches. He wore glasses for office work but not outside. One of Wingate's intelligence officers, Nevill Smyth of the Bays (who was a brother of Ethel Smyth the composer and would win the VC at Omdurman), thought Kitchener's eyes his most notable feature.

They appeared to look from a kind of ambush, not a stealthy ambush, but a courageous and strategic ambush, and to scan the distance above and beyond the faces or the foreground which he was actually contemplating. His eye was often likened to a lion's, and this illusion was helped a little by the colour scheme of light blue orbs in a dark ruddy face and the straight line of the eye-brows. His expression was generally grave and thoughtful, his smile flattered the fancy, he was very fond of humour, and his eyes sparkled when he was amused and in battle.[22]

Three months would pass before he was in battle again, months of unexpected near-disasters.

12

DONGOLA, 1896

Soon after the battle of Firket the force was afflicted by dysentery and then by a severe epidemic of cholera. Whether it came down from Egypt or up from the Sudan, it spread rapidly in the base and forward camps. Doctors worked hard but were too few and medical supplies too short.[1] At Akasha the cholera patients from the North Staffordshires were crowded into one tent in the high summer heat, to suffer the stench and misery of vomit and bowel, followed too often by death. Of the total of 411 casualties of all ranks, Egyptians and British, of the entire six-month Dongola campaign, 364 died of disease and only 47 from enemy action. In this cholera epidemic Father Brindle and his Anglican counterpart worked selflessly.

The cholera subsided but the seasonal north wind failed that year, preventing wind-driven craft from taking men and supplies up the Nile, already much lower than normal. Then came an unexpected and scorching wind from the south; July and August were hell for man and beast, creating the most demanding period in Kitchener's forty-six years, on body, mind and spirit.

He was a light sleeper, needing only four hours.[2] At forward or base headquarters he was out of bed before dawn. As a brother of the Guild of the Holy Standard he had promised not only to be 'sober, upright and chaste' but regular in private prayer. His favourite prayer was the Collect for Whit Sunday: '. . . Grant us by the same Spirit to have a right judgement in all things, and ever-more to rejoice in his holy comfort . . .' 'Use the Whitsun collect and it will help you through life', he told a young cousin.[3]

He would then walk around in his pyjamas between 5 and 6 a.m. to the

tents or huts of his staff officers, who must always live near him, and dictate his orders so that they could be telegraphed and carried out that day; thus no one's sleep would be disturbed on the next night unless in emergency.[4]

He would then dress and 'wander off', recalls Cecil,

at that curious stalking stride of his soon after dawn to the railway yard, the embarkation place, the store yards, or whatever interested him for the minute. He saw everything – nothing escaped him; but he officially saw or did not see as much as he chose. Sometimes he seemed to like one with him, but more often he liked to walk ahead, plunged apparently in sombre meditation.[5]

He would return to his office and put in three hours' work before breakfast at ten. He always looked clean and neat (thanks presumably to his soldier servant) despite sand and sweat and it was a myth that papers did not stick to his arms as they did to other men's. But his office was a mess. Papers were on tables, chairs, windowsills and the floor. Only he knew where to find a list or report, and he would let no one touch the muddle except Jimmy Watson and thirty-eight-year-old Staff Sergeant William Bailey of the East Lancashire Regiment, the Chief Clerk. The Sirdar trusted Bailey absolutely and obtained a commission for him a few months later, to continue as his administrative staff officer.[6] Yet the Sirdar hardly needed to look at a paper: he had an extraordinary memory and grasp of detail, thus allowing him to be virtually his own Chief of Staff but causing difficulties to subordinates when he kept his intentions or movements to himself and then blamed his ADC for letting him slip away unaccompanied.

His meals would be at any hour, a probable cause of the chronic indigestion that made him grumpy. In the extreme heat of that terrible summer he might keep his staff waiting for dinner until ten, then eat it in solemn silence if something were on his mind. Cecil (in the privacy of his diary) called him the Great White Czar. 'Nigs' may have expected the deference due to a lord, for he complained (to the diary) of insults. Fifteen years later he became a close and admiring colleague in the government of Egypt but he did not like his chief in 1896. Kitchener seemed uncouth to an Old Etonian Grenadier and was living on his nerves as he wrestled with the problems of an army to be transported, supplied and victorious on too little money in extreme heat. He could be inconsiderate and rude. 'He was always inclined to bully his own entourage, as some men are

rude to their wives. He was inclined to let off his spleen on those round him. He was often morose and silent for hours together'.[7]

But except in a crisis he liked to stop work for an hour at six and chat to his staff over a gin and tonic, his 'most human time', with plenty of humour, mixed however with cynicism. Long experience of Arabs had made him affect to be a cynic. He was inclined, to Cecil's observation,

> to disbelieve that any action sprang from motives other than those of self-interest — or rather, he affected to be. He had in reality the greatest confidence in those who were worthy of it, and he was rarely if ever taken in. His cynicism was in a large measure a part of the curious shyness which declined to show any inside portion of his life or mind. He loathed any form of moral or mental undressing. He was even morbidly afraid of showing any feeling or enthusiasm, and he preferred to be misunderstood rather than be suspected of human feeling.

Cecil forgot, writing years later, that he was present on at least one occasion when Kitchener's deep feelings broke through in public. And shyness was cloaked by an almost childlike simplicity 'both in his outlook on life and his display of what most of us hide with care'.[8]

Kitchener's ambition to reach the top was displayed deliberately. Arab sheikhs who had no interest in patriotism or liberating the oppressed could understand fame as a spur. So the Sirdar freely asked them to help him win a great name. This offended his own people who did not display their ambition. He was too shy to tell them of his dominant desire to do the will of God.

He could be maligned far beyond anything that his defects of character might deserve in this time of supreme testing. In late August, when the high water of the Nile had allowed four gunboats and three steam transports to reach Kosheh, where the railway had also arrived with its antiquated rolling stock, Kitchener ordered Hunter to send MacDonald's brigade forward to the next stage before Dongola and to take the shorter desert route, not the curve of the Nile bank. As they marched, a renewed south wind made the desert a raging furnace of sand and dust; eight Blacks died of sunstroke before they could reach the first water depot prepared by Walter Kitchener's camel men. The brigade reached its objective in considerable distress. Lewis's brigade, sent to reinforce, and accompanied by Hunter, suffered even worse from heavy unseasonable rain with unrelenting heat. The British war correspondents

dubbed it 'the Death March'. Cecil thought Hunter irresponsible in not turning back at the first watering place, but Hunter wrote to his brother in Cairo a furious put-down of the Sirdar:

I have plumbed to the bottom of Kitchener now – he is inhuman, heartless; with eccentric and freakish bursts of generosity specially when he is defeated: he is a vain egotistical and self-confident mass of pride and ambition, expecting and usurping all and giving nothing: he is a mixture of the fox, Jew and snake and like all bullies is a dove when tackled.[9]

Hunter sent a dispatch that virtually accused the Sirdar and Rundle of murder. (He ignored their financial and political restraints.) He wrote an insubordinate letter telling Kitchener how to be a general and look after his men.

Probably he never sent it.[10]

If he did, Kitchener would not have seen it; for another crisis had blown up. On the evening of 29 August, after prolonged rain, he heard at Kosheh that twelve miles of the railway embankment had been washed away by the worst floods and torrents for fifty years. Rails were dangling, sleepers scattered and the army had only five days' supplies in the forward area. Without the railway the campaign must stop. Cromer and Salisbury might even order an ignominious withdrawal.

Kitchener saddled up and rode all night. As Smyth recalled, 'The Sirdar made a practice of always appearing on the scene of any difficulty or disaster'. He reached Akasha at dawn. He organized battalions, some to mend the embankment, others to find and replace the sleepers. He took off his coat and helped lay out curves with his own hands. As Smyth continued:

The men worked night and day at this vital work. Just as the efforts of all concerned were flagging and the troops were becoming exhausted by the great heat, the Sirdar rode along the line during the hottest part of the day on the 31st August and inspired all ranks to continue the work with renewed vigour. He spoke to many of the men in Arabic and encouraged some of the 15th Battalion who were working under Sergt. Butler, the champion boxer of Cairo and fencing instructor of the Gloucestershire Regiment, who set a fine example in carrying large rocks to build up the embankment.[11]

[101]

The line was relaid within a week, wild flowers bloomed in the desert and Kitchener returned up the line ready for the crowning act of his preparations for the assault on Dongola. Before the campaign, Kitchener and Burn-Murdoch, commanding the Egyptian cavalry, had designed a new iron-clad stern-wheeler gunboat, the *Zafir*, with more firepower, better protection for troops on deck and shallower draught than the four older gunboats. The *Zafir* had been built in London in eight weeks, sent out in sections to Egypt and up the railway to Kosheh, where it had been reassembled day by day, to the great interest of any free to watch.

By 7 September her boilers and cylinders had been inserted and the Sirdar and his staff boarded to join Colville, the naval commander, and his second-in-command, the dashing Lieutenant David Beatty, future hero of Jutland. Kitchener, standing on the bridge, was beaming: not only was *Zafir* his special toy, but he reckoned her worth more than a battalion of infantry 'because its armament insures that I can make a landing anywhere I want to in face of Dervish opposition'.[12]

Zafir steamed majestically into mid-stream. Suddenly they heard a muffled explosion below and *Zafir* stopped: her low-pressure cylinder had burst. She would be out of action until a replacement could arrive, perhaps weeks away.

Kitchener stared straight ahead, his mouth twitching. Then he said: 'By God, Colville, I don't know which of us it's hardest luck on – you, or me!'[13] He ordered the guns and Maxim machine-guns to be transferred to another steamer, left the ship and disappeared into the cabin of another. Cecil found him in tears. He threw up his arms: 'What have I done to deserve this?'[14]

All the strain of the past months came to a head at what Cecil thought trivial, but Kitchener knew it to be grievous because the Nile was falling and he could not afford delay. Cecil tactfully kept away. Kitchener recovered and ordered the advance to begin on the day he had planned, 11 September. The British battalion, the North Staffordshires which he had kept in reserve, had now arrived. Dervish activity had been negligible except for patrols which cut the telegraph wire, unaware that the messages went by a cable below the bank or in the water.

A week later the main body had joined the forward troops and they were approaching the fortified village of Karma, 110 miles upstream from their starting-point. Some battalions had marched, others 'steamered' (as the phrase was) in transports and gunboats which navigated the forty-five miles of the

gentler but rocky Third Cataract: one gunboat struck a rock and was temporarily stranded.

Wingate had reported that the dervish Emir Bishara Rayda, the Khalifa's relative, had concentrated his troops at Karma. Kitchener's men had made good their losses from cholera and storms and were eager to engage. The Sirdar, unlike Hunter, was not bloodthirsty but determined to bring Bishara to battle in the open, to avoid street-fighting in Dongola.

At dawn on 19 September Kitchener rode with the advance guard of the Egyptian cavalry to reconnoitre the enemy personally, only to find that Bishara, knowing he was outnumbered, had cunningly shipped his force across the wide river during the night, to fortified positions at Hafir. The scene was awe-inspiring, the fortifications were clearly visible, with thirty small boats (*gyassas*) and one steamer moored to the banks covered by a mile of rifle pits and three batteries of guns. Behind, some 3,000 dervishes, mounted and on foot, could be seen in the desert beyond.

At 6.30 a.m. the Egyptian horse artillery fired the first shot in the battle of Hafir. The gunboats engaged the forts. Infantry could do nothing, except for those in the gunboats, who much felt the absence of the *Zafir* and its armour. On *Tamai* a British machine-gunner was killed and Commander Colville hit in the wrist. *Tamai* withdrew 'to report to the Sirdar' but was smartly returned to the fight. Anglo-Egyptian firepower was inflicting heavy casualties and Bishara was wounded, but two of the gunboats had been holed, though not dangerously, and the Sirdar began to fear he might lose one gunboat if this inconclusive duel continued. Young Lieutenant David Beatty, future hero of Jutland, Admiral of the Fleet and First Sea Lord, spotted the answer: make a dash upstream for Dongola itself. Kitchener gave him leave, and since the Nile above Hafir narrows to six hundred yards he moved his artillery to give covering fire. Beatty led his flotilla with typical panache to the open water and beyond.

The wounded Bishara suspected a ruse to cut him off from his base, for even if the bombardment died down he could not remain at Hafir because his boats with reserves of food and ammunition were within range of the Egyptian guns. That night he abandoned Hafir and withdrew to Dongola.

Next day Kitchener used the boats to ferry the force to the western bank. Dongola lay thirty-five miles upstream. Without haste, and allowing a rest-day at Argo island, Kitchener advanced.

On 22 September he was ready for the final battle. 'The Sirdar's love of

fighting was known to all ranks of the Egyptian Army', recalled Smyth. 'Without being foolhardy, he always took the same risks as those who were most exposed to the enemy's fire, and during all the advances such as that upon Dongola on the 22nd September 1896, he moved in advance, close to the contact squadron of cavalry'.[15] His entire force was advancing on the dervish army, which could be seen, a mass of horse and footmen, with banners waving and drums beating, on the plain before Dongola. The Staffordshire men in the centre had been ordered to wear their red tunics, perhaps because Gordon had said that if British redcoats had arrived at Khartoum the siege would have been lifted.

Beatty's gunboats, with the newly repaired *Zafir*, were bombarding the town and the massed ranks. Suddenly a dervish wing turned and rode off the field. Kitchener, Hunter and Wingate supposed it a tactical withdrawal. None of them ever discovered that Bishara had ordered a frontal assault which his emirs reckoned suicide. They arrested, bound him and carried him away.[16] The dervish army melted into the desert, their flight so hasty that the Sirdar's cavalry found groups of men dead from thirst in the desert, and dead and dying babies dropped by their mothers: 'The cavalry and horse artillery came back laden with black and brown babies'.[17]

Many important emirs surrendered, along with seven hundred Sudanese Blacks who joyfully offered their services to the conquerors. The best were re-enlisted, the others sent to the railway labour battalions. Several guns, much ammunition 'and loot of all sorts' were captured.

The Sirdar entered Dongola unopposed, welcomed by the populace, who hated the Khalifa and his Baggara tribesmen.

Next morning, 23 September 1896, a staff officer recalled that on that very day Queen Victoria became Britain's longest-reigning monarch. Wingate drafted a signal that the Sirdar signed: 'On this auspicious anniversary of her Majesty's reign . . .'[18]

13

THE IMPOSSIBLE RAILWAY

ON 18 November 1896 Queen Victoria commanded Sir Herbert Kitchener, newly promoted to major-general 'for distinguished services in the field',[1] to dine and sleep at Windsor. During the rather solemn dinner, sitting some way from the queen, he was at his most shy and gauche. One of the Queen's ladies wrote to her husband that in spite of their many and strenuous efforts 'he would hardly utter to us ladies', and concluded he was 'either a woman-hater or a boor'. Knowing nothing of the facial disfigurement caused by his wound, Marie Mallet continued: 'My impression of Kitchener (which may be quite wrong) is that of a resolute but cruel man, a fine soldier no doubt, but not of the type that tempers justice with mercy'.[2]

After dinner, when brought up to the Queen he was expansive. She found him 'a striking, energetic-looking man, with rather a firm expression, but very pleasing to talk to'. His staff had sent a consignment of armour, shields, flags and other trophies from Dongola for the Queen, which had been laid out in the corridor. He had never seen them, but when she asked to be told about each he made it up as he went along, so that she wrote down in her journal that the sword was a Crusader sword although the inscription of the blade was in English and thus inevitably of later date (a sword with a hilt like a cross was often loosely termed Crusader).[3]

Later the men of the Household took Kitchener to their smoking room where, Arthur Bigge told Marie Mallet, 'under the influence of whisky and tobacco he thawed and gave an appalling account of the young Khedive. He says he could not possibly be more wicked, cruel and weak. He hates the

French, and the Turks; the Sultan most of all, and openly asked why we do not assassinate the Sultan. He simply longs for murder and executions would be his greatest joy were he to have his own way in Cairo. The Egyptians detest him and if we left the country his reign would not be long'.

Kitchener had come to England on duty to secure money from the Treasury to continue the campaign. He was determined to reach Khartoum and end the miseries of the Khalifa's misgovernment. But while in England he learned that the money produced by the Commission of the Debt must be refunded by the Egyptian government after a ruling by the Mixed Tribunal.[4] This money, now spent, and the finance for a further campaign could come only from Britain. The Chancellor of the Exchequer, 'Black Michael' Hicks-Beach, was not known for liking forward movements which cost money. Kitchener set out to persuade, helped by evidence of French intentions to control the Upper Nile basin, which Britain could not allow.

Salisbury told Cromer: 'His campaign against the Chancellor of the Exchequer was not the least of his triumphs. But all his strategy is of a piece. The position was carried by a forced march and a surprise'. On his last day in England, 21 November, he had been to Windsor again for luncheon, after which Queen Victoria knighted him as a Knight Commander of the Bath. He hurried back to London, produced his detailed estimates and persuaded the Chancellor. Salisbury had 'to give my approval at the end of a moment's notice, when the train by which Kitchener was to go away was already overdue. I need not say I was very glad to do so'.[5] Gordon would be avenged.

Kitchener returned to Egypt and the Sudan to carry out a daring plan: 'it is his idea and his only', Hunter told his brother.[6] He had decided to build 230 miles of railway across the Nubian Desert to cut out the vast curve of the Nile between Wadi Halfa and Abu Hamed, reducing the distance to Khartoum by hundreds of miles and three difficult cataracts. Even Gordon, who in his earlier reign as governor-general had ordered plans for a railway along the Nile (cancelled for want of money), had not dared to propose a desert line. Experts told Kitchener that it could never be built, especially when studies and surveys he had commissioned in 1895 caused him to reject a line following the caravan road from Korosko to Abu Hamed through the Murrall Wells oasis, which Gordon and Stewart had ridden on their way to Khartoum in 1884. He chose instead a more southerly line, starting at Wadi Halfa, which would allow easier construction but had no surface water.

Kitchener chose a twenty-four-year-old sapper, Edward Cator, to find the best route up to the low summit of the desert and down the other side. Knowing that Cator was a water diviner, he marked a sketch map in two places. Cator divined water in both and drew blank at eight others. He came back marvelling at 'Kitchener's luck' but caught typhoid and died. They dug a well and found water at the first place. The second required much trouble and ingenuity, but at last a bottle was brought back to Wadi Halfa. The commandant, Maxwell, decided to 'have some fun with the Sirdar when he arrives'. He offered him a whisky and soda. The Sirdar tasted it and made a face. Maxwell then told him that the 'soda' was water found seventy-two feet below ground. Kitchener was delighted at the joke. Success was now assured.[7]

He had come back from England well pleased at laying orders for engines himself. Girouard cross-examined the Sirdar, then pronounced that his engines would be too light and weak. The Sirdar therefore sent him off to Europe to find better, saying, 'Don't spend too much, Girouard. We are terribly poor.'[8] Girouard borrowed from Cecil Rhodes some heavy locomotives which Rhodes had ordered for South Africa. Kitchener had already selected a wider gauge than Cromer had wanted, so the Sudan Military Railway (SMR) could one day form part of the Cape to Cairo railway of Cecil Rhodes's dream.

The first sod of the yards at Wadi Halfa was lifted on 1 January 1897[9] and laying the track began in February. At the seventeenth mile a siding was added, a ragged tent went up, a field telephone installed, and Station Number One was ready. Eleven miles were laid in April. Then, with a large reinforcement of labour brought over from the other line, which had been laid close to the Nile, progress was faster. Enthusiastic young officers of the Royal Engineers under Girouard surveyed, designed and directed the operation. They became known throughout the army as 'the band of boys'.

The Sirdar never seemed far away. At the harbour, railway yard and workshops of Wadi Halfa he would often appear early in the morning in his dressing gown as rails, engines and rolling stock were unloaded from Nile steamers. Once he saw a large engine standing idle. The civilian works manager explained that the boiler was cracked and could be dangerous. The Sirdar said sadly that dangerous or not it might haul a heavy load to the railhead. 'After all, we aren't particular to a man or two!' The works manager knew him well enough not to take that seriously.

The Sirdar would travel up the line with a train carrying rails, sleepers and always tanks of water for the labour force and for its own steam engine:

Kitchener had investigated electric traction but found it too expensive. At the great, movable tented city at the railhead he would be out among the eight thousand Egyptian troops and convicts who formed the labour force, deal with any questions raised by Girouard or his band of boys, and then continue to the rail-end, the farthest point reached by the track layers, with the labourers ahead preparing the bed, the surveyors farther ahead still, the mirages all around, and patrols of the friendly Ababdeh tribe keeping watch out of sight.

A story that was long told among sappers had the Sirdar at one of the sta-tions in a hurry to reach another: stations were about twenty-three miles apart. An engine stood in the siding but no driver could be found. A sapper clerk manning the telephone said he did not know how to drive a train.

The Sirdar retorted, 'You are an Engineer. Any Engineer should be able to drive an engine.' (Starting and stopping presents no problem but handling a heavy locomotive on the road needs training.) Together they mounted the foot-plate, got up steam, pushed this lever and that until the engine was not only in motion but at speed. They reached the next station without mishap.[10]

As the spring of 1897 turned into summer the great heat did not hinder the band of boys. Their skills, experience, improvisations and refusal to be deflected by difficulties, their sense of humour and their leadership conquered the desert despite a mobile enemy never far away. Several of them rose to be generals, but all gave the chief credit for the desert railway to Kitchener, himself a sapper. He took the risk and the responsibility. He organized the preparations, was the mastermind and the driving force. He would listen to advice, some-times acted on, often rejected. The band of boys saw themselves cheerfully 'as pawns on a chess board, moved from square to square as the game demanded'.[11]

Kitchener was back in Cairo in time for the great military parade on 22 June 1897 to celebrate Queen Victoria's Diamond Jubilee. An hour or two later Hunter wrote to his sister-in-law in America sentiments that Kitchener would never have expressed but deeply shared:

> It was a wonderful event and one cannot help a glow of pride at the thought that today, as the sun broods over the Earth and across the sea, in every land and on every ocean from one end to the other, a salute of 60 guns at noon will remind all hearers that we are the greatest Nation the Universe ever saw ... And, the whole world today will realize the truth and advantage that ours is 'The Power, the Kingdom and the Glory' and that we exercise

our Might in the interests of humanity which no other Power has succeeded in doing yet.[12]

Hunter had just returned from leave in Scotland, during which he had broken off his engagement. Like Kitchener, he had reached a conviction that the Sudan and marriage did not mix. He and the Sirdar made a wager: whoever married first would give the other £100. Fourteen years later General Sir Archibald Hunter handed £100 to his best man, Field Marshal Viscount Kitchener of Khartoum.

During the days after the jubilee, while Jimmy Watson seized the opportunity for plenty of squash, polo and bicycling,[13] the Sirdar, Cromer and Hunter planned in strict secrecy a lightning campaign.

The new railway line was creeping steadily across the desert, but its intended terminus on the Nile at Abu Hamed was still in dervish hands. After the capture of Dongola, the Anglo-Egyptian Army had advanced upriver, unopposed, to Kitchener's old base of 1884 at Debbeh and on to Merowe near the western end of the long Fourth Cataract. Hunter, now military governor of Dongola province, had quickly established civil control over wide areas, but the advance towards Khartoum could not resume until the next rise of the Nile in August. By then, Abu Hamed must be captured and the railway touch the Nile.

On 6 July the Sirdar and his staff left for the frontier and arrived at Karma, the railhead of the river line, six days later. Wingate had warned Kitchener that the Khalifa's young nephew and best general, Mahmud Ahmad, had left Omdurman with a strong force and was threatening Metemmeh, chief town of the Jaalin tribe which loathed the Mahdist rule and had sent urgent requests for guns and ammunition. These were still crossing the Bayuda desert when Kitchener reached Debbeh and received news that Metemmeh had fallen. The town had been sacked. 'Women and children and all men put to the sword', recorded Watson. 'Only the young girls spared'.[14] A Jaalin sheikh, Ibrahim Muhammad Farah, had fled to Dongola some time earlier and had raised an irregular force of Jaalin and other tribesmen, known as the 'Friendlies'. Kitchener now wanted him to advance into the desert towards Berber, but he kept delaying because the days were unlucky. The Sirdar sent for him, and with a 'prophetic air but in a very forcible way', said: 'All days are made by God and must be equally lucky. You are going in a good cause and will leave tomorrow'.[15]

Sheikh Ibrahim, his mind at rest, led the Friendlies south into the Bayuda desert while Hunter and a strong Egyptian force covered the 132 miles to Abu Hamed in eight days, marching at night by a badly mapped rocky track above the Fourth Cataract, resting by day without tents or shade. Kitchener could but wait, riding most mornings with Watson, sometimes relaxing in the evening with him at a game of piquet. At noon on 9 August came a message that Abu Hamed had been captured. That night a dispatch arrived from Hunter describing the brilliant action by which the garrison had been sur-prised at 6.30 a.m. and the place stormed. But two British officers had been killed in the street-fighting. They were the only British officers of the Egyptian Army to be killed in the entire campaign of 1896–8.[16] One was the thirty-two-year-old Edward FitzClarence, a grandson of King William IV's eldest ille-gitimate son by the celebrated actress Mrs Jordan: Edward's twin, Charles, would win the VC in South Africa three years later.

The gunboat flotilla was already taking advantage of the rising Nile to nav-igate the cataract: on 4 August David Beatty had a lucky escape when his gunboat capsized. On 29 August the flotilla steamed into Abu Hamed. Four days later Kitchener at Merowe heard that the Friendlies had taken Berber, the most important town before Omdurman. Hunter had already sent a flying column of 350 Blacks to consolidate the capture and reopen the caravan route to Suakin on the coast.

Kitchener moved his forward base to Abu Hamed. He must bring the rest of his army up the cataract before the Nile fell again. He must complete the railway to Abu Hamed to shorten his lines of communication. He was out-numbered by the dervish armies who could move against him. The pressures were mounting. When Arthur Renshaw, the solicitor and family friend, wrote from England offering to look after his financial affairs, Kitchener accepted gladly as 'I have my hands full and a lot of anxious work in this most damnable country where every obstruction the Creator could conceive has been put in our way and has to be got over'.[17]

He was becoming an even harder taskmaster, driving his officers without thanking them, ruthlessly sending back any who went sick too often or failed. On 11 September a transport capsized in the cataracts with loss of life. Kitchener blamed Lieutenant-Colonel E. F. David, Royal Marines, in sole charge of passing the troop steamers up to Abu Hamed, and sacked him. Colonel David had led a brigade with distinction in the Dongola campaign and asked for an interview. Kitchener refused, saying there was no point. He

appointed David to the miserable post of commandant at Debbeh, where he had no British shoulder to weep on. The tragedy of the transport preyed on his mind; he went off his head and died the following year.[18] Lord Roberts would have seen him and helped put matters into perspective: Gordon had the gift of being at once stern and sympathetic. Kitchener gained a reputation for want of sympathy. Wingate recognized that 'K's seeming indifference – arising from shyness and dislike of scenes – was not real, but other officers did not know this'[19] or know about the inner turmoil he was now enduring behind the mask.

On 6 October Kitchener wrote a despairing letter to his friend Clinton Dawkins, a government official in Cairo:

You have no idea what continual anxiety, worry, and strain I have through it all. I do not think that I can stand much more, and I feel so completely done up that I can hardly go on and wish I were dead. Before next year's work in the field begins I must get some leave, or I shall break down. I have had none for three years now.[20]

Everything seemed to conspire against him. Cromer, who had been in Scotland (remarking that he might as well shoot grouse while Kitchener shot dervishes), wanted to delay any advance on Khartoum. The War Office had sent out Grenfell, the former Sirdar, to command the enlarged British Army of Occupation. Kitchener was 'worried to death' (in Wingate's phrase)[21] that Grenfell, a much senior general, would supersede him as Wolseley superseded Wood in 1884. Kitchener admired and liked Grenfell but longed to lead the men he had trained and fought with to the glory of taking Khartoum. (Salisbury had told Cromer that Kitchener must remain in sole command in the Sudan, but Cromer had failed to tell Kitchener.) Next he learned that the Italians wanted to evacuate Kassala on the border of Sudan and Eritrea. To protect his flank he must garrison the place; yet he had neither the troops nor the money. On 12 October Grenfell in Cairo noted in his diary: 'Received a long and despondent letter from Kitchener which I took to Lord Cromer and I have arranged some of the matters which disturbed him'.[22]

That week the gunboats steamed far into dervish territory and shelled Metemmeh under fire: *Zafir* was struck under the shield on the lower deck.[23] But at Abu Hamed Kitchener received a telegraphed demand from the Finance Ministry that he reduce expenditure. In despair he wired his resignation.

Resigning was not a cynical ploy to get his way. George Gorringe, RE, ADC in Watson's temporary absence, was taking the telegram for encoding when he realized the state the Sirdar was in. 'That evening I induced him to come out duck shooting with me, a thing he rarely did, and it took his mind off his worries'.[24]

Cromer ignored the telegram, merely telling Salisbury that 'my Sirdar is a changed man' and that the letter to Dawkins which arrived the same day as the wire was the product of a sick man who had lost his nerve. 'Those who know Kitchener best tell me that he is liable to fits of extreme depression from which, however, he rapidly recovers. In the meantime his frame of mind causes me some anxiety, for everything depends on his keeping his head, and judging calmly of the situation'.[25] Cromer was still against an advance to Khartoum.

On the afternoon of 1 November Kitchener arrived in Cairo. 'We rode to meet him', recorded Grenfell. 'He looked rather cross but was very pleasant to me'.[26] Cromer told him to hand over his command temporarily to Hunter and spend a month in Egypt to sort matters out and recover his health, with a visit to the Red Sea coast to arrange the takeover of Kassala. The Sirdar hurried back to the Sudan, sent Watson ahead to open up the Cairo Sirdarieh (Watson travelled overnight to Wadi Halfa by the new line and thought it excellent)[27] and arrived in Cairo again on 18 November. Grenfell 'thought him rather depressed and ill. Assured him of my desire to help him in every possible way'.[28] His morale rose when Reuter reported that Hicks-Beach had told the House of Commons, to cheers, that the advance would continue to Omdurman and Khartoum at the next high water in 1898: French progress towards the Upper Nile had swung the Cabinet.

The change of air and scene and the temporary lifting of pressure restored the Sirdar's health, though in telling Renshaw on 9 December that he was off for the frontier in a day or two he added: 'no rest for the weary'.[29] He left Cairo with the firm promise that he could have a British brigade whenever he asked.

On the last day of 1897 Wingate landed at Wadi Halfa, the rear base for the campaign, and went up to the Sirdar's pleasant bungalow. The Sirdar had already made a swift tour of his far-flung front. Wingate found him nursing a heavy cold and 'in a state of considerable perplexity owing to conflicting news'.[30] Hard on Wingate's heels came telegrams from Hunter at Berber and Rundle in Dongola confirming that the Khalifa had amassed almost his whole army outside Omdurman ready to move down the Nile to recapture Berber.

Wingate urged Kitchener to call for the British brigade at once. Kitchener was not sure. If it came too soon, his supply problems at the end of a long line would be vast. If too late, he could be defeated. They had a long discussion. Kitchener agreed at last. Wingate was astonished 'to see the difference in the Sirdar once he had made his decision; he became quite light hearted and cheery. I think he is very happy that he has made up his mind'.[31] His cup ran over when Cromer wired that he hoped to arrange for Kitchener to be in sole command of the whole offensive expedition to Khartoum: 'K immensely pleased', noted Wingate.[32]

Wingate did not, at that stage, hero-worship Kitchener. He was genuinely fond of him but knew his foibles. A week later, when Wingate refused to reject Colonel Frank Rhodes, elder brother of Cecil, as a war correspondent and Kitchener had to do so himself, 'K furious with me . . . K is the quintessence of a coward and was afraid to tell Rhodes he did not want him'. A few hours later an opportunity came to induce Rhodes to withdraw. 'K greatly relieved but episode only serves to further lower that time-server character in my eyes'.[33] Wingate had not remembered that Cecil Rhodes might refuse more rolling stock for the SMR if Kitchener personally offended Frank. (He was allowed after all to represent *The Times*.)

Again, when the Sirdar found refugees and prisoners arriving without food or water at Abu Hamed because Hunter had disobeyed orders at Berber, yet would not rebuke him, Wingate grumbled in his diary: 'The long and short of it is that K is afraid of Hunter but I suppose that situation will last out until Omdurman is taken'.[34]

Kitchener's wire to Grenfell to send a British brigade and to prepare a second brought a rush of activity in Lower Egypt, where the brigade commander, William Gatacre, had trained it to a peak of fitness and excellence and earned the nickname of 'Back-acher'. The brigade moved down the SMR. By early February the bulk of the Anglo-Egyptian force was concentrated north of Berber. The railway was still under construction. The British regiments – Warwicks, Lincolns and Cameron Highlanders, with the Seaforths arriving later – had marched the last thirty miles across sand and rock, and their boots wore out and must be replaced. Walter Kitchener's camels remained important for transport where lowwater or the Fifth Cataract made the Nile useless. He joked to his wife in England about brotherly correspondence:

You'd be amused at the wires between me and Herbert. Of course I have a good deal of work direct with him now. He gets fairly shirty at times and is horribly obstinate – whereas as you know I am only firm and have a knack of expressing myself a bit more than I mean. I heard through Blunt that he had sent my saddle to Assouan [Aswan] for new camels, so I ended my wire of expostulation 'I had hoped at last to get a camel that would not require 2 months patching up', which drew him properly. He deserved it.[35]

The Sirdar had asked Grenfell for an additional staff officer. Grenfell sent him a thirty-four-year-old baronet, Sir Henry Rawlinson of the Coldstream, whose late father had been eminent as an Assyriologist and diplomat. Rawlinson had come on leave to Egypt for his wife's health and cannily had brought his gear. He proved a great help to Kitchener and became a friend. Early in February, soon after their meeting for the first time, Rawlinson described the Sirdar as a curious and very strong character.

I both like and admire him, but on some minor points he is as obstinate as a commissariat mule. He is a long-headed, clear-minded man of business, with a wonderful memory. His apparent hardness of nature is a good deal put on, and is, I think, due to a sort of shyness. It made him unpopular at first, but, since those under him in the Egyptian army have come to realize what a thoroughly capable man he is, there is a great deal less growling than there used to be . . .
 The one serious criticism I have is that this is too much of a one-man show. If anything were to happen to the Sirdar there would be chaos, as no one but he knows the state of preparedness in which the various depart-ments are. He keeps all information regarding the details of railways, trans-port, steamers, supply and intelligence, in his own hands, and shows wonderful skill in working the various strings.

Wingate was writing in his diary on almost the same day: 'K irritates me by keeping his movements secret from me'.[36] Rawlinson concluded: 'Everything works smoothly and well as long as he is at the head of affairs but he does too much and may break down if he is not hit'.[37]
Shortly afterwards Kitchener came to the crux of his career.[38]

14

CRUX OF A CAREER

KITCHENER SENT RAWLINSON on short compassionate leave when his wife's health worsened. He returned on 18 March 1898 to the vast tented city that had sprung up south of Berber, and on to Fort Atbara, a strong defensive position that the Sirdar had built at the point where the Atbara river (dried up at that season) entered the Nile. Rawlinson found them 'all in a state of great excitement at the prospect of an early engagement with the enemy, the coolest and most deliberate being the Sirdar himself who had the whole situation at his finger ends', partly because unlike most generals he messed together with his staff, not in splendid isolation.[1]

The young Emir Mahmud had advanced north down the Nile boasting that he would recapture Berber. He had 18,900 fighting men and large numbers of camp followers and women: other wives had been left at Shendi opposite Metemmeh where he had massacred the inhabitants. With Mahmud was Osman Digna, the veteran of the Suakin campaigns, but the Khalifa had not given him overall command and the two disputed. Mahmud wanted to march north beside the Nile and meet the Sirdar head on. Osman advised swinging out into the desert to outflank him. When the gunboats harried the river march, Mahmud accepted Osman's advice, marched away from the Nile until his army, exhausted by lack of water, stopped near a village beside a stagnant pool in the dried up Atbara, forty miles from its confluence. Kitchener had already moved some way up the Atbara to forestall him. Osman urged Mahmud to base his force many miles further up the river bed but he refused.

Egyptian cavalry patrols reported that Mahmud had constructed a circular zariba (defensive encampment) of thorns and stakes, a thousand yards wide, above the river bed. Deserters revealed to Wingate and the Sirdar, who loved to examine them himself, that the zariba was only a first line. The dervish encampment had a stockade, trenches and numerous blockhouses of dried mud. Kitchener waited. Even with desertions, Mahmud had more than 16,000 defenders, many with women, children and slaves, and when food ran short he would come out to do battle. but he remained in his stronghold.

Kitchener continued to wait, his force camped in an excellent site, shaded by dom palms, some thirteen miles away. Walter looked on his brother's waiting 'as a very fine display of strength and knowledge. All of course', Walter told Arthur in New Zealand, 'urged him on, the chance of Mahmud clearing off untouched was a terrible risk to him as it would have made a fool of him before the world at large'.[2] And he would have an unbeaten enemy on his flank as he advanced towards Khartoum. But the Sirdar's knowledge of the Arab mind assured him that Mahmud would never face his women if he slipped away like a coward.[3]

Mahmud's zariba looked impregnable from a distance. A clever foray by his cavalry almost trapped a reconnoitring company of the Sirdar's. They were saved by Maxim machine-guns and the quick thinking of Douglas Haig, who thus came to Kitchener's attention.

Still waiting, Kitchener sent gunboats upriver to land at Shendi, destroy the base and bring back the women left behind, in hopes that their men would desert. Not many did. The women were welcomed by the Sirdar's Blacks and by Berber men whose wives had run off to follow the drum.

With Hunter and Gatacre to advise on tactical details, he planned an order of battle which could either repulse Mahmud if he sallied out or assault him. In the three weeks since the arrival of the British brigade he had trained and welded his force so that every officer and man knew his exact task in battle – and knew his Sirdar, whose great distinctive moustache was a talisman, like Monty's beret before Alamein.

'Herbert is a real King out here, I tell you', wrote Walter in his letter to Arthur, continuing:

'Sirdar's order' is an expression equivalent to 'Czar's decree' in Russia and overrides every regulation and law. He certainly is a wonderful man. He never keeps any record of his telegrams (all is done by wire) and yet remem-

bers everything. He has *no* staff officer except an ADC and an intelligence man and attends to every detail himself . . . Herbert looks 'the Sirdar' all over. He rides lovely arabs and has a perfect seat.[4]

He was deeply respected and trusted, though never seeking the affection that Lord Roberts, with his very different character, had won from his men in India. Yet in the words of a staff officer of the British brigade, 'There has probably never been a force in the field which has been bound together by a better feeling of good comradeship, and in which quarrels and rivalries have been so conspicuously absent'.[5]

By 31 March Kitchener had to decide whether to follow his instinct and assault the zariba. He called a council of war, with Hunter, Wingate and the brigadiers. The fire-eating Gatacre, with little experience of the Sudan, favoured assault. But Hunter now advised against: Gatacre possibly changed his opinion to accord with Hunter's, for sixteen years later Ronald Storrs recorded after dining alone with Kitchener: 'K said the crux of his own career as a general was at the Atbara, when all his advisers were against his giving battle, and he gave it and won it in their teeth. The thought of taking an army out to fight 40 miles in the desert had completely destroyed his night's rest and he had determined, if defeated, never to return himself.'[6]

His memory had exaggerated the distance but not the agony of decision. His numbers, though great, were too low by contemporary military wisdom to assault a well-defended fortress. His British brigades might be exhausted by the night march and the heat. His superiority in small arms would be of no avail. If he failed, or incurred heavy losses, the political and military consequences could be crippling.

In the morning he decided to seek a fresh mandate from his political masters. He wired to Cromer: 'I am rather perplexed by the situation here . . .' and set out the options to fight or not to fight. Cromer showed the wire to Grenfell and sent it to London. Salisbury consulted Wolseley, who answered: 'You have a first rate man in command. Trust him and let him do as he thinks best.'

Grenfell told Cromer it was impossible to advise, but Cromer wired caution. Before his wire arrived, Hunter had withdrawn his objection.

Afterwards, when the result had been 'all that the most critical could desire', Wolseley told Kitchener:

Were I in your place, I would not however ask such a question. You must be a better judge than Lord Cromer or me or anyone else can be. You have your thumb upon the pulse of the Army and can best know what it is capable of. This is my only criticism and I give it for what it is worth.[7]

The Sirdar had a second, brief hesitation when he realized that the fight would take place on a Friday, which he usually avoided as the Muslim holy day, not from superstition. One of the staff pointed out that 8 April 1898 was Good Friday, 'a good day for an act of liberation'. The Sirdar laughed and agreed. 'I have been two years bringing you face to face with these fellows. Now go in and fight it out.'[8] He had already warned the force not to slaughter the wounded, and had ordered that the British battalions be taught the Arabic word and symbol for surrender. Quarter should always be granted, though most dervishes would fight to the death.[9] He added a final word: 'The Sirdar is absolutely confident that every officer and man will do his duty, he only wishes to impress upon them two words: "Remember Gordon." The enemy before them are Gordon's murderers.'[10]

At first light on 8 April Mahmud saw a great line of Egyptian, Sudanese and British troops spread in a semi circle about 600 yards to the north of his zariba, with their guns about 30 yards in front. He rode around the perimeter to check that riflemen and spearmen were in place and that every emir knew what to do. He retired to his underground command post. Within the zariba a great cloud of dust arose as men dug pits for their donkeys, tying their legs to prevent them running amok in the battle. Osman Digna, certain of disaster, slipped away with fifty of his own cavalry.

At 6.16 a.m. the Anglo-Egyptian batteries pounded the zariba, with the Maxim machine-guns in support. The dervishes disappeared from the parapets. Shells smashed parts of the thorn and earthwork defences and started fires. Shrapnel killed Mahmud's gun-crews, so that his guns were silent when most needed. 'Herbert was a bit anxious but did not show it – gave very few orders – stuck in one place and let the gunners do their work without bothering them.'[11]

After three-quarters of an hour the shelling stopped as planned. Kitchener could not keep his infantry, especially the British, waiting longer in the strengthening sun. He ordered the Advance to be sounded on the bugles. To Charles à Court of his staff, writing five days later, 'It was a truly magnificent

sight as the twelve battalions swept forward in perfect order and beautiful alignment to within 300 yards of the zariba'.[12] They halted and fired volley after volley at the parapets now crowded again with dervishes, who directed a hot fire from rifles and elephant guns at the ranks in the open without cover. The Camerons particularly suffered. After twelve minutes the Advance sounded again. The massed troops moved forward, with bands playing and pipes swirling. The British marched as if on parade, which caused them casu-alties but terrified the defenders as they saw cold steel drawing slowly nearer. The Egyptians and Sudanese ran at the zariba, with Hunter riding and waving his sword at the head of Maxwell's brigade. The line crashed through the thorn fences and the pallisades to cries of 'Remember Gordon'. The next half-hour in the labyrinth of trenches, pits and blockhouses was a hell of blood, screams and pain, a savage nightmare of hand-to-hand fighting. Blacks wreaked vengeance on Arabs for the despoiling of tribal homelands far away to the south; kilted, unshaven Highlanders and English boys in their first fight almost lost control of themselves as they thrust and parried and fired. More than twenty thousand men were locked in brutal combat within less than a square mile. Frank Scudamore of the *Daily News*, who covered almost every Sudan fight from 1884 to 1898, thought it the hottest of all.

Blood lust rose on both sides. Arabs slaughtered deserters and escaping slaves. Walter, who had ridden to the reserve brigade with a message, rejoined the Sirdar 'just as he was trying to stop black troops shooting down men who came out to give themselves up. I saw some of these shot at a yard off as they ran forward with bits of palm held up in their hands – but "Tommy" was just as bad as the blacks'.[13]

By 8.20 the line had reached the river bed. Mahmud's army had ceased to exist. Two thousand were dead, thousands more lay wounded, others were being rounded up as prisoners (many of whom were happy to change sides and fight for the Sirdar). Hundreds streamed into the desert.

The victorious brigades re-formed outside. The Sirdar rode up as the British, almost mad with excitement and glee, were coming out. 'They gave Herbert a grand reception', grouping around him and cheering so loudly that his words of thanks and praise were drowned. Charles à Court remembered it as 'a scene of . . . tremendous and tumultuous enthusiasm', and Walter was reminded of the Diamond Jubilee when the Queen came by. 'Herbert is tremendously popular with the British'.[14] He was beaming, his eyes lit up as he exclaimed his delight at victory.[15]

As sporadic firing continued he ordered the Cease-fire to be sounded. Detachments were left inside to search and mop up. The Sudanese found that Mahmud's men had burdened themselves with loot. The Sirdar gave his Blacks leave to loot as permitted by the rules of war after a fortress fell by assault. Ancient chain armour, helmets, spears, prayer mats, robes, numerous flags and banners were soon being distributed around to the victors by purchase or gift. An officer's horse was led past the Sirdar laden with loot. He stopped it, used his collector's knowledge to pick out the best and told an ADC to take it to General Gatacre with his compliments and thanks for fine leadership.[16]

The Sirdar rode on across the field with Hunter. An officer galloped up with news that Mahmud was a prisoner, saved from Sudanese bayonets by a young gunner officer. They wheeled their horses and saw a Sudanese sergeant leading a tall, proud man in an ornate bloodstained jibbah, his hands bound behind his back. He scowled at them, which annoyed Hunter.

'This is the Sirdar', said Hunter angrily in Arabic. Kitchener quietly ordered Mahmud to sit, the recognized prelude to beheading or pardon in the Sudan. But instead of kneeling to learn his fate, Mahmud sat down cross-legged, the attitude of an equal.

Kitchener on his horse, the Egyptian flag carried beside him, looked down on Mahmud.

'Why have you come into my country to burn and to kill?' asked the Sirdar.

'Same as you', replied Mahmud. 'I must obey the Khalifa's orders as you the khedive's'. Kitchener smiled and remarked to his staff, 'Rather a good answer'.

Further questions followed, which Mahmud answered without fear. As he was taken away he shouted at the Sirdar: 'You will pay for all this at Omdurman. Compared with the Khalifa, I am but a leaf'.[17]

By now the Sirdar had a headache. He dismounted and lay on the ground while his orderly splashed water on his face. The stink from the stricken zariba was dreadful in the heat of the day. Many enemy bodies were being buried in the trenches where they fell. One officer counted a heap of sixty in the river bed, evidently deserters cut down by their own cavalry. Numbers of wounded had fled or crawled into the bush or the desert, where many died, for wounds were fearful. Gatacre had ordered his brigade to file the tops of their bullets to make the dreaded scooped-out dumdums that were never used against a white enemy and were later outlawed by international convention. Men who died in

the desert were left unburied: six months later the Duke of Connaught was astonished to see bodies of men, donkeys and camels preserved by the dry heat.[18]

A hospital was set up to tend the wounded until they could be carried back to the Nile, but the British brigade's medical side was poor compared with the Egyptian 'and K was furious', wrote Rawlinson to his wife: 'He had a pretty anxious time from the beginning of the night march until the end of the battle, but the only thing I saw him disturbed about was the treatment of the British wounded, who, from lack of proper arrangements, suffered unnecessarily from the heat and from thirst'.[19]

Kitchener had lost only 74 men killed, mostly British (3 officers and 57 other ranks), with 499 wounded: He attended the British funeral that after-noon. He stood impassive but tears rolled down his cheeks. An English officer, who knew him only from afar as the 'Sudan machine', said the Sirdar was human for more than fifteen minutes.

They began their return to the Nile, the wounded being carried on Walter's camels by a Sudanese battalion which volunteered. Hunter stayed on the field until late at night, searching for wounded who had been overlooked. They all rested on the Saturday, and on Easter Sunday held thanksgiving services after which the Sirdar read out telegrams of congratulation from Her Majesty and others including the Kaiser.

By any reckoning the battle of the Atbara had been a remarkable victory, at minimal cost to the Sirdar's army and devastating loss to the enemy. 'There's no doubt he is a wonderful man', Walter enthused to Arthur.

I think all felt it might not have been quite the same under any of the men that would take his place were he knocked over. Hunter would have just gone straight in and would have got off lucky with a butcher's bill of 1,000 instead of our 500. Old Gatacre would have fussed about until no one knew what was wanted of them. No! there can be no doubt Herbert is a wonderful administrator and, for a fight, the very best.[20]

Four days after the battle Kitchener rode with Hunter beside him at the head of his Sudanese and Egyptians (but not the British — sent tactfully to summer quarters) down the wide main street of Berber through cheering, clapping crowds. Flags and colourful garments decorated trees. G. W. Steevens, the *Daily Mail*'s war correspondent, thought it like a Roman triumph as he

watched the Sirdar, 'tall, straight and masterful in his saddle'.[21] Behind him rode the brigadiers and staff officers, then a cavalry escort. The people pressed forward more eagerly , noted Steevens, as 'farther behind, in a clear space, came one man alone, his hands tied behind his back. Mahmud! Mahmud, holding his head up and swinging his thighs in a swaggering stride – but Mahmud a prisoner, beaten, powerless. When the people of Berber saw that, they were convinced'. Women hurled insults at the butcher of Metemmeh whose approach had brought fear a few weeks before. Now they hooted at the satirical slogan in Arabic held over his head by two Sudanese soldiers: 'The Conqueror of Berber'.[22]

Mahmud was displayed with a long line of bound prisoners to convince the populace that he was beaten – in battle. He was not lashed as he marched or whipped to keep up with cavalry, as a late-twentieth-century writer alleged. The bound hands (Mahmud had no shackles on his legs) were the traditional symbol of defeat, but for a defenceless captive emir to be lashed in a public procession would be a humiliation so contrary to Sudanese custom – and to British fair play – that eyewitnesses would have recorded it and folklore never forgotten. Contemporary evidence, including Walter's sketch, done the same day, rejects such brutality. 'The Dervish leader', reported Bennet Burleigh of *The Daily Telegraph*, 'was not in the least downcast, but walked with head elate, as a central personage in the parade. He was gibed and hooted in the oriental way as he passed the crowds of those who had but recently cowered before him.'[23]

Mahmud was sent north, in chains, by a saloon carriage of the SMR, talking volubly to British journalists who knew enough Arabic. He died in captivity at Rosetta aged forty in 1906.

The battle of the Atbara gave the army and the Sirdar a surge of confidence. Kitchener became the hero of the British people as they read exuberant accounts by the war correspondents, which quite embarrassed some of the soldiers, who knew that they owed most to the Maxim machine-guns and the field guns. Senior officers discussed tactics, Gatacre being privately criticized by Hunter, but Charles à Court, who knew far more about military affairs than Walter Kitchener and was unaffected by family feeling, wrote within days of the victory a verdict that endorses Walter's: 'I consider the Sirdar is as good in the field as he is in administration, head and shoulders above all his subordinates here'.[24]

Kitchener's own view, expressed to Wolseley some months later, was unequivocal: 'I had such good men under me that it would have been difficult to go wrong'.[25] Good men – and Maxim machine-guns, the decisive factor.

With Mahmud's army eliminated, Kitchener could estimate how many extra troops he would require to take Khartoum. He told Neville Smyth, soon to win the VC, that he had been repeatedly asked by the War Office 'but I could not make the estimate until now'. Smyth knew that 'Kitchener's power of visualizing the future was so great that many of the wild Arabs with whom he had to deal in the Sudan credited him with prophetic powers'.[26]

15

APPROACH MARCH

AT ABOUT 5 a.m. on an August morning the train of cattle trucks which had carried the 1st battalion Grenadier Guards 385 miles from Wadi Halfa across the desert and beside the Nile drew into Atbara. Colonel Simon Hatton jumped down in his pyjamas. He was astonished and abashed to find the Sirdar, spruce as always, beside the train to greet the battalion.[1]

The Grenadiers, from Gibralter, were the last to arrive of the four infantry battalions which made up the 2nd British brigade, together with Maxims, gunners and the 21st Lancers. They brought Kitchener's force up to approximately 20,000 men. They soon found that desert country in the rainy season could test even the discipline of Grenadiers. 'The dust storms were awful', wrote one officer, Captain Humphrey Stucley. 'Great dust devils would rush through camp, overturning tents right and left, and all would be pitchy dark for half an hour or more.'[2] Heavy rainstorms sometimes soaked equipment while the expedition was organizing for the final march on Omdurman and Khartoum.

The Sirdar had used the four months since the battle of the Atbara to rest and refresh his force. Walter Kitchener was one of those who were delighted to be sent on a month's leave in England, where Carry and the children were living at Dover. He returned a few days ahead of time, to the approval of Herbert, who had gone no further than Cairo and then was back, organizing everything. Walter was most impressed that Herbert had accumulated two months' supplies at forward bases, less than a hundred miles from Khartoum. Against a strong current and a south wind the Egyptian and Sudanese troops

had dragged barges and cut wood for steamers; they had never seemed to tire and 'every man a guardsman in physique'.[3]

Three new armoured gunboats, twin-screwed, had arrived in sections from England. At Wadi Halfa 'Monkey' Gordon loaded them on to the desert railway. At Abadiya, near Berber, George Gorringe and his men assembled them. The Sirdar loved hurrying to the dockyard in the early mornings to help, not always usefully. When he hammered a rivet a sapper would quietly mark it with chalk so that it could be properly hammered after he had left.[4] And one morning when Gorringe was on some vital job inside a perilous crib-pier of sleepers supported by a girder with a rope attached, he was horrified to hear the familiar voice saying, 'Now then, you men. What are you waiting for? Haul on that rope!' Choosing mutiny to death, Gorringe swore at the unseen Sirdar, then heard: 'Wingate, perhaps we had better go and have breakfast!' Shortly afterwards Gorringe was invited to join them.[5]

The desert railway which brought gunboats also brought new staff and special service officers. The fashionable military world vied for the honour and glory, rather to the resentment of those who had borne the heat and burden. The sprinkle of princes, peers and heirs made Walter laugh at Herbert's 'brilliant' staff. Herbert, however, would have no one not 'a real workman'. He selected Lord Roberts's only son, Freddy, a man of dedication, efficiency and charm who the next year in South Africa would win a posthumous VC saving the guns at Colenso; and he took a thirty-one-year-old grandson of Queen Victoria, Prince Christian Victor, a keen professional soldier in the 60th Rifles (and a first-class cricketer). But when the Prince of Wales, who could not be refused, personally recommended an excellent officer for whom Kitchener had no vacancy, the letter was mysteriously lost.[6] The Egyptian Army already had Prince Francis of Teck, a brother of the Duchess of York, the future Queen Mary. Tall, handsome, with the gaiety, kind heart and extravagance of his mother, Princess Mary Adelaide of Cambridge, Frank Teck was a favourite with all who knew him. When he died comparatively young, twelve years later, Kitchener felt it 'deeply as he was such an old friend of mine both on service and at home'.[7]

The Sirdar would not have Winston Churchill, then aged twenty-three, serving in India with the 4th Hussars. Winston's mother, Lady Randolph, had tried for the Dongola campaign. Kitchener had sent her a polite assurance of bearing him in mind. In 1898 she left no stone unturned and no cutlet

uncooked, in Winston's own apt phrase. Sir Evelyn Wood, Adjutant-General, agreed to press his case. In February the Sirdar replied to her that he had noted her son's name and 'I hope I may be able to employ him later in the Sudan'. Winston took this as a promise and when no appointment came he grumbled, 'He may be a general – but never a gentleman'.[8]

Churchill was unpopular with brother officers for unrestrained belief in his manifest destiny and for writing an excellent book about a frontier campaign in which he had fought. But Kitchener objected to Churchill's using the campaign as (to adapt Churchill's later remark about the Mother of Parliaments) a public convenience on his path to politics and journalism. The Sirdar wished to keep coveted places for soldiers of military promise. He was not pleased when Churchill managed an attachment to the 21st Lancers at the last moment through the intervention of Lord Salisbury.

Churchill also had a commission from the *Morning Post* to report the coming battle. Fifteen full-time war correspondents had already arrived. Kitchener shared Hunter's opinion that journalists got in the light, over used the telegraph lines, quarrelled among themselves and drank too much,[9] despite this being officially a 'dry' campaign. However, the story that the Sirdar kept them waiting in the hot sun and then strode out of his tent exclaiming 'Out of my way, you drunken swabs' has no contemporary source and is out of character. He would have preferred to restrict them to base, but when he noticed them he was courteous, especially as he would need their help to fulfil a vision not yet disclosed. He enjoyed the company of little Frank Scudamore of the *Daily News* and appreciated George Steevens of the *Daily Mail*, as 'such a clever and able man. He did his work as correspondent so brilliantly and he never gave the slightest trouble. I wish all correspondents were like him'.[10]

Two other observers were the Italian and German attachés. Captain Baron Adolf von Tiedemann, whose sartorial elegance caused amusement, found the Sirdar 'generally reticent and unapproachable, but occasionally most amiable and positively charming, on these occasions showing a keen and ready wit' and whatever he was doing, 'always perfectly natural'.[11]

By mid-August all was ready. Kitchener packed his men, horses, supplies and ammunition into the gunboats, transports and barges, ignoring the Plimsoll line ('Plimsoll's dead') and accepting the dangers of overcrowding, the stink and the sweat. 'The river is just full and *rushing* by', wrote Walter. 'The new steamers (*Melik*, *Sultan* and *Sheik*) make very poor fight against it.'

The transport steamer *Ambigole* stuck on a sandbank. Eight hundred and sixty men and officers of the Lancashire Fusiliers had to strip and wade ashore for the vessel to be refloated. Later, the ill-fated *Zafir* gunboat that had brought the Sirdar to tears in Dongola sprang a leak as she approached the Shabluka gorge (Sixth Cataract) and sank, without loss of life. Meanwhile, the Camel Corps, Walter's camel transport and the cavalry marched on shore, followed by the inevitable women and children of the Egyptian and Sudanese troops.

At the final point of disembarkation, when all had arrived safely by water or land, the Sirdar reviewed his army. The previous day Walter 'went for a ride with Herbert this morning – he is very cheery and in great fettle'.[12]

For the last two days of the approach to Omdurman and the ruins of Khartoum, Kitchener marched his 20,000 men (including 8,200 British) in fighting formation on a front of nearly three miles on the western bank of the Nile, followed by Walter's 2,300 camels. These looked like a solid wall a mile long. 'With his usual luck', wrote Walter, 'Herbert had the most perfect two cool days of the year', so that the army covered twelve miles a day, from 5 a.m. to 1 p.m., 'without knocking up the British'.[13]

They passed through an area of thick bush. In Gordon's day it had been fertile pasture; now it was covered by mimosa scrub up to twelve feet high. They had expected the Khalifa to defend it or harry their flanks, but even the villages were empty. They approached the low Karari hills. MacDonald's Sudanese were merry and talkative at the thought of action, but the hills were not defended and the summit gave a first limited view of the spread-out city, dominated by the Mahdi's tomb and, in the distance, the ruins of Khartoum and Gordon's palace.

Shortly before midday on 1 September the Sirdar encamped his army round the village of El Egeiga on the western bank of the Nile. The cavalry formed a screen ahead, accompanied by Royal Engineers with a heliograph. Behind, on the Nile, were the gunboats, which had begun bombarding the city. On the farther bank the Friendlies were ranging, rather murderously, under the command of Edward Stuart-Wortley who in 1885 had been on the gunboat that penetrated nearest to Khartoum, saw that Gordon's flag no longer flew from the palace and realized that the city had fallen.

Kitchener's troops were erecting the defensive zariba. His plan was to advance early the following morning and defeat the Khalifa's huge army

outside Omdurman. His fear was that the enemy would refuse a major fight, retire within the city and defend it street by street, inflicting heavy casualties.[14]

He was sitting on a wall in the scanty shade eating his lunch when the heliograph began to flash from a small hill (Jebel Surgham, at 328 feet) which rose to the south-west between his position and the city: a very large dervish army was advancing.[15]

16

OMDURMAN

THE SIRDAR FINISHED his lunch, remounted his white arab and galloped with his ADCs towards the hill. An officer riding down from the detachment of the 21st Lancers reported more detail. And thus Herbert Kitchener and Winston Churchill met for the first time.

Kitchener rode to the top. Soon afterwards Hunter met him 'just come down from the hill, looking as if he had seen a ghost and no wonder, for he said the Enemy were only 5 miles beyond the hill, advancing 50,000 strong against us'. Hunter said they must dig in and all would be well.[1]

The Sirdar immediately deployed the infantry in a wide arc beyond the village and zariba, personally laying out the general line of the perimeter, allotting the British to the left and the Egyptians and Sudanese to the centre and the right: they dug trenches but the British made a thorn hedge. The desert gave a clear field of fire. Then the dervish army stopped about three miles short.

Walter made his camels snug in the village and rejoined headquarters at about 5 p.m. With darkness coming, he expected the Sirdar to withdraw into the original close-packed zariba, according to normal practice. When he did not 'It fairly took my breath away'.[2] Walter had been sure

Herbert would reform into the zariba for the night, but his ways are not common men's ways; all lay down where they were, and the information (quite correctly) was that they intended to attack at night. I have seldom put in such a bad night. I could see *nothing* that could prevent their getting through our weak line and once well amongst us there would have been the

most hideous mêlée ever seen. I asked Herbert about it next day, and to my astonishment he admitted at once, 'O yes! I think they would have got through us,' but he sent word by spies that we were going to attack them and instead of coming on and scuppering us, they sat up all night waiting for our attack. To be able to accept a risk like that means simply extraordinary nerve. Of course to have formed close zariba would have had a very bad effect on our troops – they had had a hard day and it would have caused infinite confusion and loss of rest. As it was at dawn all were in their places and fresh, and with baggage loaded ready for anything.[2]

Gunboat searchlights had played all night under a full moon, though a drenching storm passed through. Villagers and camp followers, placed out in the open, would have given warning. Except for one false alarm nothing had happened, but many officers shared Hunter's feelings: 'When the sun rose on 2/9/98 I never was so glad in all my days.'[3]

By then, Kitchener had set them in battle line, fresh, fed and eager, with field guns and Maxims in support. He had put on his white uniform, and on his white arab he stood out beside the prevailing khaki.

A squadron of 21st Lancers reported that the dervish army was advancing across the Karari plain. Soon the Sirdar, with his field glasses, could see Broadwood's cavalry retiring as ordered towards the Karari hills to the north, and the glint of the sun on thousands of spears and banners. They were moving north across the front. Whether following Broadwood, or misled by Wingate's spies or bad advice, they appeared to suppose that the Sirdar's main force lay behind the hills, not beside the Nile. They were gaining on Broadwood's cavalry. At 6.23 a.m. the Sirdar sent a staff officer to order the guns to fire, at a range of 2,700 yards. The gunboats joined in. Shrapnel shells burst above the distant horde with no clearly visible effect until suddenly a great segment of the dervish army wheeled and bore down towards the zariba.

To the defenders it looked as if the whole world were come against them. Rawlinson, on his horse behind the Sirdar, thought it 'a magnificent sight, those thousands of wild brave savages advancing to their destruction. We could plainly hear their yells and see them shaking their spears, but they did not think so small a party, as we were, worth shooting at. They kept a wonderfully good line in their advance.'[4] Kitchener trotted to a position behind the Cameron Highlanders, at left-centre of the line, and sat impassively on his

arab, field glasses in constant use. His staff brought messages and answered his stream of quiet questions, then galloped off with his orders.

The horde drew nearer, a wide arc of white-smocked warriors led by emirs on horseback and chanting ceaselessly, *'La llaha illa llah wa Muhammad rasul Allah.'* 'Immediately our guns opened', recalled Stucley of the Grenadiers, 'and I saw the first shell burst right in the middle of the advancing mob. There was a flash, a cloud of dust and then just a space, where a few seconds before had been a densely packed mob of howling, cursing human beings.'[5]

Then the Maxims opened, and at eight hundred yards the infantry fired volleys by company. For Walter it was 'a case of binoculars and a bad time for the Dervishes – cruel slaughter of very brave men'. As the bodies piled up 'one's feelings went over to the enemy – they just struggled on. As far as I could judge the standard bearers were the only men who seemed to be able to live under it. One man with a white and red flag getting to within 200 yards or possibly less – the reason being I suppose, that he was aimed at!'

The Khalifa had played into the Sirdar's hands and caused terrible loss of life by choosing the worst possible course against modern firepower. But when Wilfrid Blunt, the poet, philanderer and friend of all nationalists, wrote a furious letter to *The Times*, contrasting Kitchener's slaughtering with Gordon's renowned clemency, he forgot that otherwise the Sirdar's men would have been massacred. Yet as Walter wrote, 'All the pluck was displayed by the Dervishes, our side had no chance of showing anything but discipline'.

While the approaching horde faltered and died by thousands on the plain of Karari, Kitchener knew that Broadwood's cavalry might be in difficulties from the huge other wing of the dervish army, and he sent Lord Tullibardine to order Broadwood to retire on to the zariba. Tullibardine galloped back with a message from Broadwood: he was too far for a retirement; he would draw them into the desert beyond the hills. The Sirdar sent Tullibardine to the fighting Camel Corps, between Broadwood and the Nile, with an order to retire towards the Nile. Swinging his binoculars he saw them hard pressed and sent Freddy Roberts to signal to 'Monkey' Gordon in the *Melik*, who steamed inshore, brought his guns to bear and saved the Camel Corps.

By 8.30 a.m. the dervish assault on the zariba had petered out in a misery of

* 'There is one God and Muhammad is the Messenger of God.' Both sides were relying on God, an irony that would be even more marked in South Africa the following year and sixteen years later in Europe.

wounds and death and with ghastly piles of bodies, at the price of a comparatively small number of casualties for the Sirdar, including one British officer killed – the tallest in the expedition, hit in the temple.

The way was open to Omdurman. Walter was 'just beginning to think Herbert was going to fall into the over-cautious trap and throw away his chance when the "Advance" sounded and on we went'. As the brigades moved forward, with MacDonald's Sudanese on the right, the Sirdar sent an order to the 21st Lancers on his left to reconnoitre over the ridge between the higher Jebel Surgham and the Nile and make contact with the retreating enemy. 'Annoy them as far as possible on their flank,' he told Colonel Martin, 'and head them off if possible from Omdurman.'[6] The Lancers (with Winston Churchill from the 10th Hussars leading a troop) trotted off.

The 21st Lancers were a new regiment, determined to win glory. Martin made a detour to attack a small group of the enemy and thus led his regiment into a trap laid by Osman Digna, who had secreted a large number of warriors in a *khor* (shallow depression). Martin did not hesitate. The charge of the 21st Lancers, a brief saga of supreme valour, became the most famous incident of the battle. Yet like the charge of the Light Brigade at Balaclava it achieved nothing. Robin Grenfell, the former Sirdar's nephew, was killed and twenty lancers. Twenty-two horses were killed or had to be destroyed. Two VCs were won. Winston Churchill wrote an immortal account.

The Sirdar was annoyed at unnecessary loss of life, at Martin's failure to report a large force that he should have seen, and that later the exploit rang around the world to steal glory from MacDonald, the real hero of the battle. Walter, however, probably represents the more general feeling when he wrote:

> Of course the charge was unnecessary, but they came up to find an opportunity and they seized a real good one and did the work in real cavalry style. Old Martin, to my mind, deserves infinite praise all through . . . 'Ce n'est pas la guerre' no doubt – but good work and sound for recruiting.

While the Lancers were out of sight the Sirdar advanced. He knew that the Army of the Black Flag under the Khalifa and his brother Yakub had been waiting beyond the hill (Jebel Surgham), but he must get between them and Omdurman and reach the city before the fleeing remnant from the assault on the zariba. When Walter (who knew nothing of the Black Flag) returned to headquarters after getting his camels on the move, he heard Herbert say to Gatacre:

'Get on – get on, step out for that ridge and you've got them' – and old Gatacre to the Colonel of the Guards – 'Now Colonel Hope [*sic*, i.e. Hutton] address your men – a few words you know.' – What the few words were to be to prelude rapid volleys at 1,000 yards into a crowd of unarmed fugitives, struck me as possibly embarrassing for the Colonel but very much 'Gatacre'. It was *picturesque and safe*, which is my idea of what a battle should be!

For MacDonald and his mainly Sudanese brigade of 3,000 men on the far right, the battle was picturesque but not safe. The 17,000 warriors of the Black Flag were coming at him. Far away to the right the Green Flag armies (15,000 men) were pouring out of the Karari hills: Osman Sheikh el Din and Ali Wad Helu had turned back from their fruitless chase after Broadwood's cavalry. MacDonald sent a message asking Taffy Lewis,[7] moving his Egyptian brigade behind, to reinforce him, but Lewis would not disobey his orders to proceed to Omdurman. MacDonald could see, as he wrote to General Knowles after the battle:

that the force in front of me was a very large one and I knew that the one on my right was a very large one and I determined to defeat if possible the nearer force before the other could join. At a range of 1,100 yards I brought forward the artillery and opened fire, the infantry which were advancing in fours from the flanks of companies forming line. No sooner had we opened fire than up went innumerable standards, amongst them a prominent black one, the Khalifa's, and they opened a furious fusillade and at once bore down upon us. Their advance was very rapid and determined and though they appeared to be mowed down by the artillery and Maxims they still pressed on in such numbers and so quickly that I brought up the infantry into line with the guns, but in spite of the hail of lead now poured at effective ranges into their dense masses they still pressed forward in the most gallant manner until between 300 and 400 yards when they practically melted away leaving the Khalifa's black flag flying alone within 250 yards of Jackson's Bn. A fine performance truly for any race of man.[8]

Kitchener heard the firing but could not see MacDonald from his position with Maxwell's[9] brigade. Harry Pritchard, one of 'the band of boys', galloped up with a message from MacDonald: should he attack the Green Flags and

could Lewis's brigade alter direction to help? The Sirdar refused. 'Cannot he see that we are marching on Omdurman? Tell him to follow on.' Pritchard tried to explain MacDonald's dangerous situation without effect, 'so I had to take this cold comfort back to MacDonald'.[10]

Kitchener immediately galloped to a higher vantage point. For various reasons the landscape was less masked by smoke than most battlefields. He saw the situation, suspended the march on Omdurman, and by a rapid flow of orders wheeled the brigades so that Yakub's army was caught in a pincer between Lewis and MacDonald, who thus saw the enemy melt away. The speed of the Sirdar's change of front had justified his unorthodox habit of giving orders direct, not through the usual channels of command. He also told Maxwell to send a company to seize Surgham hill.

During Yakub's attack MacDonald, now in much pain from the kick of a horse which broke bones in his foot, was anxiously watching the movements of the enemy on his right, the Green Flag armies 'whom I now saw advancing in huge masses, and I was just in time to bring a Battery onto the new front to open fire at 800 yards'.[11] Had these masses arrived simultaneously with Yakub's, MacDonald might have been overwhelmed. Instead, by an extraordinary feat of drill and discipline he made a complete change of front at the double, battalion by battalion, in such a way that the fighting remnants of Yakub were held off on one front while the fresh hordes of the Green Flag were faced on the other. During the movement about a hundred of Yakub's cavalry charged to the death, 'a heroic deed'. Yakub died facing the enemy.

Two Green Flag columns, densely packed, were drawing closer: MacDonald rejected an agitated Hunter's order to retire, made his excitable Blacks hold their fire until the enemy columns were almost on them, and then broke the columns by disciplined firepower. They 'slunk away to the west'. By the time the Lincolns, famed for marksmanship, had doubled up to help, the last dervish assault was almost over.

Kitchener was later criticized by students of strategy, including Douglas Haig, for advancing on the city while the Green Flag armies were at his rear; critics claimed that MacDonald had adjusted the Sirdar's blunder and saved the day. But Kitchener knew that the Green Flag thousands were in the field. He must get to Omdurman before them: that was his winning card. Knowing the danger, he had moved MacDonald to the flank instead of Lewis's less steady Egyptians; his trust was not misplaced.

At 11.15, from the height of Surgham hill, Kitchener swept his gaze

around the ghastly ruin of the dervish armies then shut away his binoculars. 'Well,' he said, 'we have given them a good dusting!'[12]

The Sirdar sounded the Advance. The cavalry raced ahead around the landward side of the city, hoping to catch the Khalifa. The main army swept forward on a wide front across the Karari plain with its shallow depressions. 'We passed over hundreds of dead and wounded Dervishes', recalled Stucley of the Grenadiers, 'approaching all with caution, as they would feign death till one passed and then jump up and spear one'.[13] He saw a gunner speared while sitting on a timber as the guns drove forward. In another part of the field two war correspondents had ridden ahead and dismounted to loot bodies (as some said) when an enormous dervish sprang up and charged them with a spear, ignoring their panic pistol shots as they turned tail. He was about to strike when Neville Smyth of the Bays ran between, received the charge with a wound in his elbow and killed the man. Smyth was awarded the VC, though to spare the blushes of the press the citation disguised the correspondents as 'camp followers' and the warrior as 'an Arab who ran amok'.

This incident did not stop an Oxford don and temporary war correspondent claiming in an article three months later that Kitchener had given an order that the wounded be killed. Inevitably British soldiers and their allies were prone to take no chances – 'It's you or me, mate, and it won't be me' – but Kitchener categorically denied the accusation, and although Churchill believed it the Italian attaché, Major Count Luigi Calderari, an independent witness much better placed to know the truth, denied 'in the most absolute way' that wounded or prisoners were molested except in legitimate defence'.[14]

Kitchener himself nearly lost his own life when some nearby Sudanese took no chances. 'A wounded man had jumped up in front of the line to "kill his man",' Walter told Arthur, 'and a whole company were firing straight in our direction, and worst of all not aiming at us. It was quite extraordinary some of the crowd were not hit. We legged it back to behind the British real smart I can tell you.' Steevens of the *Daily Mail* and little Scudamore of the *Daily News* rode up at that moment after covering MacDonald's fight, 'just in time to hear the great man give vent to some of the most violent expressions of disgust and anger – in English and Arabic – that probably he ever used in his life'.[15]

After watering their horses in the fouled Khor Shambat, the Sirdar and his staff rode at a trot with Maxwell's Sudanese brigade, a British battery and Maxims, to enter the wide main street of Omdurman; troopers carried his

own flag behind him, with the captured Black Flag of the Khalifa, embroidered with verses from the Koran. The street was empty except for an elderly sheikh and his entourage who stood across their path. He asked whether the Sirdar intended to massacre the women and children. On being assured to the contrary, he presented an enormous key, and the roofs of the houses suddenly filled with women screaming a welcome.

As the Anglo-Egyptian troops entered from different directions (one Sudanese battalion forded the main sewer) and penetrated deeper, 'the streets were all a huge latrine', noted Stucley, 'and dead men, women and donkeys at every few yards, the result of the bombardment. The smell was beyond words.' The Grenadiers' chaplain, Reginald Moseley, vomited. They passed gallows, one with a recent corpse. No organized resistance was met but many pockets of warriors would not surrender.[16]

The Sirdar reached the Sur, the Khalifa's citadel dominated by the cupola of the Mahdi's tomb, damaged by gunboat shells. He entered through a breach as Hunter rode up in great excitement, shouting to Kitchener that he could be Lord Khartoum if he wished, and that the government should give him a big sum. All earlier criticism forgotten, Hunter felt that 'Kitchener deserves all he gets. He has run the show himself. His has been the responsibility. Some of us have helped too.'[17] Walter shared Hunter's opinion, as he wrote to Carry a fortnight later: 'It has been a well managed show and Herbert has run it absolutely off his own bat. His staff were not given a chance of remembering the most ordinary details. As a matter of fact I think he was afraid to trust any of them, and he was just about right.'

The Sirdar, with Hunter, Walter and the staff rode into the great walled area of the Khalifa's quarter, which had only just been captured from his tribal bodyguard, and passed a great storehouse of corn and rotting dates and along a causeway over pools drawn from the Nile; then through an archway into the wide square of the Iron Mosque, littered with red leather-bound copies of the Koran. Ahead stood the Khalifa's house and the Mahdi's tomb. A Sudanese battalion had failed to capture the Khalifa, who fled with his women as they entered, and were happily looting his chickens. They stopped at once, tucked chickens into their belts 'and stood grinning in wide-mouthed devotion towards their beloved Chief', as Scudamore saw.[18]

Then Kitchener nearly lost his life again. A shell burst overhead and shrapnel rained down. Hunter picked up a fragment and saw it was from one of their own guns, but another splinter had tragically killed Hubert Howard, the

Earl of Carlisle's daredevil (and teetotal) younger son who was covering the campaign for newspapers. 'Then came two more shells,' wrote Walter, 'and we all skiddadled smart by the way we came.'

Kitchener was determined to find and release Charles Neufeld and the Khalifa's other Western prisoners. With a company of Blacks they had a 'most exciting afternoon' working their way through the city. They never knew whether the next wall would be held. They went through narrow alleys. Sometimes shadowy figures 'potted at Herbert through windows and it was wonderful luck his not being hit . . . Herbert just did all he could to get himself shot and wouldn't stop till well after dark.' By then, most of the staff had dropped off. Herbert and Walter pressed on, with a guide and an escort of half a dozen Blacks until they found the jail, high walled with only one door, which was fast shut.

> After considerable parley through the door the Jehadier guard came out (some twenty men) and laid down their arms – and Herbert, *very keen*, pushed into the low inner court-yard which was full of prisoners. The moon was up now and it made quite an impressive picture when Neufeld was, after some delay, brought out of a dark inner mud hut, so heavily chained he could hardly walk and then only swaying from side to side – in jibbeh and Dervish cap, but unsunburned white face – he hobbled forward to shake hands with Herbert.

Despite the chains he had not been badly treated and had refused to leave his native wife when Wingate had contrived an opportunity for escape.

That night, outside the city on what they discovered afterwards to be the execution ground, the Grenadier officers had the curious sight, by a campfire, of the Sirdar lying on his back on a rough bed dictating telegrams for the Queen and Cromer to Wingate, who was lying on his stomach on the ground. Two ADCs were providing light from a succession of thick wax matches which Scudamore happened to have. A few feet away an armourer was filing off Neufeld's steel chains.[19]

Kitchener finished his despatches. As he prepared for a brief sleep he said: 'I thank the Lord of Hosts for giving us victory at so small a cost in our dead and wounded.'[20] And, if the Sirdar's actions next day and his lifelong attitudes are a guide, his thoughts ranged also to the suffering of the other side.

17

'HEROIC SOUL
WHOSE MEMORY WE HONOUR'

KITCHENER NAMED the victory the Battle of Khartoum but was overruled by the War Office, who named it officially as Omdurman; to the Sudanese it is the Battle of Karari. On the morning after, the Sirdar appointed one of the prisoners he had liberated, an Egyptian physician named Hassan Effendi Zeki, to be General Superintendent for the care of the dervish wounded, later estimated at 16,000. Zeki set up a hospital in a central position where more than 400 of the worst cases were tended and out-patients flocked in daily. The military field hospitals had to give priority to the expeditions's wounded but did what they could for dervishes. Uncounted numbers were carried to their homes by relatives, since every Omdurman male who could march had been conscripted for the fight.[1] Some wounded undoubtedly had been slain in the night by looters, whether from the city or camp followers, and others would have died of wounds before being found in the very extensive battlefield. Kitchener categorically rejected 'cruel and disgraceful' accusations, made three months later, of inhumanity. 'Considering the condition of the troops and the means at my disposal, I did all that I could to relieve suffering amongst the enemy.'[2]

Kitchener also ordered a count of dervish bodies, which came to a horrifying 10,883. Eighteen years later nearly double that number of British soldiers would be killed on the first day of the Battle of the Somme, three weeks after Kitchener's death.

While the divisional generals were reorganizing their troops, the Sirdar took Ned Cecil and Walter, with no escort except orderlies, in a gunboat

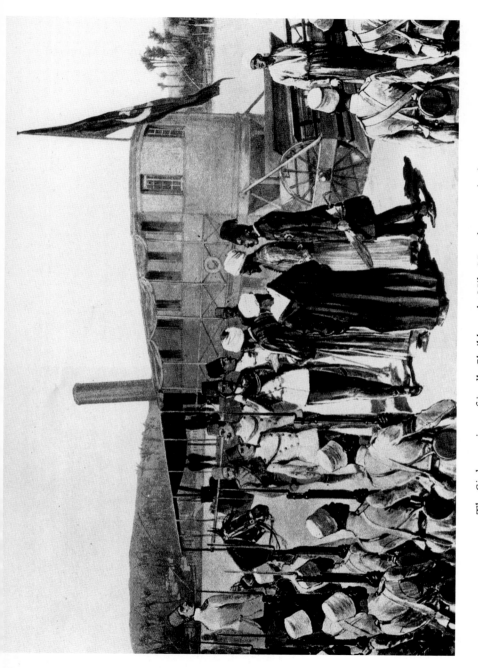

The Sirdar receives a friendly Sheikh on the Nile. Note the sternwheeler

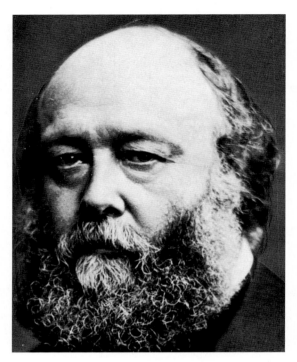

Lord Salisbury (3rd Marquess)

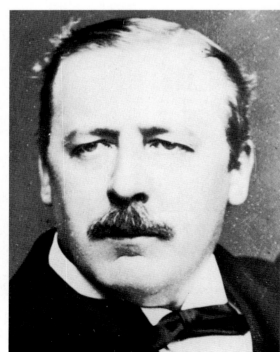

Lord Cromer (Sir Evelyn Baring)

Archie Hunter
'Kitchener's Sword Arm'
(later General Sir Archibald Hunter)
(from a *Vanity Fair* cartoon)

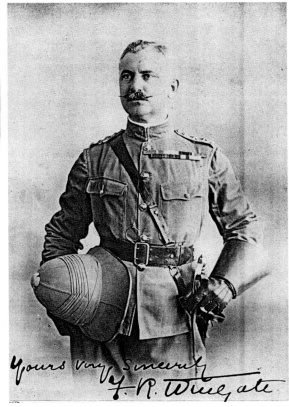

Yours very sincerely
F. R. Wingate

Rex Wingate
Kitchener's indispensable chief of
Intelligence (later General Sir
Reginald Wingate)

Walter Kitchener's immediate sketch of Mahmud in the Berber 'triumph'.
He was *not* lashed

Wingate interrogates Mahmud.
A posed photograph by Captain Loch four months after the battle of the Atbara

'Friendlies' at Berber, ready for action

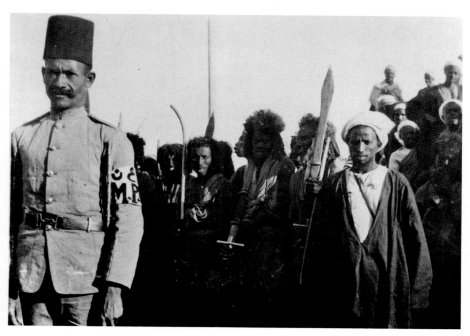

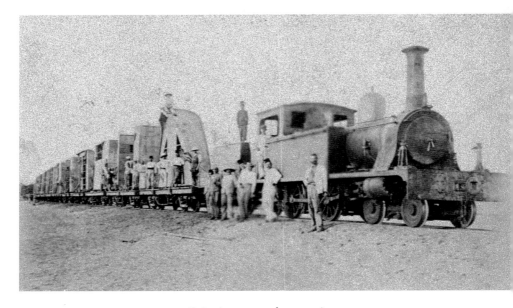

Bringing up gunboat sections

Bringing up the troops: early morning toilet beside the train

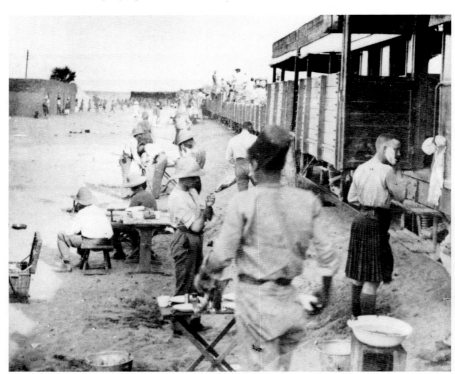

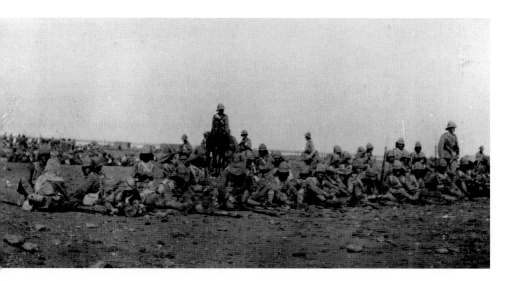

The Grenadiers at ease: waiting for battle

The 'Friendlies' do a War Dance

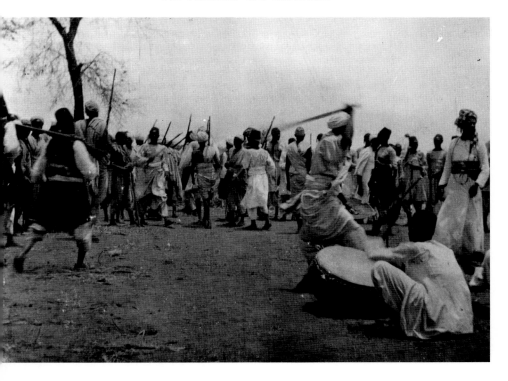

The Union Jack and the Egyptian flag fly out

A Lancer and a Grenadier hold Gordon's telescope

Father Brindle, DSO,
the best loved man in the Expedition

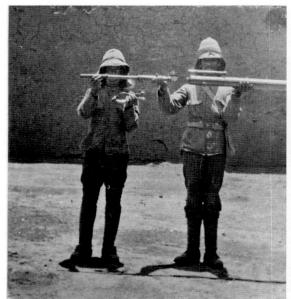

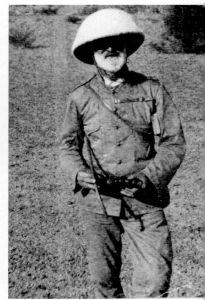

the three miles up the Blue Nile to set foot in the ruins of Khartoum, the city that had been the lodestar of his life for fourteen years. Walter was 'dead beat and the river trip was delicious'. He was even able to have a tub bath on board, 'which quite pulled me together'. On landing, they explored the ruins of Gordon's palace. Kitchener was much moved as he identified the site of the stairs where Gordon had been killed and where his body had lain unburied. Gordon's old gardener came up with a present of oranges, weeping lest he be dismissed after fifty years' service. Cecil saw Kitchener gentle and kind, 'as he always was to the poor'. He reassured the gardener that he would tend the roses in the garden of the palace soon to be rebuilt: Kitchener was already planning the new Khartoum, but his eyes were on the south, to complete Gordon's work by bringing peace and liberty to the tribes.[3]

They re-embarked and went a mile or two upstream before turning back to Omdurman. Kitchener now drafted a memorial service for Gordon, to be conducted next day, Sunday, by chaplains of each Christian denomination in the expedition. But when an ADC took the form of service to the senior Anglican chaplain, A. W. Watson, he objected that as Gordon had been Church of England he alone should officiate; or, in Walter's words, 'unless he *ran* the service he'd not play'.[4] The Sirdar was amused rather than irritated. He had other Anglican chaplains if Watson were out of the way, and after checking with 'Monkey' Gordon that his nominally Anglican uncle had worshipped with any sincere Christian (and had been ahead of his times in friendship with Roman Catholics) the Sirdar sent for Padre Watson. As Walter put it, the parson 'was given his choice of Khartoum or Cairo – and gave in'.

Next morning detachments from every battalion were ferried by gunboat to Khartoum and drawn up on what had been the lawn, facing the broken wall of the palace, its windows filled with the rubble of years, where Gordon had paced and prayed and looked through his telescope for the relief that never came. Two flagstaffs had been erected; the expedition was operating under two flags as a temporary answer to the problem that the Mahdist rebellion had been caused by Egyptian bad government before and after Gordon. Two officers stood by each flagstaff. Anchored immediately behind the troops lay the *Melik*, commanded by 'Monkey' Gordon, with other gunboats nearby. The generals, and the German and Italian attachés, stood at the head of the troops.

[139]

The Sirdar raised his hand. An enormous Union Jack flew out. All presented arms or saluted, the *Melik* fired a gun and the band of the Grenadier Guards played 'God Save the Queen'. The Blacks, from the far south, were excited and delighted.

The Sirdar raised his hand again. The Egyptian flag flew out. The gun fired and the khedival anthem was played. The Sirdar called for three cheers for each monarch, but when General Wauchope, commanding the British division, called for three cheers for the Sirdar the noise was deafening.

Then the four chaplains, Anglican, Roman Catholic, Presbyterian and Methodist, stepped forward and faced the parade. The Guards' band played the Dead March from *Saul* to commemorate Gordon, as the gunboats fired solemn minute guns: they had no blanks so fired upriver into the Nile. To Rawlinson

the moan of the shell hurtling through the still air added a weird and unusual note to the ceremony, which marked it, in my mind, as being not an occasion for triumph but for solemn resolve . . . We had pledged ourselves to complete the work for which Gordon died thirteen years ago, and to free this land from brutality and tyranny.

The band of the 11th Sudanese then played Handel's march from *Scipio* ('Toll for the Brave') in memory of the Blacks and Egyptians who had died with Gordon and those massacred after the fall of the city. About a hundred survivors and locals had gathered at the far end of the lawn.

As the last shot was fired, the Anglican chaplain led the congregation in the Lord's Prayer, and the Presbyterian read the fifteenth Psalm: 'Lord, who shall dwell in thy tabernacle? Who shall rest upon thy holy hill? He that walketh uprightly, and worketh righteousness, and speaketh the truth in his heart . . .'

The pipes of the Camerons and the Seaforth Highlanders then played the Coronach lament, with a muffled roll of drums, at which the local survivors cried with a shrill lament of their own.

'Abide with Me', known to almost every Briton present and believed to be Gordon's favourite hymn, was played by the band of the 11th Sudanese, to Monk's famous tune 'Eventide', which they afterwards renamed 'Khartoum' and played wherever they performed, immediately before the National Anthem.

The emotion, for the British, was already almost unbearable. Then Father Brindle, with his floating white hair and white beard, the best-loved man in the army, stepped forward, put his helmet at his feet and read from a sheet of paper the benediction prayer he had specially written:

O Almighty God, by whose providence are all things which come into the lives of men, whether of suffering which Thou permittest, or of joy and gladness which Thou givest, look down, we beseech Thee, with eyes of pity and compassion on this land, so loved by that heroic soul, whose memory we honour before Thee this day. Give back to it days of peace — send it rulers animated by his spirit of justice and righteousness — strengthen them in the might of Thy power that they may labour in making perfect the work to which he devoted, and for which he gave, his life.

And grant to us, Thy servants, that we may copy his virtues of self-sacrifice and fortitude, so that when Thou callest we may each be able to answer, 'I have fought the good fight.'

A blessing which we humbly ask — in the name of the Father, the Son and the Holy Ghost. Amen.[5]

'By then there was not a dry eye', recorded Rawlinson in his diary. The Sirdar 'who is, as a rule, absolutely unmoved, had great round tears on his cheeks'. Men's shoulders were shaken by sobs, wrote Prince Frank of Teck to his sister Princess May (Queen Mary) that evening. 'One leant over Brindle and cried like a child — in fact it was terribly affecting.'[6]

Teck's detail may be doubted but Kitchener was too overcome to dismiss the parade. He signalled to Hunter.

Afterwards the senior officers shook the Sirdar's hand, silently, one by one according to rank, and then they wandered about the garden and Gordon seemed almost as if among them. Charles à Court came up to Kitchener to congratulate him.

He was very much changed; the sternness and the harshness had dropped from him for the moment, and he was as gentle as a woman. He spoke in affecting words of Gordon, and of the long years which had been spent in recovering the lost Sudan, and of all he owed to those who had assisted him. The lines of thought had gone out of his face. His manner had become easy and unconstrained. He was very happy.[7]

Then he summoned the war correspondents and unfolded his great vision for a Gordon Memorial College, to be built facing the Blue Nile a little upstream from the restored palace, to educate Sudanese tribesmen's sons, from the Muslim north and the animist (and later largely Christian) south, 'to give them the intellectual force to act as governors of their own destinies'. Gordon had done so much for poor boys in England and the Sudan that a college would be after his heart, a twin, as it were, to the Gordon Memorial School in England.

'Now, gentlemen', the Sirdar said after explaining his plan, 'you can help me. I require £65,000 to put this scheme through, and I believe that if you give me your help in your papers, I can get it at once from the British public.'

He looked around at each of them, 'with his usual half-commanding, half-whimsical smile', and rested his glance on little Frank Scudamore, his friend since Debbeh in 1884. Scudamore said: 'Why £65,000, sir? At this height of your success you can just as well ask a hundred thousand and put your scheme beyond risk of failure.'

'Well, Scudamore, if you think that is so, put forward an appeal for a hundred thousand, and God bless you if you get it.'[8] He would find that he needed even more for this, his own special cause.

Back in Omdurman the Sirdar said farewell to the British wounded as they left in barges towed by steamers for Abadan, where a hospital had been prepared. Then he wrote to Queen Victoria's Private Secretary. As the Royal Engineers had run out of telegraph wire (the Sirdar must have missed a detail) the message had to be carried by steamer downriver to be telegraphed from Nasri island and only reached Balmoral on the following evening, 5 September. The Sirdar's plain prose so excited the Queen that she described it in her journal as 'a most touching account, and most dramatic, of his entry into Khartoum and of a memorial service held to the memory of poor Gordon on the spot where he was killed! Surely he is avenged!'[9]

The Queen, who had already sent a telegram of congratulation which had been read to the troops,[10] wired at once to Lord Salisbury suggesting a peerage for Kitchener. 'I should much like to announce it to him myself if you propose it'[11] – an exceptional honour. Salisbury concurred warmly in a telegram the next morning. Victoria wired her announcement at once, in the first, not the usual third person, another exceptional honour.

And no answer came. Fifteen days later, still waiting, 'It is very annoying,'

she wrote, 'as the good effect of the early recognition of his services has thus been marred.'[12]

The telegraph wire had been broken in two or three places. By the time the wire reached Nasri island for onward transmission by steamer, the Sirdar had left in a hurry for the south.

18

THE DIPLOMAT OF FASHODA

KITCHENER HAD CARRIED sealed orders in Salisbury's own hand sewn into a jacket, to be opened after capturing Khartoum. He found that he was to head a flotilla south up the White Nile to find and warn off a French expedition under Commandant Marchand which had set out long ago from French West Africa to claim the Nile basin for France; but Salisbury wanted no corpses. And Hunter would ascend the Blue Nile to turn off any Abyssinian troops from Sudanese territory.

On the fifth day after the battle the Sirdar was still organizing the homeward dispatch of the British brigades when one of Gordon's old 'penny steamer' gunboats, captured by the Mahdists in 1885, the *Tewfikieh*, came in from the south, having hastily hoisted a white flag. Her captain reported that some hated 'Turks' had installed themselves at Fashoda, five hundred miles upriver. After 'a scrimmage' (the bullet holes were plainly visible) the dervishes had retired and dispatched the gunboat to the Khalifa for reinforcements to destroy the 'Turks'. Wingate and the Sirdar realized that these 'Turks' were Marchand and his French.

Having no information about the strength of the French force at Fashoda and not knowing whether the escaped Khalifa had gathered a new army, Kitchener formed a strong expedition of two Sudanese battalions of six hundred men each, a company of the Cameron Highlanders and an Egyptian mountain battery to be conveyed by three gunboats and two stern-wheelers towing barges. At 7.30 a.m. on Saturday 10 September, while Queen Victoria's telegram was still stuck in the desert, the flotilla steamed away from

Omdurman, the Sirdar sailing in the stern-wheeler *Dal* with Wingate, Jimmy Watson, Cecil, Freddy Roberts and Malcolm Peak, who commanded the guns.

The voyage was a discovery for all the British officers. First the White Nile at its broadest, almost like a lake, then narrowing as they pushed against a strong current and wind for four days, tying up at night while soldiers were sent ashore to cut wood for the boilers and endure mosquitoes, flies and bees. They saw hippos and crocodiles and herds of hartebeest. On the fifth day, as the scenery began to change, they met groups of naked Dinkas who warned them of a dervish fort a few miles south. They approached in battle order and quickly overcame a defensive zariba guarded by another of Gordon's old gun-boats, the *Saffiyeh*, which Beatty riddled with shells and set briefly on fire so that Kitchener teased him afterwards: 'You dam' sailors can never see anything afloat without wishing to destroy it!'[1]

The banks were now lined with forest. On 17 September the flotilla reached the large Shilluk village of Kaka. A Shilluk sergeant was sent ashore to invite the chief to come aboard to meet the Sirdar. The chief was in his national dress of nothing, clothes being considered a sign of slavery, so the sergeant handed him a towel for his middle. But on seeing the Sirdar the chief pulled it off and wound it around his head as a mark of respect. All the notables then came aboard. The Sirdar was puzzled that they were being presented in groups of seven, until told that there were only seven spare towels. He ordered that the rest should come as they were.[2]

That night, as Jimmy Watson recorded in his diary, 'large numbers of Shilluk warriors came down to us. Dances etc. Our bands played.'[3]

Fashoda lay fifty miles upriver. Kitchener had thought out very carefully how to ensure Marchand's removal without causing an incident that might even lead to war between Britain and France. Having lived in Brittany as a youth and served with the French Army, he knew the French mind. He sent off two Shilluk sergeants carrying a letter in elegant French addressed to the Commander of the European Expedition at Fashoda, to congratulate him on his magnificent feat of bringing his expedition so far across Africa. Kitchener announced the victory outside Omdurman and made plain that he was coming to re-establish the khedive's authority at Fashoda and everywhere else. He would arrive in two days.

The sergeants travelled Shilluk-style, but the French were astonished when two handsome Blacks in khaki drill and red tarboosh saluted smartly at the

gate of 'Fort St-Louis' and handed in the letter. Marchand was also relieved, because natives had warned him that a force of 1,500 hostile dervishes was approaching in a flotilla of gunboats.[4]

The Sirdar wished to give Marchand time to reflect on his impossible position, and approached Fashoda only on the morning of 19 September, having given Horace Smith-Dorrien, commanding the troops, alternative orders for hostilities or peace. He kept the Cameron Highlanders out of sight and put on Egyptian uniform. Fashoda came into view on a spit of land surrounded by marshes, once a district capital but abandoned by the Khalifa. Kitchener and Wingate, on the upper deck of the *Dal*, could see the French flag flying from the old government buildings. A small steel boat approached. An enormous French flag flew at her stern, and a crew of Senegalese in smart red jerseys plied rough wooden paddles. When the boat drew alongside, a Senegalese sergeant came on board with a letter from 'the High Commissioner' of the Bahr-el-Ghazal province, polite and congratulatory but uncompromising.

The flotilla steamed in line astern into the narrow channel and anchored with every gun trained on the French post and every deck lined with the Sirdar's Black soldiers fully armed. Marchand and another officer in spotless white uniforms came on board and were conducted to the Sirdar as he stood with his staff on the upper deck. Saluting and bowing and exchanging compliments, Kitchener and Marchand spread out a map and began a negotiation that could lead their countries to war or peace. Both men immediately took to each other, Kitchener admiring Marchand's achievement as explorer, Marchand appreciating Kitchener's fluency in French, though he groped for words now and again. Of all officers in the British Army, Herbert Kitchener was best shaped for this moment of fragile diplomacy between serving soldiers.

Kitchener said he was authorized to state that the French presence was a direct violation of the rights of Egypt and Britain and that he must protest in strongest terms. Marchand replied that he had carried out his orders and must await further orders from France. Kitchener asked if Marchand would resist the re-establishment of Egyptian authority and pointed out that the Anglo-Egyptian force was much more powerful than the French, at which Marchand gave a deep bow of his head. Kitchener said he was 'very averse' to hostilities and begged Marchand to consider his decision most carefully. He added that he would be pleased to put a gunboat at his disposal to take the gallant explorers and their escort to Egypt.

Marchand said he was ready to die at his post.

After further discussion Kitchener proposed a face-saving compromise: he would hoist the Egyptian flag but both flags would fly together and Marchand's party remain until he received instructions from his government to withdraw. Would Monsieur Marchand resist the hoisting of the Egyptian flag? 'M. Marchand hesitated and then said that he could not resist the Egyptian flag being hoisted. I replied that my instructions were to hoist the flag and that I intended to do so.' Marchand's hesitation was caused by a 'terrible desire' to refuse, and die for the glory of France, but then he dared not take the responsibility for peace or war by himself.

Kitchener had prepared for resistance but now arranged for them to carry out the ceremony together.

Smith-Dorrien, watching the proceedings by field glasses from another gunboat, had mistaken Gallic gestures for anger and was mightily relieved when he saw 'golden liquid' being brought up and toasts exchanged. Kitchener never knew what a sacrifice Marchand and his companion made for France by drinking lukewarm whisky and soda.

'During these somewhat delicate proceedings,' wrote Kitchener, 'nothing could have exceeded the politeness and courtesy of the French officers,'[5] nor indeed of Kitchener. Both sides could now fraternize. Marchand admitted that they had expected to be wiped out by the dervishes. Kitchener was too polite to express his amazement that the French government should have attempted a vast undertaking with such a tiny force: he found seven French and fewer than two hundred Senegalese troops. Marchand had expected to meet another party coming by Abyssinia.

The Egyptian flag was hoisted at a mutually chosen mudbank on the only road to the interior, with bands and gun salutes. Kitchener and his staff returned Marchand's visit amid much hospitality and good wine. They also left newspapers that revealed to the French the scandals rocking their army and country over the Dreyfus case. Kitchener remarked as he left that 'your government won't back you'. When the French read the newspapers they wept.

Kitchener sailed farther south to place a strategic but unsalubrious post at a river junction, welcomed as liberators from the Arabs, then took the remainder of his force back towards Khartoum, carefully avoiding another contact with Marchand, whom he left a virtual prisoner, with swamps on two sides, guarded by a Sudanese battalion and shadowed by a gunboat commanded by

young Walter Cowan, who went on to become an admiral and a baronet in the First World War and a commando in the Second, earning a bar to his 1898 DSO at the age of seventy-three.

Kitchener's 'chivalrous character and diplomatic gifts', as Lord Salisbury described them,[6] which would prove even more important in another sphere a few years later, had prevented the 'Fashoda Incident' becoming a *casus belli* in itself. Kitchener had no part in the high-level negotiations between Paris and London against a background of cross-Channel popular fury and news-paper warfare. By late October Marchand had become so upset by hearing nothing that he took a lift in one of the Sirdar's gunboats and arrived unexpectedly in Omdurman. Walter, in Herbert's absence, entertained him, expressing admiration and sympathy so that on leaving for Cairo 'Le Chef de la mission française en Afrique Centrale' wrote to say that he was 'très touché de votre opinion trop flatteuse sur la marche de la mission'.[7] `He sent his most profound respects to the Sirdar.

On 4 December Marchand arrived sadly back at Fashoda with the news that France had renounced all pretensions to the Nile Valley and that the expedition must withdraw, allowed to evacuate through Abyssinia as a sop to French pride. Marchand and one of his officers rose to be distinguished generals.

On leaving Fashoda on 20 September the Sirdar and his staff in the *Dal* sailed swiftly down the Nile, helped by a strong current. At the Shilluk village where they had watched the dancing they met Walter bringing up telegrams in the *Tewfikieh*, including Queen Victoria's dated 6 September:

It is with feelings of admiration and thankfulness that I announce to you my intention of conferring a Peerage on you as a mark of my deep sense of the services you have rendered under such most difficult trying circum-stances. VRI[8]

Kitchener had not expected a peerage.[9] Roberts had received only a baronetcy for Kandahar; his peerage came later. Wolseley had been made a peer for Tel-el-Kebir, but he was commanding a larger, wholly British army and serving directly under the Crown. When Kitchener's staff talked of a peerage his inclination was to refuse on ground of poverty. Peerages, always hereditary except for Law Lords, were sparingly given and a newly created

peer was expected to maintain appropriate style, yet Kitchener had little beyond his pay, although a Parliamentary grant was probable. The Queen's gracious words made refusal impossible. As Herbert read them Walter is supposed to have said, 'You had better take it as you'll never get another chance!' Herbert ordered champagne and they all drank 'success to "Khartoum of Aspall". I'm rather sorry he drops the Kitchener', Walter wrote to Carry, 'but as he says who knows where Lord Harris is Lord of . . .'[10] Harris's great-grandfather, conqueror of Tipu Sahib, had been gazetted as Baron Harris of Seringapatam and Mysore, but the family had long dropped the mouthful. Herbert also remarked in a letter which presumably he did not show Walter, that 'Kitchener is too horrible a name to put a Lord in front of'.[11]

'Lord Khartoum' had been the title they had all been using in confident expectation of the peerage, but in Britain Kitchener had become a household name, the focus of hero-worship and the pride of the empire: dropping it was impossible. He was created (1 November 1898) Baron Kitchener of Khartoum, of Aspall in the County of Suffolk, with remainder to the heirs male of his body.[12]

'K of K' was born.

Before leaving for Fashoda the Sirdar had given two orders: by the first, Walter Kitchener, using dervish prisoners and following a design already sketched by Herbert, began the new Khartoum, 'cutting roads through the mass of ruins and developing a real R.E. chess board pattern town. When roads are levelled and blocks marked out, the people now in Omdurman will be told to move over, and we shall have a flourishing town again', Walter told his brother Arthur.[13]

The second order caused a storm to blow around Herbert's head. The Mahdi's tomb had been damaged by gunfire, rather unnecessarily although a highly visible target. The structure was now dangerous. The Sirdar consulted Muslim officers from the Sudanese battalions. They regarded the Mahdi as a heretic and feared that his tomb might become a second Mecca, and advised that it be demolished. The tomb was the only large structure in Omdurman. If repaired, to continue dominating the skyline, the Mahdi would seem still to be dominant. Several influential citizens did not disagree, whether through fear or conviction.

The officers went further: they urged that the Mahdi's bones be thrown into

the Nile. The iron railing was removed and the tomb opened. By Muslim burial custom the body had not been embalmed or placed in a coffin and had long since decomposed. Some Sudanese soldiers present who believed that the Mahdi had been taken to heaven were astonished to find a skeleton and cried out, 'By God, this was not the Mahdi after all he told us'. The bones, except the skull, were placed in a weighted box and dumped (probably at night) in the Nile.[14]

Kitchener told the Queen: 'When I returned from Fashoda the Mahdi's skull in a box was brought to me and I did not know what to do with it.' Some insensitive wag suggested making it into an inkpot, and the rumour lingered for years: a charming playlet, wholly fictitious, shows Kitchener presenting it to an alarmed Queen.[15] He thought of sending it to the Royal College of Surgeons.

Meanwhile 'Monkey' Gordon, as the only man who knew how to lay a circle of guncotton, had blown up the tomb and reduced it to rubble.[16]

Radicals in England were outraged. Even Churchill, in his *River War* the next year, did not hesitate to declare that 'to destroy what was sacred and holy to them was a wicked act, of which the true Christian, no less than the philosopher, must express his abhorrence.'[17] Churchill's editor, Frank Rhodes, who was wounded at Omdurman, publicly differed in a footnote, holding that the Sirdar's action was politically necessary, if done the wrong way. The controversy rumbled for months. Queen Victoria, although accepting her beloved Sirdar's need to destroy the tomb, felt that as to 'the destruction of the poor body of a man who whether he was very bad and cruel, after all was a *man* of a certain importance – that it savours in the Queen's opinion too much of the Middle Ages not to allow his remains to be buried in private in some spot where it would not be considered as of any importance politically or an object of superstition. The graves of our people have been respected and those of our foes should, in her opinion, also be.'[18]

When the Sirdar sent the skull in its box to Egypt with his baggage, suggesting burial in a military cemetery, Cromer wired to the Foreign Office: 'This is very unfortunate. It will never do to have burial here.' He wanted it sent back to Omdurman 'as quickly as possible'.[19] In the end it was buried secretly at Wadi Halfa.

Kitchener would have been wiser to have buried the whole skeleton in a remote unmarked and undiscoverable grave, for the skull haunted his reputation far into the next century. Once the generations had passed away which

venerated him for the foundation of the fine government and peace, the Sudanese remembered Kitchener chiefly for the slaughter at Omdurman, the destruction of the tomb (since rebuilt) and the indignity done to the bones, whereas Gordon continued to be venerated as a saint.

19

THE MAGIC WAND

KITCHENER LANDED at Dover on 27 October. He was long overdue for leave and his eyes were giving trouble. Walter's wife Caroline (Carry) and their children still lived in Dover. When she had told Walter that she was much involved in plans for a civic reception, he was worried: 'You will all have been a bit disappointed at Dover I expect, as I am sure Herbert will just rush thro' – don't run away with the idea he's "têtetourner" (head turned, I can't spell it) if he is off hand, as he hates *tamashas* [shows] and behaves abominably, really thro' shyness' – and did not mind how much offence he gave.[1] But Herbert was at his most charming and gracious. When the ferry *Empress*, belching black smoke because of its speed, drew near the harbour, he was amazed to see every vantage point crammed by the largest crowd ever known there. At first they were silent, ignorantly expecting a magnificent uniform, not a tall gentleman in a 'grey tourist suit', standing with two others on the platform above the paddlewheel. But when the ferry docked and the dignitaries stepped forward and shook the Sirdar's hand, the crowd erupted in tremendous cheering.

At the civic luncheon the Sirdar praised his 'magnificent' troops, for if sparing with face-to-face thanks he was generous in dispatches, recommendations for honours, and in speeches. He spoke of his hopes for the Sudan, having suppressed his horror of functions for the sake of Gordon College:

... The vast country has been opened to the civilising influence of commercial enterprise. I sincerely hope by the means of education and good

government we shall be able to raise the standard of life of the inhabitants of that country, and that in the place of persecution, tyranny, and fanaticism, we may establish the reign of prosperity and peace.[2]

He and Jimmy Watson then went by a special train of the London, Chatham and Dover Railway to its terminus at Victoria, where the scenes were extraordinary. The railway company had not expected such crowds of all classes who came to welcome the hero of Khartoum, the avenger of Gordon, the skilled diplomat of Fashoda (the crisis between France and Britain was at its height). Moreover, George Steevens's book, *With Kitchener to Khartoum*, had been rushed into print to be a runaway best seller, although annoying Queen Victoria for its rather inhuman portrait of the Sirdar as 'the Sudan machine'.[3] All London wanted to see him and engulfed the official party, which included Roberts, Wolseley and Evelyn Wood, and the two princes who had served with him in the Sudan. *The Times* commented: 'No incident of recent times, not even the arrival of Lord Beaconsfield and Lord Salisbury after the Berlin Conference, has elicited such a remarkable demonstration of popular feeling.'[4] Passengers in trains standing at other platforms even climbed to the roofs of carriages, while outside the station the crowd went wild when a hansom cab emerged and they had nearly unhitched the horse in order to drag the cab in triumph before realizing that the man inside was not the Sirdar.

Extracted with difficulty from the overexcited crowd, the Sirdar stayed one night at Pandeli Ralli's house in Belgrave Square and on the Friday evening went down to Hatfield with the Prime Minister and his nephew, A. J. Balfour, First Lord of the Treasury and Leader of the House of Commons. The Cranbornes, Lord Edward, who had carried home the Fashoda dispatch, and other Cecils made him feel at home, and Salisbury outlined his plans for the Sudan, with Kitchener at its head. On Sunday they all attended the parish church, where 'Fish' (Lord William) was rector and Kitchener could notice the old marquess dozing quietly through his son's sermon.

The night express to Scotland stopped at Hatfield to pick up the private saloon and sleeper which had been taken for Kitchener and Balfour. A royal carriage met them at Ballater for the drive to Balmoral Castle, where, directly after luncheon on Monday 31 October, the Queen, as she recorded in her journal, 'saw the Sirdar, Lord Kitchener, who only arrived in London a few days ago. he looked very well and bronzed, but had caught a bad cold.'[5]

The audience took place 'in a sort of bower of palm branches', as Herbert

described it to Walter. Victoria was most gracious, even giving him the honour, allowed to Beaconsfield but never to Gladstone, of inviting him to sit down.

Herbert was amused to see tables littered with soda-water bottles and blotting paper, for in Khartoum they had picked roses from Gordon's garden. Walter had placed six roses in soda-water bottles filled with spirits, so that they should arrive fresh, expecting the Royal Household to break the bottles and make up the roses nicely with maidenhair fern before presenting them to the Queen. He had pressed others into blotting paper. The roses had been carried to Balmoral by Lieutenant-Colonel C. G. C. Money of the Cameron Highlanders with the Sirdar's Omdurman (Battle of Khartoum) dispatch. The Household, however, had left the roses in the bottles and blotting paper, but the Queen was 'very pleased' with them. She talked of all that had passed 'and how well everything had gone off'. At dinner 'Lord Kitchener sat next to me, and was very agreeable, full of information, and Mr Balfour also made himself very pleasant'.[6]

Marie Mallet was again in waiting. She wrote to her husband:

Kitchener has conquered us almost as effectually as the Sudan. We were more or less prejudiced against him, but he is certainly a gentleman and can talk most intelligently on all subjects, he also has a sense of humour although of rather a grim order and there is no doubt he is a marvellous soldier; what he lacks is the softness so many strong men have hidden away under the roughest exterior, and there is that in his eye which makes me truly thankful I am neither his wife nor his A.D.C.[7]

She was not allowed to penetrate to the softness, kept rigorously in check; nor did she know how the the wound and his bad sight gave him the eye of a basilisk.

Next day he walked in the grounds with a courtier and laboured at the speech he must make at the City of London's banquet in his honour. Balfour tried to help, but their styles were different and Balfour's 'far too mild and aesthetic'. Ponsonby, the Queen's Private Secretary, found Balfour lying in an armchair dictating a speech 'but whenever he said anything Kitchener contradicted him' and later rewrote Balfour's speech in his own style. Balfour, knowing the plan for the new Sudan, observed him closely, recognizing his boundless courage and resolution but wondering if he could adapt himself to

different and larger problems. And 'He seems to have a profound contempt for every soldier except himself, which, though not an amiable trait, does not make me think less of his brains'.[8]

Kitchener bemoaned to Mrs Mallet that he would sooner fight a dozen battles than make a single speech. He went back to London and that night received a standing ovation as he entered his host's box at the Gaiety Theatre. Next morning at a splendid ceremony he received the Freedom of the City of London with a rather tasteless sword of honour, its hilt encrusted with dia-monds and figures of Justice, Britannia and the British Lion. In the evening the Lord Mayor gave a great banquet in his honour at the Mansion House which Sir George Arthur, present as a liveryman, voted 'a roaring success', writing to a friend three days later:

The Sirdar paid a fine – and evidently heartfelt – tribute to the Agent-General [Cromer] and fine, and equally genuine, tributes were paid by all the speakers to him: – to his diplomacy and economy no less than to his mil-itary organization and strategy. The Prime Minister must have been supremely happy on this occasion. Not only was he the chief witness to the great ovation given to the man whom he had backed in every way and whose career he was one of the first to foresee, but he could seize the occa-sion to announce the prospective French retirement from the Nile, and to associate that prudent and amiable step with Kitchener's tact and concilia-tory methods.[9]

The French ambassador had informed Salisbury that very afternoon that Marchand had been ordered to retire. The crisis was over. Salisbury's announcement brought prolonged cheering and clapping.

The Queen wired Kitchener her approval of his speech and hoped his cold was better. He wired back that he was greatly honoured by her approval. His cold was better, and he was 'much gratified at the splendid reception given him in the City'.[10] George Arthur, however, commented that 'K. has probably suffered more from the hero-worship he has had to put up with these last days than from the heat and dust, toil and trouble, which have been his lot during these past years'.[11] Arthur was right; Kitchener was tempted to bolt back to the Sudan after one week[12] but stood the hero-worship for the sake of his dream for the Sudan.

At Cambridge he received an honorary degree, staying at Christ's College

lodge with the Master, his Kitchener cousin Thomas Day, to whom he had given his stamp collection many years ago.[13] Here and at Edinburgh and at numerous functions in London his theme was that 'those who have conquered are called upon to civilize. The work interrupted since the death of Gordon must be resumed.' They must establish a good administration, give justice, organize a police force, but government could not afford to provide education: this must be given by the people of Britain. In a letter to *The Times* he appealed for the very considerable sum (for 1898) of £100,000: £10,000 to set up a Gordon Memorial College and £90,000 as endowment.[14] His vision was for a college of higher education eventually, despite critics who asserted that primary schooling to provide clerks and minor officials was enough; but Sudanese boys must first be taught to read and write. 'How Gordon would have rejoiced', the Sirdar told his Edinburgh audience, 'had he known that by his death the blessing of education would be given to the people that he loved and among whom he died'.[15]

The war correspondents back from the Sudan, who had been the first to hear of the scheme, encouraged their papers to publicize it, and the Sirdar used his skills of persuasion. The Rothschilds gave a luncheon for him; he first secured a promise from Sir Ernest Cassell and another banker to match the sum given by his host; when Lord Kitchener arrived at the luncheon he announced playfully that he would not stay unless Rothschild promised a really handsome cheque, which he was thus able to treble.

Lord Edward Cecil, still his ADC before leaving for South Africa, worked with him at the Ralli house in Belgrave Square and recalled later that Kitchener was

a dangerous man to go and see in London, as, quite regardless of the fact that you had other things to do, he seized you and set you to work on whatever he thought you could do efficiently. Few – I was going to say no one, and I am not sure it is not nearer the truth – dared refuse: and the result was that the house was always full of the most heterogenerous elements, grumbling over their servitude, but often, if they had any sense of humour, amused at the situation. A very proper friend of mine spent his time in burning, after seeing there was nothing important in them, the mass of love-letters which descended on Kitchener, and which would have offended him. He placed women on a far higher level than is usual in these days, and it really hurt him to hear or see anything which touched this ideal. Another

very sensitive man of great natural politeness [probably George Arthur] spent his time in interviewing the most intimidating people, such as multi-millionaires, corporations, big banks, and firms, to obtain from them contributions to the Gordon College. He used to come back in the evening, looking as if he had been at a disturbed mass meeting, and gloomily wonder what Kitchener would say to the result.[16]

But the richest nation on earth responded. Kitchener caught the mood of the hour, the glow still lingering from Queen Victoria's Diamond Jubilee, of pride that Britain was called to lead and civilize. The Christian conscience of the nation was it its strongest after two generations when the Christian ethic had become predominant in Britain, whatever a man's or woman's personal faith or lack of it. And even those whose conscience had disapproved of the slaughter could share 'the white man's burden'.

The money came. A hundred thousand pounds was subscribed, including £40,000 from the nation by a cheque signed with a flourish by Victoria R.I and two of her Lords of the Treasury.

20

REBUILDING A NATION

KITCHENER ARRIVED BACK at Khartoum on 28 December 1898, a week before he was due, to find that the troops had suffered severely from malaria and the exertions of campaigning against the Khalifa's remaining forces up the Blue Nile, on the Abyssinian border and far away up the White Nile. The Khalifa himself had reappeared about 150 miles south of Khartoum. Intelligence suggested that he had been badly received and was robbing and looting.[1]

Most of the Sirdar's senior officers were now acting as governors of his vast new domain. He therefore summoned Walter, whose deafness and lack of Arabic made him unsuitable as a provincial governor. Walter had been downriver and disembarked at Khartoum just in time to receive the message. He crossed to Omdurman. 'Herbert had crowds of work [*sic*] and natives on hand, but about 12 he came out of his office tent and said "Well I'm glad you turned up, you nearly lost your chance as after 12 o'clock I was going to appoint someone else. You are to go and catch the Khalifa,"' taking a compact force of an Egyptian and a Sudanese battalion, 100 of the Camel Corps and some 400 'Friendlies' a total of about 1,100, with 4 guns. 'I was never so astonished in my life', wrote the delighted Walter to his wife, asking for her prayers and telling her not to worry. 'I've had as good a training under Herbert as any man ever had, and I know he trusts me to bring all through satisfactorily. He doesn't make mistakes often. He has given me some real good hints' (on how Walter's Kordofan Field Force could defeat and capture the Khalifa).[2] But, the Sirdar told the Queen, 'owing to the difficulty of the country I am not very confident in their being able to do so'.[3]

The new Khartoum had already begun under the direction of Walter as city governor, with George Gorringe and his sapper officers. Two thousand dervish prisoners were clearing the rubble of the old city and laying out Kitchener's own town plan of a rectangular grid of avenues crossed by streets, as in ancient Alexandria and much like many American cities, although he had never seen one. Kitchener also planned diagonal streets, to ensure the swift suppression of riot. The result suggested a city designed like the Union Jack but this was unintentional.[4] Kitchener insisted that the palace should be rebuilt swiftly as a sign that the British had come to stay. Since Gordon's palace had been thoroughly looted, Kitchener ordered Wingate to 'loot like blazes' to recover its old glories.

Cromer arrived to lay the foundation stone of Gordon Memorial College on 4 January 1899 on behalf of Queen Victoria. A fortnight later the Convention was signed which created, by right of conquest, the Anglo-Egyptian Sudan, a condominium that was neither British nor Egyptian but in effect a trusteeship, new to international law. By creating a new state, Salisbury and Cromer prevented interference by the Commissioners of the Egyptian Debt, or by the legal privileges of foreign nationals.[5]

Kitchener was appointed first governor-general, remaining Sirdar of the Egyptian Army.

Cromer told the Sudanese notables to look neither to the khedive nor to himself but to Kitchener alone. Cromer, however, had intended Kitchener to be his henchman, not to spend more than £100 without his authority. Kitchener refused and Salisbury supported him, but by the terms of the Convention his position was subordinate to the Agent-General in Cairo, even as the Viceroy of India, for all his grandeur, was subordinate to the Secretary of State for India in London.

Cromer did not understand Kitchener any more than he had understood Gordon. He gave the Sirdar all credits for the reconquest, was deeply touched by his sensitive visit of condolence on the death of Lady Cromer and assured him: 'You will always find in me a true friend.'[6] But with his formal instruc-tions he wrote privately: 'Pray encourage your subordinates to speak up and to tell you when they do not agree with you. They are all far too much inclined to be frightened of you.'[7] Cromer evidently had never heard that during the campaign the Sirdar had lived with his staff rather than apart with his ADCs and had encouraged discussion when in the mood. Girouard's cheek, Watson's stories and laughter, Rawlinson's frankness were beyond Cromer's

comprehension. Possibly he had listened to disgruntled or rejected officers from the fringe.

He thought 'My Sirdar terribly bureaucratic' when in fact Kitchener still considered regulations to be for the guidance of fools. Cromer decided that the Sirdar could not see the difference between governing a country and commanding a regiment, whereas the War Office would have nervously removed any colonel who gave such free scope to his officers. Scattered across the vast country, they were already doing their unfettered best to bring peace and prosperity, settle land claims, reopen caravan and river routes and restore the rule of law. As Kitchener told the Queen on 21 January: 'The administration of the country is gradually being formed and I hope before long we may get affairs into some order.'[8]

All was still 'hand to mouth', as one of his officers put it, 'and every paper that is not absolutely urgent gets chucked aside to be dealt with later. There are only two typewriting machines with the whole force here . . . The office accommodation is inferior in every way . . . One is besieged by petitioners at every turn.'[9] When the Sirdar was absent from Omdurman, 'all is in chaos', wrote the officer he left in charge at Omdurman. 'He bottles up all reports etc. I am acting for him here but know nothing of the irons he had in the fire.'[10] Kitchener, however, rejected Cromer's charge of secretiveness, telling Wingate in Cairo that everything of consequence was telegraphed down: Cromer must be imagining things that had not occurred.[11]

The Sirdar and Jimmy Watson had left Omdurman in the gunboat *Dal* with a small escort to sail up the Blue Nile to inspect garrisons. They took a medical officer, J. W. Jennings, DSO, to advise on the health of the troops and their newly built barracks. They watched crocodiles and hippos, were grounded on a sandbank for nearly an hour and found the inhabitants everywhere 'well disposed and very glad to see us'.[12]

During this voyage Kitchener completed a memorandum or directive to governors of the provinces and their district inspectors all of whom were British officers of the Egyptian Army, with Egyptian and some Sudanese officers under them. He issued it on his return to Omdurman. He thus stamped his ideals and personality on the new nation. Long after he had left, and indeed for all the fifty-five years of the Anglo-Egyptian Sudan until independence, this directive was the inspiration of those who governed. It also throws light on his own character.

Pointing out that the uprooting by the dervishes of the old system of govern-

ment had given an opportunity for a new administration 'more in harmony with the requirements of the Sudan', he emphasized that it was not mainly to the laws and regulations which would be framed and published that 'we must look for the improvement and the good government of the country. The task before us all, and especially the Mudirs and Inspectors is to acquire the confidence of the people, to develop their resources, and to raise them to a higher level.'

The officers could do this only by being thoroughly in touch and knowing personally the principal men of their districts, showing them by friendly dealings and interest in their individual concerns 'that our object is to increase their prosperity'. Through them they would influence the whole population. He went on: 'Once it is thoroughly realised that our officers have at heart, not only the progress of the country generally, but also the prosperity of each individual with whom they come into contact, their exhortations to industry and improvement will gain redoubled force.' Proclamations and circulars would have little effect. 'It is to the individual action of British officers, working independently but with a common purpose, on the individual natives whose confidence they have gained that we must look for the moral and industrial regeneration of the Sudan.'

His next point emphasized that 'truth is always expected' and must be well received whether pleasant or not. Behind his words lay the memory of working alone among the Arabs when Gordon was cut off in Khartoum, and the difficulty of learning the truth: 'By listening to outspoken opinions, when respectfully expressed, and checking liars and flatterers, we may hope in time to effect some improvement in this respect in the country.'

He next directed that the courts of law should inspire the people 'with absolute confidence that real justice is being meted out to them'. The administration should be strong, with no signs of weakness, and 'insubordination' promptly and severely repressed; but 'a paternal spirit of correction for offences should be your aim', with clemency.

Kitchener's later points directed that religious feelings were not in any way to be interfered with and the Muhammadan religion respected. Town mosques would be rebuilt, but private mosques, shrines or other possible centres of fanaticism were not to be allowed. He said nothing about the pagan south where the animist tribes welcomed him as a liberator from Muslim tyranny and slavetrading, but he affirmed that 'Slavery is not recognized in the Sudan'. Willing service would not be investigated, but cruelty, or interference with liberty, would be sentenced severely.

[161]

The memorandum continued for several more pages of detailed instructions to mudirs (governors), inspectors (district officers) and mamurs (their subordinates). Kitchener, from the recesses of his own deepest beliefs and experiences, set forth the Victorian imperial tradition at its highest: a firm paternal hand for the benefit of the ruled, not the rulers. All Sudanese would 'feel that an era of justice and kindly treatment has begun', in contrast to the dervish rule that 'plundered and enslaved'.[13]

The country could not be fully pacified, nor hope to be prosperous, until the Khalifa was captured or killed. Walter returned in February empty-handed. His letter reporting failure had crossed one from Herbert ordering him to abandon the chase and bring back his Kordofan Field Force. To his intense humiliation, Walter had found the Khalifa reinforced and about to surround him in a waterless desert. A battle would end in disaster: 'I don't believe that one of us would have got away if I had stayed another hour where I was.'[14] Had Walter been wiped out, Herbert would need to suppress a rising in Kordofan. Herbert and Cromer both assured Walter that they approved of his retreat.

In mid-February the Khalifa was reported to be advancing on Khartoum just when the Duke of Connaught, Kitchener's Woolwich contemporary, Prince Arthur, now a distinguished general, was making a holiday visit with his duchess, the only visitors whom the Sirdar allowed up. They rode around the Omdurman battlefield, still offensive to sight and smell, saw the staircase where Gordon had fallen, took tea in Gordon's garden and the duke inspected a parade of nine thousand Egyptian and Sudanese troops, many of whom were recruits filling the vacancies caused by disease. They were scarcely ready to fight. The apparent (but false) danger from the Khalifa made an excuse to bundle the Connaughts downriver after twenty-four hours.[15]

During these early months the problems fell one after another, and though outwardly impassive, as always, Kitchener could be depressed. After another nagging letter from Cromer he wrote to Wingate, who was stationed in Cairo, to send up supplies and manpower:

> I am rather sick and low so I will not bother you. I can quite see there is no confidence in my work.
>
> I have been bothered out of my life about this refugee question, everyone

asking what they are to do with these destitute individuals. They have nothing here to live on except charity, and grain is very dear and scarce.[16]

He wired to Cromer that he had 20,000 jabbering women and no use for them.

Another bother arose from religion. The Austrian Roman Catholic fathers had returned from Egypt to restart their school. The surviving Copts and Greeks had their clergy, but the Anglican bishop in Jerusalem, Blyth, was already pressing for a suffragan bishopric in Khartoum, although, as Cromer remarked, providing means for the confirmation of naked Shilluk savages from the south 'seems to me a little premature'.[17]

Then the military railway at last reached 'Khartoum North', its intended terminus on the opposite bank of the Nile, and out stepped a Nottinghamshire vicar who had been selected by the Church Missionary Society as their first representative in the new Sudan, Llewellyn Gwynne. Although he never knew it he was a distant cousin of General Gordon. In his thirties, he had somehow slipped through the Sirdar's restriction on visitors and Bishop Blyth's dislike of the CMS.

He was soon summoned by the Sirdar, now using an office on the ground floor of the rebuilding palace, approached across planks and debris. Gwynne asked when he could start his missionary work. Lord Kitchener replied that no such work might start: the Egyptians had spread a rumour that the British had reconquered the Sudan in order to convert Muhammadans to Christianity. The rumour had 'greatly disturbed the people and the new government must do all in its power to reassure them'. Gwynne explained that he wanted to work only among the pagan or animist tribes in the south. Kitchener said he was inclined to approve, once the south had been fully brought under administrative control. Even then, Lord Cromer wanted to discourage proselytizing which might offend Muhammadans: the Indian Mutiny had been sparked by similar false rumours.

'What harm can I do?' asked Gwynne. 'I can't stir up any trouble among the natives as I don't know any Arabic.'

'I know your sort,' replied Kitchener. 'You'll soon pick up enough Arabic to make yourself understood. What you can do, is to look after the spiritual needs of the British officers and non-commissioned officers attached to the Egyptian Army in various parts of the Sudan; there are plenty of heathen among them!'[18] Kitchener knew them well and if a sergeant or corporal were

leaving the Sudan in broken health he might well be summoned by the Sirdar and depart with a fistful of Egyptian pound coins or English sovereigns, given with muttered remarks as if the Sirdar's left hand must not know what his right hand had done.[19]

Gwynne left the palace to begin a notable chaplaincy, continued alongside an even more notable missionary and episcopal ministry. Kitchener's appreciation led him, sixteen years later, to put Bishop Gwynne in command of all the British chaplains on the Western Front.

A missionary could be disposed of quickly. Far more worrying was the Sudan's financial dependence on Cairo until the country's revenue and production should flow strongly. The new financial adviser to the khedive and holder of the purse strings of Egypt was the thirty-eight-year-old Eldon Gorst who had been his predecessor's deputy, much trusted by Cromer but soon loathed by Kitchener. 'Gorst', exclaimed Kitchener to Wingate, 'is the meanest little brute I ever met, professes all sorts of help and then leaves you in the lurch. We will have as little as we can to do with him. Am very sorry Cromer backs him up as he is not and never has been straight.' Kitchener claimed that Gorst 'bagged' revenues from Dongola and the railways and the posts but never gave anything back. He tinkered with Egyptian army allowances, which did great harm, yet accused the Sirdar of diverting some of the army's pay to other purposes. Kitchener became exasperated with 'that little creature Gorst', as he called him in one furious letter to Wingate. Gorst and his people were leaving officers and men homeless and suffering while taking Sudanese money 'in their comfortable offices in Cairo. To my mind it is quite a scandal' which needed a question in the House of Commons. 'The troops did good service and this is all the consideration we get – just what one would expect from Damned mean civilians. *Yours disgustedly, K of K.*'[20]

Kitchener was working fourteen hours a day, wrestling not least with the famine conditions that were blighting the Omdurman region and up both the Blue and the White Nile. The root cause lay in the later Mahdist years, when many grain-growing areas reverted to scrub, but failure to finish off the Khalifa made shortages worse. Kitchener called a meeting of the leading merchants. When he stood up to speak, 'he pronounced Arabic as we pronounce it and understood it as we understand it'. He allowed a sharp discussion. Merchants complained that camels and boats which had brought grain had been requisitioned to bring building materials. When the youngest merchant asserted that

the government had cornered the market, His Excellency 'thrust his hands behind his back and came quickly towards me until he stood in front of me and bent his head down a little to bring him face to face with me (for he was tall and I was short) and he said, "Is it the Government that is cornering the grain?"

'"Yes," I replied.

'"How so?" he asked.'

Babikr Bedi gave his reasons. The Sirdar shot back a question, then he announced that from that day the government would buy corn only from contractors appointed by the merchants. He also put a proposition that big foreign merchants should not be allowed to live in the Sudan: they could invest money and send goods, and the Sudanese would act as their agents, thus pursuing Kitchener's unfashionable aim that the country should be for its inhabitants, not for foreign exploiters. But the merchants disagreed. 'Uncle' Ibrahim Bey Kalil, in whose garden Gordon used to relax, who had survived the loss of all his property under the Khalifa, cried out, 'No, no, your Lordship! Better that the great mercantile houses come to us with their owners to work alongside us and we shall benefit from them.' After discussion Lord Kitchener said: 'As you will.'[21]

Kitchener would not allow private traders to travel to the south while it was still a region of military operations, yet no further expedition could be made against the Khalifa during the summer heat. Cromer thought this policy wrong, and a cause of the famine. When Kitchener came to see him in Cairo in late May, Cromer begged him to remember that he was a Christian ruler dealing with human beings, not blocks of wood. Kitchener resented the implication. Trade in the south would fall into the Khalifa's hands without ending the famine, which at least deprived him of local support. It also provided the government with cheap labour for all needs at Khartoum and Omdurman. Once again Cromer could not comprehend that Kitchener refused to allow sentiment to impede the Sudan's future. Cromer even told Salisbury (without explaining the context) that Kitchener had become 'especially bored with his own creation – the Gordon College – at which I am not at all surprised'.[22] College affairs were in limbo until the building was up, the staff formed and the first boy selected: towns such as Berber wanted to enrol far more than could be taken. Whatever had prompted Cromer's curious conclusion, it did an injustice to Kitchener, for whom the college was an intense and abiding interest to the end.

Kitchener left Cromer and Cairo for his summer's leave in England, saying he needed rest and 'had had about enough of the Sudan';[23] he even talked of service in India. Yet his mind was full of ideas for the Sudan; part of his purpose in going home was to select men who would meet his ideal.

He left a Sudan which was much like Khartoum itself at that moment: an excellent plan, much rubble, but some fine structures emerging.

PART THREE

Fighting for Peace

1900–1902

21

BOBS AND K

On a summer morning of 1899 at Taplow Court on the Thames, the eleven-year-old Julian Grenfell, home for the holidays from Summerfields Preparatory School, had got up long before breakfast

and on going downstairs found a gentleman whom I did not know at all. He asked me to come for a walk, and we went for over an hour. He found out that I was to be a soldier, and asked me what regiment I was going in for, and how I was getting on at school, and a great many other questions; he told me a great many things about the army, and yet he never mentioned himself at all, and I had not the least idea who he was. I enjoyed the walk very much indeed, and when afterwards I was told who he was I was not at all surprised.

Lord Kitchener had arrived late the evening before to stay with his friends, Willie and Etty Grenfell (later Lord and Lady Desborough). 'When I come here I feel like coming home. I have no home.'

Julian, who grew up to be a supreme athlete like his father and to be killed in action, with posthumous fame for his poem 'Into Battle', was writing down his memory three years later when at Eton. He continued about his new friend:

It was easy to see that he was no civilian; he looked a soldier from head to foot, and there was something about his manner that showed that he was no ordinary man, and yet he said nothing about himself or his own doings.

He spoke in a way that showed he meant what he said, and it was easy to see that he was used to being obeyed. I think that on seeing him for the first time one would feel an impulse to say 'That is a man who would never leave what he had once resolved upon till he finished it to his satisfaction.' I should think it would be impossible to find features on which self-restraint and tremendous will are more clearly marked.[1]

Kitchener was on a round of country-house visits, having gone first to Hatfield as usual. He specially enjoyed Welbeck, home of the Duke and Duchess of Portland, 'quite a wonderful place and everything so perfectly arranged'. He also crossed over to Ireland. While in Ulster he stayed at Mount Stewart with the Marquess of Londonderry, immensely rich from landown-ership and from Durham coal royalties, a former viceroy of Ireland and soon to join Salisbury's Cabinet.

This visit produces a mystery. The Londonderrys' elder son was away serving with the Household Cavalry but their younger son, nineteen-year-old Lord Charles, lay seriously ill. Kitchener's kindness to the boy and sympathy with his only sister, Lady Helen Vane-Tempest-Stewart, then aged twenty-three, led to a friendship. After he had left Mount Stewart she wrote to say that Charles was better. Kitchener in his reply from the Curragh Camp near Dublin wrote: 'I know how anxious you are about him.'[2] Charles died that October after Kitchener had returned to the Sudan. The correspondence con-tinued. He destroyed her letters with the rest of his private correspondence, but she kept his. They read like the letters of a kindly uncle (he was more than twice her age), not of a lover, but two years later, in September 1901, the future Queen Mary's aunt, Augusta, a Grand Duchess in Germany, remarked in the course of their regular correspondence: 'There is a story that Lord Kitchener, wanting to become fashionable, proposed to Lady H. St. Vane (sic) and was refused. I can't believe it . . .'[3]

One month after the Grand Duchess wrote, Lady Helen became engaged to young Lord Stavordale, future Earl of Ilchester and a noted historian, land-owner and patron of the arts. Kitchener in South Africa wished her 'every joy and though rather filled with envy of the lucky one I hope when I get home I may have the pleasure of seeing you again'.[4] The correspondence stopped.

If Kitchener had vague thoughts of founding a dynasty, the only daughter of a rich Tory nobleman would have been a suitable match. But the previous year one of his staff officers in South Africa, William Birdwood, had written

to his wife: 'I don't think he will ever marry. I spoke to him about it one day and asked him when he was going to think of it! "Marry," he said, "Why I have never had time to think of it. I've always been too busy in Egypt and at work generally." I think', commented Birdwood, 'he would look on it as a sort of campaign which he regularly had to undertake and would require so many months set aside for hard work to get through it successfully!'[5]

Long after Kitchener's death the myth arose that he was homosexual. A new generation found it hard to believe that any male could be fulfilled unless sexually active. Because Kitchener never married and was affectionate towards his young personal staff officers (who all except one married later), he was retrospectively labelled homosexual regardless of evidence to the contrary, including the absence of any substantive rumours in his lifetime, although in the Sudan 'everything is known',[6] as Kitchener himself remarked.*

Any thoughts of matrimony would have faded because war clouds were gathering in South Africa. Apart from possible comments at Hatfield, Kitchener knew no more about the causes than any newspaper reader, but by that summer of 1899 two masterful men were on a collision course: Paul Kruger, President of the South African Republic (the Transvaal) and Sir Alfred Milner, the new High Commissioner for British South Africa and Governor of Cape Colony. When the Boer (Afrikaner) republics of the Transvaal and the Orange Free State had repudiated annexation and defeated a British force at Majuba in 1881, a convention was signed which left vague the question of suzerainty. The discovery of gold in the Transvaal in 1884, and the earlier discovery of diamonds in the Orange Free State, had transformed their economies and had brought in many Britons and Continentals, whom the Boers termed Uitlanders, and large numbers of Africans to work the mines. The mining companies and the Uitlanders were taxed but allowed no representation in the Volksraads, a grievance which had led to the disastrous Jameson Raid in 1896 when, backed by Cecil Rhodes and secretly by Joseph Chamberlain, the British Colonial Secretary, a scratch force of British and foreign volunteers led by Leander Starr Jameson attempted to invade the Transvaal and raise rebellion.

The Kaiser's telegram of congratulation to Kruger on their capture, and the increasing wealth from the mining taxes strengthened Kruger's vision of a

* Kitchener's sexual orientation is discussed at more length in Appendix 1.

South Africa entirely under Boer control. He imported arms. Milner's vision was for a South Africa wholly under the British flag.

Public opinion in Britain supported Milner and particularly deplored the harshness of Boer treatment of native Africans and the injustice inflicted on the heavily taxed Uitlanders. But a small and vocal group in Britain, the 'pro-Boers', saw Kruger and his burghers as brave rural farmers bullied by the British Empire.

Milner and Kruger conferred at Bloemfontein in June 1899 but found no compromise. Every sign pointed to war – a white man's war. Until its last months the dispossessed natives would be only the helots of the warriors. Boer and Briton alike would have been astounded that less than a century later the African majority would rule South Africa.[7]

As war looked more likely, Kitchener wanted to run it; indeed, when the editor of the Liberal *Westminster Gazette*, J. A. Spender, met him on the lawn at Lord Rosebery's house near Epsom that June, and Kitchener expounded his plan of campaign, 'It was perfectly clear that he both hoped and expected to have the conduct of the coming war. I remember being struck by the extreme frankness of this talk in the presence of a chance comer whom he was seeing for the first time.'[8]

Unknown to Kitchener, Queen Victoria pressed Lord Salisbury to name him 'to command the whole expedition', as she reminded the Prime Minister when disasters struck, 'but she was not listened to'. (Lord Salisbury tactfully replied that he had no recollection of being told of her recommendation.)[9] Sir Redvers Buller, much the senior, with considerable South African experience but defects of character which Kitchener had experienced in the Gordon Relief Expedition, was selected to lead the strong force to be sent should war look inevitable. Many, including Kitchener's former staff officer Rawlinson, believed that Buller would fail to win the swift victory expected by the public and that Lord Roberts, the greatest soldier of the day, would be sent for. Kitchener, eleven years younger, and Roberts had served in different continents and did not know each other, for Roberts was commanding in Ireland when the Sirdar had returned briefly after Omdurman. Rawlinson, who had worked closely with both, brought them together in Dublin, where they reached an informal understanding that if Roberts were sent out to South Africa he would ask for Kitchener as second-in-command and chief staff officer.

Before he returned to the Sudan, the Sirdar received a charming commis-

sion from the Queen. He had already sat for von Angeli for the portrait she wanted, and now she asked whether, on his return to Egypt, 'he would be so kind as to procure a white female donkey for her'. Wolseley had sent a big and handsome male in 1882, named rather naughtily Tewfik after the khedive, which had sired several fine white donkeys, and now she would like an Egyptian female. The Sirdar obliged, and the Queen duly wrote that 'the donkey is in perfect health, having borne the long sea voyage very well. She is a remarkably big one and very handsome', and soon was gently pulling the Queen in her garden chair along the paths of Osborne.[10]

While the donkey was at sea the Sirdar resumed the government of the Sudan. Many of his River War officers had now left the Egyptian Army – for South Africa or India, including Hunter, MacDonald, Smith-Dorrien and Walter. Jimmy Watson, for his career's sake, had regretfully left Kitchener's side to be military secretary in Cairo.

The new state showed progress. In Khartoum Gordon College was going up, streets had been laid out, a hotel and two banks had opened, but the palace was still unfinished. At the Atbara the permanent bridge had been built in nine months. The Sirdar drove the last rivet, then steamed across the bridge in one of their biggest engines, breaking a silk rope while the troops fired a *feu de joie* and bands played. His Excellency had to make a speech.[11]

These last months in the Sudan were dominated by the need to hunt down the Khalifa. His followers were deserting, but he would not surrender. Kitchener led a hunt in Kordofan across open country where deer, giraffe and ostriches seemed tame, then into forest, where Khalifa eluded Sirdar. Late in October the Sirdar left the hunt to settle financial questions in Cairo. The discussions went very smoothly, Kitchener told Lady Cranborne in one of his regular letters for the Hatfield circle. Lord Cromer was very nice and happy 'and gives me no trouble at all, such a blessing when one has one's hands full'.[12]

Kitchener cut short his time in Cairo and hurried south. To strengthen the prestige of Sir Reginald Wingate, whom he was determined should succeed him as governor-general, he placed the final operation in his hands. On 24 November, at the battle of Um Dibaykarat, the Khalifa was brought to bay and when all was lost died gamely, sitting with his lieutenants on their sheepskins, facing Mecca: Queen Victoria admired the manner of his death, 'grand and fine'.[13]

By then the Boers had invaded Natal, and Buller had arrived with his army. Not knowing how the war would develop, Kitchener had asked the Cecils to

lobby the War Office for a command. But in December Reuter's daily wire service brought to Khartoum the news of 'Black Week', one severe British reverse after another.

On 18 December a cypher telegram carried the call that Kitchener had expected since Black Week: Lord Roberts was appointed Commander-in-Chief and about to sail from Southampton. Kitchener was ordered to join him at Gibraltar..

'I had to get off sharp and travel fast to catch him at Gib', he told Lady Helen. 'I reached there in just a week from Khartoum and five hours before Lord Roberts arrived.'[14] At Cairo he was met by Jimmy Watson, released from his hated headquarters desk by a wire from the Sirdar who appointed him ADC again.

They sailed from Alexandria in the cruiser HMS *Isis* at midnight on 21 December and reached Malta through very heavy weather on Christmas Eve, continuing on Christmas Day, 'a fine bright day', in the faster HMS *Dido*. They arrived in pouring rain at Gibraltar on 26 December.[15] The liner *Dunottar Castle* put in at midnight carrying Roberts with various generals and colonels, including Percy Girouard to take over the railways.

The little sixty-seven-year-old field marshal and the tall forty-nine-year-old major-general had met only once, at their discussion in Ireland, but despite very different characters they bonded swiftly, helped by mutual grief for the valiant death, winning the VC by saving the guns at Colenso, of Freddy Roberts. Kitchener's affection and admiration for his former ADC touched Roberts, desolated by the death of his only son.

Among the letters that Roberts brought out for Kitchener was advice from an elderly Royal Engineer retired general, Sir John Stokes, whom he had known in Egypt. 'You have many well wishers in your old Corps', wrote Stokes, 'but there are probably not a few in the Army generally who are not so well disposed'. Stokes pointed out in a rambling way 'the danger when men who have held almost autocratic positions' are transferred to a staff appointment where they must subordinate themselves to the orders of another. 'In your case there is no question of reputation – that is made. Rather your reputation stands in your way: some of it by your very personality may be the anticipatory cause of friction'.[16]

Stokes's fears were groundless. Kitchener allowed no friction: Roberts was one of the very few senior officers he admired without reservation. As the

Dunottar Castle speeded south, the white hair and heavy white moustache of the one and the brown hair and famous moustache of the other were frequently seen bent over maps and papers as Roberts unfolded his plan to turn the tide of war. Kitchener wrote to Lady Helen while the ship lay briefly at Madeira:

> We shall have a pretty hard time to get things right at the Cape, as it seems things have got a good deal mixed up but Ld Roberts is the right man and when we have got things square I hope we shall be able to show the Boers a somewhat different war game to that they have been having lately.[17]

Soon after they had landed at Cape Town on 10 January 1900 there was a little incident that lights up the contrast in character. A newly arrived battal- ion, still on board ship, learned that they were to disembark and entrain for the front, and that Lord Roberts and Lord Kitchener would inspect them very soon on the quay. A young volunteer officer formed up his troop in time, only to realize that he had left his gloves and stick on deck. As he rushed back up the gangway his helmet fell into the slimy water, to be retrieved by a ship's cook with a marlin spike which made a hole in the crown. He shoved the dripping helmet on his head and stood rigidly at attention at the front of his men, ignor- ing sniggers from behind.

> The C-in-C was going through the inspection as quickly as possible, and walked down the ranks without comment until he came opposite me; then he stopped and a crinkle crept round his eyes as he said: 'Ah, I see you have been in the wars already, Sir,' and he passed on. I remember Lord Kitchener's face: it was perfectly expressionless; not so, however, the face of the Colonel and our Adjutant, both of whom I thought were going to have fits.[18]

Roberts and Kitchener spent nearly a month at the Cape laying the founda- tions of the new strategy. Instead of a three-pronged advance on the Boer heartlands, Roberts concentrated all available forces for a single thrust to the north, aiming to defeat General Cronje's invasion of Cape Colony, relieve Kimberley which De Wet besieged, and then move across swiftly to capture the Orange Free State capital, Bloemfontein.

Until Roberts's arrival in South Africa the British had mostly used infantry and thus were confined to the neighbourhood of railway lines. Roberts turned

several battalions into mounted infantry to make them more mobile (when they had learned to ride) and raised two regiments of irregular horse – Roberts's Horse and Kitchener's Horse – from the sons of Cape farmers, born to the saddle, Uitlanders exiled from the Rand, and the young men flocking in from Canada, Australia and New Zealand, including Millie's second son, James Parker, aged twenty-six. He joined Kitchener's Horse and was killed in action three months later.

Roberts also changed the time-honoured system in which each regiment had its own transport of horse- and ox-drawn vehicles (motor cars had not yet been seen in South Africa) which he considered wasteful, and put them all together to be used where required. Kitchener carried through Roberts's reform with enthusiasm and took the blame when the new transport system, at first a major element of success, proved later to be unworkable and earned him a title among indignant colonels: K of Chaos.

Kitchener harried and pushed and rode roughshod over feelings and objec- tions. Whereas the great German general von Moltke thought the organiza- tion of Kitchener's Nile expedition the finest in recent military history,[19] Kitchener thought the War Office's organization for South Africa so poor, and rent by petty jealousies and refusals, that 'if we had worked the Sudan campaign like this we should never have reached Dongola – most of us would be in prison at Omdurman or dead by now! Lord Roberts is splendid.'[20]

Roberts and Kitchener left Cape Town incognito on 6 February 1900. Two days later they arrived at Modder Camp, 600 miles north, where 37,000 men, 12,000 horses and 22,000 transport animals had been concentrated secretly. Roberts then took Cronje by surprise with a swift flanking movement away from the railway in broiling late summer heat. By 15 February French had relieved Kimberley, and Cronje lay trapped on the banks of the Modder river. Roberts fell ill with a severe chill. Kitchener had the future of the war in his hands.

22

THE BATTLE
THAT WENT WRONG

THE MODDER RIVER flowed strongly below sloping banks. The surrounding hilly veldt was treeless. Close to the river grew mimosa trees and scrub. Cronje's laager of four thousand men, with guns and carts, women and some children, lay in a confined space at a drift (ford) east of the small town of Paardeberg and plainly visible from the higher ground. In high summer the fast-flowing river did not cover its sandy flood plain, so Cronje, unknown to Kitchener, had dug a trench system with clear views of the veldt: he even had made a two-mile-long communication trench for his burghers to move, out of sight, from one strongpoint to another. He had placed sharpshooters in the outer scrub but was short of ammunition because Kitchener had caught many of his wagons (sending back to Roberts 'a bottle of Cronje's best champagne' with the list of captured equipment).[1]

By dawn on Sunday 18 February 1900, two of Roberts's infantry divisions with a brigade of mounted infantry, totalling some 15,000 men, were investing Cronje's laager, while to the north-west stood Major-General John French's cavalry and guns. They had ridden back hard after relieving Kimberley, and their horses were exhausted: French could stop Cronje escaping but could not take part in an assault. The senior divisional commander was a tall Catholic bachelor Irishman Thomas Kelly-Kenny, ten years older than Kitchener. As he held the local rank of lieutenant-general he had assumed he would command in Roberts's absence since Kitchener was only a major-general.[2] He was therefore not pleased when handed a note from Roberts: 'Please consider that Lord Kitchener is with you for the purpose of communicating to you my

[177]

orders',[3] especially as Kitchener made plain that Roberts had given him a free hand to conduct the battle. Kitchener's plan was to assault the laager, whereas Kelly-Kenny had intended to invest, bombard and starve it.

Kitchener knew that speed was essential before Cronje could break out or be relieved. He therefore planned for simultaneous assaults from all directions, both sides of the river, after a sharp bombardment. He may have expected (although he never mentioned the comparison) a repeat of the battle of the Atbara — an overwhelming advance on a battered enemy in a confined space beside a river, some grievous casualties followed by swift and total victory. He would have been wise to recall the words of Queen Victoria in her letter of good wishes and 'great confidence' when he was appointed: 'It must however be borne in mind', the little old lady told her famous general, 'that this is a very different kind of warfare to the Indian and Egyptian. The Boers are a horrid brutal people, but are skilled in European fighting and well armed.'[4]

Kitchener stood on a well-defended kopje, soon to be known as Kitchener's Kopje, looking down at the Modder river. His divisional and brigade commanders had precise orders, and Kitchener had impressed on Colonel O. C. Hannay, commanding the Mounted Infantry, his key role: to cross the Modder upstream, creep up as close to the laager as possible and rush it, supported by T. E. Stephenson's 18th Brigade from the other side of the river, while MacDonald and Smith-Dorrien, veterans of the River War, put in an attack from the opposite direction.

Kitchener took out his watch and said to Jimmy Watson: 'It is now seven o'clock. We shall be in the laager by half past ten.'[5]

The guns opened. Soon he could see Cronje's carts and tents in flames. Then the divisions advanced across the open veldt. Kitchener sent a heliograph message to Roberts: 'It must be complete surrender.'

But everything started to go wrong. As the British lines advanced, man after man dropped, hit by accurate fire from smokeless rifles. Kitchener saw the converging divisions, one after another, falter then stop, and because Roberts had given him no proper staff he was unable to co-ordinate the battle quickly as the situation changed. Half-past ten passed and the advance had become hardly a crawl. The river ran tantalizingly fresh a few hundred yards away, but accurate Boer fire denied it to men who were lying or moving in the hot summer sun, their thirst maddening, the Highlanders' kilted legs roasting (MacDonald had urged some days before that the kilt should be replaced by trews).[6]

Then Stephenson and Hannay, on the northern flank, suddenly turned their men away from the direction of the laager: Boer snipers, approaching the battlefield from elsewhere undetected, were causing havoc. Kitchener sent furious messages, believing that these casualties should be accepted and nothing should impede the main advance. But the impetus was lost.

At about half-past one he rode down from Kitchener's Kopje to regroup the divisions and inch them forward. An hour later a staff officer (whether acting on a direct order or believing that he interpreted Kitchener's wishes is uncertain) withdrew the experienced troops on the kopje and sent them to reinforce the crippled advance below. He replaced them by men of Kitchener's Horse, untried in battle, to hold the most important feature of the field, which Kelly-Kenny had recognized as the key to victory, even if Kitchener did not.

All that dreadful Sunday afternoon under the blazing sun the casualties mounted on both sides. The British suffered more dead and wounded in that one battle of Paardeberg than in any single action of the South African war, and more than the combined Anglo-Egyptian losses of the entire River War.[7]

While the battle continued below, still undecided, with gallant charges which pushed back the Boers but could not reach the laager, a disaster occurred on Kitchener's Kopje at about five o'clock. De Wet, having abandoned his siege of Kimberley when French broke through, had ridden hard with three hundred men and several guns to aid Cronje. Undetected, he had crossed the Modder river higher up and galloped behind the British and up to the kopje, surprising the inexperienced young troops, who put up a poor fight and then surrendered. De Wet seized the whole south-west ridge and trained his guns. The first shells fell on the hospital tents, causing panic and misery to the wounded and seriously endangering the morale of Kelly-Kenny, who was about to visit them but never did.

With darkness nor far away, Kitchener believed that one more co-ordinated attack would overwhelm the laager despite De Wet's attack on his rear. If more soldiers were killed and wounded, the price must be paid. Kitchener was not reckless with lives, hence the low casualty rate in the River War, but he would not allow sentiment or harrowing sights to deflect duty.

He sent a strong message to Hannay:

The time has come for a final effort. All troops have been warned that the laager must be rushed at all costs. Try and carry Stephenson's brigade on

with you. But if they cannot go the mounted infantry should do it. Gallop up if necessary and fire into the laager.[8]

Some said afterwards that this message to Hannay was dishonest because all troops had not been warned; but in the fog and din of war Kitchener may have believed that his intention had been conveyed, or he may have meant that the order to rush the laager had been in force since morning, although Kelly-Kenny had refused to renew the attack. Hannay took the message as a reflection on his courage and honour. He made no attempt to co-ordinate with Stephenson's brigade but collected some fifty men and rushed forward in the spirit of the charge of the Light Brigade, to die under a hail of bullets.

Night fell and the battle died down, with Cronje unable to escape but Kitchener frustrated. He determined to renew the attack on Cronje the next morning despite failing to dislodge De Wet from the south-west ridge. At ten o'clock on the Monday morning Roberts arrived, recovered from his chill, and resumed command. His first instinct was to agree with Kitchener, but Cronje sent a white flag and asked for an armistice to bury his dead. He also wanted British doctors to treat his wounded. Roberts refused, and Cronje politely breathed defiance. Much of Monday passed in negotiation. On Tuesday evening Jimmy Watson recorded laconically: 'Situation unchanged and not very pleasant.'[9] Roberts had wanted to renew the assault but first called a council of war. Kitchener pressed for assault. Smith-Dorrien urged they remain quietly in their lines until Cronje surrendered. Roberts accepted Smith-Dorrien's advice, to Kitchener's dismay. As Smith-Dorrien was mounting his horse, before Roberts had issued any orders to confirm his decision, Kitchener went up to him 'saying that if I would attack them at once I would be a made man'. Smith-Dorrien smiled and replied that Kitchener knew his views and that he would attack only if ordered.

By Wednesday morning De Wet's rifle and gunfire from the kopje and ridge and the continued failure to dislodge him had so affected Roberts that in confidential discussion with Kelly-Kenny he contemplated withdrawal, a move that would have been disastrous. That afternoon the cavalry under Brigadier-General Broadwood, another River War veteran, with Watson at his side,[10] drove De Wet from the kopje, although some claimed afterwards that De Wet was already evacuating the position by his own decision. Roberts dropped all thought of retirement and settled down to starve Cronje into surrender.

Roberts's mind was now on capturing the Free State capital, Bloemfontein, by swift moves afterwards. He needed the co-ordination of his columns oper-ating to the east, and the opening of the railway line. He ordered Kitchener to ride across country to ensure this, and he left the battlefield with Watson at half-past four on the afternoon of Thursday. He was not therefore present the fol-lowing Tuesday (the nineteenth anniversary of the Boer victory at Majuba) when Cronje surrendered to Roberts and went into captivity with four thou-sand fighting men, the first great British victory of the war.

By then the Modder river had become so polluted by dead horses and oxen and the filth of the siege, yet so tempting to thirsty British soldiers, that it was the direct cause of a serious outbreak of enteric fever which claimed more British lives in the weeks to come than would have been lost had Roberts renewed the assault at once.

Kitchener was heavily and justly criticized (except by Roberts) for his tactics and handling of the battle of Paardeberg, but his instinct was sound.

During the next three months, as the hot summer turned to the South African autumn, Roberts used Kitchener more as second-in-command than Chief of Staff. He sent him wherever trouble arose, such as the rising of the Cape Dutch which might have grown into a dangerous rebellion had not Kitchener crushed it by a sledgehammer blow after riding with mounted troops forty miles in one day.

Kitchener would have preferred a cut-and-dried campaign like his advance on Omdurman. The flavour of the war is well caught by a letter that Kitchener wrote to the Grenfell boys, Julian and Billy, during Roberts's advance on Pretoria, in reply to theirs

. . . which caught me up on the march here, and I read them while our guns were pounding away at the Boers, who were sitting on some hills trying to prevent our advance. However, they soon cleared out, and ran before we could get round them. I wish we could have caught some of their guns, but they are remarkably quick at getting them away, and we have only been able to take one Maxim up to the present.

Sooner or later we are bound to catch them, but they may give a lot of trouble. The Boers are not like the Soudanese who stood up for a fair fight, they are always running away on their little ponies. We make the prisoners we take march on foot, which they do not like at all . . .[11]

[181]

Actions often had to be fought far from the main line of advance. Boers could be effective soldiers one day and apparently innocent farmers the next. Writing regularly to the Queen, Kitchener told her of British troops being fired on by Boers holding up white flags. 'On one occasion they put the white flag up over some farm buildings and when a squadron rode up they fired on them at close range. It is very sad but it is a good deal the fault of our men for not taking proper precautions.'[12] Sometimes he was discouraged by casualties and deaths from enteric and other setbacks. 'I hope the authorities at home keep their hair on', he wrote to Lady Cranborne, 'and if they want a victim to sacrifice, I am always at their disposal'.[13]

He told the Queen that Lord Roberts was 'the most delightful chief to work under',[14] but her Assistant Private Secretary, Arthur Bigge, received an illuminating letter from a fellow gunner, Colonel James Grierson, forty-one years old, who had lately joined Roberts's staff as quartermaster-general. Grierson had wide experience and had published books on military affairs. 'I don't think somehow that Kitchener is quite in the proper place as Chief of Staff,' he wrote.

In the first place, he is too big a man for it, and having held an independent command, finds it hard to be only chief staff officer to another. Secondly, he is accustomed to absolute autocracy and to everything being done according to his own method. Now his own method is to do everything himself, which works with 25,000 troops along a river, but does not work with 200,000 scattered over half a continent. He has only been a few days at Headquarters since I joined.

Both Roberts and Kitchener tended to do things 'off their own bat', which made difficulties for those who had to carry out their orders. 'The best man in the world can't do everything by rule of thumb.'[15] For his part, Kitchener felt that the army were looking on the war 'too much like a game of polo with intervals for afternoon tea'.[16]

Nevertheless by the end of May a flying column had relieved Mafeking (the news sent London wild – 'Maffiking') and Roberts had captured Johannesburg and all the gold mines intact. Kitchener believed that the Boers were tired of war, but no one liked to be the first to give in. On 7 June 1900 the British Army entered the Transvaal capital, Pretoria. As at Bloemfontein, Roberts ran up his wife's small silk Union Jack above the President's house.

Kitchener wrote, that very day: 'in another fortnight, or three weeks we may have peace.'[17]

At the formal entry into Pretoria as the Cameron Highlanders marched past the saluting base, a young officer noticed that Lord Kitchener, standing beside Roberts, concentrated his gaze on the men's boots. The War Office had sent out too many which failed the rigours of marching across the veldt. The Camerons' boots looked good. 'He had known the battalion in Egypt', noted Craig Brown in his diary that day, 'so had evidently made a mental note of their marching powers, for he sent us off on the trek again the very next day'.[18] To Kitchener's satisfaction many of his Sudan troops and senior officers were serving in South Africa. Major-General Sir Archibald Hunter, KCB, as he now was, had been second-in-command in Ladysmith during the siege. He had led a daring night raid to silence guns that were bombarding the town from a height. After the Relief of Ladysmith he secured a great victory by the surrender of a Boer Army at Brandwater Basin. Lord Edward Cecil was with Baden-Powell at Mafeking; Hector Macdonald commanded the Highland Brigade under Roberts and Kitchener.

While the Camerons marched east to take part in the action that culminated in the battle of Diamond Hill, Kitchener was sent south down the railway to deal with De Wet. The Boer generals Botha and de la Rey had opened negotiations for surrender by sending Botha's wife under flag of truce to arrange a meeting, but Christian De Wet had embarked on a series of guerrilla raids on British communications. His string of successes banished thoughts of surrender, which gave way to a hope that if the Boers continued the war, Germany or another great power would come to their aid. Capturing guns, ammunition and supplies, De Wet seriously embarrassed Roberts's campaign. And on 12 June 1900 De Wet nearly brought Kitchener's career to a stop.

Kitchener's headquarters saloon was coupled to a train carrying troops and railway repair men. At each station he alighted to hustle the officials in charge of strengthening the line and repairing bridges.[19] Having reinforced and reorganized the scattered detachments along the railway, he was returning towards Pretoria and had bivouacked with his staff in tents a few yards from his train which stood at Heibron Road station guarded by an infantry company. He was sleeping partially undressed when Jimmy Watson shook him awake: De Wet and his men had ridden in under cover of darkness, had surprised and

overwhelmed part of the protecting company and were rounding them up as prisoners, unaware what a quarry lay on the other side of the line. Kitchener, Watson and their orderlies ran to the train, unstabled horses and rode for their lives some miles across the veldt in the moonlight to the safety of a yeomanry camp. By a curious chance of war the British just missed taking Kruger prisoner near Diamond Hill at almost the same time as the Boers missed Kitchener at Heibron Road.

Roberts had proclaimed an amnesty for any Boer (except leaders) who would surrender and many did, some even changing sides; but the guerrilla war dragged on. Roberts also proclaimed on 16 June that wherever Boers broke up the railway, severed telegraph lines or wrecked bridges and embankments, the homesteads in the immediate neighbourhood would be burned down: De Wet's own farm near Roodewal, where he had captured a large supply convoy, was set on fire that very morning. Roberts also organized camps for the women and children made homeless. Thus the policy of scorched earth and camps which would blacken Kitchener's memory originated with Roberts: Kitchener, with his instinctive concern for the welfare of women, at first opposed Roberts's plan.

Despite bloodshed and misery continuing, the end of the war still appeared to be close. Roberts and Kitchener both looked to their futures. Roberts had been informed that he would succeed Wolseley as Commander-in-Chief of the British Army and that Kitchener would succeed him in South Africa. After that, Kitchener had set his heart on India as Commander-in-Chief. This most important and influential post normally went to an officer with Indian experience, but Lord Curzon, the viceroy, wanted the glamour of Kitchener's name and his powers of organization.[20] Roberts, who had spent forty-one years in India, pressed Kitchener's appointment on the Secretary of State for War, Lord Lansdowne, a former viceroy.[21] On 29 September Lansdowne wrote to Arthur Bigge, Queen Victoria's Assistant Private Secretary:

Roberts who knows the Indian army, if anyone does, and who also knows Kitchener has strongly recommended us to send him to India. I was at first opposed to the idea, fearing that Kitchener's inexperience of the country and hardness of disposition might lead him into trouble. Roberts I think held this view at first but he tells me that Kitchener has improved immensely

and has got over any little failings of manner which he may have possessed and that he, Roberts, considers him far better qualified for this most impor-tant post than any other candidate.[22]

Queen Victoria, however, felt 'most strongly' against Kitchener's appoint-ment. She said that she had the greatest admiration and regard for him and did not want him placed where he might fail. He had not perhaps the right gifts for dealing with native armies – and that his appointment 'might lead to serious consequences detrimental to her rule in India and also to Lord Kitchener's own career in which the Queen takes a very great interest'.[23] And to pass over more senior generals with long Indian experience would cause great resentment.

She urged instead that his 'remarkable qualities as an organizer' would be of great value at the War Office. This was the other option that Lansdowne had put to the Queen. 'Kitchener would be very valuable here', he wrote from his desk in Pall Mall. 'He is a man of independent views and great courage, and the public believes in him.' He would inspire confidence in the new regime under Roberts.[24] The point had already been put forcibly to Bigge by a knowledgeable correspondent:

He is an ideal man to carry out a policy of reform in the Army at home. And however much fond he may be of smart people etc I think he is one of the few men who would ignore the immense social pressure and opposi-tion that will be formed and brought against any reform that touches the comfort of the office. I mean, that entails an office working after lunch, for that is what it amounts to.[25]

Kitchener was 'quite frightened' when he heard rumours that he might be sent to the War Office. 'I could do no good there and would sooner sweep a crossing.' If not India he should be given the Sudan again. Otherwise, he told Lady Cranborne, he had better try civil employment.[26]

He had a thorough contempt for the War Office, its regulations, red tape and leisurely ways. Once, in the Sudan, he had joked that he would like to start a new War Office with a small staff of selected officers and proceed to issue orders by telegram and telephone, and 'it would probably be three months before the old War Office realized that he had taken over control of the Army'.[27]

[185]

For the moment his future was clear. He would tie up loose ends and bring, as he thought, a quick peace. On 12 October 1900, some six weeks before Roberts handed over, Kitchener wrote to the Queen: 'Madame, I feel sure Your Majesty will be pleased to hear that the war is almost over. Although there are still several bodies of the enemy in the field they can do very little harm now, and are running short of ammunition.'[28]

He would have been horrified to know that the end was more than eighteen months away. Had the politicians let him have his way he would have brought an honourable peace to the Boers in less than four months from the date of his letter.

23

1901: PEACE ABORTED

KITCHENER WOULD NEED to increase his staff, and asked Buller in the Natal to send a suitable officer. Buller chose William Birdwood, a Bengal Lancer aged thirty-five who had seen action in frontier wars in India and was mentioned in dispatches five times during the South African war. Roberts approved, wanting to advance Birdwood's career.

Birdwood presented himself in Pretoria with considerable misgiving, but on 16 October 1900 he wrote to his wife, 'My own, very darling dear Jenny Jane', in India: 'He was most awfully nice and after all one has heard of his being such a brute, I was quite astonished how very nice and easy he was to get on with.' Kitchener made him Deputy Assistant Adjutant-General and 'gave me no time to answer anything or think of anything but plunged into it at once'.[1]

Birdwood first had to work out a reorganization of troops on the lines of communication, doing it in Kitchener's dining-room. K (as he was generally known in the army) came in to speak with him several times a day. 'I am quite astonished', Birdwood wrote to Jenny Jane, 'how well I get on with him and I find him most awfully nice to work for'. When Kitchener took him on his afternoon rides, Birdwood noticed how he would deliberately look the other way to avoid returning salutes, which annoyed Birdwood as he knew it was unpopular, but 'He really is, what people I think don't give him credit for, very shy indeed and hates new people about him (so I don't know how I have ever got to know him so well)'.[2]

Not long after Birdwood had joined the staff Lady Roberts told him that she had happened to mention his wife to Kitchener, who

nearly bounded out of his chair with a shout of 'What! Birdwood married! married!!' She said she had never seen him so excited and it was just as if a bombshell had fallen on him. I was most awfully amused for it sounded as if he looked on my little Jenny Jane as an ogress! Lady Roberts finished up by saying, 'I told him you would be far more useful to him as a married man than as a bachelor, on which we had a great argument, as I have always maintained that a good soldier is only improved by marrying!'[3]

Kitchener, perhaps not realizing that Jenny Jane was far away in India, had feared that she would be a distraction. When he came to know her in India he was charmed, and grew very fond of their children. Once, at a viceregal garden party, a sudden loud noise frightened five-year-old Christopher, who ran at once to Kitchener and held his hand tight. Kitchener told a cousin years afterwards that it was the proudest moment of his life.[4]

Kitchener also selected, as another ADC, a twenty-nine-year-old cavalry-man who had recently won the Victoria Cross: Francis Aylmer Maxwell of the 18th Bengal Cavalry. Frank Maxwell, while adjutant of the volunteer Roberts's Horse, had saved the guns at Sanna's Post when the Boers had surprised a forward column during the advance on Pretoria. Maxwell came from a military family, and his five brothers were all serving. In India he had been recommended for a VC in the Chitral campaign. His was a delightful personality with charm and perfect manners and a great sense of humour. As he looked very youthful, Kitchener nicknamed him 'the Brat'. The Brat was to be a vital member of Kitchener's 'family' for many years to come.

Lord and Lady Roberts left Pretoria for England at the end of November 1900, having delayed their departure until one of their daughters recovered from enteric. Kitchener took command of the 230,000 British and Imperial troops in South Africa and was promoted lieutenant-general, with temporary rank of full general.

He had a new master in Whitehall as Lord Salisbury, who had been confirmed in power by the 'khaki election', no longer wanted to carry the Foreign Office with the premiership and handed it to Lord Lansdowne. Lansdowne was replaced at the War Office by St John Brodrick, six years younger than Kitchener, and heir to Viscount Middleton, who owned estates in Ireland and Surrey. Kitchener and Brodrick worked harmoniously in South Africa and later in Indian affairs, perhaps partly because Brodrick was not a dominant personality.

Kitchener had not been long in command when his strongest supporter, Queen Victoria, died in January 1901, aged over eighty-two. Subject and sovereign had been drawn even closer in her last months through mutual grief at the death in Pretoria of her grandson, his former staff officer, Prince Christian Victor, a fine soldier who had survived battles in India, the Sudan and South Africa, only to die of enteric following malaria. 'The Queen knows', she wrote, 'how fond Lord Kitchener was of our darling Christian Victor, who was much attached to Lord Kitchener'. She spoke of the great loss to the army and the country, and conveyed the thanks of her broken-hearted daughter to Lord Kitchener 'for all his kindness to him. The Queen feels much upset and shaken by this event and the loss of her grandson who was very useful to her, and at whose birth she was present. The war drags on, which is very trying.'[5]

Grief and anxiety sapped her strength. During January she fell ill. Princess Beatrice told Kitchener that on the day before she died, when hardly conscious of her surroundings, she suddenly asked, '"What news is there from Lord Kitchener? What has been happening in S. Africa?" Her whole mind was wrapped up in her soldiers fighting for her.'[6]

Their fighting seemed to bring victory no nearer. The army had rightly expected that Kitchener would prosecute the war with more vigour than Roberts in his final months, but as Kitchener wrote to Lady Cranborne: 'The country is so vast out here that the troops we have are all swallowed up.' So many were holding towns, guarding bridges and railways that he had too few 'to act vigorously against these roving Boers'.[7]

Sir Alfred Milner, the High Commissioner, had put up ideas on the policy to follow 'to put an end to this tiresome war, or brigandage, or whatever you like to call it'.[8] Milner and Kitchener, outwardly friendly, distrusted one another. Milner thought Kitchener in too much of a hurry, while Kitchener deplored Milner's aim of unconditional surrender: Kitchener aimed for a negotiated peace leading to a new South Africa in which the qualities displayed by the Boers would be harnessed in a free association within the British Empire.[9] But first he must convince them militarily that guerrilla warfare could end only in defeat. 'I puzzle my brain', he wrote to Lady Cranborne in January, 'to find out some way of finishing but without much result';[10] and a few days later, writing about personal finances to Arthur Renshaw, who had invested for him the Parliamentary grant given for Omdurman, he closed: 'I am so full of work that I am sure you will excuse a scrawl like this. I wish

I could finish up this war and get out of the country but I do not see at present much signs of the boers giving in for some time. Anyway we will all do our best.'[11]

Some in the army thought Kitchener not much interested in strategy,[12] but early in 1901 he conceived the strategy of the drive and the blockhouses: General French's cavalry swept through eastern Transvaal to round up roving commandos, using the blockhouses (built to guard the railways) as stoppers, rather as beaters in a grouse shoot drive the birds against butts. The 'bag' was disappointing, but Kitchener soon had evidence that 'our drive sweeping the high veldt has changed the idea of the boers and made them far more peace-fully inclined than they were a few days ago'.[13] On 22 February Mrs Louis Botha, wife of the Transvaal commandant-general, appeared in Pretoria with a letter desiring that he and Kitchener should meet 'with the view of bringing the war to an end'.

Kitchener agreed at once and wrote excitedly to Brodrick that a personal meeting 'may end the war if we are prepared not to be too hard on the boers . . . It will be good policy for the future of this country to treat them fairly well and I hope I may be allowed to do away with anything humiliating to them in the surrender if it comes off.'[14]

Kitchener arranged that they should meet six days later at Middleburg, north-east of Pretoria, in a countryside of rolling downs of grassland and 'a most glorious climate', as the Brat wrote home. 'One feels as fit as a lark, and the rest and change is doing K a lot of good.' Before Botha's final acceptance of the rendezvous Kitchener 'with his usual impatience was beginning to fidget but is now quiet again',[15] and went for a good ride.

At 8.30 a.m. on Thursday 28 February Watson rode out and met Botha and four others about a mile and half beyond Gun Hill Post. They were back by 10 a.m. at the requisitioned house where Kitchener was staying. Botha made a good impression: heavily set but with a pleasing expression and a quiet manner. While the ADCs entertained the Boer staff ('Quite good fellows . . . much chaff was bandied'), the two leaders were closeted by them-selves.[16]

Botha had brought ten points for discussion, and hoped for some form of independence to be allowed if the Boers laid down arms. Kitchener, knowing the home government's mind, ruled that out, but Botha's other points seemed capable of adjustment, although Kitchener found him greatly opposed to any vote being given to African natives: Kitchener then suggested that this should

wait until representative government was restored to the former republics; Botha agreed. Some historians, long after, attacked Kitchener for this compromise. But his primary aim was to create a stable, united nation, rising from an early peace. Moreover, not many of his own countrymen were interested in votes for natives. His thinking was ahead of his time.

Kitchener offered generous terms, including acceptance of their legal debts and a large sum for the rebuilding and restocking of farms. He agreed to an amnesty for acts of war, even for the Boers in the Cape and Natal, who had taken up arms and therefore were rebels against the Crown, since Botha could not desert them to be severely punished, although agreeing that they should lose the vote. Kitchener's conclusion was that if the home government wished to end the war, he did not see any difficulty. Botha spoke of Boer and Briton being friends again, and hoped to bring his Free State allies round to accept the terms.

The luncheon between sessions, with both staffs present, was somewhat heavy but cheery. Before Watson escorted the Boers away in the evening, Kitchener allowed a group picture to be taken despite his dislike of being photographed. But when, later, he discovered that the Boers circulated the photograph as proof that Botha had captured Kitchener, he ordered that the plate and all copies that could be found (except his own) should be destroyed.[17]

Kitchener cabled to Brodrick and to Milner, for forwarding to Chamberlain as Colonial Secretary, with great optimism. But Milner stiffened the terms and specially objected to any amnesty for Cape and Natal rebels. Kitchener 'did all in my power to urge Milner to change his views, which on this subject seem to me very narrow'[18] and vindictive. Chamberlain backed Milner and even rebuked Kitchener in Parliament.

Kitchener was exasperated. 'We are now carrying the war on to put 2–300 Dutchmen in prison at the end of it. It seems to me absurd and wrong, and I wonder the Chancellor of the Exchequer did not have a fit!'[19] 'I was amazed the Govt were not more anxious for peace', he wrote to Lady Cranborne, but remembering she was the Prime Minister's daughter-in-law he added tactfully: 'Of course there are some reasons for it, I do not understand or know of, probably political.'[20]

In England the rising Radical, David Lloyd George, a leader of the 'pro-Boers', contrasted Kitchener and Chamberlain: 'There was a soldier who knew what war meant; he strove to make peace. There was another man, who

[191]

strolled among his orchids 6,000 miles from the deadly bark of the Mauser rifle. He stopped Kitchener's peace!'[21] It would have been well, eighteen years later in 1919, had Lloyd George recalled his words when he forced through a vindictive peace, which Kitchener, had he lived, would have made a 'peace of reconciliation'.

The guerrilla war resumed with increased bitterness and atrocities on both sides. If a commando captured British soldiers, they would strip them (needing their clothes and boots) and send them naked and bleeding to find their way back, then take advantage of their uniforms: when a squadron of Colonel Douglas Haig's 17th Lancers was cut up at Elands River Poort (during Smuts's invasion of Cape Colony) they had held fire until too late because the men approaching were wearing British khaki.

With the roving Boers using homesteads on the veldt for supply cover and camouflage, Kitchener was forced to burn farms, the policy he had opposed under Roberts. 'It is a horrid war', he wrote in April. 'No straight fighting. I wish we could get it over but I have done all I can and do not see how it is to end except by utter exhaustion on the part of the Boers.' And again, in June, he commented to the Cecils: 'There is no pleasure in destroying a country and catching the inhabitants and yet there is no other way of bringing irreconcil- ables to book.' He admired their tenacity and recognized that they were fight- ing for their independence, which the British government would never grant. Thus the war must continue, and on 21 June he told Lady Cranborne: 'I hope if they have anyone who can do the work better they will send him – it is not fair on the Army if anyone else could bring matters to a nearer end.'[22] But the government had every confidence. Moreover, when Milner left for home on leave in May they approved Kitchener's appointment as Acting High Commissioner.

Milner arrived in London to an effusive official welcome and a peerage. He had an audience with King Edward VII, who apparently spoke somewhat dis- paragingly of Kitchener, probably echoing Lord Esher, who despised his uncouth face and had heard that no one who worked with him liked him.[23] Milner, after reflection, sent a long letter to the king's Private Secretary to correct the 'rather unfair impression' left on His Majesty's mind.

'. . . No doubt', wrote Milner, 'Kitchener is not a genial man and is a hard taskmaster. On the other hand I do not think he is slow to recognize good work. I remember his saying more than once that he wished it was easier to

reward men promptly when they had done anything specially distinguished.' He would be most pleased at the king's recent special awards.

'Another very strong point is his enormous energy and power of work. In this respect I do not think I have ever met his equal. No doubt the weak point is the enormous number of different operations which he has to control, and there is *a tendency* to control them too much.' Milner welcomed Kitchener's recent grant of more operational independence to Sir John French in the Cape and hoped he would allow wider discretion to column commanders as the Boer formations broke up.

> But when every deduction is made, there is a great source of strength in Kitchener's grasp and driving power and iron constitution for work . . . He is doing a terribly heavy bit of work with splendid zeal and devotion, and the least I can do, who have seen him at it, is not to allow this side of the case to be forgotten.[24]

And another 'side of the case' was shown by a letter that Kitchener had received when the Egyptian Army reclaimed Jimmy Watson. Their farewells had been typically British – a last game of billiards and scarcely a word. Watson wrote from Durban when his ship was about to sail:

> I wanted to say so much. Even now it's difficult. But my 'home' has been with you so long and I do want you to know how awfully sorry I am to leave it, and to thank you very very much for all you have done for me. I hate going more than I can say. Goodbye again, I shall always look back on these five years as the best and happiest I've ever had.[25]

24

I WISH
I COULD SEE THE END

KITCHENER WAS NOW both political and military ruler of South Africa. He soon found himself at the centre of a storm.

The burning of farms made women, children and the elderly destitute unless the authorities took action. Lord Roberts had formed 'camps for refuge' and 'government laagers' for refugees, especially Boer families who had surrendered (the 'hands-uppers') and were in danger of reprisals from the 'bitter-enders'. Kitchener made these laagers the pattern for accommodating the increasing number of Boers brought in from the veldt as the scorched earth policy took hold. Families who had lived in isolation, miles from their neighbours, were concentrated in camps hurriedly sited and laid out, which became known as concentration camps. The motive was humanitarian and the term had none of the sinister meaning and purpose which it was to acquire in Nazi Germany. But the army had no experience of interning large numbers of civilians, and the Boer women no experience of living in communities. They continued their usual habits of hygiene which mattered little on isolated farms but were disastrous in camps. As Kitchener wrote, 'the doctor's reports of the dirt and filth that these boer ladies from the wilds revel in are very unpleasant reading'.[1] He thought the inmates better off than in their homes or than the British refugees in Boer hands.

Sickness was followed by epidemics and a rising death rate, especially among children. Newspaper reports produced unease, then outrage, in England, especially after a committee, formed by some who opposed the war, had sent out Miss Emily Hobhouse, middle-aged daughter of the late

Archdeacon of Bodmin in Cornwall.[2] Her brief was to lessen distress, and she had been given permission to visit the camps. She was appalled . On return to England she stirred the national conscience, but mixed her humanitarian mission with pro-Boer politics, speaking of the Cabinet and Kitchener as the enemy. *The Times* attacked her, but the Liberal leader Campbell-Bannerman, in a phrase that became famous, said the war was being carried on by 'methods of barbarism'.

Kitchener, as supreme in South Africa, cannot escape some of the blame for deaths, which he did not foresee – or intend, as Boer propaganda claimed. He should have sent to England for experienced civilian administrators, not rely on harassed servicemen and medical officers. He visited camps[3] but too hurriedly to realize the growing problem until the statistics became alarming. He would probably have acted more swiftly had Miss Hobhouse not seemed to be encouraging the enemy. When she returned to South Africa she unwisely held a conference in her liner in Cape Town harbour with Cape women who were known to be hoping for a Boer victory. Kitchener forbade her to land. She went home and took out an action against him in the courts. 'I shall prob-ably be put in prison on arrival in England, I suppose',[4] he joked to Lady Cranborne when he wrote to her on New Year's Day 1902.

By then the death rate was falling dramatically. The government, respond-ing to Opposition furore and public unease, had sent out a commission headed by a noted social worker and patriot, Mrs Henry (later Dame Millicent) Fawcett, widow of a blind MP. The commission toured the camps and made many wise recommendations, including the sending out of nurses from home.

But the bitterness ran deep, and Kitchener would be remembered among the Afrikaner people as the creator of concentration camps and 'murderer of children', and not for the enlightened peace he brought, at the last, despite the politicians.

'The boers are growing very weak', wrote Kitchener to Arthur Renshaw on 5 July 1901. 'The constant drain of killed, wounded and prisoners is telling on them but they won't chuck it hoping for something to turn up. They very rarely now let us get within 4 miles of them except at night and they are gener-ally off when we are 20 miles away. We have to ride 40 or sometimes 50 miles to catch them.'[5] The 'we' referred to his columns, but he visited them when-ever he could get away from Pretoria. Sometimes his carriages for staff and Cameron Highlander bodyguard, with horse wagon, would be attached to a

troop train. If, when he stepped down at a station, an officer should snap him with his Kodak, the film would be promptly confiscated by an ADC. More often the C-in-C travelled in his own special train which would stop overnight in a well-guarded siding. Next morning the Chief would be ready when the Brat was still washing his teeth. The Brat sent home a vivid description:

> Everything is at high pressure; at 7.15 we were off at a gallop and visited two small columns and two large ones. Quite unofficial visits, the commanders being unwarned almost invariably being found in their blan-kets having a well-earned sleep. No one is turned out but K. just rides through the lines looking at the horses and speaking to any one who happens to be about. Fifteen to twenty mile canter, mostly through herds of lowing cattle, brought us back to the station at 10. Breakfast and an hour up the line we again disembarked, and galloped out to see more columns, the farthest being about seven miles out. Here we found the New Zealanders, who had put up a very fine fight with De Wet's lot who had broken through some three nights before. K. made them a little speech which pleased them mightily, and so on to the next.[6]

The Boer commandos had become skilled at breaking through, blowing up bridges, ambushing trains or patrols, descending on isolated depots and disappearing again. Kitchener's mind ranged continually on ways in which to end the war. Boer men and boys, captured in the field, were sent to St Helena (where Cronje languished) and to Ceylon, India and Bermuda, a total of 25,000.[7] In a long and reasoned letter to Brodrick, Kitchener even explored the possibility of sending into permanent exile in the Dutch East Indies or Fiji all Boer families who would not accept British rule: the idea was summarily rejected.[8] Despite this absurdity Kitchener's policies as High Commissioner were enlightened, using both carrot and stick. Although the former South African Republic was now the British Colony of the Transvaal, and the Orange Free State the Orange River Colony, he did not treat the burghers as rebels but as combatants. He could be ruthless with Cape rebels, born under the Crown, and Boers captured wearing British uniform might be shot without trial, but Sir Richard Solomon, the Cape lawyer who had become Attorney-General of Transvaal colony, noticed how frequently Kitchener commuted death sentences imposed by courts martial or civil. In one case he was so moved by a letter from a condemned man's father that he went through

the papers himself instead of relying on official advice, and commuted. 'He is not a cruel man or hard', Solomon concluded, 'but may behave as such to hide his softer side'.[9] Kitchener approved French's public execution of a group of Cape rebels caught with a Boer commando, for which the Cabinet rebuked him, but he did not reprieve two Australian lieutenants who had allegedly ordered their men to murder twelve prisoners of war.[10]

Five Australians and one English officer had been court-martialled for the multiple murder. The execution of only Morant and Handcock caused an outcry in Australia. Friends of Morant, who was the illegitimate son of a British admiral, contended that the court-martial had been a farce, that the Boers, including a reverend predikant, had not been shot in cold blood but in a raid that went wrong, and that the predikant was a spy. After Kitchener had signed the death warrants he disappeared on tour, removing himself from any attempt to secure reprieves. Morant's friends accused Kitchener of dishonourable conduct. The case remains contentious, a fertile field for fiction and film.

To rule as well as to command was wearying, and Kitchener must answer the flow of telegrams from the Colonial Office and the War Office, both harried by a vocal opposition. 'I saw Herbert early in July', wrote Walter, now a major-general operating in the bush country of eastern Transvaal, to their cousin Johnny Monins on 21 August, 'He was showing signs of overwork and worry, but I cheered him up a bit.' Walter gave him evidence from the field of 'quite wonderful progress' towards winning the war, and of the splendid spirit of the troops. 'Of course', added Walter, 'in Pretoria he does not see the change as we do on trek'.[11] Walter admired and liked the Boers as he pitted his wits against theirs.

General Walter Kitchener was in for a surprise. Far away in England his devoted wife, unable to throw off her lassitude and weakness although only thirty-seven, consulted a Harley Street specialist. He told Carry that the pernicious anaemia contracted in India was at an advanced stage, that there was no cure (the cure would not be discovered for another twenty years) and she had just a few months to live. Determined to see Walter again before she died, she secured a berth on a troopship without telling him, put the children in the care of her unmarried sister Hetty Fenton, arrived in Cape Town and rejoiced Walter's heart by a wire.

Caroline Kitchener was a woman who loved to help others and everyone loved to help her. Colonel Fife of the High Commissioner's staff arranged for

her to go north with the officer carrying Herbert's mail. Seeing how weak she looked Fife provided a nurse to escort her. The railway journey of three days and two nights through Cape Colony and across the devastated Orange River Colony where Boer guerrillas and British columns were operating was a sad experience for Carry: 'it was dreadful to see the dead cattle and sheep.' As the train passed each blockhouse the soldiers would come to the line for books and papers and luxuries to be thrown to them.

At Johannesburg she stayed at Heath's Hotel where she could sit on the veranda and the proprietor took her for drives. On 2 October she wrote to eleven-year-old Hal at his prep. school in England: 'Uncle Herbert came here yesterday and we had a grand lunch together and he was very kind and nice.' Herbert arranged for the best beef to be sent in, to help keep up her strength.

On Sunday 13 October at early church the matron of St Mary's hospital, Miss Lloyd, noticed Carry's prematurely grey hair and 'sweet face' and invited her to tea to see over the hospital. She came on the Monday with flowers and picture books for the wards but feeling poorly. Miss Lloyd and Mrs Kitchener became friends. A week later Carry asked the matron for two special favours: Might she have a private room at the hospital but not be treated as an invalid? And please not to tell the two generals, her husband and her brother-in-law.

She moved in, and 'all grew to love her for her sweet ways,' wrote the matron. Matron summoned Dr Pearce who said he had never seen anyone so anaemic. Evidently, despite Carry's wishes, the commander-in-chief was told, for next she wrote to Hal: 'My dear old Hal, Joy. Joy. Joy. Daddy and I are both coming home and we shall have it for Christmas. O won't that be lovely. Kind Uncle Herbert is giving him three months' leave as soon as ever he comes off his trek chasing Botha.'

But the disease was gaining hold despite all the nourishment and even a primitive (and highly dangerous) blood transfusion. Then came a wire from Walter: he was arriving that night. Carry brightened, with a look of intense joy. He came, and stayed in her room, doing all he could for her comfort, but to his great distress he was too deaf, and her voice too weak, to hear much of what she said. The matron, writing to Miss Fenton afterwards, said she never knew anyone so devoted as the general was to his wife. 'All our generals are heroes but one seldom meets such a perfect man and husband'.

Early on Saturday morning Carry seemed worse. The specialist, Dr Davis, came and warned she had only twenty-four hours to live. Walter suggested another blood transfusion and gave five ounces, which was injected into her

arm. That evening the chaplain brought them Holy Communion with the matron and Carry's special nurse receiving the Sacrament too. Very early on Sunday morning, a smile on her face, Carry died in Walter's arms.

Herbert sent him home on leave to the children. 'Poor boy he is much knocked out by his wife's death.'[12]

On 14 August Kitchener and his staff came down from Pretoria to Pietermaritzburg in Natal for a ceremonial parade to honour the heir to the throne and Princess May, now Duke and Duchess of Cornwall and York, soon to be Prince and Princess of Wales. They were on their way home after inaugurating the Commonwealth of Australia. The Duke of York had first met Kitchener in the summer of 1899 in London, when seated next to him at a dinner of fifty men given by the rich Sir James Blyth in Portland Place.[13] The thirty-four-year-old Duke had invited him to ride in Rotten Row and they became friends, so far as allowed by the wide social gap between royalty and subject.

At Pietermaritzburg the duke pinned some fifty Distinguished Service Orders on gallant breasts and nine Victoria Crosses, including the Brat's, with the citations read in full. Then came a marvellous spectacle when two hundred Zulu chiefs in full war paint advanced slowly in a semicircle, singing a deep-throated battle song, until they stopped before the duke with a thunderous *Bayete!* repeated three times. 'No cheer one has ever heard', the Brat told his mother, 'had the depth, power, and volume of this royal salute, and I would go a long way to hear it again'.[14]

After the loyal address and an inspection, the duke had 'a most interesting talk' with Kitchener at Government House. 'I thought him looking remark-ably fit and well', the duke told the king, 'and he has grown fat', (Kitchener thought the duke looked rather thin.) Kitchener, in great spirits, asked the duke to tell the king that his 180,000 fighting men were in splendid condition and working hard; blockhouses guarded thousands of miles of railway lines at 1,600-yard intervals; 839 Boers had been captured or killed that past week and they must also be getting short of horses. He was directing from head-quarters no fewer than 61 separate columns. He then rushed back to Pretoria delighted with a gold cigarette case and photographs from the Yorks, who returned to Durban and their ship.[15]

The numerous columns, and the peculiar nature of the South African war, caused cavalrymen to rise faster in their profession, and thus to high command

in the Great War, including household names such as Field Marshals French, Haig, Allenby and Byng. The future Viscount Byng of Vimy had a curious personal link with Kitchener. Back in 1890, when 'Pandeli Tom' Ralli had commissioned the famous Herkomer full-length portrait of his great friend Herbert Kitchener Pasha, aged forty (now in the National Portrait Gallery), he also commissioned a smaller Herkomer to hang near it, of his young niece Evelyn Moreton, whose father was Master of Ceremonies at Court: Ralli fondly hoped that the two would marry

No evidence exists that either showed interest in the other. In 1899 Evelyn fell in love with Major John Byng of the 10th Hussars, who went off to the South African war without declaring himself. In 1901 a column commander, he wrote from the veldt asking if she would marry him. She replied by wire: 'Yes, come home immediately. *Evelyn*.' She handed it in at Aldershot near her home. When the telegram reached the army post office in Pretoria and a clerk saw its Aldershot origin and the name *Evelyn*, he jumped to the conclusion that Sir Evelyn Wood, Adjutant-General, was urgently recalling Colonel Byng. The clerk gave an entirely unwarranted top priority to the wire and thus speeded a happy engagement.[16]

Lord Milner landed again at Cape Town on 27 August. With him, also back from leave, came Neville Lyttleton, who had commanded the British brigade at Omdurman and had distinguished himself in South Africa. He was ordered to Pretoria. When he reported to Kitchener he found him in obvious grief because Seymour Vandeleur, one of the most promising of the younger lieutenant-colonels, a good friend at Omdurman and in South Africa, had just been killed defending a train of refugees, ambushed by an Irishman and his gang which both sides looked on as brigands. 'The tears stood in Kitchener's eyes', noted Lyttleton. 'Indeed, on occasions such as this he often showed a real tenderness of heart. At other times he might appear ruthless, but this would be where a question of efficiency was involved.'[17]

The war dragged on. The young Jan Smuts with a small Transvaal commando was causing mild havoc in Cape Colony and had been joined by many Cape Dutch rebels. Transvaalers and Cape rebels alike scorned Kitchener's proclamation threatening banishment for all burghers in arms after 15 September. Milner and the home government had altered the draft in such a way that all but a few Boers ignored it.[18] Then, two British columns suffered minor defeats. Kitchener wrote to Lady Cranborne on 20 September:

Just a scrawl at the end of a hard day's work. I wish I could see the end of it all but when one has done all one can somebody goes and gives one away by losing guns. It is most ///////// you can put in the proper expression. How I wish it was over, I am getting quite worn out but I mean to see it through if the authorities think I am competent.

He enclosed for the Hatfield circle a funny sketch he had doodled of a yeo-manry trooper running away.[19]

He could moan to the Cranbornes but to his staff the Chief kept his com-posure. That very day his senior ADC, Raymond Marker, commented to his sister Gertie that these unexpected and unnecessary reverses were very hard on Lord K, for whom he was very sorry. Marker added: 'He is always wonder-fully even minded over everything and never "murmurs" in any way. At the most merely says — I do wish people would use a little common sense.'[20]

Raymond Marker, always known as Conk, had been adjutant of the 1st Battalion Coldstream Guards in the field when Kitchener invited him to be Jimmy Watson's successor. Birdwood reckoned him 'a *real* good fellow . . . one of the very best one could ever hope to meet, and so able'.[21] He was a Devonian, heir to a fine estate, and had been ADC to the Viceroy, Lord Curzon. Conk guessed rightly that he had been chosen partly to be pumped about India, though Kitchener's appointment as the next Commander-in-Chief was not yet official. Kitchener would ask questions as they rode, and Conk sent for a Hindustani grammar as Kitchener wanted to learn that hybrid of Hindi and Urdu which the Indian Army used. But first they must win the war. Conk wished that the politicians at home, who had never met a fighting Boer or understood the country, would give the Chief a free hand.[22]

The Chief, though he did not show it, was becoming discouraged and depressed. The Boers were 'utter fools' not to give in. He was not fighting a proper war, with pitched battles and front lines, but must catch or kill every man. And people at home were losing patience: the English papers 'help the enemy to keep up their spirits by the hope that we shall get tired and give it up'.[23] On 19 October Roberts tactfully asked, at the Cabinet's request, whether Kitchener would like a rest, lest his health give way and he be lost to future service. Roberts would come back and relieve him. Kitchener, con-scious of rumours that he was to be replaced, replied that if he retained their confidence he wanted to see it through. 'I only fear that there may be something I have not done to hasten the end, and that someone else might do it better. You

know I do not want any incentive to do what is possible to finish. I think I hate the country, the people, the whole thing, more every day.'[24] Milner was privately disappointed that he would stay, because it was impossible 'to guide a military dictator of very strong views and strong character'.[25]

Roberts offered, and Kitchener gladly accepted, to send back to South Africa Lieutenant-General (acting) Sir Ian Hamilton to be Chief of Staff so that Kitchener be less tied to Pretoria.

A Gordon Highlander three years younger than Kitchener, 'Johnny' Hamilton had served mostly in India, although he had managed, when on leave, to take part in the Gordon Relief, where they had first met. In South Africa he had been a survivor of the Majuba defeat in the First Boer War and in the present war had been recommended for the Victoria Cross when in command of a brigade. (The War Office refused to award it to so senior an officer.) He had returned home with Roberts, to whom he was very close, as Military Secretary.

Hamilton arrived at Pretoria on 1 December.[26] By then Kitchener had made four fresh moves.

He extended the blockhouses and connected them by barbed wire and telegraph lines to divide the veldt into vast paddocks which could be swept clean of Boers unable to escape. The land eventually was scarred temporarily by no fewer than 8,000 blockhouses covering 3,700 miles, guarded by 50,000 white soldiers and 16,000 armed African.[27]

He raised two regiments from among the surrendered Boers who were prepared to fight their compatriots in order to end the war more quickly. The National Scouts (Transvaal) and the Orange River Volunteers played a part far more important than their military contribution by gradually convincing the fighting burghers that if peace did not come soon the Afrikaner nation would cease to be one 'volk'.

He changed his policy on the concentration camps. The columns stopped bringing in civilians when an area was cleared. He allowed many in the camps to leave. Thus the Boer commandos were encumbered again with women and children.

He armed native Africans, not only for their protection but as combatants, thus worrying the Boer leaders that the Africans whom they had traditionally mistreated might become a danger after the war.

These four moves marked the beginning of the end.

This was written by Colonel William Staveley Gordon R.E.

The Mahdi's tomb

Height to top of Spear 85 feet

Guncotton placed at
at intervals
⊗ brought down the
domes.

The mahdi was
buried in the centre and his tomb
surrounded by an iron railing –
The base of the tomb was Square
47 feet and the base of the dome
octagonal. Thus –
The octagonal Eventually
developping into a
circle

Swarm of flies!!
can't write

23 feet

Dome

∞ small Tower
like Belfrie

'Monkey' Gordon's own sketch of his plans before demolishing the Mahdi's tomb

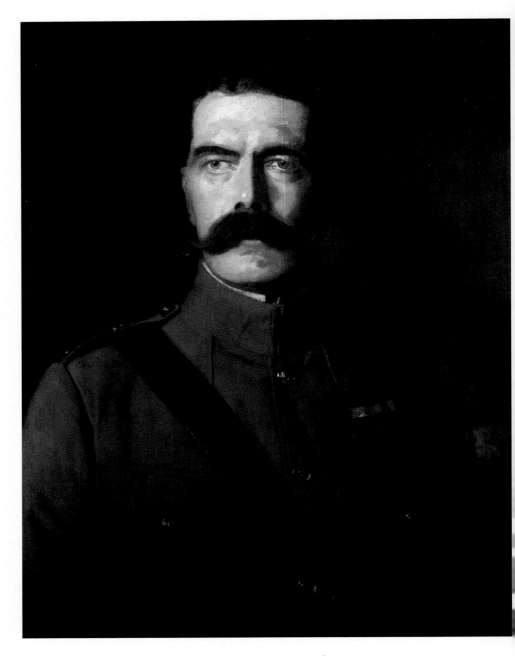

by Heinrich von Angeli
Queen Victoria commissioned the portrait 'which she thinks very like & a very fine picture'

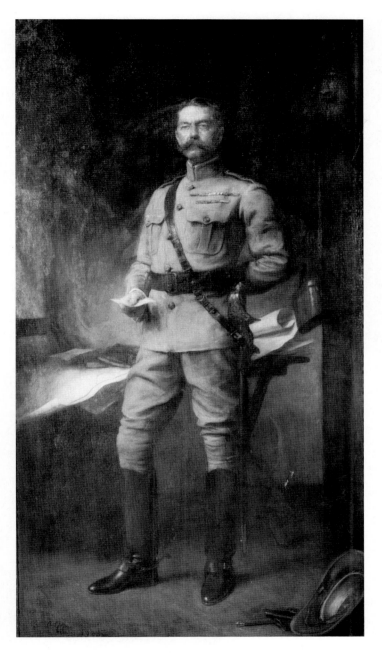

by Sir A S Cope, PRA (sittings 1899, delivered 1900)
Commissioned by the Officers of the Royal Engineers

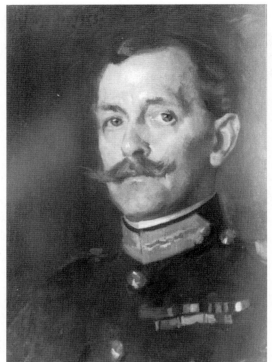

Walter, the youngest brother (Lieutenant-General Sir Walter Kitchener, KCB, 1858–1912) Painted when Governor of Bermuda, by Jongiers, 1910. He greatly admired Herbert yet could laugh at him

His wife Caroline ('Carry') *née* Fenton
Her hair is prematurely grey from pernicious anaemia. She died in South Africa, November 1901, aged thirty-seven

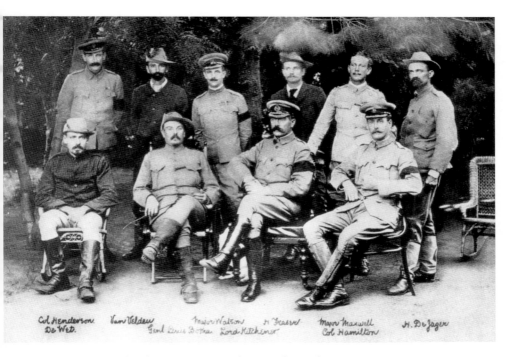

The abortive peace conference of 28 February 1901.
The British government repudiated Kitchener's generous terms.
The Boers used this photograph to 'prove' they had captured Kitchener!

With his ADC Frank Maxwell, VC,
 'The Brat' Riding a hill pony near Pretoria

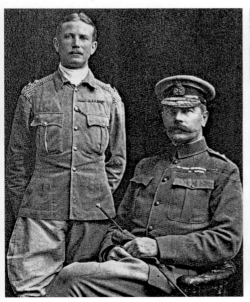

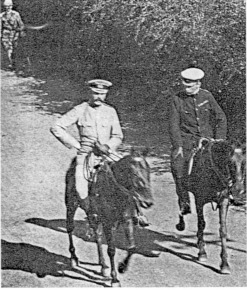

period of years with 3 per cent interest. No foreigner or
rebel will be entitled to the benefit of this Clause.

Signed at Pretoria this thirty first day of May in the
Year of Our Lord One Thousand Nine Hundred and Two.

Kitchener's copy of the last page of
the Peace Treaty [which ended the
War,] with Melrose House where it
was signed

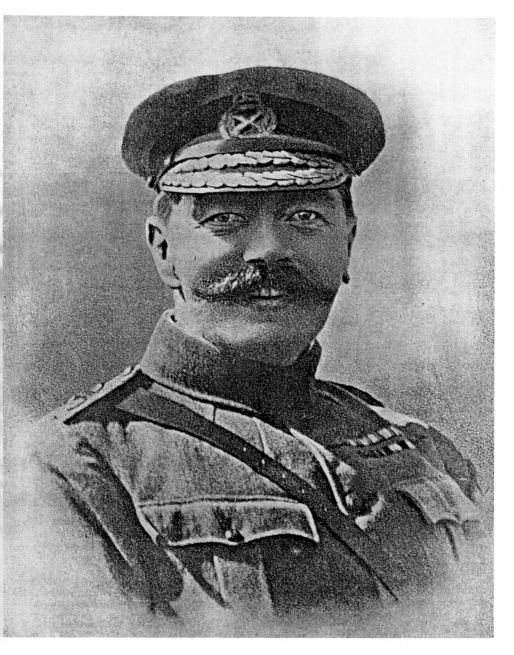

At Southampton, 12 July 1902.
Landing from South Africa he is delighed to see the Cameron Highlanders

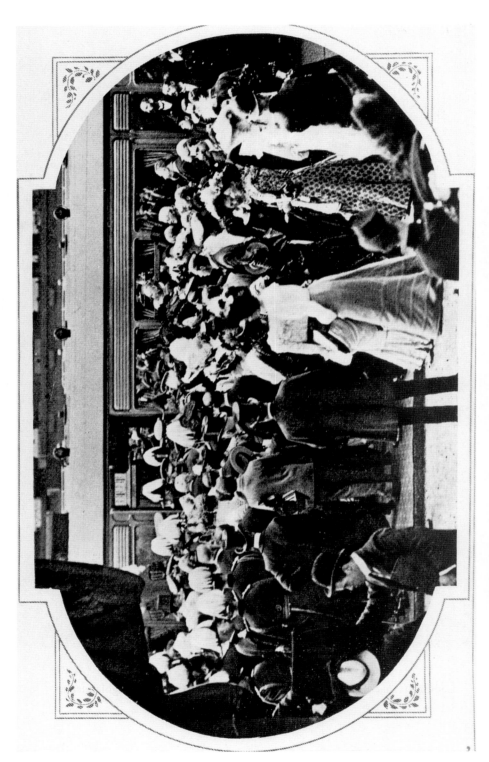

Greeted by the Prince of Wales, Lord Roberts and a happy crowd at Paddington, 12 July 1902

25

1902: 'WE ARE GOOD FRIENDS NOW'

JOHNNY HAMILTON TOOK up residence, along with Hubert Hamilton (Military Secretary, no relation, known as 'Hammy') and the ADCs at the Commander-in-Chief's residence, Melrose House, a large Renaissance-style mansion built by a prosperous general dealer of English descent, George Jesse Heys, who had leased it furnished to Roberts, the principal furniture being mostly reproduction Chippendale and Sheraton. Conveniently near the railway station and with a large garden, it was probably particularly attractive to Roberts in the South African winter because it had electricity and, very unusually, central heating operated by steam, with a system of ventilation for summer.[1] Kitchener took over Roberts's Indian servants and police but brought in a company of his favourite Cameron Highlanders as bodyguard.

At about 5.30 a.m. Kitchener and Hamilton would emerge from their bed-rooms in dressing gowns, unshaven. Hubert and the ADC on duty had already deciphered and arranged the telegrams that had poured in from fifty or sixty column commanders or elsewhere, putting aside, until later, those unconnected with operations. The two generals would then crawl over the maps laid on the dining-room floor, with telegrams and little red flags in their hands, until they knew every position, problem, opportunity or need.

Kitchener would then dictate to the two Hamiltons orders for each of the fifty or more column commanders. The orders were mostly explicit and terse: 'Halt', 'March', 'Attack', 'Make for such-a-place and entrain'. He had all the details in his head and had been thinking out the next moves, even in his sleep.

He did not use the normal method, outlining his wishes but leaving details to the staff or to the discretion of commanders, except for French; he did it all himself, sometimes against their better judgement. Haig complained that Smuts would never have slipped across the Orange River to begin his damaging raid through Cape Colony had not an order from Kitchener caused a ford to be left unguarded.

After the operational telegrams, the two generals disappeared to shave and dress before breakfast with the personal staff and then, for Kitchener, a morning of interviews with departmental heads of the General Staff and of the military government of the Transvaal and the Orange River Colony. Kitchener specially detested the Adjutant-General's questions, which he considered the trivia of military life, and at last handed him over to Johnny Hamilton. Since the Adjutant-General had relished his right of audience with the Commander-in-Chief and hated Hamilton, Johnny thought 'this inspiration sprang from one of K's strongest motives, a love of mischief'.[2] The one caller whom he really enjoyed was his director of intelligence, Major David Henderson. Ten years later Henderson became the army's first director of aeronautics; his enthusiasm for flying may well have sprung from the reflection that had aeroplanes been invented earlier the Boer guerrillas would have been spotted and suppressed (unless they had shot down the primitive aeroplanes).

Last came the representatives of the press. Kitchener knew he should humour them but disliked imparting information since newspapers tended to inflate skirmishes into battles and unfortunate incidents into atrocities, and might always unintentionally help the enemy. The press tended therefore to present 'This commander-in-chief of ours as a cold, exacting, unsympathetic figure, much more given to jumping down your throat then to patting you on the back', as one lieutenant-colonel put it, only to find on being sent to brief him that 'for twenty minutes or so I found myself enjoying the pleasantest interview with a much senior officer than I had ever had in my life. He listened to my exposition . . . occasionally interjected a question or criticism . . . but seemed not in the least displeased when I stuck to my own view. When he dismissed me he spoke in a particularly friendly way, and my experience of him on this occasion was nothing short of a revelation.'[3]

Hubert Hamilton commented to the colonel that the Chief was in one of his good moods. 'You might not always find him so tame.'

After the day's interviews and correspondence, the Chief always went for

a ride, with Johnny Hamilton or Birdwood or one of the ADCs. The whole personal staff would dine with Kitchener before a game of billiards and then, for K, more work, often far into the night. Six of the nine who sat around the dining-table in Melrose House would be killed in the next war. All were devoted to the Chief. Johnny Hamilton, near him in age, perhaps regarded him with admiration tinged with affectionate exasperation rather than with the intense devotion of the younger men. When the serious-minded Hubert Hamilton was killed as a divisional general in October 1914, leaving a wife and small children, his sister, Lady Allendale, told Kitchener that his last talk on leave before they parted 'was chiefly about you, so quiet and intense. The devotion to his chief, of course. The sure appreciation based on the experience of years. And there was more than all this. I think he loved like George Colley loved Lord Wolseley long ago.'[4] Colley, the general killed at Majuba, had been her first husband.

But the brightest spark in the mess was 'the Brat', Frank Maxwell. He quickly got Kitchener's measure:

K is not the purposely rough-mannered, impolite person those who have never even seen him suppose. He is awfully shy, and until he knows any one his manners – except to ladies – are certainly not engaging. He really feels nice things, but to put tongue to them, except in very intimate society, he would rather die . . . I suppose most Englishmen loathe any sort of gush, display of sentiment. K is unfortunately endowed with ten times most people's share of this virtue, with the result that it is almost a vice to him.[5]

Maxwell was a man of intense virility, one of six brothers in the army, a fine polo-player and shot as well as a first-rate soldier who wore the VC and the DSO. He was always cheerful and humorous and had a quiet, deep Christian faith. Kitchener treated him as a son. If the Chief were wrapped in gloom, with his facial disfigurement more like a scowl than ever, the Brat could coax him out of it. Sir Ian Hamilton recalled how, like the young David in the Bible, the Brat could 'play the harp to our Saul without ever once striking a note of discord'. He could say what he liked to K, 'and the more cheeky the better it went down. Often we all trembled, but the awful scowl melted always into a chuckle and the javelin was never hurled.'[6]

The Brat and Marker got up a polo team on a new ground laid out by another ADC, Ferdy Stanley, Lord Derby's son, 'much assisted by Lord K

with hints and advice. He takes a keen interest in polo.'[7] He played occasion,
ally, but because of his bad eyesight his team would generally lose.

The Brat kept his parents amused with many stories of his Chief, such as
that of the starlings.

The Chief always liked to have dogs around and was fond of horses, but
he had not been known as a bird,lover until one morning, early, Frank
Maxwell entered the room to find him in his dressing gown, hair unbrushed,
darting about the room trying to catch two young starlings that had fallen
down the chimney.

> We caught them after a heated chase, and deposited the poor little beggars
> in the wire pigeon,house in the garden. Then there was much fuss all day
> about their food and the good man would leave his important duties every
> half hour to see if I had given them meat or procured succulent worms, and
> bustle in and say they were starving. It was no use pointing out they hadn't
> learnt to eat by themselves yet or that the pigeons wolfed any food put in for
> the infants. The poor parents were in great distress, flying round and round
> the cage, but at length got bold and fed the little things through the wire,
> which interested the Commander,in,Chief so much that the operations in
> South Africa received no attention most of the remainder of that day.

Next morning the Chief noticed a third young starling flying around in the
garden and ordered the Brat to catch it. Since protests of inability were always
lost on K of K, the Brat sneaked out of breakfast, took the four,foot,high sham
stork from the hall, placed it in the cage and lost himself. 'The joke came off
A1. He was fairly drawn, laughed much, said I was an impertinent beast, and
hasn't murmured a word about catching any more third birds.' During the day
the C,in,C would frequently leave the war to visit the cage, chirping at the
birds or trying out his new,learned Hindustani phrases.

One bird died. The other grew up, but, when Kitchener was away on tour,
it escaped. Hubert Hamilton was thrown into gloom and eventually decided
that the awful news should be broken by telegram. The Brat composed and
sent: 'C,in,C.'s humming bird after being fed by a Highlander this morning
broke cover and took to the open. Diligent search instituted. Biped still at
large. My. Secy. desolate. ADC in tears. Army sympathises.'

When the Chief returned he hurried through two days' telegrams, sum,
moned ADCs, servants and orderlies, and rushed about the garden, several

times falling into wet flowerbeds, until lunch, which he ate dishevelled, remarking, 'I've never been so fond of that bird as since it's been loose'. It was eventually captured in the chimney of a neighbouring house, minus its tail. The Chief could again be seen in leisure moments spouting Hindustani at a starling.[8]

The most perceptive study of Kitchener's personality at this time comes from a letter written by Conk Marker to his sister on 17 January 1902. He had been on tour with the Chief, including inspection of a concentration camp, where they found conditions now satisfactory and the male internees eager to persuade the remaining Boer leaders to come in from the veldt to make peace. Conk had told Gertie that the blockhouse lines in the Orange River Colony might soon end the careers of De Wet and Steyn, and he went on:

> It has been a very great pleasure to read the appreciation of Ld. K in the recent speeches of Ld. Rosebery and Mr Chamberlain. Six months ago I felt that the Government did not in the least appreciate his gigantic work, but I think now they are beginning to get a glimmering of what a great man they have got out here. In this age of self-advertisement there was always a danger that Ld. K with his absolute contempt for anything of the kind, and his refusal to surround himself with people who attract attention, would not be appreciated at his real value, but I think the country recognizes him now.
>
> The more I see of him the more devoted I get to him. He is always the same — never irritable — in spite of all his trials, and always making the best of things however much he may be interfered with. As Chamberlain said, to praise him is almost an impertinence.[9]

A comment by Kitchener to Arthur Renshaw, at the end of a letter concerning investments, sums up his feelings more succinctly than his detailed letters to Brodrick or Roberts. 'It is a horrid nuisance', he wrote on 26 January 1902, 'these Boers will not give up. They have no chance of success and very little hope but like Banditti they can still hop down on any weak column that is not looking out and our people *will* go to sleep if they do not see an enemy. Most annoying.'[10]

But on the day before he wrote, the Dutch government, in touch with the Boer exiles including Kruger, offered to mediate. Lord Lansdowne refused: terms of peace must be discussed by the commanders on the field. Kitchener

received the correspondence on 4 March after two successful drives in the Orange River Colony, although De Wet once again evaded capture. He sent it immediately, as instructed, to Schalk Burger, Acting President since Kruger's departure for Europe, of the South African Republic. In Boer eyes the Crown Colony of the Transvaal did not exist.

Kitchener waited for Burger's reply. Then a most alarming telegram came: Major-General Lord Methuen had been defeated, wounded and captured with most of his men at Tweebosch in the Western Transvaal by de la Rey. Kitchener was devastated. Methuen was handed back very soon, but this defeat at such a critical moment 'floored poor old K more than anything else during the campaign, and he didn't appear at five meals', as the Brat wrote home. The Chief continued to work from his room, for he gave orders and wrote a long letter to Roberts, but he was distraught at the prospect of the Boers now fighting on: army reform at home would be delayed, more money would drain from the exchequer, the United Kingdom almost denuded of troops, Germany and Russia encouraged to scorn British strength. Moreover the king's coronation and Kitchener's own departure for India would be delayed. At last, after forty-eight hours, he appeared for breakfast. He remarked that he believed his nerves had all gone to pieces. Ian Hamilton had detected that though Kitchener was 'impassive as a rock in appearance, he was really a bundle of sensitive and highly-strung nerves kept under control 999 hours out of 1,000 by an iron will'. A very sound breakfast, the Brat told his father on 16 March, 'was the end of the slump in his spirits, and he is, and has been, as right as possible since'.[11]

Vice-President Burger was too much a realist to be deceived by an unexpected local victory. His reply stated that he would like to offer terms of peace but must first confer with President Steyn (Orange Free State). Kitchener was not optimistic because Steyn and his commandant-general De Wet were more bellicose than the Transvaalers. Before they hunted for Steyn under British safe-conduct, Kitchener made sure that Burger, Botha and their small party were brought to see him as they passed through Pretoria. They gave nothing away at Melrose House but were deliberately treated as honoured negotiators, not defeated suppliants. Kitchener even arranged that the wife and daughter of one of them, 'tubby little Krogh', should be in the garden to greet him; at a later meeting Botha introduced his ten-year-old son.[12]

Thus began thirty days of negotiations, Boer with Boer, Boer with Kitchener and Milner; and, in effect, Kitchener against Milner.

Twenty years later, in 1922, three years after the Peace of Versailles which Kitchener had not lived to influence, Sir Ian Hamilton was unveiling a war memorial in Scotland. 'How is it', he asked, his rhetoric not masking the fundamental truth,

> that the Boer War put an end to the feuds, race hatreds, bankruptcies, disorders and bloodshed which had paralysed South African progress for a generation, whilst the Great War has on the contrary inflicted race hatred, bankruptcy and murder over the best part of the old world from Ireland in the West to the Near East . . . ? I'll tell you why it is; it is because our Politicians entirely ignored the ideals of those to whom we have raised this memorial by making a vindictive instead of a generous peace . . . it was only by fighting those rulers for half a year that Lord Kitchener forced them to make a good peace in South Africa. Indeed, so few seem to realise it now that I feel it my duty, as Lord Kitchener's Chief Staff Officer that was, to keep the fact in being, alive. Lord Kitchener forced them to make a good peace in South Africa. For six months Lord Kitchener fought the politicians who wanted to make a vindictive peace, an 'unconditional surrender' peace as they called it, a peace which would above all things humiliate and wound the feelings of the conquered. They were death on this, I promise you. Well, Kitchener fought them fairly with one hand whilst he fought the Boers with the other, – and he beat them both. He beat them and made his own peace; a generous soldierly peace. He lent the Boers money; he rebuilt their farms; he rebuilt their dams; he re-stocked their farms. He always said; 'We must not lose one moment setting business on its legs again, otherwise South Africa will be ruined and many of us with it.' What has been the result? The war lasted three years; South Africa was more completely ruined than Central Europe; hate was stronger than it is in Germany:– and yet, within one year South Africa was smiling and so were we.[13]

Kitchener's magnanimity was neither merely pragmatic nor a cynical ploy but arose from the deepest recesses of his heart, informed by his Christian faith.

On 12 April twelve Boer leaders representing both republics conferred with Kitchener at Melrose House. On the first day, by order of the Cabinet in London, Milner was excluded: Hubert Hamilton was present as a witness because Sir Ian was in the Western Transvaal commanding five columns in a

drive planned in great secrecy: Kitchener explained the scheme on the ground to the column commanders, including Walter. The drive had ended the day before with a crushing Boer defeat at Rooiwal, where Commandant Potgieter died in a gallant, impossible charge.

At the Pretoria meeting on the next day, when Kitchener showed surprise that the Boers should ask for independence, and President Steyn interjected that the people must not lose their self-respect, Kitchener replied that there could be no loss of self-respect for men who had fought so bravely.

He advised them to accept the British terms and bargain later for self-gov-ernment. Hubert Hamilton told the Brat that 'K did the business extraordi-narily well, they were all afraid of him and respected him tremendously'. The two presidents had tea with him the next day, Sunday, and on the Monday Milner arrived and terms continued to be hammered out. Milner complained that Kitchener, though 'extremely adroit', did not care how much he gave away, even willing to name a date for self-government;[14] Milner was still manoeuvring for unconditional surrender. Kitchener told Lady Cranborne that the Boers had 'a deadly loathing for Milner which makes it difficult at times as he realizes how much they detest him'.[15]

While waiting for the Cabinet's reply to the terms agreed, the ADCs took the Boer leaders to watch them play polo, which was much admired, Milner and Kitchener both coming too. The Cabinet sent a good reply, and on Friday 18 April the Boers left Pretoria to put the terms to the commandos in the field, which would take three weeks at least. Kitchener gave safe-conducts for dele-gates but firmly refused an armistice. Drives maintained the pressure to early May.

On 15 May sixty Boer delegates met under British protection in a large marquee at the border town of Vereeniging, where the railway crosses the Orange River from the former Free State into the Transvaal, about sixty miles south-east of Pretoria. Through his director of intelligence (Henderson) Kitchener kept abreast of the debate: Botha speaking strongly for peace as the only alternative to the ruin of the Afrikaner nation; de la Rey, with all the pres-tige of his defeat of Methuen, stunning the delegates by his conversion to peace, 'lest the door be bolted in our faces'. The conference would not accept the terms as they stood. They therefore appointed a commission of four, led by Botha, to negotiate further at Pretoria. For two days British and Boer wrestled verbally at Melrose House. At one point, when General De Wet became so obdurate that Milner was a about to break off negotiations (and resume his

campaign for unconditional surrender), Kitchener cannily suggested that the military members withdraw and leave the lawyers to work out the point – and thus removed De Wet from the discussion. At another critical moment Kitchener drew Smuts aside in the open air and confidentially gave his personal opinion that in two years the Conservative government would fall and the Liberals come in. The Boers had been deeply touched by the Liberals' sympathy over the camps, and believed that the Liberals would be more willing to hasten self-government. Kitchener's intervention was decisive. 'That', said Smuts afterwards, 'accomplished the peace'.[16]

Smuts, thirty-two years old that week, had been born in Cape Colony and worked with Cecil Rhodes until transferring his allegiance to Kruger after the Jameson Raid. He had been a brilliant commando leader but now was ardent for reconciliation. Thus Botha, Smuts and de la Rey out-argued De Wet and won over the wavering Hertzog.

The commission returned to the Assembly of the People at Vereeniging and presented the ten articles 'to terminate the present hostilities'. The Boers would agree to lay down arms and become subjects of King Edward VII. No one would be prosecuted or sued except for criminal acts contrary to the usages of war. Dutch would continue to be taught where desired and used in administration and law alongside English. Civil government would replace military 'at the earliest possible date' leading up to self-government. However, 'the question of granting the Franchise to Natives will not be decided until after the introduction of Self-Government'. Kitchener had striven for a franchise at once, since otherwise it might be postponed indefinitely, but had to concede the point.

The most generous clauses came last: no levy would be imposed to defray the costs of the war, in stark contrast to the vindictive reparations that Versailles would impose on the defeated; and the British government would give the then very considerable sum of three million pounds sterling, together with loans, to aid reconstruction.

The delegates took the terms back to Vereeniging. They were debated long and hard until the late afternoon of Saturday 31 May 1902, when the Assembly agreed to the treaty by fifty-four votes to six, in a resolution that amounted to acceptance under protest, with side-swipes at British barbarity.

The result was wired to Pretoria at 3.30 p.m. with a request that it be kept secret until signed, and not signed until the Monday. Kitchener and Milner rejected delay: the treaty must be signed that night.

Burger, Botha and eight others were 'bundled into a train', as Frank Maxwell put it, brought up to Melrose House at 10.30 p.m. and taken to the dining-room, which the patent steam heating made warm on that autumn night of 31 May 1902. They asked to be left alone to reread the typed document and were given three minutes. Then Kitchener and Milner came in and sat at the head of the heavy dining-table (which now bears a plaque) with the six Transvaalers on one side, next to Milner, the four Free Staters on the other, next to Kitchener.

Four copies — one for the king, one each for the archives at Pretoria and Bloemfontein, and one for Kitchener — lay on the table, of a four-page document merely headed *Army Headquarters, South Africa*. Acting President Burger signed first, the Boers signing on the left of the last page, Kitchener and Milner on the right.

A stunned silence followed. Milner sat impassive. As the Boer leaders rose to leave, Kitchener went round giving each a handshake and saying, 'We are good friends now'.[17]

26

LOOKING FORWARD

CONGRATULATORY TELEGRAMS and letters poured in. 'Perhaps', wrote one friend, 'the greatest thing about it, is the way in which you have succeeded in conquering deep seated animosities and making the end radiant with the spirit of conciliation and goodwill.'[1]

Six days after the signing Kitchener received a telegram from the Prime Minister offering him a viscountcy. He accepted gratefully and asked if the patent of this peerage might include a special remainder to his two nephews in succession (if the elder had no male heir). Kitchener backed his request by a telegram to Salisbury's long-serving Private Secretary, Schomberg MacDonnell, who had also fought in South Africa in the early months of the Boer War and would be killed on the Western Front thirteen years later. Kitchener's telegram caused amusement at Downing Street, for after thanking MacDonnell for his congratulations he wired: 'Arrange if you can what I asked Lord Salisbury as I do not want at all in order to keep title in family to have to take a permanent encumbrance.'[2]

Salisbury minuted in red ink, in his now shaky handwriting, 'Does he mean a wife?' MacDonnell minuted back: 'The "encumbrance" to which K alludes is certainly a wife!'

In sending on the request to King Edward's Private Secretary, MacDonnell wondered whether, until Kitchener 'reaches an age when his celibacy seems more assured it might cause inconvenience to give remainder to his nephews'? He added that Lord Salisbury regarded Kitchener as 'a confirmed celibate' and that since both Wolseley and Roberts had peerages with

special remainders to daughters it would be a gracious act for the king to bestow a similar favour.[3]

The College of Arms objected that a generation could not be skipped: in default of sons or daughters of his own, the peerage must go in succession to brothers and their male offspring. Schomberg wired to Kitchener for details and was given the names of Chevallier and his son Henry (Toby), who was nearly twenty-four and in the Navy, and Walter, whose only son, another Henry (Hal), was nearly twelve. 'I have one other brother between the two, Arthur Buck Kitchener, but as he is not in the Service, and is not likely to have children, I think he might possibly be omitted unless there is any legal desirability for putting him in.'[4] They were on affectionate terms but Arthur had married, in 1898, a middle-aged spinster, Edith Paterson from Melbourne, a novelist and spiritualist who held seances at Waihemo Grange before they left New Zealand for England. If Chevallier and his son should be dead, Herbert had no wish for the peerage conferred for military achieve-ment to stick on a civilian before Walter could have it. However, Arthur was the first of the brothers to die, in 1907, followed by his widow in 1908.

The peerage was gazetted, with the special remainder omitting Arthur, as Viscount Kitchener of Khartoum, and of the Vaal in the Colony of the Transvaal, and of Aspall in the county of Suffolk.[5] Kitchener was even more grateful to be promoted to full general in the army 'as it completes the series of my ranks from Captain on, having all been obtained by brevet for active service'.[6]

On Sunday 8 June Kitchener attended early Holy Communion celebrated by the Archbishop of Cape Town who had reached Pretoria in the middle of the night. Then followed a great peace parade of more than five thousand men, eleven bands, all Pretoria church choirs and one from Johannesburg, one arch-bishop, two bishops and parsons from all denominations. The Chief deco-rated nurses and nine VCs and a Thanksgiving Service then followed. Nine days later the Chamber of Mines and Commerce gave a great banquet to Milner and Kitchener. All differences were forgotten. 'Milner made an A.1 speech, *most* generous to K.', recorded Frank Maxwell in his diary. 'K. made an even better one and did it splendidly. Everybody, delighted – a most success-ful evening.' The following day Kitchener spoke at Johannesburg, ending with a resounding tribute to his late enemies.

Three days later he and his staff left Pretoria through streets lined with

troops presenting guard as his carriage passed. Arms of Honour were drawn up at each station the train steamed through , and at Kroonstadt came a typical K. incident.

His train had stopped. At the opposite platform stood a train full of troops going north to the front for routine guard duties. Recognizing his carriage, they began to shout, 'We want the Chief! We want K!' Kitchener looked embarrassed and shy and remained seated. A senior staff officer said, 'Don't mind, Sir, these are only the troops shouting'. But the Brat, with sure instinct, dashed up to the Chief. 'These men want to see you, Sir! We are going home. They are going back.' And on the instant Lord Kitchener went out with Maxwell and along the troop train, receiving a great ovation.[7]

Kitchener sailed from Cape Town after a resounding civic farewell. No doubt he had trophies and booty in his baggage like any victorious general, but he had not yet seen a magnificent gift from a South African.

Sammy Marks was a Jewish industrialist of great wealth and wide interests from agriculture to coal mining: his company had founded Vereeniging to exploit coal seams. Before the War he had commissioned from Europe a great bronze statue of Kruger, who chose a young sculptor, Anton van Wouw who went to Italy to supervise the casting by Francisco Bruno. Using Neapolitan fishermen as models van Wouw also sculpted four supporting figures representing Voortrekkers in typical attitudes. He had intended to present the whole group to the city of Pretoria. The statues had arrived in packing cases at Lourenço Marques harbour in Portuguese East Africa, where they stayed throughout the war. In June 1900 Marks had encouraged the start of the guerrilla war, but by February 1901 he was active in promoting Botha's peace talks. The longer the war continued, the more he deplored the refusal of Kruger in Europe to advise the Boer leaders in South Africa to accept that the war was lost and to make peace. He transferred his admiration from Kruger to Kitchener. After the signing of the peace he approached him and offered the four Voortrekker figures as a free and personal gift: Kruger should be erected in Pretoria in due time but without the magnificence conveyed by the supporting statues.

Kitchener accepted and arranged for them to be shipped from Lourenço Marques to England. Two could form part of a Royal Engineers South African War Memorial at Chatham and two would grace his park when he bought an estate: he had received another Parliamentary grant which Renshaw

would invest wisely. Through Renshaw he had already made on abortive enquiry from Pretoria about Rothley Temple, since the man who had bought it from Harry Parker, when he and Millie had returned to New Zealand, had apparently left the district.[8] The Parkers were no longer well off. Herbert had brought one son into the Egyptian Army and had paid for a daughter's education at Cambridge.

The statues reached Chatham during 1902 and were placed at temporary sites. When Kitchener bought the Broome estate in 1910 he chose two, which were erected in 1913; the other two he gave to the Royal Engineers to form part of their memorial. The government of the new Union of South Africa had tentatively asked for the statues, but no action was taken because they were not loot but a gift to Kitchener from their rightful owner.

By then, opponents of Kitchener in his controversy with Curzon in India had spread the rumour that he had removed 'statues of Kruger and other famous Boers from public squares in Bloemfontein and Pretoria'. This libel crept into biographies, although the true facts were easily obtainable and the figures had never been unpacked from their cases until they reached Chatham.

In 1921, five years after Kitchener's death, his nephew Viscount Broome, who had inherited Broome Park, visited South Africa with his wife, saw the Kruger statue in Pretoria (erected in 1913) and met General Smuts. Lord Broome consulted the Royal Engineers and together they decided to present their statues to the city of Pretoria. The Colonial Office arranged transport to the Union. Years later, after her husband's death, Lady Broome visited Pretoria and saw them at the four corners of the Kruger Memorial 'and recognized our dear old lead [sic] friends from Broome'.[9]

Kitchener landed at Southampton on Saturday 12 July 1902 to a tremendous civic and popular welcome. He had sailed from Cape Town on ss Orotava with French, Ian Hamilton, Rawlinson and his personal staff. His beloved Cameron Highlanders had arrived too late at Cape Town to sail with him. Their ship later passed his at sea. He had Orotava's captain signal to ask for their transfer, but wireless telegraphy was still a few years in the future and the lamp signal went unnoticed. When he found them drawn up on the quay at Southampton with other troops, his great smile of pleasure was caught by a photographer using the new fast film, to become almost the only public photograph of Kitchener with a smile.

After the mayor's address he boarded a decorated train with the generals and

staff. The engine carried a great K on its front; its journey was among the first public events to be recorded on film. People crowded the platforms at every station passed. At Basingstoke the special train stopped for another mayoral address, then was diverted from the usual boat-train route to arrive at a beflagged Paddington Station at ten minutes to two. The Prince of Wales and his uncle the Duke of Connaught went on board to greet Kitchener and the other two generals 'all looking very fit and well'. More royalty, and Lord Roberts, were on the platform. When K of K saw the Mayor of Paddington, he asked, 'How is the dam?', for Sir John Aird was head of the civil engineering company build-ing the Aswan Dam, made feasible by the victory of Omdurman, now nearly four years ago. While Sir John read his mayoral address Kitchener fidgeted.

Then came the drive through London. The Prince of Wales wrote in his diary: 'He got a tremendous reception from thousands of people, the whole route from Paddington to St. James was lined with troops including the Indians, and Colonials who looked splendid.' They were still in London awaiting the coronation, postponed by the king's appendicitis operation: the stands along the processional route were freely used by the public. Both Birdwood and Rawlinson caught a glimpse of the wives they had not seen for three years. As the procession passed Buckingham Palace, not yet refaced with grey Portland stone, Queen Alexandra, the Princess of Wales and other royal ladies watched from the centre window.[10]

For Kitchener, hating fuss, this magnificent reception was a sore trial. He looked grim as he tried to suppress emotions that might cause him to burst into tears. George Arthur wrote two days later to his friend in Paris that he expected that at heart K 'really appreciated the warmth of it but unfortunately he is constitutionally unable to show that he enjoys anything like a noisy welcome'.[11]

At St James's Palace the Prince of Wales was host at a luncheon for fifty in honour of the returned victors. Then the Duke of Connaught took Kitchener up the Mall to Buckingham Palace for an audience of the king, lying in bed. To mark his coronation King Edward had founded the Order of Merit, an honour without title, to be limited as originally constituted to six generals, six admirals and twelve civilians chosen for their contribution to science, literature or the arts. The king fished the insignia from behind his pillow and delighted Kitchener by saying that he was the first to be invested.[12]

The next three months were spent partly in London on official work, such as completing his dispatches, testifying before the commission on the war,

consulting with the India Office, and forming his staff as Commander-in-Chief, India, to include Birdie, Conk, the Brat and other devoted men; partly in country-house visiting; and, too frequently for his taste, enduring public occasions in his honour.

While in London he lived as before at Pandeli Ralli's house in Belgrave Square, along with the Herkomer portraits. If he walked out he was recognized and mobbed,[13] but he rode on Rotten Row, once with the Prince of Wales whose horse that day, to mutual amusement, was K of K,[14] and several times with Arthur Renshaw, discussing K's portfolio. Renshaw had recently married at the age of forty-eight. He and his brother had gone fishing in Ireland where both fell in love with the red-headed barmaid at their inn, only to discover that she was Lady Winifred Clements, sister of the young local landowner, the Earl of Leitrim, who was away at the war. Arthur won her, and when their son Tom was born Kitchener gladly stood godfather by proxy and took much interest in his godson. Like her husband Winifred became a great friend. Herbert Kitchener could relax with her sense of humour and uninhibited Irish ways and appreciate her wise head. He would bring their children presents and play trains on the floor with Tom. Lady Winifred grew to know the real Kitchener and was a doughty defender of his reputation until the end of her long life.

That summer of 1902 Walter and Herbert stayed at their mother's ancestral home, the moated manor at Aspall in Suffolk: the oriental rug that K gave to his Chevallier cousins was still on the floor in the last years of the century.[15] K stayed at Hatfield, as on every leave. The old marquess was ageing and had resigned the premiership the day before Kitchener had landed; his nephew, A. J. Balfour, had succeeded him. Kitchener stayed again with the Grenfells at Taplow Court. Julian, now fourteen, was home on Long Leave and wrote down his impressions on his return to Eton: Lord Kitchener looked just the same except more sunburned.

> When I asked him about South Africa he told me without the slightest 'swagger' or self-praise; in fact, I think modesty is one of his greatest qualities: he said he was very glad to get back to England again . . . Whatever was going on he seemed to pay the greatest attention to it, even if it was not of the slightest importance. He saw me catch a pike once, which got into a deep bed of weeds and took a very long time to land, and proposed that we should get up early next morning and see

if we could have any luck. The next morning there was a high wind and frequent showers of rain, an ideal day for fishing, but one when most people would prefer to be in bed. He was dressed before the time, and came to my room when I was still in bed. We managed to land two nice fish that morning, and Lord Kitchener seemed very pleased; while he could not help laughing as he just slipped the landing-net under the biggest we had yet seen and it gave a sharp turn, made a frantic push and broke the line.

'Lord Kitchener', added Julian inconsequentially, 'cannot stand two things – state dinners and being photographed.

'I think it would be very hard to find a man in whom there is so much will and so much ability to carry it into execution, and who in addition is so modest, so interested, and so clever and amusing.'[16]

Julian Grenfell was Kitchener's page at the delayed coronation in August. Shortly afterwards Lord Kitchener presented the Boer leaders Botha, De Wet and de la Rey to the king at Cowes at the time of the Coronation Naval Review. They had come over hoping to increase the indemnity promised in the treaty. The Prince of Wales wrote to his wife with unintended snobbery: 'They seemed quite decent sort of people but distinctly common, but were very civil and nice.' They wore frock coats and high hats!'[17] Kitchener did all he could to make the Boers welcome, and they received much applause from the crowds.

After the coronation and the review he visited several great houses, such as Wynyards, Welbeck and Knowsley, then at the height of their glory, with scores of well-fed indoor and outdoor servants, their ducal or noble masters the centre of the political and social life of their counties. The strongly hierarchal structure of the English class system still had twelve years to run before the Great War brought great changes.

Earl and Countess Cowper invited him to Wrest, their curious Italianate villa up a long avenue in a beautiful Bedfordshire landscape. The old earl, a Knight of the Garter, was a great-uncle of Etty Grenfell and a cousin of Alice Cranborne. In the large house party which included the new Prime Minister, was a diarist, Adolphus Liddell, a middle-aged bachelor barrister in the Lord Chancellor's office who knew everyone and was asked everywhere. He liked to study in detail those he had not met before, and he noted in his diary at Wrest: Lord Kitchener the lion.

He has a curious face, something of the bulldog and something of the man of intellect, a long upper lip and huge moustache, which makes his strong chin look quite small. The whole skull is massive, and the bones of the brow are singularly prominent, so much so that in profile the upper part of the forehead seems to recede, though in full face the brow is wide. In repose there is rather a rough, heavy look about him, but his face lightens up strongly when he smiles, as is often the case with big men. His eyes are clear and alert, and his figure strong and youthful. He never held the floor, and did not talk much unless questioned, when he answered generally from a stock of platitudes about the war, which he seemed to keep for fashionable consumption.[18]

The lion went to Balmoral. 'We had a deer drive to-day', he wrote to Arthur Renshaw. 'The three first drives were blank and at the fourth and last I got a stag, the only one shot – not a bad beast. I hit him twice first in the chest at about 200 yards, then at 150 yards right in the centre of forehead which floored him. I like stalking better.' He added that Balfour was taking him to stay at his home in the Lowlands next day and that the king was wonderfully well.[9]

Interspersed with these delights were the sore trials of public dinners and presentations, including a Sword of Honour from South Africa. If a livery company or city fathers wished to give him their freedom he would bargain. He did not want the usual ornate gold casket of elaborate design, which would spend its days in the bank. He asked for gold cups, or saltcellars or other collections to grace his table in India. The man who had won the Sudan by calculating every penny wanted value for fame. This bargaining caused considerable ill feeling and grumbles about greed. Moreover he hated making speeches: he would get Ian Hamilton to draft them, then learn them by heart. If, as on one occasion, the gift was different from what he had been led to expect, and his prepared speech useless, he bowed, said Mr Joseph Chamberlain being more eloquent should speak at once, and sat down.

At Sheffield he was about to be presented with a magnificent service of silver plate before a distinguished gathering. Hamilton, beside him recalled:

We were all up on the platform 'on view'. So also were the plates. The applause had died away and now we were only waiting awkwardly for an aged duke to bring himself to the moment when he would begin his

speech. K was very nervous but kept encouraging himself by looking at the plate.

'What do you suppose one of those plates would weigh?' he whispered to me.

'Half a pound,' I hazarded.

'Great Scot, man!' he exclaimed. 'They weigh three pounds if they weigh an ounce. Pick one up and see.'

I was seated next the plates and so I took one up delicately between fore-finger and thumb and had just balanced it when, in one flash, a shout of laughter shook the hall to its foundation. The people simply rocked with laughter. No one on the platform knew what had happened except the two of us and, if I was blushing, K was as red as a beetroot! He simply could not understand that anyone should think our close and obvious interest in the face-value of the gift was either amusing or in any way out of place.[20]

In October Kitchener slipped away from Victoria Station, refusing the official farewell which was customary for Commanders-in-Chief designate, and crossed the Continent while the staff and baggage went round by sea. On Tuesday 27 October he was in Cairo, where he was met by Wingate, now Sirdar of the Egyptian Army and Governor-General of the Sudan. They journeyed south by river and rail to fulfil Kitchener's dream – the opening of Gordon Memorial College.

Lord Edward Cecil told his sister Alice: 'From the moment we started from Cairo K. informally but firmly annexed the Sudan.' 'Nigs' Cecil was amused in his sardonic way to see Wingate, his present master, deferring to Kitchener at every point as if he were still governor-general. They inspected the construction site of the Aswan dam, still far from completion, and they landed on Kitchener Island, where Kitchener directed young sapper officers in laying out the measurements of a house. Cecil was amazed, because accord-ing to Cairo gossip Kitchener had sold his island. He had indeed put it on the market when India was confirmed, and had accepted an offer from George Denison Faber (later Lord Wittenham), MP for York, a rich banker and sup-porter of grand opera and of the turf, who had recently given far more for the Derby favourite than his offer for Kitchener Island. But Faber had not paid up, querying this and that. In September Kitchener had thought the sale might not come off, and Faber had still not paid when Kitchener had left Cairo.

But instead of giving the facts, Kitchener's sense of mischief made him pull the puzzled Cecil's leg when he 'ventured to enquire', as he told Alice, 'how the general impression, which was shared by the would-be purchaser, had got about that he had sold his island'.

'There are three,' said K., 'and the one I sold is the small one lower down the river.' 'What, the black rock,' I most incautiously said (it is not 30 ft. square and has a solitary thorn bush on it). 'The smaller stony one,' corrected the Great Man. Curiosity overmastering my terror, I asked if the purchaser had understood this. 'Not at first,' said K. indulgently, 'but I explained it. Besides, he has a son in the Hussars.' The subject then dropped.' [Faber was childless.][21]

After they crossed the border into the Sudan, 'We have lived under a merciful despotism', recorded Cecil. 'Everyone in turn has had the errors of the last three years clearly but kindly explained to them . . . "Ah, Kennedy, I thought I told you to build these houses two stories high." A hurried explanation. "Yes, a very great mistake. Quite spoilt, but they can be pulled down later." Such is the ordinary type of conversation I listen to.'

The ex-Sirdar's criticisms, however, were constructive. He told Reuter's correspondent of his pleasure at the progress. The mass of ruins of three years earlier had become a rapidly rising city with fine buildings, avenues of young trees and an immense future, under the skilful eye of Lieutenant M. R. Kennedy, one of the finest young engineers the corps had produced.[22]

Kitchener stayed at the palace, now complete. The ADC, Captain C. E. C. G. Charlton of the Royal Horse Artillery, 'had never met him before and had always heard that he was a silent, taciturn man. But on this occasion at least he was in great spirits and ready to chaff and joke with us junior officers.'[23]

He opened Gordon Memorial College in its new brick building with due ceremony on 8 November 1902. Cromer had found a young Scottish educationalist, James Currie (afterwards Sir James), who was not only the first principal of the college but director of education, steadily placing primary schools throughout the Sudan. Kitchener was impressed, saying the growth of education was 'a most essential factor in opening up the country'. In future years he read the annual reports and sent encouraging messages to Currie through Wingate. He aimed for higher education provided, he would write from India, that it avoided creating 'the dissatisfied educated class we suffer from here'.[24]

His hopes for a medical college were fulfilled by the Sudan's choice of his own memorial. Gordon truly avenged, Kitchener left Khartoum on 11 November 1902.

Back in Cairo, where he was fêted by the khedive, 'that beast Faber has at last paid up after giving us an enormous amount of bother'.[25] The sale of Kitchener Island seemed to draw a line under the African period of his life. Ahead lay India, with its imperial magnificence, its opportunity for much-needed reform, which would lead unexpectedly to the resounding dispute with the viceroy which turned into a personal quarrel, not of Kitchener's making. Afterwards would come years of achievement in India and beyond, followed by a disappointment which led to further opportunity to serve Egypt, especially its poor. And then the sudden and supreme moment when he was called to save England.

That would be fourteen years ahead. In Khartoum, this November 1902, a speech by an Egyptian kaimakan (lieutenant-colonel) at a dinner in Kitchener's honour at the Egyptian officers' club, offers a fitting coda to the Africa years. Despite the natural exuberance of the original Arabic, the colonel's declamation demonstrates Lord Kitchener's hold, at the age of fifty-two, on the people of the East.

Verily! To your Lordship's prowess the decisive conquest of the Sudan is attributed. What a splendid and experienced leader you are! And how crushing the glorious victories were! Yours is a name that will live as a white mark on the brow of time for ever.

O! Noble minded General, the great hero of South Africa! We will never forget your eminent name. It is engraved on our hearts for ever.

Your glorious deeds coupled with your wonderful fore-thought and admirable management whereby we marched into the tumult of battle and affronted the soldiers' glorious death under your gallant command, have gained for us the highest honour to which one can aspire – to be numbered amongst the gallant warriors.

Your Lordship, all that you have noticed of the vast improvements and the progress of Khartoum City and throughout the places you alighted at or passed by since entering the Sudan on your present visit are the outcome of your brilliant conquests, reflecting great glory and unlimited credit upon you. At last all your stupendous efforts have been crowned with success.

In South Africa you were as one horse against the field, and yet, with

your unfailing energy and indomitable pluck, you conquered, and gained not only the credit of the whole British Nation, but also that of the whole civilized world.

How great is our joy to see you amongst us once more! May'st thou live long! O great and noble General! and enjoy life with felicity and prosperity.[26]

APPENDIX I

KITCHENER AND SEX

A theory gained acceptance after Kitchener's death that he was a homosexual. This became an accepted part of the later twentieth-century portrait, sometimes expanded to suggest that he had a 'taste' for boys.

The theory is destroyed by the contemporary evidence. It was not believed in his lifetime by any who knew him. *The Times* correspondent in Peking in 1909 was told by a British officer who had served in Egypt that Kitchener, 'like most officers in the Egyptian army', had a tendency to buggery, but this was guilt by association. Peter King's *The Viceroy's Fall* (1986) records second-hand gossip, recalled at least seventy-two years later, which would not be accepted as evidence by a court of law; but contemporary private diaries and letters give not the slightest support to the theory, rather the reverse.

The death of his mother when he was on the verge of puberty may have frozen or retarded Herbert's sexual development, yet at 'the Shop' he went to balls, though gauche and shy, and enjoyed the relaxed friendship of his fellow cadet's sisters and friends during the visit to Truro and danced happily with them. Then came the years of intense dedication to his profession in Palestine and Cyprus. Army officers of his time were not expected to marry until at least their late twenties, hence the row over Walter. Many officers may have taken the occasional prostitute, but Kitchener's strong morality and his spiritual experiences at Chatham and Aldershot would have kept him away from brothels even before he joined the Guild of the Holy Standard and pledged himself 'to be sober, upright and chaste'. Working among Arabs and Turks, he could not fail to be aware of sodomy (the word 'homosexual' had not been

coined), but he would have agreed with St Paul's judgement against men who 'burned in their lust towards another'.

Kitchener's unofficial engagement at the age of thirty-three to Hermione Baker is another indication of a heterosexual character. Her death, coinciding with the pressures of the desert campaigns, seems to have turned him into a confirmed celibate, 'married' to his profession, sublimating any sexual urges into the intensities and ambitions of his career, apart from mild flirtations with such as Ellen Peel. As Birdwood noted, K. had no time for marriage.

In 1981 a retired medical major-general, the late Frank Richardson, who was respected for administrative rather than medical gifts, included Kitchener in his book, *Mars Without Venus: A Study of Some Homosexual Generals*. He suggested that Kitchener's passion for porcelain and his love of flower arrang-ing were symptoms of homosexuality. Porcelain is not the preserve of homo-sexual collectors and as for flower arranging, the present writer knew a retired senior general of the Second World War, happily married with three sons and a daughter, who would come down to the village church on the day before a major festival, with his gardener loaded with flowers, and transform the chancel screen into a floral display of great beauty as an aid to Easter or Whitsun worship.

General Richardson insinuates a homosexual implication to the nickname of the creators of the Sudan Military Railway: Kitchener's 'band of boys'. To any contemporary in the Sudan that idea would have been ludicrous. 'The band of boys' label was attached to those sapper officers because they were so young for the job. Any 'boy' whom Kitchener saw on his frequent inspections of the desert line in the making would have been hard at work surrounded by Arab labourers and British NCOs.

Proponents of the homosexual theory also write of 'Kitchener's boys', refer-ring to his ADCs and younger staff officers. Most of these were in their late twenties or older, and later married: the Chief had plenty of godchildren. In the Sudan and South Africa his personal staff were always hard at work in a close-knit team. And as Lord Edward Cecil noticed, K would not allow smutty stories at mess. It is a matter for admiration, not sexual inuendoes, that the stern general had such excellent and even affectionate relations with ADCs like Jimmy Watson and 'the Brat'.

The India period (in Volume 2, to come) is even less encouraging to the theory that Kitchener was homosexual or had a taste for boys. When Hector MacDonald was summoned home from Ceylon to answer allegations that he

had been having sex with native boys, Kitchener wrote to Hunter: 'What a horrible thing this has been about MacDonald. I expect he went quite mad after leaving South Africa. Did you hear anything of the sort before about him? I never did.' That was hardly the reaction of a man affected by a similar sexual pull. And when, in the great quarrel, Curzon's allies spread every libel (such as heavy drinking) they never even hinted at what they would have called unnatural vice or sodomy – even one story half-confirmed would have wrecked Kitchener's career, yet in the gossipy society of Simla, where nothing could be hidden for long, no such story emerged.

General Richardson ends the essay with a comment that Lord Kitchener was drowned in HMS *Hampshire* with Colonel Oswald Fitzgerald with whom he had been *living openly* (author's italics) for over three years. To the reader of 1981 that phrase had only one meaning, and to use it to describe their professional and human relationship during the Great War is offensive. Moreover, at York House 'Fitz', as Military Secretary, was not the only one living at close quarters with the field marshal, now Secretary of State for War in terrible times. His Private Secretary (civil), Sir George Arthur, had parked his beloved wife in the country so that he could be at Kitchener's side whenever needed, day or night. Arthur was a deeply religious man, as also were Fitz (who never married) and Kitchener himself.

Sir Philip Magnus concluded in chat with a friend (and hints at it in his book) that Kitchener was probably homosexually inclined but kept it so tightly controlled that it never had physical expression. No one can fully know another's intimate thoughts, but Kitchener's proposal of marriage to Lady Helen (if true) and his platonic friendships in later life with older women in India, Egypt and England, together with the social, legal, moral and religious attitudes of the period, all suggest strongly that Lord Kitchener was not homosexual.

In a letter to a young cousin who had announced her engagement to a Captain Preston, Kitchener wrote that he hoped to meet him before leaving England again. 'Not having been in the happy state you are in now I hardly know what the correct observation should be but I am quite sure Preston is not good enough for you and though I shall delight in your happiness I cannot help envying his good fortune.'

'Your affectionate cousin, Herbert.'

APPENDIX 2

KITCHENER'S MASONIC
APPOINTMENTS
1883–1902

Like King Edward VII, King George V and many senior officers, including Sir Reginald Wingate, Kitchener was a freemason.

1883	Initiated in La Concordia Lodge, No. 1226, Cairo (lodge erased in 1890).
	[Kitchener does not appear in the Grand Lodge Register under Lodge No. 1226, nor under No. 1355, which is given as his lodge when later a founder of Drury Lane Lodge, No. 2127.
	United Grand Lodge Grand Officers file states his initiation presumed to be in Star of the East Lodge, No. 1355, in 1883 or if not there in the Egyptian Grand Lodge or La Concordia, No. 1226.]
1885	Founder of Drury Lane Lodge, No. 2127, London.
2 November 1889	Joined Bulwer Lodge, No. 1068, Cairo (now meeting in London).
12 February 1890	Exalted in Bulwer Chapter, No. 1068, Cairo.
8 March 1890	Joined Grecia Lodge, No. 1105, Cairo. Worshipful Master, 1892.
15 November 1892	Joined Star of the East Chapter, No. 1355, Cairo. Most Excellent Zerubbabel (i.e. Head of Chapter), 1896.

1895	Founder and 'Honorary Worshipful Master' of the Fatieh Lodge (National Grand Lodge of Egypt).
5 April 1895	Past Senior Grand Warden of Egypt.
1896	Made 'Honorary Worshipful Master' of El Lataif Lodge.
c. 1896	Appointed Past Third Grand Principal of Grand Chapter of Egypt.
1897	Appointed Junior Grand Warden (Past Rank) United Grand Lodge of England (at special Queen Victoria Jubilee Celebration Meeting; Jubilee Medal in Grand Lodge Museum).
1897	Appointed Grand Scribe Nehemiah (Past Rank), Supreme Grand Chapter of England.
1898	Made honorary member of Lodge of Edinburgh, Mary's Chapel No. 1.
1899–1901	District Grand Master, Egypt and the Sudan.
7 November 1902	Joined Khartoum Lodge, No. 2877 (later made honorary member).
29 November 1902	Appointed District Grand Master, Punjab, India.

[Information kindly supplied by the Librarian of the United Grand Lodge of England, Freemasons' Hall, London)

REFERENCES AND NOTES

MANUSCRIPT SOURCES

ABBREVIATIONS

CK Charles Kitchener Papers
Earl K 3rd Earl Kitchener Papers
KP Kitchener Papers, Public Record Office
NAM National Army Museum
RA Royal Archives
RE Royal Engineers Archives
SAD Sudan Archive, University of Durham
Own Words *Kitchener in His Own Words* by J. B. Rye and Horace G. Groser
Kitchener is referred to as K throughout References and Notes

KITCHENER FAMILY COLLECTIONS

Kitchener Papers, Public Record Office. PRO 30.57. Deposited by 3rd Earl Kitchener 1958–59, catalogued 1980.

 124 files, some very extensive: files 1–25 cover 1850–1902; files 26–85 cover 1902/3–1916; files 86–124 are Sir George Arthur's collection of Kitchener biographical material (letters, memoranda, etc.).

 The Kitchener letters to St John Brodrick, afterwards Earl of Midleton, have been incorporated in the Kitchener Papers from the Midleton Papers.

3rd Earl Papers. Manuscripts and press cuttings, etc. remaining in the personal

possession of 3rd Earl Kitchener, including Arthur Kitchener's letters to their father.

Charles Kitchener Papers, collected by the late Charles Kitchener and owned by the Hon. Mrs Charles Kitchener, including K's correspondence with Arthur Renshaw, Mrs Alexander Marc ('Cousin Flo') and others.

Hall Papers. Letters of Major-General Sir Walter Kitchener to his wife and brothers Chevallier and Arthur, letters of K to his father and to his brother Arthur.
Owned by Sir Walter Kitchener's granddaughter, Mrs Peter Hall.

Parker Papers. Letters of K to his sister Millie, Mrs Harry Parker. Owned by her great-granddaughter, Mrs Harriet King.

ROYAL ARCHIVES

Journals of Queen Victoria, King George V when Duke of York and Prince of Wales, and his wife, the future Queen Mary.
Letters to and from Queen Victoria, King Edward VII and King George V, Queen Mary, their Private Secretaries and other members of the Royal Households.

OTHER MANUSCRIPT COLLECTIONS

Biddulph Papers of General Sir Robert Biddulph. Royal Artillery Institute, Woolwich.

Birdwood Papers. Letters and Diary of William Birdwood, afterwards Field Marshal Lord Birdwood. National Army Museum.

Craig-Brown Diary. Imperial War Museum.

Gainford Papers. Diaries and notes of the Rt. Hon. Jack Pease, 1st Lord Gainford. Nuffield College, Oxford.

Gordon Papers. British Library.

Guild of St Helena Archives.

Hamilton Papers. Papers of General Sir Ian Hamilton. Liddell Hart Centre, Kings College, London.

Hatfield Manuscripts. K to Lady Cranborne, later Lady Salisbury, wife of 4th Marquess. Correspondence of 3rd Marquess. Diary of Lord Edward Cecil. Owned by the Marquess of Salisbury, Hatfield House.

Ilchester Papers. Letters of K to Lady Helen Vane-Tempest-Stewart, afterwards Countess of Ilchester. British Library.

Magnus Papers. Papers of Sir Philip Magnus-Allcroft, Bt., relating to his biography of K. Owned by Sir Philip's nephew, Mr Charles Sebag-Montefiore.

Methuen Papers. Letters of K to General Lord Methuen. Wiltshire Record Office.

Marker Papers. Letters of Colonel Raymond Marker to his family. National Army Museum.

Letters of K to Marker, and related papers. British Library.

National Army Museum Archives. Collections as noted, plus miscellaneous items.

Public Record Office. Cromer Papers; Foreign Office Papers.

Rawlinson. Diary of Major Sir William Rawlinson, Bt., afterwards General Lord Rawlinson of Trent. National Army Museum.

Royal Engineers Archives, including K's Confidential Reports and miscellaneous items concerning him.

Stucley Papers. Diary of Colonel Humphrey Stucley, owned by Sir Hugh Stucley, Bt.

Watson. Diary of Major James Watson. National Army Museum.

Wingate Papers, including his diaries, official journal, letters from K. Sudan Archive, University of Durham Library.

Woodliffe Papers. Items about K collected by Mr Allan Woodliffe.

Prologue

1 Kitchener family information.
2 Lady Winifred Renshaw, widow of Arthur Renshaw, to the Hon. Charles Kitchener, 25 November 1964. CK.

Chapter 1: 'A Loving, Affectionate Child'

1 Mrs Marc (cousin Flo, daughter of Emma Day, née Kitchener) to her son Alexander Marc, 7 November 1916. CK.
2 Information from John Chevallier Guild, present owner. See also the *Dictionary of National Biography* for Fanny's father, and Parry-Jones, *The Trade in Lunacy*, 1972.
3 Information on Lieutenant-Colonel Kitchener's army career kindly supplied by the Worcestershire Regiment Museum and the Royal Norfolk Regimental Museum, based on Hart's Annual Army Lists and Regimental Histories.
4 Letter to *The Times*, 1850, reprinted in Webster, *Ireland Considered for a Field of Investment or Residence*, pp. 14–15.
5 Ibid.
6 J. Anthony Gaughan, *The Knights of Glin*, pp. 120–21, and *Listowel and Its Vicinity*, pp. 315–16; Magnus, pp. 4–6. For a fuller study, see Royale, *The Kitchener Enigma*, pp. 7–15. Royale is the only K biographer to have explored his Irish

boyhood. The 29th Knight of Glin, Desmond FitzGerald, FSA, believes that Ballygoghlan had probably been part of the Glin estate and that his ancestor, when the tenant went bankrupt, preferred to sell the freehold to Colonel Kitchener rather than seek another tenant.

7 Sharpe MS. KP, 93, GA3, 11b. Mrs Sharpe's maiden and Christian names are not known. She may have married a Mr Sharpe or been given in later years a cour-tesy 'Mrs'.

8 Ibid., and later quotes in this chapter unless otherwsie identified.

9 Not *foul* language, as in Magnus, p. 4. Walter Kitchener's daughter Madge, who had provided her late father's memories, rebuked Magnus for his mis-take. Madge Kitchener to Sir Philip Magnus, 13 November 1958. Magnus papers.

10 From the first verse of 'From Every Stormy Wind that Blows' by Hugh Stowell (1799–1865).

11 Magnus, p. 6, quoting unspecified (and subsequently unidentified) 'family infor-mation'. Field Punishment No. 1 was abolished in 1923.

12 F. E. Kitchener (1838–1915) contributed the Rugby memoir to the composite two-volume official biography of Frederick Temple, afterwards Bishop of Exeter and Archbishop of Canterbury.

13 Magnus, p. 6, not giving any authority for the statement.

14 Royale, *op. cit.* p.14, from information supplied by the Savage family, owners of Crotta in 1910. The house was demolished in 1921.

15 Ibid., p. 12, quoting B. Beatty, *Kerry Memories*, p. 26.

16 C. E. Gourley, *They Walked Beside the River Shannon*, p. 21, quoted in Gaughan, op. cit., *Listowel and Its Vicinity*, p. 317.

Chapter 2: No Cricket at the Shop

1 In the Parker Papers.

2 Letters from the widow of a successor to Bennett state that K replied to her that it was not he but a brother who had been at the school. Another hand writes on the letter: 'It was Herbert.' KP, 91, GA2, 36, 37.

3 Royale, *op. cit.* pp. 19–20, giving details from the official report.

4 Arthur, *Life*, vol. 1, pp. 6–7.

5 Major-General Sir Lovick B. Friend, remarks to J. A. Pease (a member of Asquith's Cabinet, afterwards Lord Gainford). Gainford MS 42, f. 78. (T/S autobiography, Chapter 4.) Nuffield College, Oxford.

6 Henry Nevinson, quoted in John Fisher, *That Miss Hobhouse*, p. 115; J. A. Pease comment, Gainford MS, op. cit., f. 79.

7 MS Reminiscences (dictated 1926). RA, Add 15.8452; Duke of Connaught to KG V, 8 June 1916. RA, GV A A 42/41.

8 K to Millie, 26 July 1868. Parker Papers.

9 Société d'Émulation des Côtes-du-Nord, *Bulletins et Memoires*, Tome XCI, 1963, p. 127.

10 K to Millie, 31 May [1869]. Parker Papers.

11 K to Augusta Gordon, 16 October 1885. BL Add Mss 51300, f. 156. The early acquaintance between Gordon and Kitchener is not documented, but their meeting first at Sir Henry's home is a reasonable conjecture were it not for Gordon's comment of 1877 (below). For Gordon's story, see the present writer's *Gordon: The Man Behind the Legend* (1993).

12 Colonel Gordon to – Mason, 15 January 1877. NAM.

Chapter 3: Heart and Soul

1 Arthur *Life*, vol. 1, p. 8n.

2 As Magnus asserts, pp. 8–9.

3 The French honoured his intention to serve in battle. In 1913 the Minister of War sent Field Marshal Earl Kitchener the campaign medal, writing that France had not forgotten the Woolwich cadet 'who at a sad hour of our history did not hesi-tate to offer his services and to fight under our flag'. Arthur, *Life*, vol. 1, p. 10 (in the original French).

4 Arthur, *Life*, vol. 1, pp. 10–11. The duke's remark is as Arthur remembered K telling the story. Lord Esher (*The Tragedy of Lord Kitchener*, p. 193) reports a differ-ent version but, as his memory of K's oral reminiscence is faulty in other details, it is not reliable.

5 K to Millie, 26 May [1871]. Parker Papers.

6 Ibid.

7 Details from K to Millie, 26 May [1871], 18 August and 1 December [1872]. Parker Papers.

8 Arthur, *Life*, vol. 1, pp. 5–6. The comments by Col. R. H. Williams, RE, were given orally at Dorchester to H. N. Hill, whose covering letters of 27 and 30 January 1917 to Arthur are KP 91, GA z, 41–2. The notes themselves are not extant.

9 Ibid.

10 16 October 1873. RE, M485.

11 Williams, MS cit., quoted in Arthur, pp. 12–13.

12 Perhaps K's nearest to preaching was his admonition, 'And now Millie you must always remember your awful responsibility in the bringing up of a boy who will eventually in the course of nature be a man, and you must try and inculcate good

things etc etc'. But then he felt embarrassed and ended, 'I thought I was writing a sermon'. K to Millie, 26 May [1871]. Parker Papers.

13 Chevallier family tradition.

14 K to Millie, 3 December 1873. Parker Papers. There is no documentary evidence that Colonel Kitchener blocked this by refusing funds (as in Magnus, p. 11). K would have gone at public expense.

15 K to Millie, 7 March '1874' (misdated for 1875, from Jerusalem). Parker Papers.

16 K to Millie, 18 March 1874. Parker Papers.

17 M. E. Monier, *Dinan: Mille Ans D'Histoire*, Mayenne, 1977, p. 554. Kawara (d. 1928) received the Croix de Chevalier de la Légion d'Honneor.

18 K to Millie, 22 December 1874. Parker Papers.

Chapter 4: 'The Footsteps of our Lord'

1 *Morning Post*, 20 June 1916, letter from A.S.C.

2 K to Millie, 22 December 1874. Parker Papers. Royale (p. 30) has K flirting with her but the MS does not support this.

3 Ibid. The following quotes and details are also from that letter to Millie, or the next dated 7 March 1875.

4 Information from Wellcome Institute of the History of Medicine.

5 K to Millie, 7 March 1875. Parker Papers. Punctuation supplied.

6 Conder, *Tent Work in Palestine*, vol. 2, p. 103.

7 Clermont Ganneau, quoted in Arthur, *Life*, vol. 1, p. 23n.

8 Kitchener argued for Khurbet Minieh, but Tell Hum was positively identified in 1905 and excavated and reconstructed from 1968.

9 Conder, *Tent Work*, vol. 2, pp. 195–9; Arthur, *Life*, vol. 1, pp. 17–18; *Own Words*, p. 32.

10 Arthur *Life*, vol. 1, p. 21 (from the Palestine Exploration Fund archives). The book, obtainable only from the Fund, had a small sale. No copy is in the British Library.

11 *The Sentry*, July 1916. The other quote is from an undated article (c. 1910) by the Reverend F. Penny (Archives of the Guild of St Helena). The guild flourished under the patronage of bishops and generals and founded Soldiers' Institutes in garrison towns at home and abroad. The Anglo-Catholic emphasis of its leaders became rather marked, until the chaplain-general who succeeded Edghill in 1903 (Bishop Taylor Smith, an Evangelical) withdrew his patronage and gave it to the Church of England Men's Society. The guild declined and was wound up in 1921, but its sister organization, the Guild of St Helena, founded in 1879 by Malet's wife, flourishes as a services charity. (Information kindly supplied by the secretaries.)

The (Evangelical) Officers' Christian Union (formerly Prayer Union) ante-

dated the Guild of the Holy Standard, which in turn predated the non-denomi-
national Soldiers' Christian Association (1887), still flourishing after amalgama-
tion with the older Scripture Readers Association (1838) as the Soldiers' and
Airmen's Scripture Readers Association (see Ian Dobbie, *Sovereign Service*, 1988).

12 In *The Tragedy of Lord Kitchener*, p. 7, Lord Esher says that he first heard the name
of K when Gordon eulogized him, and the date of that conversation must be
December 1882. The last time that Gordon and K were in the same country
before that time was New Year 1877.

13 K to 'My dear Miss Hutchinson' (evidently middle-aged or elderly), 5 May 1877.
Parker Papers.

14 K to Millie, 6 June 1877. Parker Papers.

15 K to Millie, 4 September 1877. Parker Papers.

16 For a good summary, see Samuel Daiches, *Lord Kitchener and His Work in Palestine*.
Daiches was a Jewish scholar.

17 Walter Besant, *Twenty-One Years' Work in the Holy Land*, p. 127. Quoted Royale,
op. cit., p. 37.

18 The two were Edmund O'Donovan (killed with Hicks Pasha in 1883) and
Frank Scudamore, later with K in the Sudan. Frank Scudamore, *A Sheaf of
Memories*, pp. 93-4.

19 Walter Kitchener to Amy Fenton, 14 January 1878. Hall Papers. Written from
the Curragh Camp near Dublin, where he was staying with the newly married
Chevallier. Magnus, p. 22, wrongly names the recipient as 'Walter's young wife',
i.e. Caroline ('Carry') Fenton. They married in November 1884. Amy, Hetty
and Carry were daughters of Colonel Kitchener's great friend, Major Charles
Fenton, late 9th Foot.

Chapter 5: Cyprus Survey

1 K to Thomas Clement Cobbold, CB, MP, 11 September 1878. Copy (by Guy
Cobbold) in Magnus Papers.

2 Salisbury to K, 13 Septmeber 1878. No. 53, Cyprus Correspondence 1878-9,
vol. 1, pp. 66-7 (in Biddulph Papers, RA Institute); Walter Kitchener to Amy
Fenton, 3 September 1878. Hall Papers.

3 Walter Kitchener to Hetty Fenton, 4 June 1878. Hall Papers. Magnus names the
wrong sister and interpolates a smell of incense and an exotic brand of tea without
manuscript authority. A later writer then discusses whether these (mythical) fea-
tures were symptoms of homosexuality!

4 K to Millie, 2 Oct 1878. Parker Papers.

5 K to Salisbury, 27 Nov 1878. Cyprus, No. 223.

6 K to Millie, 2 February 1879. Parker Papers.

7 K to Salisbury, 16 May 1879. Cyprus, vol. 2, pp. 7–8; Arthur, *Not Worth Reading*, p. 99.

8 K to Colonel Kitchener, 21 Aug 1879. Hall Papers.

9 K to Millie, 6 September 1879. Parker Papers.

10 Arthur *Life*, vol. 1, pp. 37–8.

11 K to Millie, 12 November 1879. Parker Papers.

12 Ibid., 22 March 1880.

13 Biddulph to Lord Kimberley (Foreign Secretary), 7 July 1881. *Annual Blue Book for 1880*.

14 K to Millie, 18 April 1880. Parker Papers.

15 Arthur, *Life*, vol. 1, p. 42n, quoting an unnamed friend.

16 Biddulph's letter of 7 July 1881, op. cit.

17 Memorandum by K in 1885, printed in Arthur, *Life*, vol. 1, pp. 44–6.

18 K to Millie, 2 August 1880. Parker Papers.

19 Arthur Kitchener, with one page by K, to Colonel Kitchener, 28 September 1880. Earl K.

20 Arthur Kitchener to Colonel Kitchener, 12 July 1882. Earl K. Arthur wrote immense reports to the colonel on every aspect of the Waihemo run's affairs.

21 Arthur, *Life*, vol. 1, p. 42. The colleague, unnamed, may have been (Sir) Charles King-Harman.

22 *Cyprus Herald*, 22 March 1882.

23 K to Arthur Kitchener, 19 March 1881. Earl K.

24 K to Millie, 2 July 1881. Parker Papers.

25 Colonel Kitchener to K, undated. From Sir George Arthur's notes of letters from father to son which were lost or destroyed after 1920.

26 K to Arthur Kitchener, 19 March 1881. Earl K.

27 Arthur Kitchener to Colonel Kitchener, 1 October 1883. Earl K.

28 Colonel Kitchener to K, undated. KP, 98, GA3/13.

Chapter 6: Arabi and After

1 Biddulph family tradition, per Miss Constance Biddulph, granddaughter of Sir Robert. Sir Charles King-Harman (1851–1939) married his daughter in 1888 and was Governor of Cyprus 1904–11.

2 Tulloch, Sir A. B., *Recollections of Forty Years' Service*, p. 264.

3 Frank Scudamore, *A Sheaf of Memories*, p. 96.

4 K to Colonel Falk-Warren, 28 August 1884. *The Times*, 19 August 1932, the letter having been sent by Falk-Warren's son.

5 Colonel Kitchener to Arthur Kitchener, 7 August [1882]. Hall Papers. Because he was unattached and not in uniform he was refused the campaign medal, though recommended for both army and navy campaign medals.

6 K to Biddulph, 2 August 1882, KP, 30/57/1/A5. Biddulph gave this letter to K's family after K's death, two years before his own.

7 Arthur *Life*, vol. 1, p. 49n; Colonel Kitchener to Arthur Kitchener, MS cit.

8 K to Arthur Kitchener, 20 September 1882. Hall Papers.

9 Confidential Report, July 1882. RE, M495.

10 Biddulph family tradition.

11 See the farewell testimonial from the Archbishop, 4 March 1883, quoted in *Own Words*, pp. 76–7.

12 Pollock, *Gordon*, p. 266; Esher, *The Tragedy of Lord Kitchener*. Brett became the 2nd Viscount Esher and a close friend of Kitchener's but rather betrayed him posthumously by his strange book.

13 KP, 1 A 8–9.

14 John Macdonald, *Daily News*, 30 January 1883, quoted with another version in *Own Words*, pp. 71–6.

15 K to Millie, 21 January 1883. Parker Papers.

16 Ibid., 22 March 1883.

17 Arthur Kitchener to Colonel Kitchener, 1 May 1881. Earl K.

18 Arthur, *Life*, vol. 1, p. 50n.

19 K to Millie, 13 March and 1 April 1883. Parker Papers.

20 Ibid., 25 August 1883.

21 A. E. Linney, *Kitchener and the Five Kitchener Lodges*, Transactions of the Bolton Masonic Research Society, 1970. His appointments are listed in Appendix 2.

22 Arthur (*Life*, vol. 1, p. 53) quotes K in a letter of October 1883 to Besant of the PEF as saying he had not been home for five years. He could not have forgotten his home leave of 1881, with the uproar over Walter, so this is probably a transcribing slip at PEF.

23 Arthur, *Life*, vol. 1, p. 55. The letter probably came from Wood, as K's superior, on the instructions of Baring. The original is not in KP.

24 Hon. Secretary of PEF to Arthur, 3 March 1917. KP, 91.48. Tinted spectacles (probably by Zeiss of Jena) were still fairly unusual.

Chapter 7: Blood Brothers on the Desert

1 Quoted in Arthur, *Life*, vol. 1, p. 60. La Terrière's comments are not in KP.

2 Letters to Sir Philip Magnus-Allcroft from Valentine Baker's niece, Mrs Agatha Turning, 31 October 1957, and great-nephew, Robin Bailey, 27 August and 20

November 1957; and from Mrs Bonte Sheldon Elgood, 1959 (T/S copy). Magnus Papers. Also Chevallier family information. Edith Cobbold, a second cousin, married Fanny Kitchener's nephew, John Monins. Edith was a close friend of K's, and her daughter married Toby, his heir, after K's death.

3 K to Colonel Kitchener, 20 March 1884. Parker Papers.
4 K to Colonel Kitchener, 25 March 1884. Parker Papers.
5 K to Millie, 10 April 1884. Parker Papers.
6 Ibid.
7 Mrs Bonte Shelton Elgood to Magnus, 1959. T/S copy. KP, 102 PA 24.
8 Robin Bailey to Magnus, 27 August 1957 (Bailey was a nephew of Annie, who married General Sir Elliott Wood); Mrs Agatha Turning (Lady Wood's sister) to Magnus, 31 October 1957. Magnus Papers. Their mother, Mrs Bourne, was Valentine Baker's sister.
9 Robin Bailey heard about the locket in K's lifetime, when staying with Sir Samuel Baker's widow before 1914. Mrs Turning believed it was later handed to the Dean of St Paul's (Inge) but was unable to discover whether it is actually in the sarcophagus beneath K's effigy. Magnus Papers, MSS cit.
10 K to Colonel Kitchener, 14 May 1884. Parker Papers.
11 K to Millie, 11 July 1884. Parker Papers.
12 Arthur, *Life*, vol. 1, p. 73. Lieutenant-General Sir Frederick Stephenson to Military Secretary, War Office, 1 September 1884. RE, M495.
14 K to Millie, 4 April 1885. Parker Papers.
15 Arthur, *Life*, vol. 1, p. 99.

Chapter 8: Lifeline to Gordon

1 Sir Ronald Storrs, *Orientations*, p. 133.
2 K to Millie, 25 April 1885. Parker Papers. He was criticizing Hake's *Life of Gordon* (1884), which she had sent him.
3 Sir George Arthur, *Not Worth Reading*, p. 117; Sir Ronald Storrs, *Orientations*, p. 133; Lord Edward Cecil, *Leisure of an Egyptian Official*, p. 192.
4 H. Seymour to Sir Henry Ponsonby, 24 August 1884. RA Add A12/2216.
5 Arthur, *Life*, vol.1, pp. 74–5. KP, 4, D9–10. Lieutenant-General Sir Frederick Stephenson to Military Secretary, War Office, 1 September 1884. RE, M495.5.
6 See telegrams in KP, 4. D.
7 K to Millie, 4 October 1884. Copy in another hand in Parker Papers; KP, 4.D.22(a).
8 Arthur, *Life*, vol. 1, p. 88; K to P. Ralli, 12 January 1885. KP, 5, E12. Printed Arthur, *Life*, vol. 1, pp. 90–93, slightly edited.

9 K to Ralli, MS cit. (12 January 1885).

10 See précis of telegrams 24 August to 11 October 1884. KP, D225, 226.

11 K to Ralli. MS cit.

12 K to Colonel Kitchener, 1 December 1884. Parker Papers.

13 Ibid. 24 November 1884. Hall Papers.

14 Colonel Sir Charles Wilson to K, 10 November 1884. KP, 4, D158. As K did not file the cypher, these telegrams were decoded only in 1959 by the PRO and were not available to Magnus.

15 *The Journals of Major-General C. G. Gordon, CB at Khartoum*, ed. A. Egmont Hake, pp. 360, 362 and 363.

16 K to Colonel Kitchener, 1 December 1884, MS cit.

17 K to Millie, 12 December 1884. Parker Papers.

18 Lieutenant-General Sir Frederick Stephenson to Military Secretary, War Office, 1 September 1884. RE, M495.

19 K to Colonel Kitchener, 26 December 1884. Hall Papers.

20 Adrian Preston, *In Relief of Gordon: Lord Wolseley's Campaign Journal*, p. 108.

21 Preston, op. cit., p. 129.

22 The Bishop of Plymouth (RC) to Arthur, 22 March 1925. KP, 91, P174.

23 Brindle must have told it often, as the versions given by Sir Evelyn Wood, in *From Midshipman to Field Marshal* (vol. 2, p. 174), and Frank Scudamore are slightly different.

24 Sir George Arthur, *Not Worth Reading*, pp. 116 and 117.

25 K to Colonel Kitchener, 17 March 1885. Arthur, *Life*, vol. 1, p. 105 (original MS missing).

Chapter 9: His Excellency

1 Arthur, *Not Worth Reading*, pp. 119–20.

2 Wolseley to Queen Victoria, 5 May 1885. RA O.26/12. Sir Charles Wilson's opinion was also to be asked. Wolseley consented, while pointing out that, as both officers were on the staff of the army he commanded, the request was irregular.

3 K to Colonel Kitchener, 16 February 1885. Hall Papers. K to E. A. Floyer (head of telegraphs), 17 March 1885. RE, 5001.4/3 (ES41).

4 Diary of Colonel Willoughby Verner. *The Nineteenth and After*, August 1916, p. 289.

5 It would have been at this time that an incident could have occurred but is probably apocryphal. According to a Canadian war correspondent writing fourteen years later, Kitchener disguised himself as an Arab prisoner and spent a night in the guard tent, where he overheard details of a plot to murder Wolseley and others.

Next day he was nearly murdered himself when the ringleader recognized him as he sat in full uniform with Wolseley, trying the case. The man jumped on Kitchener and nearly throttled him before being overpowered. The story is improbable, if only because such a memorable incident finds no mention in Wolseley's day-by-day journal. (See Charles Lewis Shaw, *Canadian Magazine*, March 1899.)

6 K to E. A. Floyer, 24 May 1885. RE, 5001.41/5 (E.S.41).

7 Arthur, *Life*, vol. 1, p. 105. Original not in KP.

8 Kitchener's *Notes on the Fall of Khartoum* is printed in Arthur, *Life*, vol. 1, pp. 116–24.

9 Lord Desborough's address at the Canadian Red Cross Hospital, Cliveden, 10 June 1916.

10 K to Colonel Kitchener, 3 July [1885]. Hall Papers.

11 K to E. A. Floyer, 6 September [1885]. RE, 5001.41.2 (E.S.41).

12 Magnus's assertion (p. 69) that K pulled 'every string within reach' is not supported by contemporary evidence. He also misdates the appointment.

13 K to Millie, 11 January 1886. Parker Papers.

14 This was Charles Watson, RE, who as a young officer had served in Equatoria under Gordon, whom he admired tremendously. Watson, personally brave, had a distinguished later career in survey, etc. and was knighted.

15 K to Arthur Kitchener, 5 November 1886. Hall Papers.

16 K to Millie, 7 September 1887. Parker Papers.

17 Abd Allahi Muhammad Turshain, Khalifat al-Mahdi (1846–99). His earlier victories had been a principal factor in the Mahdi's success. See Richard Hill, *A Biographical Dictionary of the Sudan*, 2nd edn.

18 K to *The Times*, 9 January 1888; K to Major-General Sir F. Grenfell, 1 January 1889. Quoted in *Own Words*, pp. 87 and 100–101.

19 K to Grenfell, 6 February 1887, quoted in *Own Words*, p. 95.

20 Sir Francis Grenfell to ? Salisbury, 31 December 1888. Copy in RA 0.27/44.

21 Fox's letter is quoted in *Own Words*, p. 98.

22 Baring to Sir P. Anderson (Permanent Under-Secretary), 24 March 1888. PRO, FO.633.5, p. 199.

23 K to E. A. Floyer, 31 December 1886. RE, 5001.41.6.ES.41. Magnus, p. 73.

24 K to Arthur Kitchener, 5 November 1886. Hall Papers.

25 Colonel Kitchener to K, 5 November 1886. Hall Papers. Undated letters quoted in Sir George Arthur's summary of letters no longer extant. KP, 93 GA 3.13.

26 A. B. M. Shakespear Bey to Millie, 19 January 1888. Galbraith's account is 24 January and McMurdo's (below) 10 February. McMurdo had replaced Peel. Parker Papers.

27 Wolseley to K, 3 February 1888. KP, 5.E.44.

28 K to Millie, 17 March 1888. Parker Papers.

29 Sir Henry Ponsonby (HM's Private Secretary) to the Duke of Cambridge, 21 March 1888. RA, E.63/29.

30 K to Millie, 1 May 1888. Parker Papers.

31 Grenfell to War Office, 19 February 1888. RE, 5001.

Chapter 10: Sirdar

1 Lord Edward Cecil, *Leisure of an Egyptian Official*, p. 183.

2 K to Arthur Kitchener, 13 August [1888]. Hall Papers.

3 Ibid., 4 September 1888. Hall Papers (and next quote, re grouse).

4 K to Millie, 24 July 1889. Parker Papers.

5 RE, ME 5001. Grenfell's response to the printed list of personal qualities was: 1. *Judgement*: Good, 2. *Tact*: Fair, 3. *Temper*: Good. 4. *Self-reliance*: Great. 5. *Power of Commanding Respect*: Sufficient.

6 K told this *c.* 1912 to Sir Maurice Amos, who told it to Stephen J. Gordon. Letter from S. J. Gordon to Magnus, 7 November 1958. Magnus Papers.

7 K to Millie, 14 January 1891, Parker Papers.

8 K to Millie, 12 February 1892. Parker Papers.

9 Cecil, op. cit., p. 184.

10 Martin Gilbert, *Sir Horace Rumbold*, p. 18.

11 Frank Scudamore, *A Sheaf of Memories*, p. 104.

12 Betty Askwith, A Victorian Young Lady, 1978, pp. 136–9.

13 For further details, see the list of Kitchener's Masonic appointments in Appendix 2. He was District Grand Master of Egypt and the Sudan 1899–1901.

14 K to Lady Cranborne, 9 November 1889. Hatfield MSS.

15 K to Millie, 4 October 1889. Parker Papers.

16 K to Millie, 14 January 1891 and 12 February 1892. Parker Papers.

17 Margot Asquith, *More Memories*, pp. 121–2.

18 Wingate Diary of the Inspection 13–23 January 1894. Wingate Papers, SAD. Original: 102.4.1–45. Copy in W's hand: 179.4.110–127. John Marlowe, *Cromer in Egypt*, pp. 173–7; Arthur *Life*, vol. 1, pp. 181–3; KP have nothing; Magnus, pp. 83–9. Magnus wrongly says the incident was hushed up; it was fully reported in the British press. His view of the incident's effect on K is questionable.

19 K to Edith Chevallier (afterwards Preston), 23 February 1894. CK.

20 K to Arthur Kitchener, 19 August 1894. Hall Papers.

21 Ibid. Letters 33–41 in Hall Papers.

22 K to Wingate, 2 August 1894. SAD, 256.1.249.

23 Marlowe, op. cit., pp. 200–201.

24 Walter Kitchener to his wife, 9 April 1896. Hall Papers.

25 Arthur, *Life*, vol. 1, p. 187; Scudamore, op. cit., p. 99. No copy of the telegram is in KP.

Chapter 11: *Advance up the Nile*

1 Arthur, *Life*, vol. 1, pp. 187–8. The best modern account of the campaigns of 1896–8 is in Henry Keown-Boyd, *A Good Dusting: The Sudan Campaigns 1883–1899*. The classic contemporary account is Winston Churchill's *The River War*, 1899. For a Sudanese history, see I. H. Zulfo, *Karari*.

2 The French and Russian Commissioners voted against but were outvoted by the British, Italian, German and Austrian. The money was therefore advanced, but the two dissenters sued the Egyptian government for its return on the ground that the decision should have been unanimous. See Marlowe, *Cromer in Egypt*, p. 203.

3 KP, 12. K 8 and 9.

4 Marlowe, op. cit., p. 202; KP, 11, J 1–9. The telegrams from the War Office to Knowles were shown to K only when the command was settled in his favour. Wingate's remark to his son that K was 'worried to death about his own position' (Sir Ronald Wingate to Magnus, 5 March 1956. Magnus Papers) referred to a later episode, in 1897.

5 MS memories of Major-General Sir Nevill Maskelyne Smyth, VC. KP, 93, GA 12. p. 1; Arthur, *Life*, vol. 1, pp. 193–4; Sir Victor Mallet, ed., *Life with Queen Victoria*, p. 100.

6 E. W. C. Sandes, *The Royal Engineers in Egypt and the Sudan*, p. 174.

7 Scudamore, op. cit., p. 95.

8 Cromer to Salisbury, 15 March 1896. Hatfield MSS, A/109. Quoted in Marlowe, op. cit., p. 206.

9 Lord Edward Cecil, op. cit., pp. 183–4; Arthur, *Not Worth Reading*, p. 80; Kenneth Rose, *The Later Cecils*, pp. 193–6.

10 For Watson, see Repington, *Vestigia*, p. 156ff, and *Roll of Honour* of 60th Rifles, 1942, pp. 105–6. The Cecil diary, unpublished, is in Hatfield MSS.

11 For Hunter, see Duncan H. Doolittle, *A Soldier's Hero: The Life of General Sir Archibald Hunter*, p. 80, and Archie Hunter, *Kitchener's Sword-Arm*. For Wingate, see Sir Ronald Wingate, *Wingate of the Sudan*.

12 A man commissioned from the ranks was usually sent to another regiment, except for ex-regimental sergeant-majors who became 'captains and quartermasters'. For MacDonald, see Royale, *Death Before Dishonour*.

13 Scudamore, op. cit., p. 138.

14 Before modern suncreams English faces in the tropics tended to burn red rather than brown under their obligatory sun-helmets.

15 Wingate, op. cit., p. 106.

16 Doolittle, op. cit., p. 80.

17 Slatin to Queen Victoria, 26 June 1896. *Letters of Queen Victoria*, Third Series, vol. 3, pp. 51–2.

18 Cromer to Sir Francis Knollys (Private Secretary to the Prince of Wales), 20 June 1896. RA, W49/62.

19 Doolittle, op. cit., p. 80.

20 But see St Luke's Gospel, Chapter 17, Verse 9.

21 Hunter, op. cit., p. 51.

22 N. M. Smyth, VC, MS cit., p. 5. KP, 93 GA3.12.

Chapter 12: Dongola 1896

1 It was said that the doctors were terrified of Kitchener and did not dare to demand more supplies.

2 A. G. C. Liddell, *Notes from the Life of an Ordinary Mortal*, p. 335.

3 K to Edith Cobbold, afterwards Mrs John Monins, as quoted by her to her grandson Charles Kitchener on his confirmation, 26 November [1936]. CK.

4 N. M. Smyth, VC, MS cit., p. 3.

5 Cecil, op. cit., p. 187.

6 W. E. Bailey was later Assistant Adjutant-General, Egyptian Army, and retired after the First World War as a major in the British Army; he died in 1934. Keown-Boyd, *Soldiers of the Nile*, p. 25.

7 Cecil, op. cit., pp. 185–8.

8 Cecil, op. cit., p. 187.

9 Hunter to George Hunter, 31 August 1896, quoted in Hunter, op. cit., pp. 53–4.

10 Hunter, op. cit., p. 53, quoting Cecil's diary about Hunter's 'murder' dispatch, and p. 52, describing Hunter's letter. This is not in KP. Possibly the dispatch mentioned by Cecil was in fact the letter.

11 N. M. Smyth, VC, MS cit., p. 2.

12 Ibid. See also Arthur, *Life*, vol. 1, p. 199.

13 Magnus, p. 99.

14 Cecil, op. cit., p. 190.

15 N. M., Smyth, MS cit., p. 2.

16 The reason was not generally known until Zulfo found evidence in the 1970s. See Zulfo, op. cit., p. 66.

17 *The Sudan Campaign* 1886–1899, by 'An Officer' (i.e. H. L. Pritchard, RE), p. 70.

18 *Letters of Queen Victoria*, Thid Series, vol. 3, p. 80.

Chapter 13: The Impossible Railway

1 Promotion proposed by the Secretary of State for War, 24 September 1896. RE, M495.

2 Victor Mallet, ed., *Life with Queen Victoria*, p. 99. The quotation from Marie Mallet below is from p. 100.

3 Queen Victoria's Journal, 16 November 1896. RA QVJ of E. W. C. Sandes, *Kitchener the Man*, RE Journal, December 1943, p. 230.

4 The dissenting French and Russian Commissioners had appealed to the Mixed Tribunal on the ground that the decision should have been unanimous. The tribunal found in their favour.

5 Magnus, pp. 102–103, quoting Hatfield MSS.

6 Doolittle, op. cit., p. 152.

7 E. W. C. Sandes, *The Royal Engineers in Egypt and the Sudan*, p. 233; Arthur, *Life*, vol. 1, p. 208, quoting 'a staff officer'.

8 Sandes, op. cit., p. 226.

9 The story of the construction of the SMR is told in Sandes, op. cit., Chapter 9.

10 RE 5001 (Miscellaneous Papers).

11 Sandes, op. cit., p. 222.

12 Doolittle, op. cit., p. 113. Kipling's 'Recessional' appeared shortly after. Both officers would have been astonished that within a century 'our pomp of yesterday Is One with Nineveh and Tyre'.

13 Watson Diary. NAM, RC 8412–4–6.

14 Ibid., 12 July 1897.

15 N. M. Smyth, VC, MS cit., p. 5. Ibrahim not only captured Berber but lived to be received by King George V in London in 1919.

16 The British officers killed at Omdurman on 2 September 1898 were serving with the British brigades.

17 K to Arthur Renshaw, 29 September 1897. CK.

18 N. M. Smyth, VC, MS cit., pp. 7 and 8; Keown-Boyd, op. cit., p. 61.

19 Sir Ronald Wingate to Magnus, 5 March 1956. Magnus Papers.

20 Arthur, *Life*, vol. 1, p. 217.

21 Sir Ronald Wingate, MS cit.

22 Grenfell Diary, 12 October 1897. Typed copy in KP, 10.I. p. 4.

23 Watson Diary, 16 October 1897.

24 Quoted in Sandes, op. cit., p. 204n.
25 Quoted in Magnus, p. 110. The Cromer–Salisbury correspondence of this time is well set out in Magnus, pp. 110 ff.
26 MS cit. Arthur bowdlerized 'cross' to 'ill'!
27 Watson Diary, 6–11 November 1897.
28 Grenfell Diary, 18 November 1897, MS cit.
29 K to Renshaw, 9 December 1897. CK.
30 Wingate Diary, 31 December 1897. SAD, 102/1/7.
31 Ibid., 5 January 1898.
32 Ibid., 14 January 1898.
33 Colonel F. W. Rhodes, Royal Dragoons, was a distinguished soldier but had been placed on the retired list for involvement in the Jameson Raid. He was restored for his services at Omdurman, where he was wounded. Kitchener scarcely knew him before 1898, but they became warm friends. He was welcomed as a member of the Sirdar's own headquarters mess. He distinguished himself in the South African war.
34 Ibid., 5 February 1898.
35 Walter Kitchener to his wife, 3 and 6 February 1898. Hall Papers.
36 Wingate Diary, 5 February 1898, MS cit. Cromer made a similar remark to Salisbury. A joke had the deaf Walter Kitchener going to sleep in his tent in a full camp and waking up next morning to find all gone.
37 F. Maurice, *The Life of General Lord Rawlinson*, pp. 31–2. With regard to the 'growling', when Cromer had assured Salisbury in February that K's eyesight and general health were 'not poor as reported', he added: 'The other soldiers are so fanatically jealous that they would welcome any excuse to get him away.' Cromer to Salisbury, 5 February 1898. Hatfield MSS, quoted Magnus, p. 119.
38 The phrase K used to (Sir) Ronald Storrs when describing it. Ronald Storrs, *Orientations*, p. 134.

Chapter 14: Crux of a Career

1 Rawlinson Diary, 19 March 1898. NAM. Charles à Court Repington, *Vestigia*, p. 167. He and his father changed their name from à Court to Repington in 1903 on inheriting an estate.
2 Walter Kitchener to Arthur Kitchener, 20 April, completed 6 May 1898. Hall Papers.
3 Repington, op. cit., p. 165.
4 Walter Kitchener to Arthur Kitchener, MS cit. K would say: 'Regulations are for the guidance of fools'.

5 Repington, op. cit., p. 128, printing a letter he (then à Court) wrote shortly after the battle of the Atbara.

6 Sir Ronald Storrs, *Orientations*, p. 134.

7 Wolseley to K, 14 April 1898. KP, 10.I.5. K's wire to Cromer (not in KP) is in Magnus, pp. 119–20.

8 Repington, op. cit., p. 161. A slightly different version is given by Lord Esher to Lord Knollys, quoting Charles à Court (later Repington), 9 August 1903. RA W 38/110.

9 Churchill, *The River War*, vol. 1, pp. 144–5.

10 Repington, op. cit., p. 33.

11 Walter Kitchener to Arthur Kitchener, MS cit.

12 Repington, op. cit., p. 117.

13 Walter Kitchener to his wife, 14 April 1898. Hall Papers. Magnus (p. 121) interpolates, without MS authority, 'and rebuking men for wasting ammunition in that way', thus turning K's act of mercy into one of economy!

14 Walter Kitchener to his wife, 14 April 1898; Repington (à Court), op. cit., pp. 159–60. Charles à Court Repington, writing twenty years later, says that he persuaded a reluctant K to come and address the men, but Walter, writing only six days after the battle, gives no indication of this and implies that their coming up at that moment was a coincidence. But there may have been a conversation outside Walter's range of hearing.

15 Arthur, *Life*, vol. 1, p. 228.

16 Repington, op. cit., p. 162.

17 Bennett Burleigh, *Sirdar and Khalifa*, p. 248. Burleigh was an eyewitness of the incident; I. H. Zulfo, *Karari*, p. 80; Arthur, *Life*, vol. 1, p. 228.

18 Noble Frankland, *Witness of a Century*, p. 213. The same phenomenon was noted in 1942 in the Western Desert campaign by the chaplain of the Queen's Bays when, after Alamein, they reached the site of their defeat seven months earlier at Msus. He could identify by facial features several bodies of officers and men found in smashed tanks. John Pollock, *Fear No Foe: A Brother's Story*, 1992, p. 134.

19 Maurice, *Rawlinson*, p. 34. Some critics blamed Kitchener because financial stringency had reduced the number of medical officers in the expedition.

20 Walter Kitchener to Arthur Kitchener, MS cit.

21 G. W. Steevens *With Kitchener to Khartoum*, p. 166.

22 Bennet Burleigh, op. cit., p. 269. Walter Kitchener's sketch is in his letter to his wife, 12 April 1898. Hall Papers.

23 The chains, halter, whipping, etc. as imagined by Magnus (p. 122) may have arisen from his misinterpreting Steevens. The Magnus version, and more lurid radio broadcast based on it by Christopher Sykes, so distressed a former head of Gordon Memorial College, N. R. Udal, that he protested to the BBC

Chairman and wrote to the 3rd Lord Kitchener to say that during his twenty-four years' service in the Sudan, 1906–30, 'I am quite sure I should have heard of it if it had been true, and it seems to me in complete variance with your great-uncle's treatment of the Sudanese, by whom he was universally venerated when I was there'. N. Robin Udal to Lord Kitchener, 5 March 1960; also 19 March. Earl K.

Magnus is not reliable on the Atbara battle and its aftermath. He seems to have slanted his account to support his claim that K was brutal: e.g. he writes that K won it 'at a cost of 583 casualties which to a general reader implies *deaths*, a vast exaggeration of the 71 actually killed on the Anglo-Egyptian side. When one of K's surviving friends read Magnus and told the Earl of Dunmore, VC, who as Lord Fincastle had served on his staff in Dongola, that a writer had portrayed K as brutal, he exclaimed: 'Kitchener brutal? Ridiculous!' Lady Winifred Renshaw to Magnus, 6 March 1961. Magnus Papers.

Lord Dunmore told Lady Winifred that he 'liked K very much' and was disappointed that the War Office refused him permission to be an ADC in the Omdurman campaign because he was on the Indian establishment. Lady W. Renshaw to Charles Kitchener, 1965. Note in CK.

24 Repington, op. cit., p. 111.
25 K to Wolseley, 6 October 1898 (referring to the Atbara). KP, 10, I 9.
26 N. M. Smyth, VC, MS cit., p. 6.

Chapter 15: Approach March

1 MS Recollections of Major Humphrey St Leger Stucley (1877–1914), 1910. Stucley Papers.
2 Ibid.
3 Walter Kitchener to Chevallier Kitchener, 16 September 1898. Hall Papers.
4 Repington, op. cit., p. 164.
5 Sandes, op. cit., p. 220.
6 H. Keown-Boyd, *Soldiers of the Nile*, p. 170; Repington, op. cit., p. 159; [George Arthur], *Some Letters of A Man of No Importance*.
7 RA, GV.cc.47/218. See also George Arthur, *Not Worth Reading*, pp. 168–9.
8 Randolph S. Churchill, *Winston S. Churchill Companion*, vol. 1, p. 971.
9 See, e.g., Doolittle, op. cit., p. 151.
10 K's verbal message to the *Daily Mail* correspondent with him in South Africa on hearing of Steevens's death at Ladysmith aged thirty-one. *Daily Mail*, 25 January 1900. Quoted in *Own Words*, p. 161. I have been unable to find a source for the 'drunken swabs' story before Magnus, who gives no authority for it but is often

quoted. Philip Ziegler has kindly told me that in his *Omdurman* he relied on Magnus for this story and K's relations with the press.

11 *The Times*, 2 December 1898. Quoted in *Own Words*, p. 130n.

12 Walter Kitchener to his wife, 22 August 1898. Hall Papers.

13 Ibid.

14 Walter Kitchener to Chevallier Kitchener, 16 September 1898. Hall Papers.

15 The general reader will find a good account of the battle in *Omdurman* by Philip Ziegler and in Henry Keown-Boyd, *A Good Dusting*. The account given in E. W. C. Sandes, *The Royal Engineers in Egypt and the Sudan*, though necessarily limited in scope, is excellent. There are numerous eyewitness accounts by journalists and officers. Zulfo's *Karari* describes it from a Sudanese standpoint. References for quoted MS sources are given in the next chapter.

Chapter 16: Omdurman

1 Doolittle, op. cit., p. 169.

2 Quotations from Walter Kitchener are taken from the following letters: to his wife, 4, 11 and 16 September 1898; to his brother Chevallier, 16 September; to his brother Arthur, begun 23 September, continued 1 October 1898. Hall Papers.

3 Doolittle, op. cit., p. 171.

4 Rawlinson, op. cit., pp. 38–9.

5 Stucley MS.

6 Quoted Ziegler, op. cit., p. 144.

7 Colonel David Francis Lewis (1855–1927). On retirement after the First World War he became military correspondent of *The Times*.

8 MacDonald to General Knowles, date unknown as first page of MS missing, but between 8 and 22 October 1898. Woodliffe Papers.

9 (General Sir) John Grenfell Maxwell (1859–1929). He put down the Easter Rising in Dublin, 1916.

10 Sandes, op. cit., p. 268.

11 MacDonald to Knowles, MS cit.

12 'A good dusting': Churchill, *The River War*, II, p. 162.

13 Stucley MS.

14 Ernest Bennett in the *Contemporary Review*, taken up by C. P. Scott in Parliament. K's official rebuttal is in *Own Words*, p. 155. See Randolph S. Churchill, *Winston Spencer Churchill*, vol. 1, p. 424; Army and Navy Gazette, 25 March 1899.

15 Scudamore, op. cit., p. 208.

16 Stucley MS.

17 Doolittle, op. cit., p. 173.
18 Scudamore, op. cit., pp. 214–15.
19 Stucley MS; Scudamore, op. cit., p. 217.
20 Magnus, p. 131, probably based on a Grenadier traditional story.

Chapter 17: 'Heroic Soul Whose Memory We Honour'

1 Memorandum by Wingate, 3 March 1899.
2 K to Cromer, 1 February 1899. Cromer Papers, PRO, 30.51.14, M 11 R2.
3 Walter Kitchener to his wife, 11 September 1898; Cecil, op. cit., p. 192. Cecil, writing twenty years later, forgot that Walter had been with them.
4 Walter Kitchener, ibid.
5 Brindle gave the paper to Rawlinson, who pasted it into his diary (now in NAM). It is reproduced facsimile in Maurice's *Life of Rawlinson*, pp. 40–41.

 K tried to get a knighthood for Brindle, but this was ruled out as inappropriate for a chaplain. He received a third bar to his DSO. After retirement from the army he became Bishop of Nottingham and died within a few days of K.
6 Maurice, op. cit., p. 42; Prince Francis of Teck to Duchess of York, begun 31 August 1898, completed after the battle. RA GV.cc.52.363. Unfortunately his handwriting on very thin paper is nearly indecipherable.
7 Repington, op. cit., pp. 170–71.
8 Scudamore, op. cit., p. 221.
9 RA, QVJ, 5 September 1898.
10 Arthur, *Life*, vol. 1, p. 245, is in error in writing that the telegram announcing the peerage was received and given out at the close of the memorial service.
11 *Letters of Queen Victoria*, Third Series, vol. 3, p. 275.
12 Ibid., pp. 283–4.

Chapter 18: The Diplomat of Fashoda

1 Smith-Dorrien, *Memories of Forty-Eight Years' Service*, pp. 121–9.
2 Sandes, op. cit., p. 280.
3 Watson Diary, 17 September 1898. NAM.
4 See Thomas Pakenham, *The Scramble for Africa*; Patricia Wright, *Fashoda*; Darrell Bates, *The Fashoda Incident 1898*.
5 Kitchener's dispatch, dated 30 September, is quoted in *Own Words*, pp. 133–9.
6 At the Lord Mayor's state luncheon to K, 4 November 1898.
7 J. B. Marchand to Walter Kitchener, 28 November 1898. Hall Papers.

8 RA, O 30/59.

9 K to his chousin, Mrs Emma Day, 7 October 1898. CK.

10 Walter Kitchener to his wife, 23 September 1898. Hall Papers.

11 Arthur, *Life*, vol. 1, p. 245. Probably to Arthur Renshaw, possibly to Sir George Arthur himself. Both MSS correspondences are lost.

12 K's title standardized the spelling as Khart*oum*. Previously it had been more usually spelt Khart*um*, which is a closer transliteration of the Arabic. K realized that English people would probably in ignorance pronounce Khartum to rhyme with tum-tum (which was Society's nickname for the Prince of Wales!).

 The Kitcheners, like many rising families in the nineteenth century, were using arms which had not been matriculated at the College of Arms and therefore were not legal until Francis Kitchener, the headmaster, petitioned for them in 1899 after the new peer's arms had been matriculated, using their traditional achievement: in lay terms, a coat of three bustards within a saltire; a crest of a stag's head pierced by an arrow; and the family motto, *Thorough*. Lord K chose two camels for supporters, suggested by Walter (as a joke, he told his wife, 1 January 1899); he replaced one with a gnu (wildebeest) when raised to a viscountcy for his services in South Africa.

13 Walter Kitchener to Arthur Kitchener, 1 October 1898. Hall Papers.

14 Details from K's letter to Queen Victoria. *Letters of Queen Victoria*, Third Series, vol. 3, pp. 352–53.

 The probability that the box was weighted is deduced from Cromer's conviction that no bones were kept as souvenirs.

15 Laurence Housman in *Victoria Regina*. The sketch was not included in the stage version of 1937.

16 W. S. Gordon's plan of the tomb is in possession of his grandson, Mr David Gordon.

17 Churchill, *The River War*, vol. 2, p. 214.

18 Queen Victoria to K, 24 March 1899. KP, II. T/S copy in RA Add V.18. See *Letters of Queen Victoria*, Third Series, vol. 3, pp. 353–4.

19 Cromer to Salisbury, Quoted M. W. Daly, *Empire on the Nile*, p. 6.

Chapter 19: The Magic Wand

1 Walter Kitchener to his wife, 10 and 16 November 1898. Hall Papers.

2 *The Dover Express*, 28 October 1898.

3 Mallet, op. cit., p. 142.

4 *The Times*, 28 October 1898.

5 RA QVJ, 22 November 1898 (and quote below).

6 Walter Kitchener to his wife, RA QVJ 31 October 1898.

7 Mallet, op. cit., p. 147.

8 Jane Ridley, ed., *The Letters of Arthur Balfour and Lady Elcho*, 1992, p. 156.

9 [Arthur] *Some Letters . . .*, op. cit., p. 67.

10 Telegram of 5 November 1898. *Letters of Queen Victoria*, Third Series, Vol. 3, p. 309.

11 [Arthur] *Some Letters . . .*, pp. 66–7.

12 Walter Kitchener to his wife, 1 January 1899. Hall Papers.

13 Mrs Florence Marc (neé Day) to her son, 7 November 1916. CK.

14 K's letter to *The Times*, 30 November 1898.

15 Edinburgh, 29 November 1898. *Own Words*, p. 143.

16 Cecil, op. cit., pp. 192–3.

Chapter 20: Rebuilding a Nation

1 K to Queen Victoria, 29 December 1898. RA O 31/39.

2 Walter Kitchener to his wife, 1 January 1899. Hall Papers.

3 K to Queen Victoria, as above.

4 Sandes, op. cit.

5 See J. S. R. Duncan, *The Sudan: A Record of Achievement*, 1932 and Sir Harold MacMichael, *The Sudan*. Both had served in the Sudan. Also M. W. Daly, *Empire on the Nile*.

6 Cromer to K, 19 October 1898. KP, 14, M1 pp. 35–7.

7 Cromer to K, 19 January 1899. KP, M3 pp. 14.42.

8 K to Queen Victoria, 21 January 1899. RA O 31/52.

9 Quoted in Daly, op. cit., p. 30.

10 Ibid.

11 K to Wingate, ND. Wingate Papers, 269.2.34.

12 K to Queen Victoria, 21 January 1899. RA, 031.52. See Watson Diary, MS cit., 8–21 January 1899.

13 The Memorandum to Mudirs, printed in Parliamentary Papers, Egypt, 1900, Number 1, pp. 55 ff., is reproduced in *Own Words*, pp. 145–54. The chief part is printed in J. S. F. Duncan, op. cit., pp. 85–7, and MacMichael, op. cit., pp. 74–6.

14 Walter Kitchener to his wife, 7 February 1899. Hall Papers.

15 Noble Frankland, *Witness of a Century*, pp. 212–13; Watson Diary, MS cit., 20–25 February 1899.

16 K to Wingate, 6 February 1899. Wingate Papers, 269.2.19.

17 Cromer to Salisbury, 2 February 1899. Cromer Papers, PRO Letter 308.

18 Quoted in H. C. Jackson, *Pastor on the Nile*, pp. 20–21. See also E. M. Edmonds to George Arthur, 28 September 1916. KP, 91.62.

19 Scudamore, op. cit., p. 94.
20 K to Wingate, 1 February 1899. Wingate Papers, 269.2.1. See also Ibid., 7 April (269.4.23). Cromer remarked to Salisbury (18 February) that K was 'such a terrible hand at quarrelling with everyone, except himself', but it was only with Gorst, and some bullying of his own financial officer, O'Leary, sandwiched between them.
21 Babikr Bedi, *Memoirs*, vol. 2, pp. 82–3.
22 Cromer to Salisbury, 19 May 1899. Hatfield MSS.
23 Ibid.

Chapter 21: Bobs and K

1 Typed copy sent by Viscountess Gage (Julian's sister) to Magnus. Magnus Papers. The boy's account is also quoted in Lord Desborough's address, *Lord Kitchener as I Know Him*, 11 June 1916 (where also is K's remark about home). KP, 119.
2 K to Lady Helen V-T-Stewart, ND. Ilchester Papers, BL Add Mss 51370, f.163.
3 The Grand Duchess of Mecklenburg to the Duchess of Cornwall and York, 27 August 1901 (Princess of Wales from November). RA GV CC 2929.
4 K to Lady Helen, 4 October 1901. BL Add Mss 51370, f. 170.
5 W. R. Birdwood (afterwards Field Marshal Lord Birdwood) to his wife, October 1900. NAM, 6707.19.236.
6 K to Wingate. N.D. [1899] Wingate Papers, 269.2.34.
7 For a full and most readable account of the origin and course of the South African war, see Thomas Pakenham, *The Boer War*.
8 J. A. Spender, *Life, Journalism and Politics*, 1927, p. 61. Spender, then aged thirty-eight, had bicycled down to the Durdans for an hour or two with Rosebery. K happened to be staying and Spender was introduced, Rosebery warning him that he might be 'eaten alive' as his *Westminster Gazette* had led the agitation over the Mahdi's skull, etc. But K seemed entirely unaware of the connection.
9 Queen Victoria to Salisbury, 10 February 1900. RA, P.6.88 (copy); Salisbury to Queen Victoria, 12 February 1900. *Letters of Queen Victoria*, Third Series, vol. 3, p. 486.
10 Queen Victoria to K, 24 July and 17 November 1899, 29 June 1900. KP, 16.R4(a), 5(c), 7(a); K to Queen Victoria, 25 July 1899. RA, O.31.76.
11 K to Lady Cranborne, 30 August 1899. Hatfield MSS.
12 K to Lady Cranborne, 6 November 1899. Hatfield MSS.
13 Queen Victoria to K, 22 December 1900. KP, 16.R.5.
14 K to Lady Helen V-T-Stewart, 28 December [1899]. BL Add Mss 51370, f. 165.
15 Watson Diary, 21–6 December 1899. NAM.

16 Lieutenant-General Sir John Stokes to K, 22 December 1899. KP, 17. S2. Stokes had known Gordon well and was vice-chairman of the Suez Canal Company.
17 K to Lady Helen, MS cit.
18 E. A. Baines, quoted in David James, *Lord Roberts*, p. 362.
19 Dudley Sommer, *Haldane of Cloan*, p. 182.
20 K to Pandeli Ralli. Arthur, *Life*, vol. 1, p. 275.

Chapter 22: *The Battle that Went Wrong*

1 K to Roberts, 16 February 1900. KP, 17 S5(b).
2 Kitchener had been promoted major-general before Kelly-Kenny and was therefore technically senior although carrying lower rank in South Africa.
3 Arthur, *Life*, vol. 1, p. 280. For a vivid and detailed account of the battle of Paardeberg, 18 February 1900, see Pakenham, *The Boer War*, pp. 332–40.
4 Queen Victoria to K, 22 December 1899. KP, 16 R.5(a).
5 Quoted in Pakenham, op. cit., p. 335.
6 Major-General H. A. MacDonald to K, 30 January 1900. KP, 17. S4.
7 Three hundred and three killed at Paardeberg; Anglo-Egyptian killed or died of wounds 1896–8, approximately two hundred and sixty.
8 Quoted from the Official History by Pakenham, op. cit., p. 338.
9 Watson Diary, 20 February 1900. MS cit.
10 Ibid., 22 February 1900.
11 K to Julian and Billy Grenfell, Kronstadt, 13 May 1900. Typed copy by their sister, Viscountess Gage. Magnus Papers.
12 K to Queen Victoria, 14 May 1900. RA P9 73. The father of a friend of the present writer was wounded in this way and carried a bullet in his body until his death aged eighty-three.
13 K to Lady Cranborne, 16 March [1900]. Hatfield MSS.
14 K to Queen Victoria, 4 March 1900. RA, p. 7.38.
15 Colonel J. M. Grierson to Arthur Bigge, 14 March 1900. RA P7 172a. Grierson rose to be a lieutenant-general. In August 1914, shortly after landing in France in command of an army corps, he died of a heart attack in a railway train. Smith-Dorrien took his place.
16 K to Lady Cranborne, 29 April 1900. Hatfield MSS.
17 Ibid., 7 June 1900.
18 Diary of Lieutenant Craig-Brown, 5 June 1900. 1 AM 92.23.2. EC.B.2.2 (photostat copy).
19 Ibid.
20 'Lord Curzon is evidently anxious to have you as Commander-in-Chief.' Roberts to K, 28 February 1901, after returning home. KP, 20. f. 6.

21 Roberts to Lansdowne, 19 September 1900. RA, p. 13.76 (copy).
22 Marquess of Lansdowne to Sir Arthur Bigge, 29 September 1900. RA W 16/78.
23 Bigge to Lansdowne, 29 September 1900 (copy). RA W 16/72. Other remarks paraphrased from RA, W 16/86, Notes by Sir Frederick Ponsonby, HM's Private Secretary, to Bigge, 4 October 1900, of the Queen's detailed comments to be passed to Lansdowne.
24 Lansdowne to Bigge, MS cit.
25 Sir A. Davidson to Bigge, 28 August 1900. RA P 12/76.
26 K to Lady Cranborne, 5 November 1900. Hatfield MSS.
27 In conversation with N. M. Smyth, VC, in the Sudan, Smyth, VC, *Reminiscences*. KP, T/S cit.
28 K to Queen Victoria, 12 October 1900. RA P 14/27.

Chapter 23: 1901: Peace Aborted

1 Birdwood to his wife, 10 October 1900. NAM, 6707.19.4, f. 230.
2 Ibid., ND, 1901. f. 238.
3 Ibid., 23 October 1900. f. 132. In his MS notes to Arthur and in his autobiography *Khaki and Gown*, Birdwood described this incident as if he had been present, but the contemporary letter is conclusive.
4 Lord Birdwood, *Khaki and Gown*, p. 118.
5 Queen Victoria to K, 16 November 1900. KP, 16.R.23.
6 Princess Beatrice to K, 8 February 1901. KP, 104 PA5.14.
7 K to Lady Cranborne, 5 November 1900. Hatfield MSS.
8 Sir A. Milner to K, 31 October 1900. KP, 17.S.7.
9 Sir George Arthur, *Not Worth Reading*, p. 98.
10 K to Lady Cranborne, 11 January 1901. Hatfield MSS.
11 K to Arthur Renshaw, 26 January 1901. Copy in CK.
12 Viscount Esher to Lord Knollys, quoting J. G. Ewart, 10 October 1906. RA W 40/62.
13 K to Brodrick, 22 February 1901. KP, 22.Y.26.
14 Ibid.
15 Charlotte Maxwell, *Frank Maxwell, VC*, 1921, p. 79.
16 Watson Diary, 28 February 1901; Maxwell, op. cit., p.79.
17 K family tradition.
18 K to Brodrick, 22 March 1901. KP. 22, Y33.
19 Ibid.
20 K to Lady Cranborne, 8 March 1901. Hatfield MSS.

21 Rayne Kruger, *Good-bye Dolly Gray*, p. 413.
22 K to Lady Cranborne, 15 April, 7 June and 21 June 1901. Hatfield MSS.
23 Viscount Esher, *Journals and Letters*, vol. 1, p. 238.
24 Lord Milner to Sir Francis Knollys (Lord Knollys from 1902), 30 June 1901. RA, W.60. 126.
25 Watson to K, 12 April 1901. KP, 17. S.13.

Chapter 24: 'I wish I could see the End'

1 K to Lady Cranborne, 2 August [1901]. Hatfield MSS.
2 See John Fisher, *That Miss Hobhouse*.
3 K's letters to Brodrick and to Lady Cranborne, and Maxwell's and Raymond Marker's (see below) to their parents mention visits.
4 K to Lady Cranborne, 1 January 1902. Hatfield MSS.
5 K to Arthur Renshaw, 5 July [1901]. CK.
6 Maxwell, op. cit., p. 94.
7 Colin Benbow, *Boer P.O.W.s in Bermuda*, passim.
8 K to Brodrick, 21 June 1901. KP, 22.Y.63. An unprejudiced reading of the original does not support the assertion by Magnus (p. 185) that K 'fulminated'.
9 Adolphus G. C. Liddell, *Notes from the Life of an Ordinary Mortal*, p. 337. He heard Solomon say this in November 1902 at a small London dinner party which included the new Prime Minister, Balfour.
10 Pakenham, op. cit., p. 539. Five Australians and one English officer had been court-martialled for multiple murder. The execution of only Morant and Handcock caused an outcry in Australia.
11 Walter Kitchener to J. Monins, 21 August 1901. KP, 17 S.20.
12 Caroline Kitchener died 3 November 1901; Caroline to Hal Kitchener, 2, 23 October 1901; Miss Lloyd to Miss Fenton, 6 November 1901. Hall Papers; K to Renshaw, 13 November 1901, CK.
13 The duke's Diary, 9 June 1899. RA, GvD.
14 Maxwell, op. cit., p. 88.
15 RA GVAl 9/35, copy ('My letter to Papa'); GVD, 14 August 1901; K to King Edward, 16 August 1901. W 60/130; Bigge to King Edward [1 September 1901]. W 6/70; Maxwell, op. cit., p. 89.
16 Byng family tradition, per Mr Julian Byng. Evelyn's father, Sir Richard Moreton, was a younger brother of the 3rd Earl of Ducie, who was Lord-Lieutenant of Gloucestershire for fifty-four years.
17 Sir Neville Lyttleton, *Eighty Years' Soldiering*, p. 257.
18 See K to Brodrick, 2 August 1901. KP, 22.Y.79.

19 K to Lady Cranborne, 20 September 1901. Hatfield MSS.

20 Major Marker to his sister, 20 September 1901. Marker Papers. NAM, 6803.4.4.f. 26.

21 Birdwood to K (after Marker's death in action in 1914), 13 January 1915. KP, 61.WL1.

22 Marker to his sister, 17 and 25 May 1901. MS cit., ff. 20, 21.

23 K to Lady Cranborne, 18 October and 23 November 1901. Hatfield MSS. K to Arthur Renshaw, 13 November 1901. CK. See also K to General Lord Methuen, 20 November 1901. Methuen Papers, Wiltshire Record Office.

24 Roberts to K ('Secret'), 19 October 1901. KP, 20.0.43; K to Roberts, ND (draft of telegram in reply to above). KP, 21.P.1; see also telegram 5 November, p. 3.

25 Milner to Chamberlain, quoted in G. H. L. Le May, *British Supremacy in South Africa, 1899–1907*, p. 121.

26 Not October, as Hamilton writes in *The Commander*, p. 100. His memory in old age was faulty on this point, but his chapter on Kitchener, partly used also in his autobiography, is excellent.

27 Pakenham, op. cit., p. 537.

Chapter 25: 'We are Good Friends Now'

1 See the guidebook to Melrose House, Pretoria; the house is open to the public.

2 See Ian Hamilton, *The Commander*, p. 102.

3 C. E. Caldwell, *Confessions of a Dug Out*, p. 43.

4 Lady Allendale to K, 31 October 1914. KP, 108 PA 8.2

5 Maxwell to his father, 13 September 1901. *Frank Maxwell*, op. cit., p. 93.

6 Sir Ian Hamilton, op. cit., p. 107. See 1 Samuel, Chapter 16, Verses 22 and 23; Chapter 18, Verses 10 and 11.

7 Marker to his sister, 18 October 1901. MSS cit., f. 29.

8 *Maxwell*, op. cit., pp. 81–2, 86–7. This occurred shortly after the Botha talks.

9 Marker to his sister, 17 January 1902. MSS cit., f. 31.

10 K to Renshaw, 26 January 1902. CK.

11 Arthur, *Life*, vol. 2, p. 73n; *Maxwell*, op. cit., pp. 95–6.

12 *Maxwell*, op. cit., pp. 96, 98 and 100 for quotes re peace negotiations.

13 Sir Ian Hamilton, 29 July 1922. Speech when unveiling Kilmadock War Memorial, Doune. Hamilton Papers, 39.12.45. Liddell Hart Centre, King's College, London.

14 Quoted Le May, op. cit., p. 138.

15 K to Lady Cranborne, 20 April 1902. Hatfield MSS.

16 Smuts's remark was to Sir George Arthur. Arthur, *Not Worth Reading*, p. 98.

17 K's copy of the Treaty of Vereeniging is in Earl K.

Chapter 26: Looking Forward

1 Sir Rennell Rodd to K, 7 June 1902. KP, 17.S.22. Rodd (afterwards Lord Rennell), diplomatist, scholar and poet, had been in charge of the Cairo Agency at the time of Fashoda and now was First Secretary in the embassy at Rome.

2 K to the Hon. (Sir) Schomberg MacDonnell, 5 June 1901. Hatfield MSS.

3 Schomberg to Sir Francis Knollys, 9 June 1901. Hatfield MSS.

4 K to MacDonnell, 11 June 1902. Hatfield MSS.

5 *London Gazette*, 28 July 1902. Salisbury had supposed K would want to be 'of Khartoum and of Vereeniging'. Birdwood, according to his not always very reliable recollections in old age, thought the omission of Arthur was an oversight and offered to put it right, but K said, 'He is not a soldier, Birdie. Leave it alone', so that Birdwood thought his attitude cavalier and that he was not fond of Arthur, quite wrongly.

6 K to Lord Roberts, 8 June 1902. KP, 17.S.25.

7 [Charlotte Maxwell], *I am Ready*, privately printed 1955, pp. 50, 11.

8 K to Renshaw, 29 July 1901. CK.

9 Both Magnus, p. 191, and Royale, p. 189, repeat this libel as if true. The facts are in the MS correspondence in RE, being 22 letters dated 11 January 1903 to 21 July 1914 (SA 61, 93), together with a typed summary. Also the supplement to the *RE Journal* for February 1921. An undated MS note from Lady Broome to Magnus after reading his book, and another typed note by her dated December 1977, both in CK, give the facts about the return of the statues to Pretoria. See also Standard Encylopaedia of South Africa, p. 474.

10 Prince of Wales Diary, 12 July 1902 (and quotation above). RA GVD. Princess of Wales Diary, 12 July 1902. RA QMD. cc68. 18. p. 193.

11 [Sir George Arthur], 14 July 1902, *Some Letters . . .*, p. 155.

12 Rawlinson, op. cit., p. 79.

13 K to Renshaw, ND, 'Thursday' (July 1902). CK.

14 RA GVD, 13 August 1902.

15 Aspall Visitors Book for 1902. John Chevallier-Guild and his mother showed the rug to the author.

16 Memo by Julian Grenfell, 1902; typed copy by his sister Viscountess Gage. Magnus Papers.

17 Prince of Wales to Princess of Wales, 17 August 1902. RA, Geo V. cc 3.32.

18 A. G. C. Liddell, *Notes from the Life of An Ordinary Mortal*, p. 334 (diary entry for 2 August 1902).

19 K to Renshaw, Thursday (19 September 1902). CK.

20 Sir Ian Hamilton, op. cit., pp. 115–16.

21 Kenneth Rose, *The Later Cecils*, pp. 203–204 (and next quote); K to Renshaw, 21 February, 10 May, 24 September and 19 October 1902. CK.

22 *The Times*, 12 November 1902; Sandes, op. cit., pp. 475–6.

23 C. E. C. G. Charlton, *A Soldier's Story*, p. 59.

24 *The Times*, 12 November 1902; K to Wingate, 15 November 1907 and 24 December 1908. Wingate Papers.

25 K to Renshaw, 18 November 1902. CK.

26 Speech by Kaimakan Mohmud Bey Husai, Khartoum, 7 November 1902. Translation T/S, KP, 36. JJ: 2.

SELECT BIBLIOGRAPHY

For the reader's convenience this list gives details of books cited in References and Notes. Many other biographies, memoires, journalists' accounts and historical works were consulted.

Place of publication London unless noted otherwise.

Arthur, Sir George, *Life of Lord Kitchener*, 3 vols, 1920

 A Septuagenarian's Scrapbook, 1933

 Not Worth Reading, 1938

 A Glance From His Letters, ed. Christopher Pemberton, privately printed, Birmingham, 1950

[Arthur, Sir George], *Some Letters of A Man of No Importance*, 1928

 More Letters . . ., 1930

Asquith, Margot, *More Memories*, 1933

Babikr Bedi, *Memoirs*, Vol. 2, translated by Ysuf Beolti and Peter Hogg, 1980

Bates, Darrell, *The Fashoda Incident 1898*, 1984

Beatty, B., *Kerry Memories*, Camborne, 1939

Benbow, Colin, *Boer P.O.W.'s in Bermuda*, Bermuda, 3rd edn, 1994

Besant, Sir Walter, *Twenty-One Years' Work in the Holy Land*, 1889

Birdwood, Lord, *Khaki and Gown*, 1942

Burleigh, Bennett, *Sirdar and Khalifa*, 1899

Caldwell, C. E., *Confessions of a Dug Out*, 1920

Cecil, Lord Edward, *Leisure of An Egyptian Official*, 1938

Charlton, C. E. C. G., *A Soldier's Story*. privately printed, 1963

Churchill, Winston S., *The River War*, 2 vols, 1899

Churchill, Randolph S., *Winston Spencer Churchill*, Vol. 1, *Youth*, 1966. Companion Volumes

Conder, C. R., *Tent Work in Palestine*, 2 vols, 1878

Daly, M. W., *Empire on the Nile*, Oxford, 1986

Daiches, Samuel, *Lord Kitchener and His Work in Palestine*, 1915

Doolittle, Duncan H., *A Soldier's Hero: The Life of General Sir Archibald Hunter*, Narragansett, Rhode Island 1991

Duncan, J. S. R., *The Sudan: A Record of Achievement*, 1932

Esher, Viscount, *The Tragedy of Lord Kitchener, Journals and Letters*, 4 vols, 1934–8

Fisher, John, *That Miss Hobhouse*, 1971

Frankland, Noble, *Witness of A Century: The Life and Times of Prince Arthur, Duke of Connaught 1850–1942*, 1993

Gaughan, J. Anthony, *The Knights of Glin*, Dublin, 1978 *Listowel and Its Vicinity*, Cork, 1973

Gilbert, Martin, *Sir Horace Rumbold*, 1973

Gordon, Charles, *The Journals of Major-General C. G. Gordon*, ed. E. Hake, 1885

Hamilton, Sir Ian, *The Commander*, ed. A. Farrar-Hockley, 1957

Hill, Richard, *A Biographical Dictionary of the Sudan*, 2nd edn, 1967

Hunter, Archie, *Kitchener's Sword-Arm: The Life and Campaign of Sir Archibald Hunter*, Staplehurst, 1996

Jackson, H. C., *Pastor on the Nile*, 1960

James, David, *Lord Roberts*, 1953

Keown-Boyd, Henry, *A Good Dusting: The Sudan Campaigns 1883–1899*, 1986
 Soldiers of the Nile: British Officers of the Egyptian Army 1882–1925, Thornbury, 1996

Kruger, Rayne, *Good-bye Dolly Gray*, 1983 edn

Letters of Queen Victoria, Second Series, 3 vols; Third Series, 3 vols, ed. G. E. Buckle, 1928–32

Le May, G. H. L., *British Supremacy in South Africa, 1899–1907*, 1965

Liddell, A. G. C., *Notes From the Life of An Ordinary Mortal.*, 1911

Lyttleton, Sir Neville, *Eighty Years' Soldiering*, 1927

MacMichael, Sir Harold, *The Sudan*, 1955

Magnus, Philip, *Kitchener: Portrait of An Imperialist*, 1958

Mallet, Sir Victor, ed., *Life with Queen Victoria*, 1968

Marlowe, John, *Cromer in Egypt*, 1970

Maurice, Frederick, *The Life of General Lord Rawlinson*, 1928

Maxwell, Charlotte, *Frank Maxwell, V.C.*

Meintjès, Johannes, de la Rey, *Lion of the West*, Johannesburg 1966

Pakenham, Thomas, *The Boer War*, 1979
 The Scramble for Africa, 1991

Pollock, John, *Gordon: The Man Behind the Legend*, 1993

Preston, Adrian, *In Relief of Gordon: Lord Wolseley's Campaign Journal*, 1967

[Pritchard H. L.], *The Sudan Campaign 1896–1899*, by 'An Officer', 1899

Repington, Charles à Court, *Vestigia*, 1919

Rose, Kenneth, *The Later Cecils*, 1975

Royale, Trevor, *Death before Dishonour: The True Story of Fighting Mac*, Edinburgh, 1982

 The Kitchener Enigma, 1985

Rye, J. B., and Groser, Horace G., *Kitchener in His Own Words*, 1917

Sandes, E. W. C., *The Royal Engineers in Egypt and the Sudan*, 1937

Scudamore, Frank, *A Sheaf of Memories*, 1925

Smith-Dorrien, Sir Horace, *Memories of Forty-Eight Years' Service*, 1925

Sommer, Dudley, *Haldane of Cloan*, 1960

Steevens, G. W., *With Kitchener to Khartoum*, 1898

Storrs, Sir Ronald, *Orientations*, 1937

Tulloch, Sir A. B., *Recollections of Forty Years' Service*, 1925

Warner, Philip, *Kitchener: The Man Behind The Legend*, 1985

Webster, William Bullock, *Ireland Considered for a Field of Investment or Residence*, Dublin, 1852

Wingate, Reginald, *Mahdism and the Egyptian Soudan*, 1896

Wingate, Sir Ronald, *Wingate of the Sudan*, 1955

Winstone, H. V. F., *The Diaries of Parker Pasha*, 1983

Wright, Patricia, *Fashoda*, 1972

Wood, Sir Evelyn, *From Midshipman to Field Marshal*, 2 vols, 1906

Ziegler, Philip, *Omdurman*, 1972

Zulfo, Ismat Hazan, *Karari*, translated by Peter Clark, 1980

Also *The Times, The Daily Telegraph, Morning Post, Daily News, Westminster Gazette, Army and Navy Gazette, Blackwood's Magazine, Contemporary Review, Cyprus Herald, The Nineteenth Century and After.*

INDEX

Kitchener is referred to as 'K' throughout index